Views of Difference: Different Views of Art

Views of Difference: Different Views of Art

EDITED BY CATHERINE KING

Yale University Press, New Haven & London
in association with The Open University

Acknowledgement

Grateful acknowledgement is made to the following source for permission to reproduce material in this book.

Pages 184–5: Tagore, R. (1930) 'My pictures', *The Modern Review*, XLVIII (48), pp.603–4. (Every effort has been made to trace the copyright owner and the publisher would be pleased to make the necessary arrangements at the first opportunity.)

Library of Congress Cataloging-in-Publication Data

Views of difference: different views of art / edited by Catherine King.
 p. cm. - - (Art and its histories : 5)
 Includes bibliographical references and index.
 ISBN 0-300-07763-7 (cloth : alk. paper). - - ISBN 0-300-07764-5 (pbk : alk. paper)
 1. Art- -Historiography Case studies. 2. Imperialism in art Case studies. I. King, Catherine, 1948– . II. Series.

N7480.V56 1999 99-11673
709—dc21 CIP

Edited, designed and typeset by The Open University.

Printed in Italy

a216b5i1.1

1.1

Contents

Preface

This is the fifth of six books in the series *Art and its Histories*, which form the main texts of an Open University second-level course of the same name. The course has been designed both for students who are new to the discipline of art history and for those who have already undertaken some study in this area. Each book engages with a theme of interest to current art-historical study, and is self-sufficient and accessible to the general reader. This fifth book examines the way in which dominant European views of difference in the colonial past tended to represent the art of the colonized, or those beyond colonial control, as inferior and inalterable, or slow to change. It looks at the different views of artistic diversity posited by the colonized, and those independent of European government, in order to propose relations of equality, rather than subordination. As part of the course *Art and its Histories*, the book includes important teaching elements and the text contains discursive sections written to encourage reflective discussion and argument.

The six books in the series are:

Academies, Museums and Canons of Art, edited by Gill Perry and Colin Cunningham

The Changing Status of the Artist, edited by Emma Barker, Nick Webb, and Kim Woods

Gender and Art, edited by Gill Perry

The Challenge of the Avant-Garde, edited by Paul Wood

Views of Difference: Different Views of Art, edited by Catherine King

Contemporary Cultures of Display, edited by Emma Barker

Open University courses undergo many stages of drafting and review, and the book editors would like to thank the contributing authors for patiently reworking their material in response to criticism. We are especially grateful to Nicola Durbridge, who worked tirelessly to improve the arguments and content of the book in general. We have signalled in the author attributions her particular assistance with the pedagogic input for four of the case studies. In these case studies, we may change voice to signal personal opinions or experiences. Special thanks also go to Professor Will Vaughan and Professor Craig Clunas, who provided detailed and constructive criticisms of an early draft of this book and whose ideas and comments influenced the development of the text. We would also like to thank Magnus John and John Picton for reading the Introduction to the book and giving helpful overall advice. The course editors were Julie Bennett and Nancy Marten, picture research was carried out by Magnus John, and the course secretary was Janet Fennell. Debbie Crouch was the graphic designer, and Gary Elliott was the course manager.

Introduction

CATHERINE KING AND GILL PERRY
WITH NICOLA DURBRIDGE

We want in this introduction to familiarize you with some of the key ideas that have shaped the formal study of cultural difference and thus provide a conceptual and historical backcloth for the body of the book – the case studies that lie ahead. Towards the end of the introduction we give some details about the contents of these case studies.

Exploring difference

This book is about the way in which views of cultural difference that were developed by European colonizers have coloured, and still colour, the evaluation of the arts made by colonized peoples and their descendants. The book explores the different interpretations of these arts, past and present, by artists and historians, some of whom share the perspectives of the colonizers and their heirs and others who do not. It is written with the belief that a productive exploration of difference between artists and cultures must include both asking artists to tell historians how they wish to define their art and seeking to reconstruct the ways in which art was used by different societies in the past.

Within recent theory (originating from sociology and art history) the term 'difference' can have many associations, although it is usually tied to the concepts of social, cultural, or psychic identity, and to the idea that identities are constructed rather than fixed or absolute. Art historians who are interested in psychoanalysis and issues of gender often use the term 'sexual difference' to represent the different sexual identities that individuals may possess or develop. In this book we focus on the nature and construction of cultural differences, and the ways in which cultural identities may be defined or understood in relation to each other. An interest in 'difference' allows us to consider the ways in which peoples and societies have often sought to define themselves in relation to (what they saw as) their opposites. Colonial European powers, for example, often defined themselves as 'civilized' in relation to what they saw as their relatively 'uncivilized' colonial conquests. This perception of difference was tied to imperial political ambitions; it involved relations of power. Perceptions of similarity and difference may be a basic way of categorizing the world. (It is often remarked, for example, that we learn to discriminate between objects by comparing their qualities – their shape, size, colour, etc. We learn, in sum, what a thing is by deciding what it is and is not like.) It is, however, one thing to recognize each other's differences. It is another matter to label others as 'different' and define them as inferior.

The 'one' is secured by the 'other'

During the nineteenth and early twentieth centuries, European colonizers treated colonized peoples' cultures and the peoples themselves not simply as different but as different and inferior. In his book, *Black Skin, White Masks* (1952), the cultural theorist Frantz Fanon noted this effect:

> I meet a Russian, or a German, who speaks French badly. With gestures I try to give him the information that he requests, but, at the same time I can hardly forget that he has a language of his own, a country, and that perhaps he is a lawyer or an engineer there. In any case he is foreign to my group, and his standards must be different. When it comes to the case of the Negro, nothing of the kind. He has no culture, no civilisation, no long historical past.
>
> (1986 translation, p.34)

Fanon suggested that a colonized culture was not treated simply as though it entailed another – presumed equal – set of practices, but as a subordinate system. His title implies that the person with black skin was turned by the power of the person with white skin into a 'white mask'. Persons designated as 'black' were not recognized as being able to announce their changing senses of themselves, and to define the white person and other black persons from their own perspectives, relative to their own identities. They were not valued like people from other European nations, Fanon argued, as being different merely in terms of language and history yet the same in their equal status as human consciousnesses. They were what he termed the silenced 'other'. As we shall see, this concept of 'otherness' has become central to contemporary debates within post-colonial theory (that is, the theory about the legacy of European colonialism).

It was during the late nineteenth century too that scholars developed disciplines that were to institutionalize the study of the art and culture of colonized societies. In particular, what was first called ethnography and later anthropology developed in Europe and North America. It is from this perspective and in this context that we find a formal vocabulary being used that served to entrench western ideas of 'otherness' and its equation with inferiority. For example, the art of colonized and formerly colonized areas was spoken of in terms of 'artefacts' and 'material culture' made by 'craftworkers', and not as 'works of art' made by 'artists'. As emphasized by the artist and critic Gavin Jantjes, writing in the catalogue to the exhibition 'The Other Story' (1989), 'the history of modernism,[1] with its Eurocentric world view, has always demanded that the rest of the world's art be explained by scientific means: anthropology, ethnography, archaeology – rather than aesthetics' (*The Other Story*, p.126). The way the 'one' had 'art' and 'craft' while the 'other' had only 'craft' had the effect of associating the arts of colonized peoples and their descendants with manual, non-intellectual, repetitive, and unimaginative dexterity.[2] In *Art Criticism and Africa* (1997),

[1] On the same page (*The Other Story*, p.126) Jantjes defines modernism: 'modernism claims leadership through its unscientific esoteric responses to the modern age. It is believed to be above and ahead of history, leaving everyone else pondering the past and trapped in traditions.' See also Wood, *The Challenge of the Avant-Garde* (Book 4 in this series).

[2] See Barker, Webb, and Woods, *The Changing Status of the Artist* (Book 2 in this series), in particular the historical introduction and Case Study 1.

the artist and critic Chika Okeke underlines the way in which these constructs 'operate as an intellectual device for trivialising, or denying the profundity of all artistic endeavours of the voiceless. The Yoruba[3] master, Adugbologe, was a "carver" – therefore a craftsman – while the Italian master, Bernini, was a "sculptor" and an artist' ('Beyond either/or: towards an art criticism of accommodation', p.91).

A related point worth registering at this stage is the different overtones to the word 'primitive' in much western art historiography (Plate 1). The idea of the 'primitive' is fundamental to the concept of an inferiorized cultural

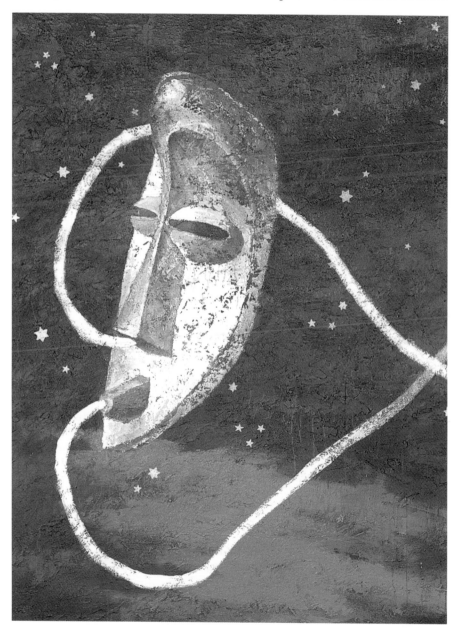

Plate 1 Gavin Jantjes, detail of *Untitled* (Plate 4).

[3] A people of Nigeria.

'other'. It is often used, for example, to represent the views of European artists, such as the painters Paul Gauguin and Pablo Picasso, who were looking to supposedly 'primitive' cultures of Africa and the Pacific as sources of artistic inspiration around the end of the nineteenth century. Although many western artists saw these cultures as a rich source of aesthetic ideas, they were considered in terms of the opposition they represented to the apparently sophisticated, industrializing West. For example, the subject-matter of Gauguin's art in the 1890s was inextricably bound up with the colonial culture of Tahiti and French Polynesia. Gauguin's images were made to be sold in Paris, and showed sensual, dark-skinned women luxuriating in a fertile, tropical environment, contributing to the various myths and fantasies through which the colonizer (France) represented the colonized society (Tahiti).

To define a society as 'primitive' denoted a belief that a culture was fossilized at a stage of evolution through which western societies had passed. It did not include an understanding of the way in which societies develop sophisticated sets of beliefs and regulations independent of their repertoire of technical skills.

Western art historians were also fond of denying that other cultures had made any art at all before the twentieth century. In *Art Criticism and Africa*, the art historian John Picton explains:

> Sometimes even in the most reputable quarters it is said that, before the twentieth century, there was no art in Africa, no 'Art', that is, as 'we' have it in the 'West'. Of course, if there were no art, there would be no art criticism either. This will not do. First, there are all the problems of an account determined by 'us' versus 'them' (not least the impossibilities of determining who is in what category, etc.), or the 'West' versus what. Secondly, it is also the case that it was not long before the twentieth century, that there was no art (i.e. 'Art') in Europe either. Words such as art, craft and technology after all derive from words for skill (Latin, Anglo-Saxon and Greek respectively) and their separation into seemingly distinct frameworks of activity is very much a part of the development of ideas and practices in eighteenth-century Europe.
>
> ('Yesterday's cold mashed potatoes', p.21)

The tendency to associate higher forms of art with a written tradition of theory and history ignores the importance of oral discussion about art. It seems likely, according to Picton, that 'art criticism as a discourse that enables, directs, understands, encourages, imagines and discourages, but which does not determine, must have evolved even as art itself evolved' ('Yesterday's cold mashed potatoes', p.22).

Even though large areas of the globe did not fall under western imperial domination, colonial observers during the nineteenth and early twentieth centuries treated all non-European cultures in similar ways. To explore this imperialist 'shadow' effect, we may consider the treatment of art in China. Here was a field that could hardly be treated as backward, since it pre-empted norms of western high art practice: it had a written theory and history before any such texts were produced in Europe. The solution – for western art historians – was to classify Chinese art as different from the progressive art of the West by interpreting it as unchanging. We should be clear that the word 'unchanging' (were this description of Chinese art even true) was intended to imply a lack, as we can see from its opposition to 'progression'.

There is no suggestion here of something more positive – such as perhaps that Chinese art had achieved some sublime height from which it would be pointless, and indeed impossible, to move on.

In other cases, western art historians saw the culture of the 'one' as making art that constantly progressed and developed, while they thought of the 'other' as making art that was decaying. In his book *Much Maligned Monsters: A History of European Reactions to Indian Art* (1977), the historian Partha Mitter shows that this was the way in which Indian art was interpreted.

There is a further dimension to the idea of the 'other' that has come under scrutiny – generally speaking, from the 1960s onwards. This has led to a focus on examining relations of power and on uncovering how the powerful remain 'on top'. As part of this, certain dominant forms of art history, such as biographies of individual artists being written in Europe and North America, have been increasingly challenged from various 'outsider' positions, including those relating to issues of class, gender, and ethnicity. (The term 'ethnicity' was often used to designate groups differentiated by such factors as supposed racial categories or religious beliefs. Increasingly, the preferred usage indicates cultural diversity that is applicable to everyone.)

For our purposes, of particular interest is the line of argument that proposes that art history has been monopolized by writers whose western-centred views have resulted in the marginalization of the art of the colonial subjects of European powers, and that of other societies loosely (and often pejoratively) labelled 'non-western'. This label – which is often used as a grouping for almost any art (such as African, Asian, Indian, Chinese, Japanese, indigenous Australian) that is produced outside North America and Europe – implies controlling status. As already noted, this is to define these other art forms in negative terms as not belonging to the West. However, a further point to register here is the significance of *who* is doing the defining for the whole process of the production, consumption, and exchange of art. The system cannot be operating on equal terms. Artists labelled as 'non-western' who want to make a living from what they produce are forced into a relationship that makes them victims of western-controlled commerce, or tourism.

As we have seen, the challenges to a eurocentric art history come initially from groups asserting that non-Europeans faced discrimination *en masse* because they were defined as different and inferior by those thereby designated as 'western'. As the debate has developed, however, there has been increasing attention to the ways in which difference can be treated pejoratively *within* groups designated as 'non-western'. This may be according to differences of, for instance, class, gender, or religion, such that sub-groups can be seen as themselves operating the psycho-social mechanisms of the 'other' towards those they in turn designate as different and inferior.

In addition, there has been recognition of cultural diversity and difference within European and North American societies, and the forms of artistic expression that they have generated. Within Europe, the post-war immigration of peoples from colonized areas has contributed to the emergence of urban cultures characterized by ethnic diversity, hybridity (see below) and complex social sub-groups.

Equal borrowing rights

Theories of racial and cultural purity pervaded colonialist discourses.[4] Such thinking entailed the disparagement of people and art forms said to be 'hybrids'. The related idea that the culture of one society is entirely different and separate from another was also prevalent. Both views connect with the convenient belief of colonists that European people were distinct from subject peoples, who did not need the same rights to political representation. Such ideas underpinned, for example, political theories of the separate development of races. They were linked to myths about different racial characteristics, which were supposed to determine the cultural proclivities of different groups and were considered to be innate or 'natural'. Such essentializing theories[5] were also taken up – this time positively to assert pride in inborn qualities – during the struggles for political independence from imperial controls. These ideas were discussed in the journal *Présence Africaine* during the 1940s and 1950s by writers and artists living in Paris, such as Aimé Césaire from Martinique and Léon Damas from French Guiana. After the achievement of independence in Senegal in 1960, theories of *négritude* (the essential[6] quality of the Negro genius) were championed by Léopold Senghor, the President of Senegal. They were also held by political movements comprising those fighting racist discrimination inside European or European-dominated societies. Essentializing beliefs remain attractive to some, but have come to be questioned, perhaps most engagingly by the twentieth-century writer Wole Soyinka: 'In a brilliant and most original one-sentence statement, Soyinka put forward his own unmistakable position thus: "The tiger does not need to proclaim its tigritude"!!' (Adelugba, *Before Our Very Eyes: A Tribute to Wole Soyinka*, p.21). Essentializing theories tend to sit comfortably with theories of nationhood, and have been invoked where artists sought to create national artistic identities. However, they may need to be regarded with some caution, in so far as they seem to set limits to how far change is possible.

Writers have criticized the idea that art develops in separable cultural capsules. It has been argued that there is always movement in both directions across any cultural boundaries (Plate 2). The scholar Paul Gilroy suggested in 1993, for example, that 'the consciousness of the European settlers and those of the Africans they enslaved, the "Indians" they slaughtered, and the Asians they indentured were not, even in situations of the most extreme brutality, sealed off hermetically from one another' (*The Black Atlantic*, p.2). Such analyses value the 'hybrid', that is to say, the creation of a new form from the amalgamation of two different forms. They expect the 'syncretic' (the gathering together from different sources of similar elements or concepts to create new systems or concepts) and the 'eclectic' (the juxtaposition of diverse elements to create a heterogeneous pattern). In 1995, the scholar Signe Howell suggested: 'Not only is it unlikely that traditions have single origins, it is equally unlikely that their manifestations develop along a single path devoid of outside influences' ('Whose knowledge', p.178).

[4] When used in this way, 'discourse' means a systematic group of apparently logical statements and practices that limit the ways knowledge about a topic may be represented (i.e. centre/periphery; mainstream/backwater; original/copy; pure/mixed; rational/irrational: used to indicate relations of power in imperial societies) (see Gieben and Hall, *Formations of Modernity*, pp.291–2).

[5] Theories supporting the idea that human traits are innate and inalterable.

[6] Determined by innate racial attributes.

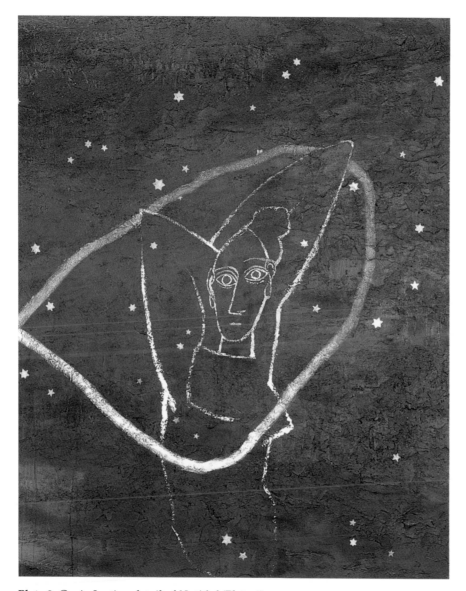

Plate 2 Gavin Jantjes, detail of *Untitled* (Plate 4).

Colonizers may have brought western innovations to colonized societies but they themselves underwent rich and complex transformations through imperial inter-relationships. Colonizers might think of such things as china, chintz, polished mahogany, aspidistras, pyjamas, or tea as characteristics of pure Englishness, but they were the results of cultural cross-breeding. The theories of separate cultural development were circulated by people who were borrowing from every culture in the globe.

Where artists from the community of the colonizers took from the art of a colonized society, they were often said to be powerfully inspired by a motif or idea they had borrowed from another culture. In contrast, where artists who were colonial subjects took from the colonizer's culture they were widely seen as copying weakly. The relations of cultural exchange were thus

represented as unequal. Colonized societies could be accused of impure mixing. But colonizers saw themselves as taking elements from another society to enrich a product, and openly boasted their appropriation or glossed over the fact that what had been taken had entailed the making of something hybrid. Cultures, then, are not to be thought of as absolutely distinct, but as able to translate and transform new ideas so that they are usable in different systems.

If we acknowledge fully the role of transactions in cultural development, individuals or practices placed in the cross-over positions between two or more cultures can be seen as particularly privileged – as located at a vantage point: a viewer standing at the boundaries of several cultures could, it may be argued, see things in a new light. Furthermore, imitation of western forms and styles by colonial subjects is not necessarily understood as an obsequious or submissive act. Some have noted its subversive potential. The cultural theorist Homi Bhabha, for example, suggested in 1990 that, where imitation mimicked or created a parody of western forms and styles, the imitator was, on occasion, being revealed as a shrewd viewer of the conventions of the colonizing power rather than a passive reflector – the mode expected of the 'other' (*Nation and Narration*, pp.318–19).

In his self-portrait (Plate 3), Yinka Shonibare seems to be exploring the subversive powers of mimicking the mannerisms of the master. He can be seen wearing the dress of, and in the conventional setting chosen by, a European of slave-owning rank in the eighteenth century. Shonibare explained that he thinks of this image in some sense as a satire in the manner of the eighteenth-century London painter William Hogarth:

> On the one hand the picture is one of me actually dressing up, having a good time, and on another level I'm actually making a strong political statement about my relationship as an African to the powerbase in the West, the thing that actually created the developed world, the roots of all that, and my own relationship to that, as an African. So there is both that element of comedy, and satire in the piece, because it is absolutely absurd and outrageous. Also there is the level of enjoyment because I actually did enjoy putting on the costume, but the curious part of that was that it was incredibly difficult for me to keep a straight face while the picture was being taken.
>
> (Interview with Catherine King for the OU/BBC television programme, *West Africa: Art and Identities*, October 1997, A216 TV 6)

Imitating another powerful art form could be seen as demonstrating that one has understood 'how the trick works' to create particular effects, and is no longer fooled by the impressive display.

Modernism and postmodernism

Both the idea of a universal modern art and the concept 'postmodernism' raise significant issues for debates about difference. Being a European colonizer or former colonizer meant being powerful enough to maintain the fiction of speaking objectively for all humanity and possessing knowledge that was not bound by one's cultural and geographical location. Hence the development of the idea of a contemporary art that was not British modern art, French modern art, or North American modern art but just modern art. Although such views purported to aim for the possibility of a set of modern

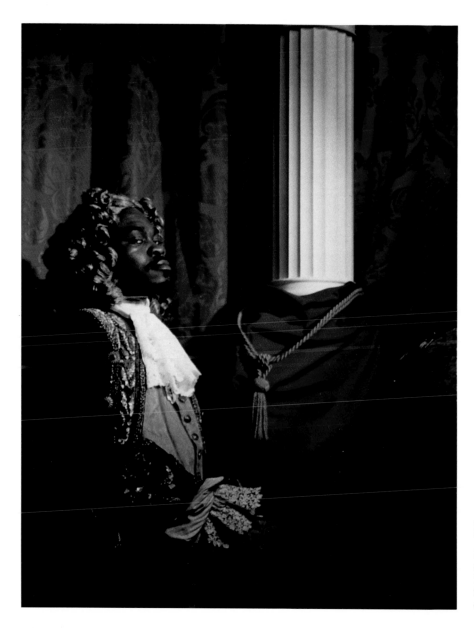

Plate 3
Yinka Shonibare,
Untitled, 1997,
colour photograph,
178 x 132 cm,
Stephen Friedman
Gallery, London.

artistic practices that was genuinely open to all, this set was originally defined and authorized by westerners. In the catalogue for the exhibition 'The Other Story' (1989), the artist Rasheed Araeen noted that the art historians Hugh Honour and John Fleming, in their *World History of Art* (1982), had claimed to represent for the first time all the cultures in the world. Of this account Araeen wrote that such pluralism only lasted in their narrative until the nineteenth century:

> As we enter the twentieth century, African/Oceanic sculpture is taken up again but only in connection with modernism, the development of various movements and styles – in particular, Cubism. After that, everything non-European, both cultures and peoples, disappears. The West then shines alone this century, the whole world reflected in its image.

(*The Other Story*, p.10)

Contemporary artists in the West merely needed to operate within, or gain approval from, their own cultural systems to 'count' as modern practitioners. In contrast, colonized cultures have been widely seen as producing contemporary art that was dependent on leadership and approval from European or North American centres, and in need of a qualifying adjective to place them geographically – as in 'Indian' modern art or 'African' modern art. Such attitudes could also entail treating artists from colonized peoples, or who worked in countries that had formerly been governed as colonies, as secondary or eccentric practitioners of contemporary art forms. Araeen drew attention to the way in which such artists had been ignored or treated differently by critics and historians, in explaining that the exhibition he curated in 1989 told 'The story of those men and women who defied their "otherness" and entered the modern space that was forbidden to them, not only to declare their historic claim on it but also to challenge the framework which defined and protected its boundaries' (*The Other Story*, p.9).

The governmental structures of empire underpin the metaphor of centre (European seats of government) and periphery (the colonial provinces where civil servants and police effected the laws of the centre). According to this model, artistic influence was thought to flow from the centre out to the margins, rather as laws and edicts had done. Artists seen as coming from the periphery could not be regarded as taking a leading role at the centre.

Turning now to postmodernism, it is often argued that the contemporary concern with 'difference' is itself a characteristic of postmodernism. The latter term, which originated within a western intellectual context, is broadly used across different academic disciplines to describe a contemporary culture and era which differs significantly from the so-called 'modern' period of the late nineteenth to the mid-twentieth century. There are numerous, contradictory definitions of postmodernism. Some definitions focus on the effects of post-industrial, technologically developed societies on western culture in general, arguing that the explosion of information technology, global communication, and the mass media have helped to fracture some of the belief systems and artistic values of the earlier modern period. Other definitions see postmodernism as signalling the collapse of the certainties of a western-controlled modernism in the face of the criticism of eurocentricity by artists who were excluded by modernism from the canon.

Although in its broadest sense the term is used to describe a culture or cultural outlook, it also has more specific meanings when applied to individual disciplines. Postmodern approaches have tended to move away from the single historical narratives of (western) art history that are often associated with modernism. For example, the modernist idea of a linear historical progression away from naturalism, through various 'isms' such as Fauvism and Cubism towards abstract art, has been challenged as a constraining and oversimplified narrative, which marginalizes many other diverse forms of modern artistic practice. What we are describing as 'postmodern' here is a theory of art. This should not be confused with postmodern *practices* of art, although there is often a close relationship between theory and practice. In keeping with the idea of multiple narratives, it is often argued that postmodern

practices are characterized by difference – by the co-existence of varied techniques and different cultural positions. For example, many artists working in Europe and North America since the 1970s have begun to use realist styles and techniques (styles regarded as outside the domain of modernism), have borrowed and pastiched photographic images from the media, or have used their art to explore cultural diversity.

However, we are always on dangerous ground when we make sweeping generalizations about art, and we should be cautious about representing too crude a division between modernist and postmodernist art. In the process we may oversimplify the nature of both. Some writers have suggested that many of the artistic forms that we now identify with postmodernism, which include the use of parody or discontinuity, were already in evidence within art of the early twentieth century.[7] Similarly, it would be unwise to assume that postmodernism means the same thing everywhere. In West Africa, for example, as pointed out in 1991 by the scholar Kwame Anthony Appiah, artworks 'are not understood by their producers and consumers in terms of a postmodern*ism*: there is no antecedent practice whose claim to exclusivity of vision is rejected through these art works' (Is the post- in postmodernism the same as the post- in postcolonial?', p.348).

A further point to bear in mind refers us back to the politics of cultural theory mentioned earlier. We need to be wary about the extent to which some forms of postmodernism disguise cultural retrenchment: they may be merely a shift in 'brand-name' adopted by those formerly in control of modernism in order to re-establish their power bases on different ground. For example, ostensible admiration of the differences in other cultures by western viewers may be seen as a rejection of the proposition that western culture could itself be a 'various' and 'different' 'other' rather than the 'one':

> In the beginning it was Modernism, modernism for everybody. Now there is 'western' culture and 'other' cultures, located within the same contemporary space. The continuing monopolisation of modernism by western culture (particularly in the visual arts) denies the global influences of modernism. If other peoples are now, in their turn, aspiring to its material achievements, and want to claim their own share, why are they constantly reminded of its harmful effects on their own traditional arts?
>
> (Araeen, 'Our Bauhaus, others' mudhouse', p.6)

What is clear, however, is that the art history of the last few decades of the twentieth century has been influenced by many other disciplines and theories – among them literary theory, anthropology, sociology, psychoanalysis, and post-colonial theory – all of which have contributed to what we now broadly label 'postmodern theory'. The influence of post-colonial theory in particular has encouraged us to look closely at the cultural origins of art-historical language and concepts, acknowledging the exclusions and value judgements that may be involved. Art history itself is now characterized by a diversity of approach and (as is argued in Case Study 1) by an increasing openness to exploring different artistic cultures in which 'we are all to each other different'.

[7] See Wood, *The Challenge of the Avant-Garde* (Book 4 in this series).

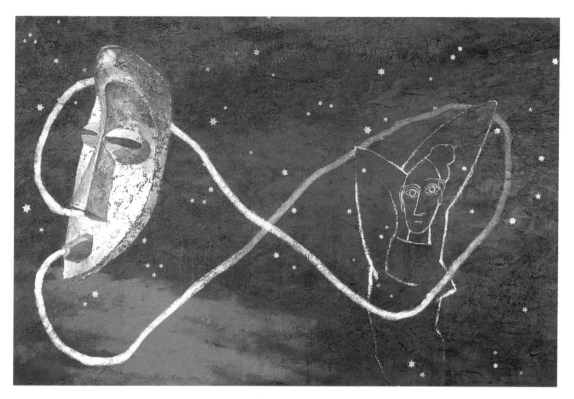

Plate 4 Gavin Jantjes, *Untitled*, 1989, sand, acrylic, and tissue paper on canvas, 200 x 300 cm, Hayward Gallery, London, The Arts Council of England Collection.

The painting *Untitled* (Plate 4) by Jantjes could be seen as a meditation on this theme, on the relationship between art in Africa, in the mask on the left, and the art of Europe, in the drawing after Picasso's *Demoiselles d'Avignon* on the right.

With reference to Plates 7 and 8 in Case Study 1, illustrating an African mask and Picasso's painting, consider possible readings of the image shown in Plate 4.

Discussion

This image is intriguing because it suggests but does not define the relationship between the representation of a mask and a drawing after a painting. The mask is shown as solid, and from its mouth and nose a stream traverses the sky. In comparison, the drawn woman is an insubstantial creature. Yet, while she is represented as if further away and held in the orbit of the mask's influence, the gaze of the mask is averted, whereas the woman looks out at the viewer. The powers of African and European art are represented, perhaps, to show the dependence of European abstraction on the traditions of Africa.

◆◆◆

This painting is open to a variety of interpretations, as shown by different reactions to it by reviewers who saw it at the exhibition 'The Other Story'. For the art critic Sadeq Khan in *New Link* (15 December 1989), the painting is 'a metaphor for cross-fertilization and interpenetration', in its depiction of 'a respiration tube' passing from the mask's nostril to its mouth. The art critic Jane Bryce, in *Arts Review* (16 January 1990), interpreted it as pointing to 'modernist borrowings of such artists as Klee, Ernst and Picasso', and consequently emphasizing the fundamental instability of modernist claims to originality. For Bhabha, *Untitled* showed that cultures could be different and of equal worth:

> The line drawing of the translucent *demoiselle* gazes wide-eyed at the viewer in the familiar figurative pose; the mask at the other end of the canvas, turns away from the priority of the figurative and the visual to suggest other senses of identity. The two images are linked through umbilical cords that suggest not an unmasking of the Picasso figure, but a challenging tension across the terrain of cultural difference between the visual locus of the aesthetic, and the *sensoria* of other cultural systems. In one sense, the two figures are incommensurable; in another, it is this difference that makes possible the negotiation of cultures on equal terms.
>
> ('The wrong story', p.41)

The contents of this book

This book is introduced and concluded by two artists – Gavin Jantjes and Rasheed Araeen – who have played key roles in analysing, in order to demolish, the mechanisms of marginalization of non-western art. This they have done using art works, curating exhibitions, and charting the contemporary history of art. What are the writings of artists doing in a book that is otherwise written by art historians? It seems to us important to seek views about issues of difference from those who are actually negotiating a path for themselves as artists in the face of categorizations that derive from colonizers' perspectives. At key points of change in the status of art, artists writing about art have played crucial parts. Some of the first European art histories written in the fifteenth and sixteenth centuries were produced by artists, and included autobiographies: Lorenzo Ghiberti's *Commentaries* (*c.*1450) and Giorgio Vasari's *Lives of the Artists* (1568). These artists literally wrote themselves, and other artists, into history, since art had not previously been the subject of history in Europe (except in ancient Rome and Greece a millennium before). Jantjes and Araeen belong to a generation of artists who, as heirs of colonized peoples, and working in the metropolis of former colonizers, have helped to shift eurocentric perspectives on art history by, in their turn, recording themselves and their fellows in history and introducing theoretical issues related to their works as well as criticism (see Case Studies 1 and 9). Both artists take as their central metaphor the idea of the traveller striving against the odds in often hostile terrain to reach some goal. That both have done so to describe their trek through the darkest depths of the imperial metropolis suggests how crucial it is for them to turn the tables on the myth of western exploration and discovery.

In the main part of this book, we draw attention to the relationships between the cultural and political locations of art historians and the kinds of interpretation they presented or present. We start in Part 1 with a critical look at the way in which pre-colonial art (meaning art produced before the coming of European colonialists to the majority of the globe) has been interpreted. Colin Cunningham examines the interpretation of pre-colonial Indian architecture by the Scots merchant and architectural historian James Fergusson in the mid-nineteenth century at the height of British imperial power (Case Study 2). Catherine King compares Fergusson's standpoint with that of the art historian, Ananda Kentish Coomaraswamy, publishing half a century later and reviewing pre-colonial Indian art from the perspective of Indian nationalism (Case Study 3). One of Coomaraswamy's concerns was to take a Hindu perspective on Indian art and thereby rebut European disparagement of it. He pursued closely focused studies to this end on, for example, the pre-colonial art of Sri Lanka and Rajput[8] painting before 1800. When we turn to look at a text on Indian art by Partha Mitter, who has developed his ideas during the period after the achievement of independence for India, we find a speaker able to take a position arguably even stronger than that of Coomaraswamy to offer an explanation as to why European historians stated that Indian art was decadent (Case Study 4). Mitter turns the spotlight off Indian art and back onto the European interpreters of Indian art and *their* cultural locations and interests. Part 1 ends by considering the interpretations by European historians of art made in China, an area beyond colonial territory but with which Europeans traded (Case Study 5). European views of art in China, with its vast period of production long predating but also paralleling the time of European imperial domination, can be compared with the views of the historians of Indian art considered in Case Studies 2, 3, and 4.

In Part 2 we consider how art made by those subject to European domination in colonies and their descendants has been interpreted over time and place. We start with two case studies concerning artists working during the period of direct colonial rule, within colonized areas (Case Studies 6 and 7), and then move to consider two case studies focusing on artists working after direct European colonial rule had ended (Case Studies 8 and 9). What seems to characterize modes of interpretation of colonial subjects' art made during the colonial period (Case Studies 6 and 7)? How do they compare with the tenor of art-historical accounts attached to the work of artists practising after independence from colonial domination, whether working in a newly independent nation free from immediate subjugation or in what was the centre of the former European colonial power (Case Studies 8 and 9)? In Case Study 6, Tim Benton examines the evidence about the original reception of the architecture of António Francisco Lisboa, an artist of Portuguese and African ancestry working in Brazil in the 1790s, and charts the interests of later historians writing in Brazil, Europe, and North America, which revived or questioned Lisboa's reputation a century later. Could he be regarded as an innovative architect on the world stage or was his importance limited to a place in Brazilian colonial vernacular architecture? The tension between international and national importance can also be found in accounts from the 1930s onwards of the work of the twentieth-century Indian artist and

[8] This is the nama given to a group of warrior clans who ruled north-west India in princedoms from the eighth century onwards.

philosopher Rabindranath Tagore, examined by Catherine King in Case Study 7. Was he a key player in the development of modern art in India? Was he innovating or imitating? In Case Study 8, Catherine King surveys the new aspirations and new narratives created in post-independence Nigeria as artists gathered to debate their approaches to making modern art. How could artists assert independence? Did this mean making works that did or did not obviously draw on African subject-matter, styles, or media? We end by considering the autobiography of an artist – Rasheed Araeen – who is descended from former colonial subjects and has practised art in London, the metropolis of a former European colonial power, after independence (Case Study 9). Was it easier or more difficult for such an artist to refuse to be interpreted as geographically and racially located according to the ideology of the imperialist maps of centre and periphery, superior and inferior, those who innovate progressively and those who cannot develop alone? Artists working in Nigeria could be seen to have the space to debate their own group approach and to begin to write their own histories – albeit with an eye to critics and gallery demand outside their community. Children of former colonial subjects working in a European metropolis (such as Araeen) could, in contrast, be individually isolated, unless they organized with other artists who saw themselves in similar positions.

This sequence of case studies allows us to take snapshots of the historiography of pre-colonial, extra-colonial (in China), colonial, and post-colonial art to obtain some sense of the power of imperialist ideologies and the cultural spaces in which other viewpoints may be offered. Each different colonial relationship presented different structures of cultural government. It is important to stress that the case study approach seeks to avoid the temptation to treat 'pre-colonial', 'colonial', or 'post-colonial' conditions in recklessly generalizing terms. Rather, the aim is to infer, in guarded terms, what may be understood from specific instances of the effects of European imperialism and its aftermath.

References

Adelugba, D. (1987) *Before Our Very Eyes: A Tribute to Wole Soyinka*, Ibadan, Spectrum Books.

Araeen, R. (1989) 'Our Bauhaus, others' mudhouse', *Third Text*, vol.6, pp.3–14.

Barker, E., Webb, N., and Woods, K. (eds) (1999) *The Changing Status of the Artist*, New Haven and London, Yale University Press.

Bhabha, H.K. (1990) 'The wrong story', *New Statesman*, 16 January, pp.40–1.

Bhabha, H.K. (ed.) (1990) *Nation and Narration*, London, Routledge.

Fanon, F. (1986) *Black Skin, White Masks*, trans. C.L. Markmann, London, MacGibbon & Kee (this translation first published P. Grove, 1967).

Gieben, B. and Hall, S. (1992) *Formations of Modernity*, Cambridge, Polity Press.

Gilroy, P. (1993) *The Black Atlantic: Modernity and Double-Consciousness*, London, Verso.

Honour, H. and Fleming, J. (1995) *A World History of Art*, London, Lawrence King (first published 1982).

Howell, S. (1995) 'Whose knowledge, and whose power?', in *Counterworks: Managing the Diversity of Knowledge*, ed. R. Fardon, London, Routledge, pp.164–81.

Appiah, K.A. (1991) 'Is the post- in postmodernism the same as the post- in postcolonial?', *Critical Inquiry*, vol.17, no.2, pp.336–57.

Mitter, P. (1977) *Much Maligned Monsters: A History of European Reactions to Indian Art*, Oxford University Press.

Okeke, C. (1997) 'Beyond either/or: towards an art criticism of accommodation', in *Art Criticism and Africa*, ed. K. Deepwell, London, Saffron Books.

Picton, J. (1997) 'Yesterday's cold mashed potatoes', in *Art Criticism and Africa*, ed. K. Deepwell, London, Saffron Books.

The Other Story (1989) exhibition catalogue, London, South Bank Centre, Hayward Gallery.

Wood, P. (ed.) (1999) *The Challenge of the Avant-Garde*, New Haven and London, Yale University Press.

Preface to Case Study 1: Towards an inclusive art history

CATHERINE KING

As an artist, a critic, and a curator, Gavin Jantjes emphasizes in this case study how artists, critics, and curators can persuade art historians to change their approaches, and, reciprocally, how the choice by the historian as to what field to research and how to interpret the data gathered can support or shape the priorities of the artist or the curator. He commends the hope – while remaining somewhat sceptical of its success – that artists and art historians may be able to move towards a genuine internationalism, in which the art of Europe and North America is considered in the same terms as that of anywhere else, and art forms that acknowledge and accommodate difference are welcomed. An inclusive art history may enable an inclusive art practice.

Jantjes compares an artist like himself, who works and belongs both in Africa and in Europe, to a 'cultural' salmon: a fish that swims in salt-water and fresh water and travels against the flow and the gradient to achieve its aims. As an artist once designated by the regime in South Africa as 'Cape Coloured' – he was initially trained in Capetown at the School of Fine Art – he feels that he had to become a determined all-rounder (like the salmon) in moving to Hamburg (the Hochschule für Bildende Kunst) during the 1970s in order to pursue what he calls the modernist thesis of questioning the world and the art produced in it. Jantjes recorded his disappointment on reaching Europe to find that modernism was not the international movement it claimed to be and did not initially welcome his kinds of question. Finding himself forced to take on a 'special exotic role' by the modernist mainstream, Jantjes embarked on a series of works – from 1982 onwards in the United Kingdom – that formed a set of convincing arguments criticizing the perceptions he encountered. Modernism, he found, attempted to tie him down as an African artist, supposedly rooted in African traditions, who could not make statements about art that might be of global interest: 'We have to desist from marginalising "otherness" by defining it as foreign, exotic, magical and extraordinary. European artists are never called upon to prove their Europeanness or to demonstrate their closeness to their cultural roots' (Jantjes, *In Fusion: New European Art*, p.53).

Jantjes has been an important figure in challenging the single narrative of modernism and forming part of the strand of postmodernism that explores different art histories. As a member of the Arts Council of Great Britain, he led the collection of data on discriminatory policies (1986), and has taken part in group exhibitions such as '15 Artists Against Apartheid' (1983) and 'The Other Story' (1989), as well as having his own solo shows. He has moved to curating exhibitions, such as 'In Fusion: New European Art' (South Bank Arts Centre, Ikon Gallery, 1993), and now (1998) takes up a post as director of the Sonja Henie Nils Onstad Art Centre, Oslo, Norway.

Jantjes sees previous eurocentric art practice and history as limited to looking from a single viewpoint. He perceives this as a cultural monopoly, to be contrasted with the free market created by opening one's mind to the idea that there are and have been many and various definitions of art, each geared to the exigencies of different societies in the past and the present, and that there is no logic in judging them by criteria that apply merely to contemporary European and North American priorities. In such a free market, Europe and North America would no longer be seen as neutral vantage points from which everywhere else looks different, but would start to be seen as themselves culturally specific and artistically idiosyncratic too. In particular, Jantjes discusses the role of artists who have recently moved from another area of the globe to work part or full time in Europe. He makes explicit the characterful ethnicities of European art traditions, and the way in which these artists' works have added to a continuously developing heterogeneity to create new cultural syntheses: new meanings as to what making 'European art' could entail.

CASE STUDY 1
Mapping difference

GAVIN JANTJES

Introduction

At the turn of the twentieth century, our views of difference, and the different views we have of art, signal a shift away from the history of visual art as a single narrative. A consensus has emerged that art and its histories are a more complex affair. Postmodern reinterpretations and (insightful) alternative views of the histories of art should give us cause to believe that we are moving forward. We are learning to question the view that cultural growth develops from a single point of origin, as if from a tap root, and then proceeds linearly with a beginning, a middle, and an end. Increasingly, we are questioning the view that art's historical narrative starts with Athenian classics, and runs as a continuum through to our postmodern present.

The history of art has, in fact, always been a collection of heterogeneous narratives, with many beginnings, numerous interwoven middle sections, and undetermined conclusions. Our cultures are richer and more complex than some historians would like to acknowledge. Yet our journey from the trope,[1] of one century to that of another is a shifting, sliding, and bumpy ride and we are constantly trying to get a foothold on the multiplicity of positions offered. We seem to enter a floating, unstable world, where the only way to cope with the shifting ground is constantly to renegotiate our ideas about where we think we are, or who we are. The once-stable paradigms of tradition, morality, history, or language all seem up in the air, juggled by philosophers, writers, and artists. In our desire to stay abreast of the present, it can seem as if we have lost our way and have neither map nor compass with which to locate a starting position in this new cultural space located outside the old fixed positions. Homi Bhabha has influentially referred to this new space as 'the beyond' ('Beyond the pale: art in the age of multicultural translation', p.32).

The trauma of postmodernism is that we seem to be everywhere at once; so many different positions seem to be available to us in our perceptions of art. If we are living in the West, our journey may threaten to take us back in time and to transplant us to many locations on other parts of the globe. If we take up a different vantage point, our view of the world of art will alter. The scholars who accompany and guide us through space and time provide tools with which to dismantle the single-minded and sometimes myopic authority of twentieth-century modernist art history. But every journey, especially to a new and different place, requires a map, and it would help to have one here. A map is a clear and helpful sign system that makes a complex network of

[1] Figure of speech or rhetorical image that is popular with an individual or group and indicates a way of thinking about a particular issue. The trope is used whenever the issue is raised and carries with it many related assumptions, which limit discussion. For example, Paul Gilroy has questioned the trope of western countries as 'developed' and non-western countries as 'underdeveloped' with the suggestion that western countries may be *over*developed compared with their non-western (developed) counterparts (*The Black Atlantic*, p.42).

information usable. Even though there is no universal map of the art world, or the history of art, there is a map we could use for our journey in this realm.

The Peter's Projection Map of the World (Plate 5) may appear a strange but obvious choice for this journey. It offers us a different world view from the more commonly used Mercator's Map (Plate 6). The former is the only map that uses an equal area grid and gives the true relationship of the continental land masses of the planet. If we study this map carefully, it will allow us to make a strategic shift in our view of the physical world and, as a result, of contemporary art.

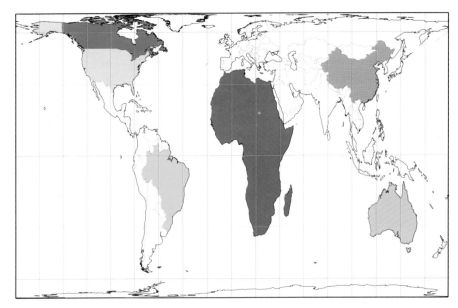

Plate 5
Map of the World, Peter's Projection, 1973.

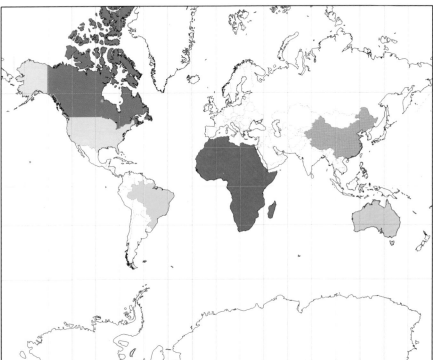

Plate 6
Mercator's Map of the World, 1538.

What strikes you about the relative sizes of the continents as depicted on the Peter's Projection Map?

Discussion

The Peter's Projection Map shows that we live in a world whose southern hemisphere holds more land than its northern one. Australia is *bigger* than the United States of America. Europe *including* the new Eastern European states fits comfortably into Africa, and the island of Madagascar is bigger than the United Kingdom.

◆◆

If you add to these comparisons the fact that every second person on the planet is a so-called 'Asian', you might be shocked by your response to the question 'What do you know about contemporary art and artists beyond the axis of Europe and North America?'

The shock of the Peter's Projection Map is therefore not how different the world appears (every two-dimensional translation of a sphere is a distortion) but rather the conclusions to be drawn from analysing this difference. Our perception of the relative importance of western culture radically alters. At the beginning of the twentieth century, European artists such as Picasso, Maurice de Vlaminck, Georges Braque, and André Derain were concerned with what is now called 'Europe and its cultural other'. Their interest in so-called 'primitive' art or *neger plastik* (German, black sculpture), which derived largely from French colonial conquests in Africa and the Pacific Ocean, was part of this concern (Plates 7 and 8). However, at the close of the century, interests have shifted towards the study of 'Europe *as* a cultural other'. In other words, Europe can now be seen to be examining itself in the same manner it once examined others, questioning its ethnicity, sexuality, and the cross-cultural referencing of its identity. In 1965, the cultural theorist Paul Ricoeur described both the insecurity and the different possibilities that this shift involves:

> When we discover that there are several cultures instead of just one and consequently at the time that we acknowledge the end of a sort of cultural monopoly, be it illusory or real, we are threatened with the destruction of our own discovery. Suddenly it becomes possible that there are just *others*, that we ourselves are an 'other' among others.
>
> ('Universal civilisation and national cultures', p.22)

If the Mercator's Map aligns to the era of European colonial domination (from the beginning to the middle of the twentieth century), and therefore to the art-historical period we call modernism, it can be seen to symbolize the way in which Europeans once understood the world and its art, and the relative importance of different cultures in it. Acceptance of the Peter's Projection Map signals an open-minded position from which the discourse of 'otherness' is not about objects and people in the world who are distant and different (as it was for many western artists working at the beginning of the twentieth century), but rather one that includes all of us, and in which we are all to each other 'different'. I want to argue that the debate about 'otherness' should always be about global interrelationships and interdependencies. It should seek to overturn earlier positions of sexual, cultural, racial, or religious dominance by any one group or person over another.

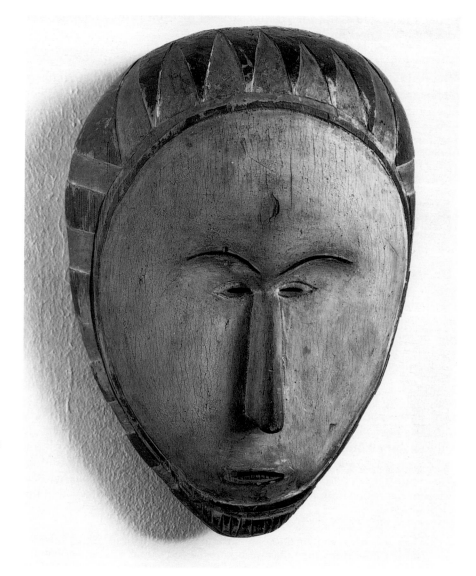

Plate 7
Anonymous,
Fang mask,
accession 1982,
Gabon, wood,
without
accompanying
costume and
decorations,
nineteenth
century, Musée
National d'Art
Moderne, Centre
Georges
Pompidou, Paris
(formerly in the
Maurice de
Vlaminck
Collection).
Photo: Musée
National d'Art
Moderne, Paris.

Postmodernism and cultural diversity

It is now possible to excavate from our cultural histories a past that thrived
on diversity and syncretism. Such diversity denies the claims of past and
present xenophobes of a purity of visual language, of single cultural traditions,
and of essential[2] mother tongues. Case Study 2 features the work of the
nineteenth-century British architectural historian James Fergusson, whose
studies of Indian architecture reveal a narrow-minded fear of cultural
contamination or 'decadence' within a non-European civilization. Yet cultural
'contamination' – or diversity – has increasingly been recognized as a
characteristic of all cultural development, Europe's included. In Europe,
though, it has been customary to believe that western artists are always more
modern than those elsewhere and always 'influencing' rather than themselves

[2] See footnote 6 on page 12 in the Introduction.

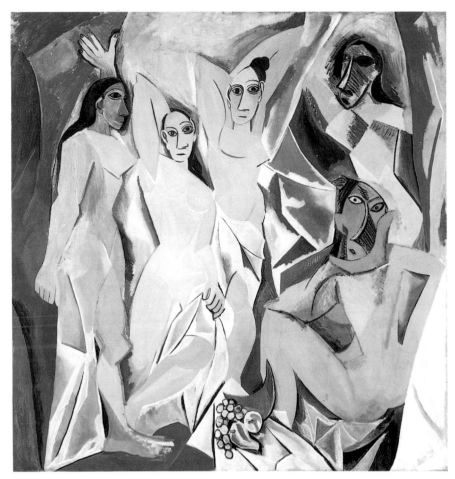

Plate 8
Pablo Picasso,
*Les Demoiselles
d'Avignon*, 1907,
oil on canvas,
244 x 234 cm,
Collection of the
Museum of
Modern Art,
New York,
acquired
through the
Lillie P. Bliss
Bequest, 1939.
© Succession
Picasso/DACS
1999. Photo: ©
The Museum of
Modern Art,
New York.

also 'being influenced' by others. Such a cultural model does not seem tenable, given the way in which, apart from the small number of cultures that are and have been isolated and self-sufficient, cultural change seems, generally, to proceed by means of interchanges, not one-way transactions. We can no longer escape the bastardized nature of cultural growth. In a manner of speaking, we have returned to a truer and very early practice of cultural interchange, which understood reciprocity as fundamental to development. The phenomenon of cultural diversity has featured prominently within the debates of postmodernity, where it has become a fashionable discourse for contemporary cultural critics.

One way of thinking about how cultures develop compares cultural growth to a monolinear model, like a plant with a tap root. This is a useful image for a western society that likes to think of itself as belonging to a history of civilization flowing from ancient Greece to the present day. But another model could be chosen to represent a more complex pattern of interweaving cultural growth. The example here might be a plant like the iris, which networks across the earth on horizontal underground stems called rhizomes from which new plants develop.[3] The many stories of contemporary art emerging from different areas of the world have therefore changed the trope of its debate.

[3] See Jantjes, *A Fruitful Incoherence*, p.162.

The close of the twentieth century marks the emergence of an idea of internationalism that is distinctly different and new. The perspectives we are now able to draw on contemporary art give a broader and more inclusive view of its history. Those of us in the West are learning to be less indifferent about the cultural differences of artists and to acknowledge everyone's contemporaneity.[4] The challenge of internationalism is to allow it to make a difference in our reading and understanding of art and its history, and not just simply to reflect on it as some exotic showpiece.

Difference in the visual arts

If we understand the visual arts as a form of language, with its own grammar and vocabulary, then our concern with cultural difference will involve an act of translation. In other words, we can translate the artistic forms into other meanings, which may have broader cultural resonances.

If we look closely at a work by Anish Kapoor called *Three Witches*, we can see how this process of translation might work (Plate 9). This piece consists of three blocks of limestone, the appearance of which *seems* to challenge our expectations of the materiality of sculpture. What appears to be solid is in fact hollow and what appears as a two-dimensional, flat surface is in fact a three-dimensional space, which (according to some interpretations) alludes to infinity. Kapoor is not concerned to confirm that this is three-dimensional sculpture; he has not engaged in an exercise to test assertions of the 'stoniness of stone' or 'truth to materials' made by the sculptor Henry Moore earlier in the twentieth century. Such sculptural qualities are those exalted by the canon of modernism, and any emphasis on these aspects overlooks the work's syncretic messages. As the art historian Sarat Maharaj has written (1994): 'An artwork does not carry meaning like a bag of coins, which one can swap at a *bureau de change* into another currency, into some other meaning' ('Perfidious fidelity', p.32). Translation, then, is always an incomplete, even impossible, act, which places the translator in the overlapping grey areas between meanings; it is never straightforward.

Kapoor opens new approaches to the reading of sculpture. The tradition his work is steeped in is the desire to challenge our knowledge and understanding of sculpture. This links him to artists and sculptors working in the twentieth century, such as Constantine Brancusi, Marcel Duchamp, Isamu Noguchi, Joseph Beuys, and Martin Puryear. Kapoor, who was born in India and moved to the United Kingdom in 1972, reintroduces into the language of sculpture ideas of organic and transformative materiality, which a western/eurocentric modernity deliberately overlooked but which can be found in the sculpture of India, Africa, and Latin America. His allusion to organic imagery is most evident in *Part of the Red* (Plate 10).

The South American artist Carlos Capelán also engages in his work with themes of difference. His *Maps and Landscapes* (Plate 11) seems at first glance to be about an earlier idea of otherness, the kind framed by early twentieth-century ethnography. Closer examination reveals that what confronts us is a self-reflection.

[4] Contemporaneity is used in the sense of the ability to challenge perceptions of the past, whether as a person or through an idea or work of art.

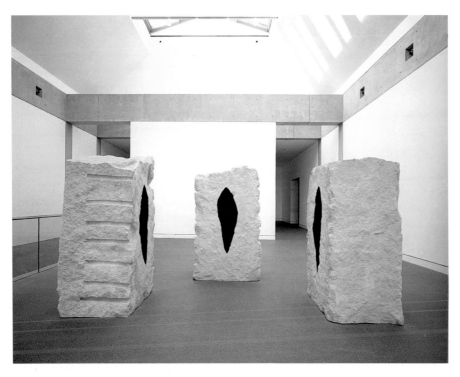

Plate 9 Anish Kapoor, *Three Witches*, 1990, limestone and pigment, left element 205 x 109 x 90 cm; centre element 201 x 117 x 84 cm; right element 195 x 116 x 89 cm, National Gallery of Canada, Ottawa.

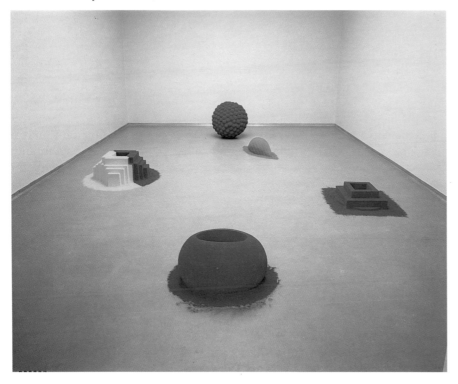

Plate 10 Anish Kapoor, *Part of the Red*, 1981, five elements, earth, resin, pigment, 500 x 400 x 30 cm, Kröller-Müller Museum, Otterlo, The Netherlands.

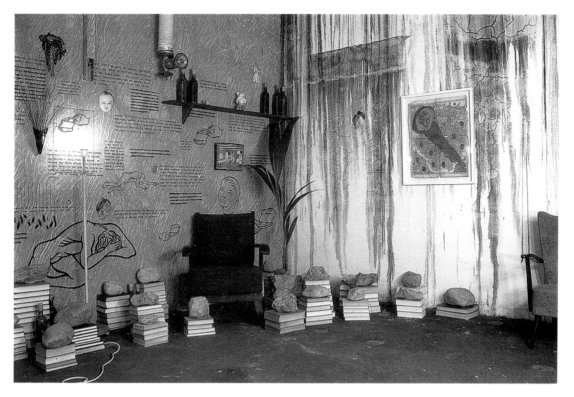

Plate 11 Carlos Capelán, *Maps and Landscapes* (*The Living Room*), 1996, installation[5] (partial view), Reininghaus, Steirischer Herbst, Graz, Austria. Photo: A. Pernin, by courtesy of the artist.

What sorts of cultural reference are evident in this work?

Discussion

The objects Capelán uses are from western culture, relics of an earlier age that linger on into the present. For instance, living-room furniture, lamps, books, pieces of kitsch, and tourist art recall memory and cultural history. (Yet the memory is not what one normally associates with an artist who has lived in many Latin American countries and is supposedly rooted in Gaucho or Andean culture. The specificity of his memory is Latin and therefore equally rooted in the cultural traditions of Spain and France.)

◆◆

The subject of Capelán's installations is 'Europe as other', Europe as something strange and different but no longer distant. His quasi-ethnographic displays bring home an awareness that ethnography (that is to say, anthropology) is a branch of science and therefore applicable to all human cultures and not just to those Europe has called 'primitive'. What once left European shores now returns, re-contextualized and altered through reciprocal exchange. What once represented a fixed, myopic view of civilization has been opened, revitalized, and extended. A feature of colonialism, then, was that it underlined syncretism as an intercontinental phenomenon while trying to deny it.

[5] Temporary grouping of designs to make a more general artistic statement than would be possible using one piece: often the viewer can walk inside and around an installation.

'The History of Chinese Art' and 'A Concise History of Modern Art' After Two Minutes in the Washing Machine (or *Pulp Books*) (Plate 12) by Huang Yongping is a work we could describe as combining sculpture with the residue of a performance. For a young artist in Beijing in 1978 searching for an authentic visual language matching his genuine concerns, books carrying titles such as these symbolically marked old and new traditions, and the authority of written language over the visual. By simultaneously washing them in his mother's newly acquired home appliance, Huang contaminated them, each with the other, and thus collapsed their authority. His new creation speaks of the wish for progress in art through reassessment and change. His vision is not shaped by ethnicity but rather by the desire to respond to questions artists deal with all over the world, such as how to be a contemporaneous being. It could be argued, then, that Huang returns us to the basic communicative power of the visual experience, to art as a first-order practice that disrupts logic but still conveys meaning. In a world where what is written about art often seems more important than what is seen, he asks us to look, and to decipher the visual experience. As strange as his object may appear, it becomes the catalyst in the act of translation. It seeks everyone's attention, irrespective of their location. It reveals the world and makes a difference in the world of art.

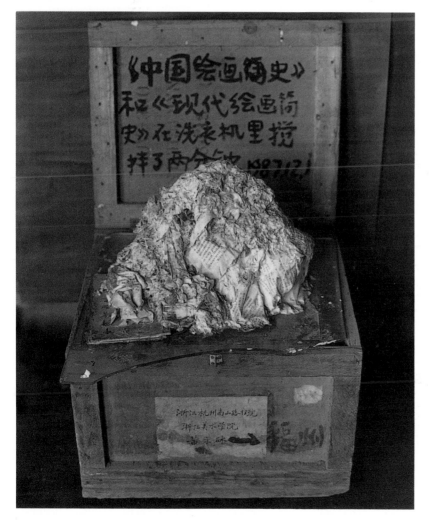

Plate 12 Huang Yongping, *Pulp Books*, mixed media, 1978, 80 x 50 x 50 cm. Photo: © Huang Yongping.

An artist who has made us face the complexity and diversity of our humanity is the South African born Marlene Dumas. Her portraits are compelling because of the raw energy of their graphic marks and their subtle beauty (Plate 13). But it is the dialogical element in her work that grabs our emotional attention, by establishing a rapport not only with every face portrayed but also with the idea of community that her exhibitions evoke. Face to face with multiple images of humanity, we can recognize the space between ourselves and others as the vital space in art and culture. Her work invites us to seek to bridge this space through means other than domination or exploitation. Whether lovers or neighbours, enemies or friends, we stand to learn more about one another through a dialogue that genuinely seeks knowledge about our differences. Dumas's evocative drawings and paintings reiterate one's individuality within the group and as we get to know the strangers in her work, our empathy for dialogue grows. Her aim is to close the many gaps and misunderstandings that silence buffers. *Black Drawings* makes us look at others beyond the context of race. It questions the binary oppositions of black/white, male/female, and self/other. Dumas's self-assured belief that it is good to talk aligns to her use of the simple, some would say old-fashioned, technologies of ink drawing and figurative painting. Through her use of such techniques, she proves that the most complex things are often best expressed through the simplest of means.

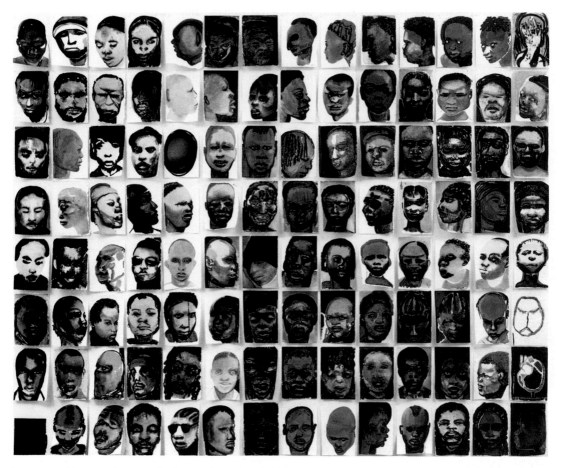

Plate 13 Marlene Dumas, *Black Drawings*, detail, 1991–2, ink on paper, 221 x 288 cm, De Pont Stichting voor Hedendaagse Kunst, Tilburg, The Netherlands.

Textiles and fashion have often taken the lead in signalling syncretic exchange. Yinka Shonibare has used textiles in many works, but always in a manner intended to question our ideas of authenticity. What appear to be contemporary African textiles have designs that were originally made in Indonesia in the eighteenth century using the Batik or Dutch wax method. The Dutch in Indonesia copied this process and found they could sell their products in West Africa. The textiles have been transformed in turn by designers in Holland and England and sold in marketplaces to Africans or people of the African diaspora (versions are made in factories in West Africa as well). These textiles function as symbols for an African identity. If one believed in an 'authentic otherness' (meaning the idea that people of different cultures should refer only to their supposedly 'own' home-made, home-grown traditions), this could be seen as a 'false' identity. Or, antithetically, it could be seen to evoke a postmodern African identity that acknowledges the phenomenon of syncretism.

Shonibare has made Victorian dresses from these textiles (Plate 14) and covered 1000 dinner plates with them (Plate 15). He has also used them to replace the canvas, as in *Double Dutch* (Plate 16). Yet their use is always to underpin contradiction and ambivalence, a 'purloined seduction' as he himself puts it: he makes something artistically attractive, but knowingly 'naughty' or unofficial in terms of the mainstream. When these bold and colourful textiles replace the canvas and become paintings, they question the fixed relationships between the centre and the periphery (the high arts of

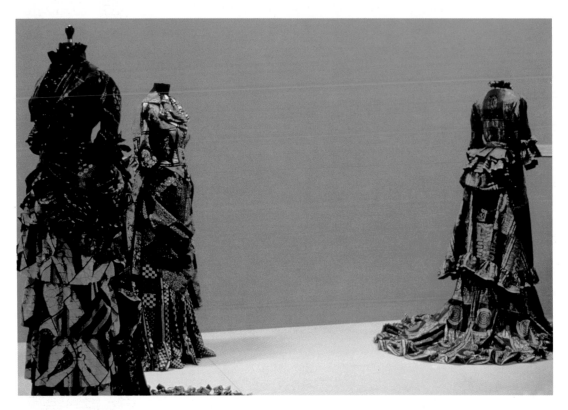

Plate 14 Yinka Shonibare, *How Does a Girl Like You, Get to Be a Girl Like You?*, 1995, installation of three costumes of wax print cotton textiles tailored by Sian Lewis, height approx. 168 cm, width approx. 40 cm, Saatchi Gallery, London.

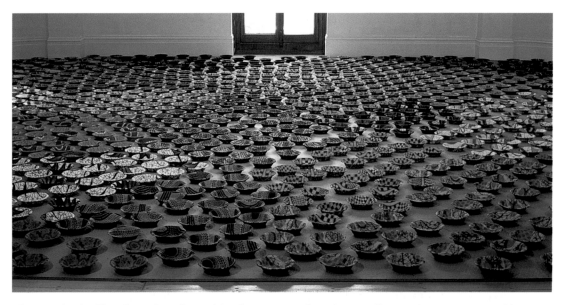

Plate 15 Yinka Shonibare, *Sun, Sea and Sand*, 1995, mixed media installation, dimensions variable, Stephen Friedman Gallery, London.

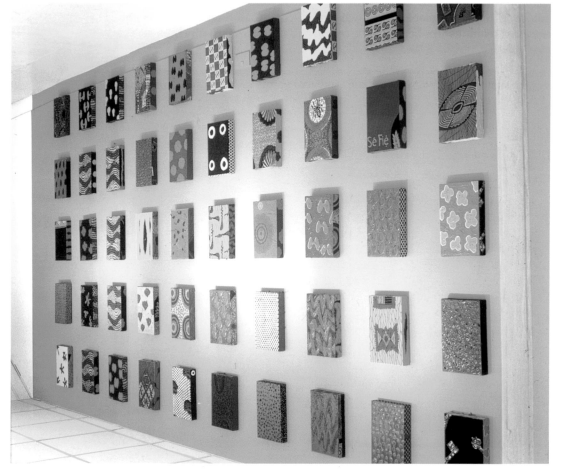

Plate 16 Yinka Shonibare, *Double Dutch*, 1994, emulsion, acrylic on textiles, 50 panels, each panel 32 x 22 x 4.5 cm, Saatchi Gallery, London.

painting on canvas and the low arts associated with machine-made textiles and fashion) that are implicit in modernist theory. By painting either the edges or the surface of the textiles in these paintings, he points to these polarities. He also unsettles the modernist concept of the single, authentic 'master-work' displayed in a sparse modern 'white cube' gallery space[6] by installing his paintings across the walls of the gallery as a multi-faceted or overall manifestation. Shonibare, like all the artists discussed above, takes on the role of a *passeur* or 'ferryman' taking us across an apparent divide, and his work stands in between polarities, establishing a new vantage point between meaning and incoherence, between mainstream and margin, high and low art, heroic and non-heroic painting, Africa and Europe. His work calls for an open mind, willing to explore and discover.

We are often lead into the realm of memory by works of art themselves. In a fleeting moment, time past and time present can become inseparable. The here and now can be enveloped with an aura of what has been. The use of memory by the Indian artist Sutapa Biswas in her installations and photographic work makes one consider the present and future in the context of the past. The role of her art is to be a tool for transmitting knowledge and knowing one's self, and she once clearly defined that role by comparing all her work in a particular exhibition to a 'synapse'. In the catalogue to this exhibition, the art critic Gilane Tawadros wrote:

> The title of Sutapa Biswas' first major solo exhibition suggests a compelling metaphor for the way we recall and reconstruct the past. Derived from a medical term which describes the anatomical relation between nerve cells – the junction through which a nerve impulse is transferred from one part of the nervous system to another – the notion of 'synapse' has been appropriated by Biswas to designate the conjuncture of the seemingly disparate realms of body and mind – at least as it is configured by the traditions of Western philosophy. Transposed from its original context, synapse here comes to signify the uncharted and shifting terrain through which memories and desires pass.
>
> ('Remembrance of things past and present, p.4)

Biswas wants us to make the great leap of the imagination of which Tawadros speaks. Using her own body and the bank of memories she brings from India to the hegemonic and chauvinistic practice of art in the West, she wants us to think beyond ourselves: to cross the divide between her and us, as well as to understand her leap from there to here. The five large photographs that constitute *Synapse I* (Plate 17) each show a small image projected on her torso. The body becomes both background and reservoir for memory. Biswas assumes the posture of a heavily pregnant mother, with hands clasped below her belly as if to hold each memorable image prior to its rebirth in the here and now.

The axiom of identity may be to define yourself lest you be defined by others, but the artists mentioned above all have one thing in common: they are aware that identity and difference are matters of negotiation and of artistic strategies. If the quintessential question of the late twentieth century is 'Who am I?', then they have tried to answer this in their own ways and on their own terms.

[6] Brian O'Doherty (*Inside the White Cube*) explains some of the ideas and contexts of the 'white cube' gallery and its use in the period of modernism. See Case Study 1 in Barker, *Contemporary Cultures of Display* (Book 6 in this series).

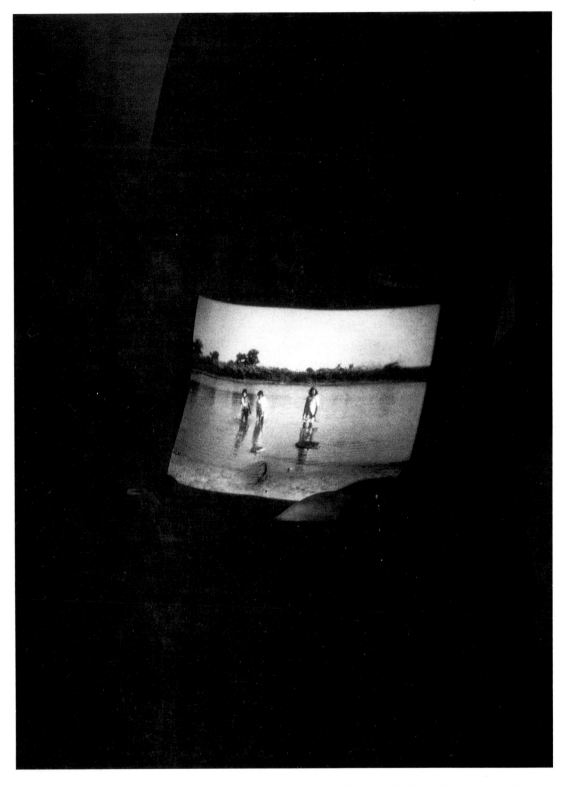

Plate 17 Sutapa Biswas, first of five images in *Synapse I*, 1992, photograph. Photo: by courtesy of Sutapa Biswas.

They have considered their positions in the world and their possible positions in art and have created images that reflect both identities in an imaginative, innovative, and often critical way.

When asked about my own position as an artist, I have said that I think of the artist as a cultural salmon:

> It's an intriguing and ambiguous fish, at home in both fresh and salt water. It migrates thousands of miles to regenerate itself; it swims against the current rather than with it; risks leaving the water to climb up rapids and thereby exposes itself to the greedy eyes of the bears on the banks, hungry for rich pickings; and after doing all this, it still has the energy and cunning to spawn something personal and new. Its intention is to return to the wild and salty ocean, knowing that it has left behind something of value, and learnt something new on each journey.
>
> (Jantjes, 'The artist as a cultural salmon', p.106)

References

Barker, E. (ed.) (1999) *Contemporary Cultures of Display*, New Haven and London, Yale University Press.

Bhabha, H.K. (1993) 'Beyond the pale: art in the age of multicultural translation. Figurations for an alternative consciousness', in *Cultural Diversity in the Arts: Art, Art Politics, and the Face Lift of Europe*, ed. R. Lavrijsen, Royal Tropical Institute, Amsterdam, K.I.T. Publications.

Gilroy, P. (1993) *The Black Atlantic: Modernity and Double-Consciousness*, London, Verso.

Jantjes, G. (1993) *In Fusion: New European Art*, London, Pale Green Press.

Jantjes, G. (1993) 'The artist as a cultural salmon: a view from the frying pan', *Third Text*, vol.23, pp.103–6.

Jantjes, G. (1997) *A Fruitful Incoherence*, London, Iniva.

Maharaj, S. (1994) 'Perfidious fidelity', in *Global Visions: Towards a New Internationalism in the Visual Arts*, ed. J. Fisher, London, Kala Press.

O' Doherty, B. (1986) *Inside the White Cube: The Ideology of the Gallery Space*, intro. T. McEvilley, San Francisco, Lapis Press.

Ricoeur, P. (1965) 'Universal civilisation and national cultures', in *History and Truth*, trans. C.A. Kelbley, Evanston, Northwestern University Press.

Tawadros, G (1992) 'Remembrance of things past and present', in *Synapse: New Photographic Work by Sutapa Biswas*, London, The Photographers' Gallery and Leeds, City Art Galleries.

PART 1
ART AND ARTISTS IN PRE-COLONIAL
AND EXTRA-COLONIAL CULTURES

Preface to Part 1

CATHERINE KING

Gavin Jantjes ends his case study by stating that artistic identity is a matter of negotiation and acceptance of difference, although it may be important to be ready to define oneself as an artist because otherwise someone else will do the defining for you. The case studies that make up the first part of this book consider just such a situation. They look at how art historians from colonizing countries have defined the art of subject peoples, and compare this with how art historians who belonged to the colonized peoples have defined this art – which they regarded as their own.

During and after European colonization

Case Studies 2, 3, and 4 focus on successive viewpoints from which Indian art has been interpreted, in order to sample the kinds of reading of art that were acceptable at different periods in the era of European imperial rule and its aftermath. The Indian subcontinent was one of the largest areas to be controlled by a single European power – namely the United Kingdom – during the eighteenth and nineteenth centuries. It is, therefore, a pertinent area to consider to mark both the grand ambitions of imperialist historians in pronouncing upon the art of those they governed, and the effort of reconceptualization required to rebut them.

Case Study 2 considers the first art-historical book-length text to be devoted to Indian architecture, *A History of Indian and Eastern Architecture* (1876) by James Fergusson. Composed in the 1860s and early 1870s, this derived from the period immediately after the beginning of direct government of the subcontinent by the parliament of the United Kingdom (1858), which signalled the crushing of the First War of Independence (1857).[1] Perhaps, in this sense, the composition of the book, and its success, signified a cultural claim to possessing knowledge of Indian art that paralleled the political control of Indian society and economy.

Case Study 3 looks, in contrast, at the anti-imperialist interpretations of both Indian and Sri Lankan art put forward by Ananda Kentish Coomaraswamy between 1908 and 1916. While Fergusson was a Scots merchant who had prospered in India in the textile industry, Coomaraswamy was partly of Sri Lankan descent, and had been educated in England. Coomaraswamy was writing at a time when movements for independence were gaining strength in India, following the foundation of the Indian National Congress (1885) and the boycott of imported European goods (1903–8). His desire to offer

[1] In colonial times, this was referred to as the Indian 'Mutiny', see footnote 9 on page 44.

Plate 18
(Facing page)
Detail of *Ravana Sends the Spy Sardula to Rama's Camp, He is Captured, and Rama Sends him Back* (Plate 52).

interpretations of Indian and Sri Lankan art which were based on research into the beliefs and requirements of the artists and indigenous spectators and which saw European influence as baleful may be related to the cohesion of critical attitudes towards the invading European forces.

Case Study 4 presents views formulated well after the advent of Indian Independence (1947) by Partha Mitter. While Coomaraswamy's texts are composed in a defensive tone, Mitter takes a more assertive position, choosing as the subject for his first work the complete historiography of European interpretations of Indian art, which he published as *Much Maligned Monsters: A History of European Reactions to Indian Art* (1977). Since then, he has continued to research the western representation of the history of art.

Fergusson's text could be termed 'colonial', both in terms of being written when colonial government was in force and in terms of representing views that were in the interests of colonizers. Coomaraswamy's texts were also chronologically colonial, but if we define the terms 'colonial' and 'post-colonial' conceptually, his art histories are 'post-colonial', in the sense that they rebutted colonizers' views of Indian and Sri Lankan art. Mitter's text is not only post-colonial in chronological terms, but also conceptually. He surveyed all the European texts composed about Indian art and architecture and analysed the way in which they represented Indian art as decadent, as a foil to the supposedly inventive, progressive, and modern arts of Europe. Such an act of unmasking to reveal the interests at work in imperialist writers was, arguably, not possible until colonial government had retreated.

Beyond European empire

What of western views of the art of areas that were never subject to European rule? In Case Study 5, Craig Clunas considers the perception of art made in China. He shows that there has been a tendency to treat such art as relatively unchanging or even static, and as focusing on its own past and traditions, rather than developing and moving forward into new means of artistic expression.

A colonizer's viewpoint

Colin Cunningham's analysis of Fergusson's *History of Indian and Eastern Architecture* celebrates the latter's attempt to provide a coherent account of the art of India over more than two millennia. As Cunningham points out, Fergusson was the first art historian to make extensive use of photography in recording and comparing buildings, and had seen all the designs he discussed during extensive travels in the subcontinent. Cunningham draws attention to the part played in Fergusson's interpretation by belief in the cultural superiority of so-called Aryans[2] or those then categorized as 'Indo-European' peoples; by his sympathy with the building forms produced by the Muslim Mughal Empire,[3] which had preceded the Europeans in India; and by his knowledge and appreciation of the art of ancient Greece and Rome. These factors played an important part in shaping the readings and the judgements that Fergusson presented in his book.

[2] Aryans were the peoples who moved into northern India in the second millennium BCE. Aryan culture is the early Hindu culture of northern India.

[3] The Mughal Empire lasted from the sixteenth to the eighteenth centuries.

James Fergusson's history of Indian architecture

COLIN CUNNINGHAM

Introduction

> It is in vain, perhaps, to expect that the literature or the Arts of any other people can be so interesting to even the best educated Europeans as those of their own country. ... How different is the state of feeling, when from this familiar [European] home we turn to such a country as India! Its geography is hardly taught in schools, and seldom mastered perfectly; its history is a puzzle; ... its literature a mythic dream; its arts a quaint perplexity. ... Were it not for this, there is probably no country ... that would so well repay attention as India.
>
> (Fergusson, *A History of Indian and Eastern Architecture*, vol.I, p.1[4])

These sentences from the opening page of James Fergusson's monumental *History of Indian and Eastern Architecture* both suggest a rich field for study and remind a western audience that it is difficult to get beyond preconceptions born of familiarity. The book incorporating the history of Indian architecture, which he published in 1876, is still in print. Fergusson (1808–86) is a good example of a westerner who became passionately interested in the architecture of another culture, so it is worth establishing his background before beginning to study his views on Indian architecture.

Fergusson was a Scot, educated at Edinburgh High School, and he would thus have had a thorough grounding in the classics. Yet he was not a professional scholar. He trained as a clerk in London and went to India as a teenager to join his brother in a trading house in Calcutta operating under the British East India Company.[5] He very soon set up an indigo plantation and factory on his own account and by the time he was 25 had amassed a sufficient fortune to retire and pursue his interests in archaeology. He was therefore both successful businessman and classically trained amateur.[6]

Between about 1825 and 1835, he travelled extensively across India, at a time when there was no quick or easy mode of travel, making voluminous descriptive notes on the buildings he saw. By 1845, however, he was settled in London where he published widely, Indian art being only one of the topics he covered. His own most cherished work was *An Enquiry into the True Principles of Beauty in Art* (1849), which included a study of how Greek temples such as the Parthenon were lit. His other works included a treatise on *A Proposed New System of Fortification* (1849), geographical studies of the Ganges Delta, and *An Illustrated Handbook of Architecture of all Ages and Countries* (1865), the first history of world architecture in the English language.[7]

[4] All quotations from Fergusson's *History* in this case study are taken from the most recent (1972) re-issue of the book, on the assumption that this will be the most widely available. However, it should be noted that this ignores the fact that a number of minor alterations and omissions have crept into the more recent text.

[5] The Company was founded in 1600 and eventually controlled most of the subcontinent through three presidencies of Madras, Bombay, and Bengal, with a Governor General in Calcutta.

[6] The great nineteenth-century archaeologist Heinrich Schliemann dedicated his book on the ancient Aegean city of Tiryns to Fergusson, presumably out of respect for his classical scholarship.

[7] See also Pevsner, *Some Architectural Writers of the Nineteenth Century*, pp.238ff.

Although Fergusson was made a member of the Royal Asiatic Society as early as 1840, and had advised on the display of Indian art in the Crystal Palace at Sydenham in the mid-1850s, his *History of Indian and Eastern Architecture* did not appear until 1876. It was therefore a distillation distant in both time and space from its source material. However, he had travelled widely; and papers he had published in the 1840s were sufficiently distinguished to persuade the East India Company to make measured drawings of the major temples (Plate 19). In addition, the intervening years had seen the development of photography and the growth of the Archaeological Survey of India (ASI). The ASI gave him access to archaeological reports and photographs and he had a collection of some 3000 photographs of his own. (I have illustrated this study from these sources as far as possible.) His early records and photographs meant that Fergusson was able to study sites before they decayed,[8] or were damaged in the fury of British revenge after the Indian 'Mutiny'.[9] Access to such material might appear to add to the worth of his study, but against this we have to set the inevitable western bias of his view. As a member of the conquering 'race', Fergusson shared the view of India as a society more primitive than his own. His schooling had imbued him with the classical belief in a golden age against which later periods were measured. As a result, he tended to see change as a matter of decline from a supposed early purity, and transferred this idea to his critique of Indian culture.

This case study has two aims. It aims, first, to provide a glimpse of the riches of Indian architecture and, second, to consider the extent to which Fergusson's view of Indian art was filtered through his own, western preconceptions.

Plate 19 Great Temple, Srirangam, Tamil Nadu, eastern half, engraving, from James Fergusson, *A History of Indian and Eastern Architecture*, vol.1, London, 1876, figure 219.

[8] There was hardly any serious restoration of Indian artworks prior to the viceroyalty of Lord Curzon (1899–1906), and it was then often in the hands of military engineers who happened to have an interest in the subject.

[9] Uprising of Indians against the British, which started in Meerut on 10 May 1857 and spread across much of the subcontinent. It was quelled in 1858, with considerable severity. This episode is known in India as the First War of Independence.

The scope of Fergusson's *History*

Fergusson's *History* fills two volumes and runs to almost 1000 pages, of which the first 750 are devoted to the subcontinent of India, and Burma, Cambodia, Thailand, and Java (then known collectively as 'Further India'). China and Japan are more summarily dealt with in the last 250 pages. The book is therefore best considered as a study of the architecture of the land now divided as India, Pakistan, and Bangladesh. Since these territories extend approximately 2000 miles from north to south and almost 3000 miles from east to west at their widest, and since the period covered by Fergusson stretches back to approximately 500 BCE, it is easy to see that even as a history of the architecture of this region alone his book has an enormous scope. The very title begs the question of what 'Indian' architecture comprises.

It is important first of all to remember that what the Victorians knew as India was far from being a unitary country. Its history was one of a succession of tribal migrations or invasions that resulted in a sequence of different kingdoms controlling larger or smaller parts of the subcontinent. In fact, after a period of unification under the Mauryan kings (321–185 BCE) (see Plate 20a), the country was not governed as a single entity until the middle of the nineteenth century, well on in the period of British rule, and even then many areas retained a nominal independence.

One crucial element in the diversity is the existence of three major religions (Hinduism, Buddhism, and Islam) and their associated patterns of 'race' and culture, which have been major determinants in India's historic architecture and artistic production. Hinduism is the oldest of the three religions, with its roots in prehistory, although it did not develop the forms we know today until the first century. It is the principal religion of modern India. Buddhism grew from the teachings of Gautama Buddha, who lived from 563 to 483 BCE, and became the chief religion of the Mauryan Empire. Islam, the religion of the followers of the prophet Mohammed (*c.*570–632), did not arrive in India until the Arabs invaded the country in the eighth century. It reached its first peak of power when the Delhi Sultanate was established in 1192. It was also the official religion of the Mughal Empire. Each of these religions has made its distinctive contribution to Indian architecture, hence the huge scope of Fergusson's work.[10]

There is, therefore, enormous variety in different parts of the subcontinent in terms of both climate and materials but equally in terms of period and the different cultures of the succeeding powers. You might like to use the maps shown in Plates 20 and 21 to see how widely scattered are the selection of works illustrated in subsequent plates, which Fergusson considered major monuments, and how they relate to the different dynasties.

[10] Fergusson ignored the influences of smaller religious groupings such as Sikhism, Jainism, and Christianity. (Sikhism was a north Indian monotheistic sect founded in the sixteenth century. Jainism developed from Hinduism in the sixth century BCE as a more puritanical cult and spread rapidly among the trading and mercantile classes.)

Plate 20 Map of India (subcontinent) showing pre-British Indian empires: (a) Mauryan Empire under Ashoka (239–232 BCE) (Buddhism); (b) Gupta Empire under Chandra Gupta (375–415) (Hinduism); (c) Delhi Sultanate (c.1236) (Islam); (d) Mughal India at the death of the emperor Akbar (1605) (Islam). From S. Wolpert, *A New History of India*, 5th edn, New York, Oxford University Press, 1997, pp.64–6. Copyright © 1997 by Oxford University Press, Inc. Used by permission of Oxford University Press, Inc.

Fergusson's criteria for inclusion in the *History*

Partly because of India's great diversity, but also because so much of its early history is recorded only in Hindu epics such as the *Ramayana*, it is the archaeological and architectural legacy that reveals the degree of wealth and sophistication in so many periods of Indian history. India's first urban civilization, Mohenjo-daro, and the cities of the Indus Valley date from as early as 2600 BCE. These would have been unknown to Fergusson as the buildings had not been excavated in his time. In comparison, the Mughal Empire did not come into being until 1526, when Babur, an Afghan chieftain who became the first Mughal emperor, seized Delhi. Today, architectural historians are likely to rate highly such structures as Mohenjo-daro, on the grounds of sophisticated planning, fine construction, and great age, criteria that, as we shall see, only partly match those of Fergusson. Yet it is the Taj Mahal, a late Mughal work built for Shah Jehan, that has become the icon of Indian architecture and seems to epitomize 'Indian' culture, however partially representative. We need therefore to be aware that we are just as likely to be the prisoners of prejudice as was Fergusson.

Plate 21
Map of India
(subcontinent)
showing, in bold
type, the location
of monuments
illustrated in
subsequent plates
in this case study.

For most westerners, the Taj Mahal is the first Indian building with which they are familiar. Read Fergusson's account of it reproduced below, and study Plates 22 and 23. What was it that Fergusson valued in the Taj Mahal and why?

It … has been fortunate in attracting the attention of the English, who have paid sedulous attention to it for some time past, and keep it now, with its gardens, in a perfect state of substantial repair.

No building in India has been so often drawn and photographed as this, or more frequently described; but with all this, it is almost impossible to convey an idea of it to those who have not seen it, not only because of its extreme delicacy, and beauty of material employed in its construction, but from the complexity of its design. … Beautiful as it is in itself, the Taj would lose half its charm if it stood alone. It is the combination of so many beauties, and the perfect manner in which each is subordinated to the other, that makes up a whole which the world cannot match, and which never fails to impress even those who are most indifferent to the effects produced by architectural objects in general.

(*History*, vol.II, p.313)

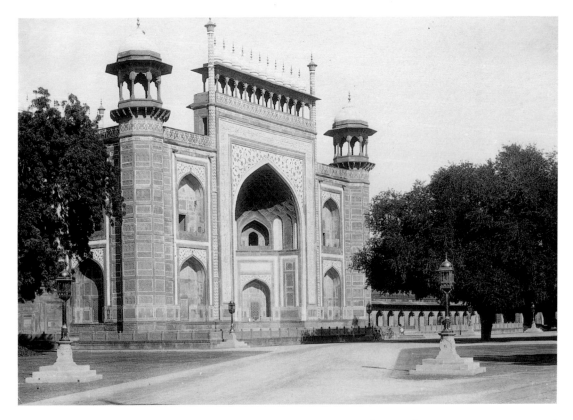

Plate 22 Taj Mahal, Agra, Uttar Pradesh, 1629–51, outer gateway. The British Library, London, Oriental and India Office Collection.

Discussion

Fergusson sings the praises of this monument in aesthetic terms. The attributes that impress him are delicacy, beauty, and complexity. When he talks of the 'delicacy and beauty of material', he is surely thinking of the relief carving of the white marble and the inlay of semi-precious stones. The complexity of the design must include the proportion and relationship of all the parts.

◆◆

The complete description from which this extract is taken details the arrangement and dimensions of the parts and describes the materials. There is not only the tomb with its four minarets, but its platform, the adjacent mosque, and a matching hall as well as an immense garden with fountains and canals and gateways laid out on a geometrical grid. As Fergusson says, the tomb alone would lose half its charm. He is also impressed by its preservation, although his attribution of this to the English is a little disingenuous, since one Governor General in the 1830s, Lord William Bentinck, had suggested demolishing the monument and reusing the stone.

Fergusson asserts that the Taj Mahal is great art, although he does not discuss why it is important. In order to assess the basis on which he makes his claim, we need to be familiar with some comparable examples of Mughal

Plate 23
Taj Mahal, Agra,
Uttar Pradesh,
detail of gateway.
The British
Library, London,
Oriental and
India Office
Collection.

architecture. Equally, we need to know how he placed Mughal architecture in the overall picture of Indian architecture. If we look at some other Mughal buildings (Plates 24–27), we can see that, while other royal tombs may lack the elegant proportions of the Taj Mahal, there are near-contemporary monuments that use fine materials in a similar rich but ordered manner. The tradition of fine building deriving from the Mughal emperors went back at least to Akbar, the first of the 'Great Moguls', in the mid-sixteenth century.

Fergusson's view closely echoes that of another Victorian, the Welsh architect Owen Jones, who included seven plates of Mughal ornament in his *Grammar of Ornament* of 1856. He wrote:

> The Exhibition of the Works of Industry of All Nations was barely open to the public ere attention was directed to the gorgeous contributions of India.

> Amid the general disorder everywhere apparent in the application of Art to manufactures, the presence of so much unity of design, so much skill and judgement in its application, with so much of elegance and refinement in the execution, as was observable in all the works, not only of India, but of all the other Mohammadan contributing countries ... excited a degree of attention from artists, manufacturers, and the public, which has not been without its fruit.

> (chapter XII, p.1)

Clearly, Jones found similar qualities of order and elegance in Islamic decoration as did Fergusson. However, his description is revealing, for he speaks of Islamic ornament as though it were all there was to India. To be fair, he does include two plates of 'Hindoo' ornament, but his position is almost the same as thinking of the Taj Mahal as exemplary of all Indian architecture. In Jones's case there was a particular reason for his bias in that he was concerned with the suitability of the decoration to machine production. Islamic art avoids natural representation for religious purposes, and is correspondingly rich in geometric ornament, which is well suited to mechanical reproduction. This element of Indian art offered a fruitful set of sources to contemporary producers.

Plate 24
Jami Masjid,[11]
Fatehpur Sikri,
Uttar Pradesh,
1572, Badshawi
Darwaza (Gate of
the King of Kings).
Photo: Colin
Cunningham.

Plate 25
Tomb of Itimad ud
Daulah, Agra,
Uttar Pradesh,
1622–8, detail.
Photo: Colin
Cunningham.

[11] *Masjid*, mosque. The *jami masjid* or congregational mosque is usually the principal mosque
in a city.

Plate 26
Mosque of
Sidi Said,
Ahmedabad,
Gujerat,
1572–3,
window of
perforated
limestone.
The British
Library,
London,
Oriental and
India Office
Collection.

Plate 27
Bibi Ka Maqbara
(tomb of the wife
of Aurangzeb),
Aurangabad,
Uttar Pradesh,
1678. The British
Library, London,
Oriental and
India Office
Collection.

Another possible reason for the adulation of Mughal art and architecture might be that it was the product of an imperial realm to which the colonists of the British Empire, as its successors, could relate easily. (The British Raj[12] also imposed its own monuments on the subcontinent: see Plate 28.) The empire of the Great Moguls had lasted until 1707; the last Mughal emperor was in fact used as the figurehead for Indian resistance in the 'Mutiny' of 1857 (the First War of Independence). Mughal architecture was, therefore, very much in evidence, and often very impressive.

Both these factors could have affected Fergusson. Yet it is significant that, although he clearly admired Mughal architecture, he deals with it in one chapter of 50 pages. In spite of the fact that the Mughal emperors and their governors were prolific builders, scattering their domains with mosques, *madrassahs*,[13] caravanserais,[14] tombs, and palaces, Fergusson's coverage of Mughal architecture forms only a small part of his study. This is a marked contrast to the current (1998) standard guide to Indian architecture[15] where Islamic (which includes Mughal) and Rajput monuments and the work of the British Raj fill the larger of two volumes, while Buddhist, Jain, and Hindu monuments fill the other.

Fergusson's summary treatment of so many impressive monuments was dictated by his intention to treat the whole course of Indian architecture. His chapter on Mughal architecture is one of eleven chapters on Indian Islamic architecture, which in turn form one seventh of his coverage of Indian architecture.

Plate 28
Victoria Terminus, Bombay, Maharashtra, 1878–87. Photo: Colin Cunningham. The architect was F.W. Stevens.

[12] British government of India, 1858–1947.

[13] Schools for the teaching of the Islamic faith, usually attached to mosques.

[14] Open courtyards surrounded by rooms and functioning as inns where travellers and their entourages could rest.

[15] G. Michell, *The Penguin Guide to the Monuments of India. Volume I: Buddhist, Jain, Hindu*, and P. Davies, *The Penguin Guide to the Monuments of India. Volume II: Islamic, Rajput, European*.

If Fergusson's intention was to be comprehensive, he nevertheless had to be selective. Among the Islamic monuments Fergusson covers is the series from Bijapur, whose capital 'was adorned with a series of buildings as remarkable as those of any of the Muhammedan capitals of India, hardly excepting even Agra and Delhi' (*History*, vol.II, p.269). It is interesting that he gives prominence to Bijapur, a small independent Muslim kingdom on the southern borders of the Mughal Empire, whose architectural heyday lasted barely 100 years from 1557. He describes the Jami Masjid at Bijapur (Plate 29) as:

> one of the finest mosques in India
> … it would have been, if completed, a rectangle of 331ft. by 257ft. The mosque itself is perfect, and measures 257ft. by 145ft., and consequently covers about 37,000 sq. ft. It consequently is in itself just about equal to the mosque at Kulbarga; but this is irrespective of the wings, which extend 186ft. beyond, so that, if completed, it would have covered about 85,000 sq. ft. – more than the usual size of a mediæval cathedral. It is more remarkable, however, for the beauty of its details than either the arrangement or extent of its plan.
>
> (*History*, vol.II, pp.270–1)

Fergusson compares the building to a medieval cathedral, the most typical great religious monument of his own country, which would have been built in the – then admired – Gothic style. We need to reflect that such comparisons are another way of seeing Indian architecture through western eyes. In discussing both types of building, plan and ornament are clearly important. Fergusson goes on to enthuse about the structure of the mosque at Bijapur, with its 47 unusually flat domes and principal dome covering a 70 foot square. This sixteenth-century mosque he cites as an example of progress in construction, by comparing it with the great medieval mosque at Kulbarga (Gulbarga, near Bangalore in south India) of 1367 (Plate 30). He also praises the slightly later tomb of Mohammed Adil Shah, the Gol Gumbaz (Plate 31), as 'remarkable for simple grandeur and constructive boldness' (*History*, vol.II, p.273). Structural daring was, it appears, something that impressed Fergusson.

On the other hand, Fergusson appears to have been uneasy about the wealth of ornamentation that was common in Indian buildings. In the same chapter that he discusses structure, he expresses reservations about the tomb of Ibrahim Adil Shah, the Ibrahim Rausa (Plate 32). He describes its daring, flat stone roof spanning a 39 foot square, but is less enthusiastic about the decoration:

> The ornamental inscriptions are so numerous that it is said the whole Qoran is engraved on its walls. The cornices are supported by the most elaborate bracketing, the windows filled with tracery, and every part so richly ornamented that had his artists not been Indians it might have become vulgar.
>
> (*History*, vol.II, p.273)

In the 1870s, when Fergusson was writing his text, the prevailing taste in Britain was for simple shapes, and there was a widespread acceptance that the mid-Victorian love of ornament was vulgar and unacceptable. This was a view that had been partly fostered by the writer and art critic John Ruskin (1819–1900), who advocated simple styles executed with dedicated craftsmanship. Fergusson was one of those who popularized Ruskin's ideas.

Plate 29 Jami Masjid, Bijapur, Karnataka, 1557–79. The British Library, London, Oriental and India Office Collection.

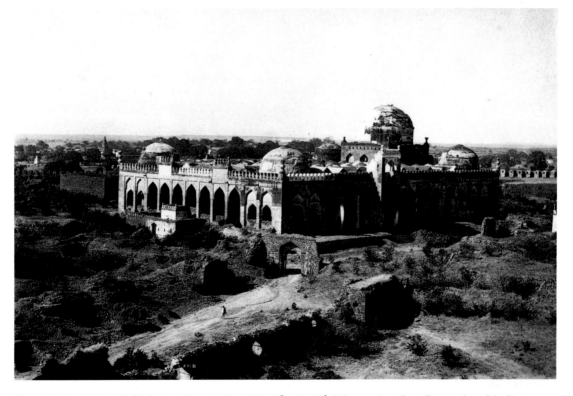

Plate 30 Jami Masjid, Gulbarga, Karnataka, 1367. The British Library, London, Oriental and India Office Collection.

Plate 31
Gol Gumbaz,
Bijapur,
Karnataka,
1636–60, detail.
The British
Library, London,
Oriental and
India Office
Collection.

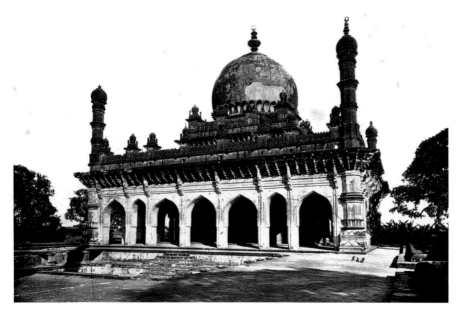

Plate 32
Ibrahim Rausa,
Bijapur,
Karnataka,
1579–1626. The
British Library,
London, Oriental
and India Office
Collection.

Fergusson's method and aims

To say that Fergusson was biased by his European background is not, however, to devalue his work altogether. There is no doubt that he was a dedicated scholar, and his book deals with a wide range of Indian architecture from about 500 BCE on. He was able to make a detailed survey of a vast field, and to make comparisons between buildings of different dates and styles. Yet his method, although it ensured accuracy of description, did not cover the whole range of structures. He was happy to ignore those buildings he considered unimportant, and it is significant that his work is almost entirely confined to mosques, tombs, temples, and palaces. The subcontinent was covered with other buildings as well, which filled important roles in the society. Buildings for travellers and for water supply, for example, would be essential elements on the Indian subcontinent, and many are as richly built as the temples. Caravanserais were falling into disuse as the British-designed railways advanced, and those that remained standing were all too easily converted into jails (a function for which their high walls and secluded courts were well suited), so that they would have been unattractive on social grounds. Wells (see, for example, Plate 33) had religious associations and were often impressive structures, but as mere service buildings they are overlooked by Fergusson.

Similarly, it could be argued that his work is seriously lacking in presenting a picture of Mughal society, in that it does not describe the gardens that were such a feature of the constructed environment of the Mughals. The walled 'paradise' was very much a creation of their civilization, but in strictly architectural terms it was manifest only in various series of small pavilions (Plate 34). Fergusson evidently took a narrow definition of architecture, as grand structures: walls, kiosks, and watercourses did not count. The unique and impressive step wells of Gujerat and Rajasthan (Plate 33), a building type that had been perfected by 1000, do not even rate a mention.

Another omission was domestic architecture, a field that is only now being studied as revealing much about the familial and tribal organization of different parts of India. Yet in the 1870s there were many more old houses surviving than today, and there was still a living and vibrant tradition of carving on façades (Plate 35).

In some cases, Fergusson appears to have misunderstood the function of the architecture. For example, when describing a pilgrimage temple at Srirangam, he spoke of the central enclosure as small and insignificant. It was approached by a series of *gopuras*,[16] the largest of which were on the outside of the complex. Fergusson thought that the design should have been reversed, with the building increasing in size and grandeur towards the most revered part of the temple. The builders of the temple, though, had perceived the largest outer *gopuras* as providing the central gilt shrine with the first line of protection from desecration, the need for which decreased progressively as the object of pilgrimage was approached.

[16] Ceremonial gateways to Hindu temples, generally surmounted by tall, carved towers.

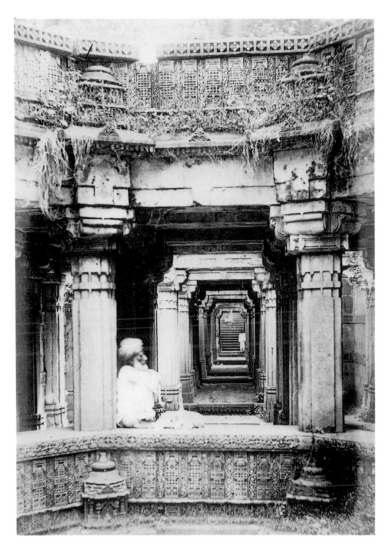

Plate 33
Bai Harir's
step well,
Ahmedabad,
Gujerat,
1499. The
British
Library,
London,
Oriental
and India
Office
Collection.

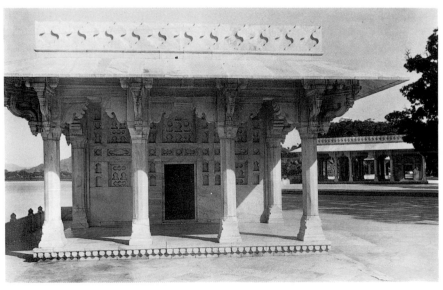

Plate 34
One of Shah
Jehan's lakeside
pavilions, Ajmer,
Rajasthan,
completed 1636.
The British
Library, London,
Oriental and
India Office
Collection.

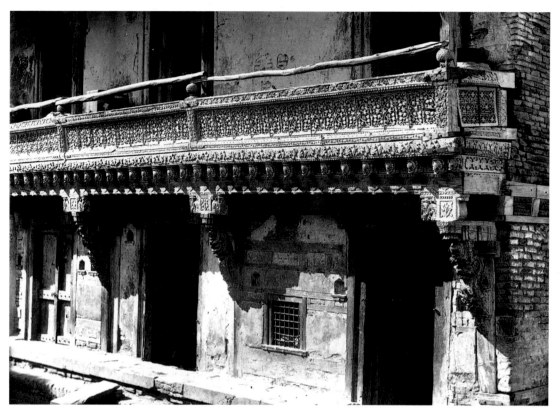

Plate 35
Detail of a *haveli*,[17]
Ahmedabad,
Gujerat, *c*.1870.
The British
Library, London,
Oriental and India
Office Collection.

A further criticism might relate to the incompleteness of Fergusson's book as a picture of India as an economic nexus. It is difficult to recover much from the book of the way in which the different kingdoms interacted other than in warfare, yet there was plenty of evidence of trade from the earliest times. The architectural evidence of this could be seen across the whole of the north of India in the many caravanserais that had been built.

For all his scholarly method, Fergusson set out to write a history of Indian architecture as high status artistic monuments. Instead of considering function or economics, he viewed the buildings solely as representative of the technical and aesthetic abilities of the different eras. Even so, in attempting to cover the building types representing the diversity of culture in the subcontinent, he required an organizing structure.

Underlying philosophy of the *History*

The structure of Fergusson's book is basically chronological, but that does not mean that he merely follows the centuries through without comment. It was a common view among westerners at the time that India was a decaying nation (after all, the West had quite literally just conquered the country and swept aside the last, and rather diminished, Mughal emperor), and there is a subtle transference from the appearance of political decline to the assumption that this will necessarily be reflected in artistic decline. It is easier today to

[17] Timber courtyard house derived from a traditional village dwelling, found mainly in Gujerat.

see that different periods, different parts of a country, or different societies may quite simply have had different priorities in their architecture. Fergusson, on the other hand, sets out to paint a unitary picture that is predicated on his view of the decline of Indian civilization. Inevitably, this was a westerner's view.

Consider the following extracts from Fergusson's text (*History*, volume I). Can you identify from them any preconceptions that may have coloured his attitude to Indian architecture? How might they have affected the historical picture he gives?

> It cannot, of course, be for one moment contended that India ever reached the intellectual supremacy of Greece, or the moral greatness of Rome; but, though on a lower step of the ladder, her arts are more original and more varied.
>
> (p.4)

> What, however, really renders India so interesting … is that it is now a living entity.
>
> (p.4)

> They may contain nothing so sublime as the Hall at Karnac [Egypt], nothing so intellectual as the Parthenon, nor so constructively grand as a mediæval cathedral; but for certain other qualities – not perhaps of the highest kind, yet very important in architectural art – the Indian buildings stand alone.
>
> (p.6)

Discussion

Fergusson compares India, unfavourably, to Egypt, ancient Greece, and medieval Europe, but praises the variety in Indian arts. This should hardly surprise us, given the variety of different cultures that made up the India of his day. In referring to India as a 'living entity', the point Fergusson was making was that India provided a contrast to the classical world whose civilization was dead. This begs two questions: whether there could be said to be a single culture in India (Fegusson was well aware that there could not) and to what extent earlier cultures were really 'living' after centuries of Mughal rule. (The Buddhist tradition, for example, was certainly alive, but it had changed since the first century BCE.) Fergusson is less specific about the qualities he admired in Indian art, retaining primacy of 'sublime', 'intellectual', and 'constructively grand' architecture for the civilizations of the West.

◆◆◆

So deeply steeped was Fergusson in the assumption of western superiority that he enthused over the Buddhist architecture and sculpture from the Gandhara[18] workshops of the first century as clearly influenced by Greeks: 'It is an imitation of Greek forms with divergences – not a copy – but the suggestion must have come from those travelling Greek artists – probably Ionians – who were the agents by whom the Gandhara sculptures were inspired, and Greek statuary was the model' (*History*, vol.I, p.220). Of the Gandhara monasteries themselves (referring to Jamalgarhi near Peshawar, see Plate 36), he wrote 'The extraordinary classical character and the beauty of the sculptures found in these Gandhara monasteries is of such surpassing

[18] Region in the north-west of present-day Pakistan.

Plate 36 'Corinthian' capital from Jamalgarhi, near Peshawar, Pakistan, from James Fergusson, *A History of Indian and Eastern Architecture*, vol.I, London, 1876, figure 121.

interest for the history of Indian art, that it is of the utmost importance their age should be determined' (*History*, vol.I, p.218). The age was crucial in arguing that the works might be Greek influenced. Yet, although it is easy to recognize Gandharan work as a distinct style, historians today do not see the style as a crucial turning-point in the whole history of Indian art.

Part of the problem for Fergusson in evaluating Indian art was the multiplicity of cultures in India and the temptation to rank them in importance rather than simply to recognize differences.

Read the following extracts from Fergusson's *History* (volume I). How far does he seem to recognize differences, and does he appear to consider some traditions superior?

> The Hindu religion, which was probably always supreme in the Dravidian[19] districts, now commonly designated the Brahminical,[20] is divided into the worshippers of Siva and Vishnu,[21] which are quite distinct and almost antagonistic; but both are so overloaded with absurd fables and monstrous superstitions that it is very difficult to ascertain what they really are or ever were.
>
> (p.308)

> The Aryans, who were dominant before the rise of Buddhism, wrote books and expressed their ideas in words, … but they do not seem successfully to have cultivated the æsthetic arts, or to have sought for immortality through the splendour or durability of their buildings.
>
> (p.53)

Discussion

Fergusson recognizes the importance of religious tradition in studying the architecture of a country. He is also well aware of the different faiths that go to make up India, correctly pointing out two of the principal traditions within Hinduism. But he is scathing about the belief itself. (One wonders how he would have explained the paganism of ancient Greece!) He thought that the tradition of Buddhism was superior to the Aryan culture that preceded it.

◆◆◆

[19] Dravidian is the name given to the Hindu culture of the south, principally in Tamil Nadu.

[20] Brahminism evolved during the sixth century BCE as a variation of the Hindu religious practice based originally on ancient ritual texts. The title 'Brahmin' is also used for a member of the highest or priestly caste in the Hindu religion.

[21] Shiva is one of the principal Hindu gods, credited with the power of universal disintegration and re-creation, as part of the cycle of nature. Vishnu is the other major god, protector and preserver of the world.

Fergusson notes that the Aryans 'do not seem successfully to have cultivated the æsthetic arts', in spite of the fact that the great Hindu epics, the *Ramayana* and the *Mahabharata*, which dated from the ninth century BCE, derived from this culture. The period from about 1000 to 700 BCE did not leave many physical remains, but striking examples of Hindu architecture made a millennium later can be seen in the rock-cut temples of Mamallapuram[22] (seventh century, Plate 37) and Ellora (eighth century, Plate 38). Ellora is quite impressive enough to suggest a long period of developing craftsmanship. In the light of Fergusson's strictures, this Hindu tradition is particularly interesting, in that Hindu masons worked for Muslim emperors from the sixteenth century onwards (and also for the British Raj) while their own traditions of carving lived on. It is even possible to make out Hindu elements in Muslim buildings.

Without looking at large numbers of examples it is difficult to spot characteristic features, but you may recognize that the brackets of the Gol Gumbaz, a Muslim tomb dating from the seventeenth century (Plate 31), are manifestly Hindu in character. So too are the squat pilasters on the balustrade of Bai Harir's step well in Ahmedabad, built during the Mughal Empire (Plate 33). There are also many Muslim mosques built from elements of destroyed Hindu temples. Yet it was the surviving monuments – the mosques, palaces, and tombs of the Muslim tradition – which were most in evidence and which even today most westerners think of as Indian. So they are, but Indian of a particular sort, an amalgam of different cultures produced by a variety of princely rulers. The Hindu religious architecture, which belonged to an even older unbroken tradition, was too easily dismissed as fantastic or barbarous. However, in conflict with this perception of early Hindu work, Fergusson also believed in the superiority of early work.

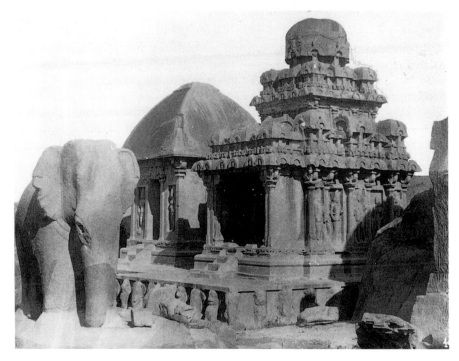

Plate 37
Nine raths,[23]
Mamallapuram,
Tamil Nadu,
seventh century.
The British
Library, London,
Oriental and
India Office
Collection.

[22] Now Mahabalipuram, near present-day Madras.
[23] Small shrines or temples.

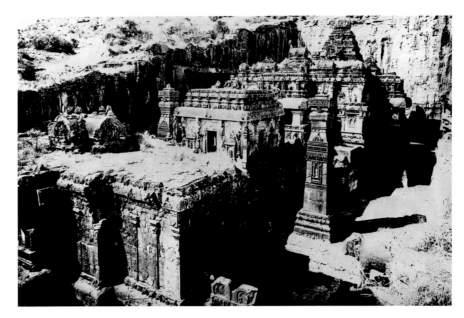

Plate 38
Kailasha temple,
Ellora,
Mahrashtra, mid-
eighth century.
The British
Library, London,
Oriental and
India Office
Collection.

Read the following extract from Fergusson's *History* and look at Plates 19 and 37–39. What is the main difference between the early and the later work that seems to be the basis of Fergusson's objection to later buildings?

> This change is invariably for the worse, the earlier specimens being in all instances the most perfect, and the degree of degradation forming … a tolerably exact chronometric scale, by which we measure the age of the buildings.
>
> (vol.I, p.307)

Discussion

The principal difference between the seventh-century Hindu temples at Mamallapuram (Plate 37) and those dated thirteenth to seventeenth century at Srirangam (Plate 39) seems to be the extent of the carved ornament. The earlier buildings were simpler and easier to appreciate visually than the vast complexes of the later pilgrimage temples. There was also less multiplication of 'absurd fables and monstrous superstitions', simply because there was less carving.

◆◆

Now consider the following extract from Fergusson's text. What are the justifications for his interest in 'Alexander's raid' (the invasion of north-west India by Alexander the Great of Greece in 326 BCE)?

> [It] will, if I mistake not, become quite clear when we examine the earliest 'rock-cut temples' that, whether from ignorance or choice, the Indians employed wood and that only, in the construction of their ornamental buildings before Asoka's time [that is, before Buddhism came to the fore in the Mauryan Empire during the third century BCE]. … From this the inference seems inevitable that it was in consequence of India being brought into contact with the western world, first by Alexander's raid, … that led to this change [that is, the change to stone building]. … From that time forward, however, all is clear and intelligible; we have a sufficient number of examples whose dates and forms are known to enable us to write a fairly consecutive history of the architectural style during the 1000 years Buddhism was prevalent in India.
>
> (*History*, vol.I, p.52)

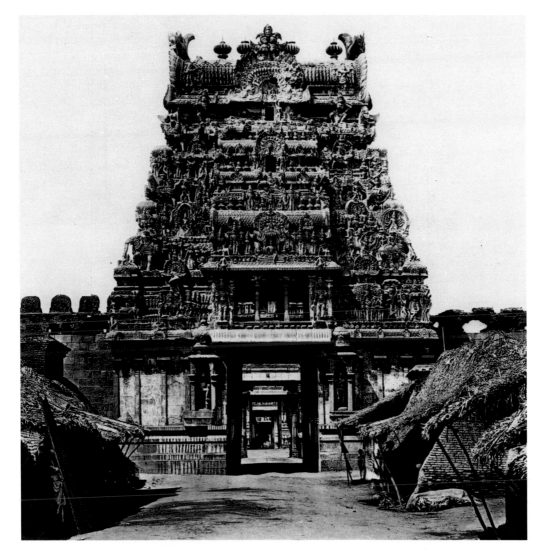

Discussion

'Alexander's raid' was important to Fergusson because it allowed him to infer Greek influence. In addition, Fergusson indicates that it was only from after Alexander's time and the adoption of stone for building that there were surviving monuments for studying. (The massive brick structures of Mohenjo-daro, dating from the second millennium BCE, had not been excavated in his time.)

❖❖❖

Fergusson was impressed with a number of rock-cut temples at Ajanta, by what look like the ends of rafters cut from solid stone. The explanation of the derivation of stone architecture from timber would have been familiar to him, since a similar explanation was accepted for the origins of Greek classical architecture. Such explanations may well be true, and Fergusson accepted that there had been splendid timber architecture in earliest times. In addition, the timber building tradition survived in Fergusson's time in India (Plate 35), although not in the buildings of the status he was prepared to consider.

Plate 39
Ranganatha temple, Srirangam, Tamil Nadu, thirteenth to seventeenth centuries, south gateway. The British Library, London, Oriental and India Office Collection.

One of the earliest monuments he discusses is the Great Stupa[24] at Sanchi (Plate 40), of which he says 'the sculptures of these gateways form a perfect picture Bible of Buddhism, as it existed in India in the second century before the Christian Era, and as such are as important historically as they are interesting architecturally' (*History*, vol.I, p.116). The comment is interesting, for it raises an issue in Indian architecture: of the relation between sculpture and architecture. In fact, as Fergusson indicates, the two cannot be separated, both are integral to the whole. Too often, in the later western tradition, sculpture, such as the Parthenon marbles,[25] has been seen as distinct from architecture. Effectively, this view dates from the Renaissance in Europe, when sculptors began to specialize and to acquire status as individual geniuses. There had been no such distinction in the Middle Ages, when anonymous

Plate 40
Great Stupa, Sanchi, Madhya Pradesh, third to first century BCE, north gate. The British Library, London, Oriental and India Office Collection.

[24] Buddhist site containing relics, hemisphere usually faced with stone and often decorated with elaborate walls and gates.

[25] See Colin Cunningham, 'The Parthenon marbles', in Perry and Cunningham, *Academies, Museums and Canons of Art* (Book 1 in this series).

masons had produced richly carved stonework on churches and cathedrals. We may note the similarity of this with both Buddhist and Hindu architecture (as well as with Jain work), where temples were richly and extravagantly carved by unnamed craftsmen.

Conclusion

Fergusson's view of Indian architecture was distorted by his preconception of Indian art as decaying, by his belief in the influence of European culture on it, and by his distaste for extensive ornamentation.

He found that the first stone architecture was Buddhist, and was able to argue that this followed from the arrival of Greek influence in the subcontinent. Although Hinduism predated Buddhism, it was not until the Gupta Empire in the fourth century that Hinduism began to come to the fore again in northern India and stone temples were built there. On Fergusson's principles, these could be rated as inferior to the earlier Buddhist works.

The Hindu temples of southern India, where neither Buddhism nor Islam ever flourished, were dealt with in the same way. When discussing the temples of Mamallapuram (Plate 37), Fergusson equates the oldest with the 'most interesting'. The great period of temple building in southern India was in the sixteenth and seventeenth centuries (Plate 39), but Fergusson is severe in his criticism of work of this period: 'We may admire beauty of detail, and be astonished at the elaboration and evidence of labour [in a temple of this type] … but as an architectural design it is altogether detestable' (*History*, vol.I, p.368). The dismissal is outright, although he might very well have been impressed by the elaboration and workmanship of the huge temple complexes.

We may accept that there was a tradition of ornamental architecture before stone became the norm, and, if so, the Hindu tradition of carving had been developing continuously for 2000 years. It was still very much alive in Fergusson's day. Even so, Fergusson had no doubt that the Greek and Roman civilization, the civilization from which the West traced its descent, was somehow automatically superior to Indian civilization rather than merely different.

Perhaps one reason Fergusson found it easier to appreciate Islamic architecture and ornament rather than Hindu work was that the ordered logic was so evident, and the architectural forms tended to symmetry, a feature that was crucial to the western classical tradition. In contrast, much Hindu architecture was laid out in what we might today recognize as a more organic way, with the practical functions of the site dominating the design. These are two different approaches, and it is probably more sensitive to accept that each has its own validity. Fergusson, on the other hand, was not afraid to criticize (he even criticized Greek architecture!), and wrote from a confident but particular view of history.

References

Davies, P. (1989) *The Penguin Guide to the Monuments of India. Volume II: Islamic, Rajput, European,* Harmondsworth, Penguin.

Fergusson, J. (1972) *A History of Eastern and Indian Architecture,* 2nd Indian edn, reprinted from revised edn of 1910 printed by John Murray, London (first published 1876).

Jones, O. (1856) *The Grammar of Ornament,* London, Day.

Michell, G. (1989) *The Penguin Guide to the Monuments of India. Volume I: Buddhist, Jain, Hindu,* Harmondsworth, Penguin.

Mitter, P. (1977) *Much Maligned Monsters: A History of European Reactions to Indian Art,* Oxford University Press.

Perry, G. and Cunningham, C. (eds) (1999) *Academies, Museums and Canons of Art,* New Haven and London, Yale University Press.

Pevsner, N. (1972) *Some Architectural Writers of the Nineteenth Century,* Oxford, Clarendon Press.

Preface to Case Study 3:
Revising colonialist viewpoints

CATHERINE KING

We turn next to look at some of the art history about India and Sri Lanka published by Ananda Kentish Coomaraswamy (1877–1947) in the early decades of the twentieth century. Because Coomaraswamy was the son of a Sri Lankan father and an Englishwoman, he wrote from a very different cultural viewpoint from that of Fergusson. As a scholar who was half Sri Lankan and half British by birth, he was in a unique position to undermine colonial perceptions, because he could claim the 'inside' knowledge of 'native' society through his paternal ancestry, and the authority to speak from his maternal side.[1] Coomaraswamy was from a well-off family and had an English public school education. His father was a prominent judge, a member of the Legislative Council of Ceylon,[2] and no less a figure than the Archbishop of Canterbury had officiated at his marriage service. However, with the synthesis of two cultures in his parentage, Coomaraswamy would always be treated as 'different' by the upper classes of colonial society. Significantly, he avoided the Anglican strongholds of Oxbridge and read geology at University College London (1897–1900), the first university college in the United Kingdom to open its doors to students without religious qualification.

Coomaraswamy was appointed to make a geological survey of Sri Lanka in 1902. Once there, he became increasingly interested in the vanishing art of his father's people. He published his first book as a commemoration of what he termed 'Sinhalese art' in 1908. Coomaraswamy's views on Sri Lankan and, later, Indian art were the product of his sense of identifying with the cultural interests of colonized subjects, encouraged by the new political movement for Indian independence. (Since Sri Lanka had been governed by the United Kingdom from 1802 onwards and India from 1858, he tended to see himself as a patriot both of Sri Lanka and of India.) His views were also the result of changes that had taken place in the writing of art history since Fergusson published his *History of Indian and Eastern Architecture* (1876).

In contrast with Fergusson, Coomaraswamy, who had adopted the Hindu faith in 1907, praised the beauties of Hindu religious images, enjoyed lavish ornament, and disparaged interpretations of Indian art that gave what he considered undue attention to the influence of the ancient Greek civilization and the importance of the Muslim Mughal Empire. Unlike Fergusson, Coomaraswamy refused to consider that Indian art was in decline – until, that is, the arrival of the destructive effects of the British invaders. Coomaraswamy was influenced both by historians like Jacob Burckhardt (1818–97), who had studied the history of art and architecture in a holistic way as integral with the history of society and culture, and by cultural

[1] His parents were Sir Mutu Coomaraswamy and Elizabeth Clay Beeby: see Lipsey, *Coomaraswamy*, pp.7–11.

[2] Ceylon was the name by which Sri Lanka was known during colonial times.

polemicists (those taking controversial standpoints) like William Morris (1834–96), who accepted no distinction between such arts as weaving and painting. Coomaraswamy discussed Sri Lankan and Indian art with reference to social, political, and religious structures and adopted an inclusive definition of art and architecture. Not surprisingly, Coomaraswamy was scathing about Fergusson's methodology, noting that a scholar who had written that it 'cannot, of course, be for one moment contended that India ever reached the intellectual supremacy of Greece or the moral greatness of Rome' could only have as his object of research to confirm his *a priori* judgements (judgements that he had already made) (Coomaraswamy, *Rajput Painting*, p.6, n.3). In fact, Coomaraswamy's views were equally marked by his political interests. For example, his vision of Indian nationalism was exclusive, politically and culturally. Where Fergusson had admired Muslim architecture, Coomaraswamy disparaged Muslim, Mughal art on the subcontinent and enthused about an 'Indianness' in art which was largely Buddhist and Hindu. In this sense we can perhaps see him applying the psycho-social mechanisms of 'othering' to Muslims, in bold, even totalizing ways.

Parity with the West:
the flowering of medieval Indian art

CATHERINE KING

Introduction

It is the aim of this case study to discuss the way in which Coomaraswamy's cultural positioning and the historiographical models available to him framed his new look at Indian and Sri Lankan art and architecture. I want, too, to consider the extent to which Coomaraswamy could and could not create a paradigmatic shift, that is, alter a whole set of beliefs, in relation to the art of these two cultures.

Coomaraswamy set about redefining the art of subject peoples in at least three ways:

(i) He proposed that Indian and Sri Lankan art was not in decline until the arrival of European imperialist direct rule.

(ii) He stressed that the art of colonized peoples should be studied with reference to documentation of their artists' and patrons' requirements and beliefs.

(iii) He emphasized that if medieval European art was acclaimed, so should be the art of India and Sri Lanka, for similar reasons.

On the other hand, Coomaraswamy's approach was also, arguably, somewhat conventional in several ways. For instance:

(i) Like Fergusson, Coomaraswamy employed the idea of 'racial' groupings to explain artistic characteristics.

(ii) Although he admired the art of the colonized, he still compared it with the art of European colonizers.

(iii) He read narratives in terms of stereotypical concepts of the masculine and the feminine.

We need to start our investigation by looking at the views on Indian and Sri Lankan art that were available to Coomaraswamy as a young man.

The historiography of Indian art after Fergusson

The colonial approach to Indian art – of admiration tempered by profound reservations – had been sustained during the period following the publication of Fergusson's *History*. In 1880, for example, the future director of the Victoria and Albert Museum in London, George Birdwood, wrote a detailed handbook warmly praising the arts and crafts of India. However, he emphasized that they were to be differentiated from the past art of the Aryan peoples (believed to have created the rock paintings at Ajanta and the great Sanskrit[3] epic poems

[3] Ancient literary language of India.

of the third century BCE), as well as from contemporary fine art of Europeans, because, he said, Indian decorative arts lacked genius:[4]

> It is not of course meant to rank the decorative art of India, which is a crystallised tradition, although perfect in form, with the fine arts of Europe, wherein the inventive genius of the artist, acting on his own spontaneous inspiration, asserts itself in true creation. The spirit of fine art is indeed everywhere latent in India, but it has yet to be quickened again. In operation it has slept ever since the Aryan genius in the people would seem to have exhausted itself in the production of the Ramayana and the Mahabharata.

(Birdwood, *The Industrial Arts of India*, p.131)

Plate 41
Shiva as Nataraja,[5]
tenth to twelfth
century, copper,
height 1.22 m,
South Indian,
Madras Museum,
from A.K.
Coomaraswamy,
*The Arts and
Crafts of India and
Ceylon*, London
and Edinburgh,
T.N. Foulis, 1913,
plate I.

In giving his book the title *The Industrial Arts of India*, Birdwood explained, he intended to cover all craft industries, among which he included the making of sculpted figures. Although colonial writers on Indian art shifted their views, they tended to disparage Indian images for their so called 'lack' of realism. In 1911, the historian Vincent Smith, for instance, felt that he was being adventurous in his willingness to count some Indian art as fine art, in a book entitled *A History of Fine Art in India and Ceylon from the Earliest Times to the Present Day*. He explained that it was possible to pick out some objects as inimitable 'since they were showing creative power in a greater or lesser degree' and distinguishable from 'that which is merely the outcome of skilled hereditary craftsmanship', which artisans can reproduce easily (Smith, *A History of Fine Art*, p.1). Although he criticized the scholar Richard Westmacott for his sweeping dismissal in 1864 of 'monstrous combinations of human and brute forms, repulsive for their ugliness and outrageous defiance of rule and even possibility' (*Handbook of Sculpture*, p.51), Smith was still horrified himself by the 'hideous extra arm' (*A History of Fine Art*, pp.6, 252) on bronze statues of Shiva (Plate 41) and prescribed surgery.

Enthusiasm for medieval European art: rejection of exclusive genius and realism

Coomaraswamy took issue with the statements of Birdwood and Westmacott. With his background, he felt he could take the role of cultural middleman. On the one hand, he could rely on the enthusiastic support of Ernest Binfield

[4] The term 'genius' was interpreted during the Romantic period in Europe around 1800 as meaning 'superhuman inspiration'. Before this time it meant 'innate personal talent'. See Barker, Webb, and Woods, *The Changing Status of the Artist* (Book 2 in this series), especially Case Study 2.

[5] Nataraja is Sanskrit for Lord (or King) of the Dance. Shiva is here portrayed as the source of all movement in the cosmos.

Havell, Principal of the Calcutta School of Art. On the other, he could look to the Arts and Crafts Movement[6] in the United Kingdom for ideas that could be transposed from the praise of medieval European art to the celebration of Indian and Sri Lankan art. As someone with a doctorate in mineralogy (1906, University College London), he had scholarly qualifications – but these were in science rather than in the arts. He had not therefore been indoctrinated through his university career with conventional ideas about art history. In addition, in India he had the cultural companionship of the Tagore family of artists and writers, whose poetry and painting asserted the strength of colonial subjects to debate their own cultural directions.

Since Fergusson had first published his *History*, a critical stance towards classical Greek and Roman art had gained ground, and there were plenty of European historians who much preferred medieval European styles. Such a preference could be harnessed to the appreciation of Indian and Sri Lankan art because, like medieval European art, these seemed to Europeans to be dominantly religious and symbolic rather than realistic, and had been created by groups of, often anonymous, craftsmen. The leading English critic of Greek and Roman art had been John Ruskin who, in texts published from 1852 onwards, had also condemned the Renaissance European artists because they had tried to recreate Greek and Roman styles. Ruskin argued that the pursuit of skills for making idealized and imagined figures seem realistic, and the search for one ideal of beauty, which he thought characterized classical and Renaissance art, denied the real and lovable individual differences and imperfections in human beings. For Ruskin, a more humane art was created in medieval Europe with the development of Christian faith, because of its belief in the forgiveness of faults in all individuals. In his view, Renaissance and classical art chased the impossible goal of soulless perfection in the works of supposedly faultless named geniuses, such as Apelles or Michelangelo. Ruskin considered that ordinary, anonymous, medieval craftworkers had created much greater art through pooling their collective strengths and weaknesses for joint spiritual and social good (Ruskin, *Stones of Venice*, p.190). Ruskin had gone on to associate the desire for perfection evinced in the classical and Renaissance period with Victorian admiration for the perfect uniformity and finish made possible by machine industry. He lamented the loss of the craftworker's personal control over and satisfaction in the production of objects. For Ruskin, medieval art had encouraged the work of the imagination: 'if you will make a man of the working creature, you cannot make a tool. Let him but begin to imagine, to think, to try to do anything worth doing; and the engine-turned precision is lost at once' (*Stones of Venice*, p.192). These ideas, without the Christian element, informed all that Coomaraswamy wrote in his book *Medieval Sinhalese Art* (1908).

Distinctions between fine and decorative or applied art are erroneous

The artist William Morris had developed Ruskin's ideas in a series of lectures given during the last quarter of the nineteenth century, which related these ideas to socialist theories. Morris argued for a wide definition of art to include, 'every one of the things which goes to make up the surroundings in which we live' (*On Art and Socialism*, p.133). The division between the fine arts of

[6] See page 72.

painting, sculpture, and architecture and the decorative arts like pottery, weaving, and goldsmithing, which had been institutionalized by the academies of art from the sixteenth century onwards, should, he thought, be dissolved, and society should return to the inclusive medieval concept of artists as craftworkers, when any work showed 'a man's mind in it always, and abundant tokens of human hopes and fears', and when 'the best artist was a workman still, the humblest workman an artist' (*On Art and Socialism*, pp.121, 134). Morris valued personal expression and goals in the work of art, writing that the worker should 'be allowed to think of what he is doing, and to vary his work as the circumstances of it vary, and his own moods. He must be for ever striving to make the piece he is at work at, better than the last' (Morris, *The Collected Works*, vol.22, *Lectures on Art and Industry*, p.115), but he saw these qualities as part of everyday creativity, not as something extraordinary. Morris pointed disparagingly to the contrast in the West between the exaggerated individualism of the fine arts, with their small group of great artists producing distinctive innovations in style or technique, and the destruction of individuality for the multitude of ordinary workers, whose personal pride and pleasure in their work was removed by machine processes. He believed that if the items of everyday use were of poor design, the vitality and quality of fine arts would soon be sapped, for in 1881 he termed popular art 'the foundation on which all art stands' (*On Art and Socialism*, p.106). Rather than art being for and by an élite, Morris held that it should be made by all, for the pleasure and use of all. A group of people who tried to carry out Morris's ideals of living a well-balanced life as craftworkers came together to form the Arts and Crafts Movement, which Coomaraswamy later joined.

Look back at the quotation on page 70 from Birdwood. What would one of Morris's followers have had to say about his views ?

Discussion

Whereas Birdwood had placed Indian decorative arts on a lower level than fine arts, since he did not believe that Indian arts required inspiration and genius, a follower of Morris would have denied any such distinction. He or she would have considered that imagination and thoughtfulness belonged simply to the exercise of daily creative skill, rather than to an élite.

◆◆

Nationalism in Europe and India

From the mid-eighteenth century onwards, nationalism in Europe had encouraged scholars to re-evaluate Celtic, Romanesque, and Gothic arts created north of the Alps, rather than despising them by comparison with Italian Renaissance and Roman imperial or Greek styles created south of the Alps. (The invasion of classicizing styles into the North had occurred only in the sixteenth century and onwards, and Northern European nationalists sought to retrieve what they thought of as their native styles.) The ideas of Ruskin and Morris were something of a summation of this re-evaluation, and could offer models for those outside Europe seeking to boost their own countries' historical identities. Indian nationalism had developed since the first edition of Fergusson's *History* had been issued, with the formation of the Indian National Congress in 1885. It was making itself felt in political actions, such as the *Swadeshi* or boycott of all imported European goods,

especially imported textiles, in 1903–8, which Coomaraswamy supported. Indian hopes for political independence were paralleled by aspirations for cultural self-determination. Coomaraswamy seems to have been impressed when, in 1906, Havell, as Principal of the Calcutta School of Art, sold the working collection of European art and got rid of the casts made from ancient sculptures, announcing that Indian artists needed to study their own traditions and not the paraphernalia of European art academies. Havell bought Indian art for the School instead. In 1908, he published *Indian Sculpture and Painting*, with the dedication: to 'artists, art workers and those who respect art, this attempt to vindicate India's position in the fine arts is dedicated'. Havell rejected previous accounts of Indian art as 'archaeological' rather than artistic. For example, he favourably compared the sculpture celebrating the lives of the Buddha at Borobudur (Plate 42), which was made by Indian colonists in Central Java in the eighth century, with the marble reliefs on the Parthenon at Athens by Pheidias[8] and the bronze ones on the baptistry at Florence by Ghiberti.[9] In his view, the Indian sculptures were 'original imaginative conceptions which, rightly understood, are worthy to rank with the noblest conceptions in the West' (Havell, *Indian Sculpture and Painting*, p.241).

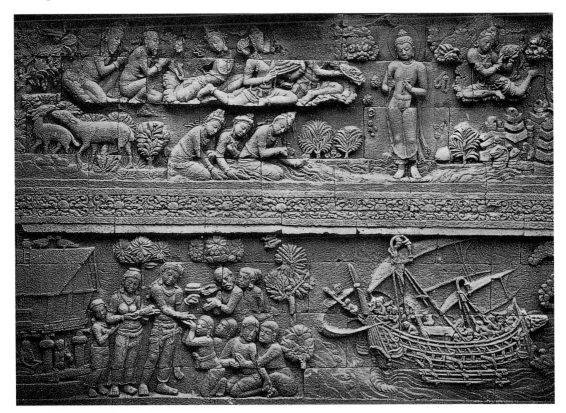

Plate 42 Upper relief: *Buddha Reaches Nirvana*[7] *and Bathes in the River Nairanjar*; lower relief: *Inhabitants of Java Give Food to Indian Colonists Landing on their Shores*, detail, eighth century, volcanic trachyte, Borobudur, Central Java, from E.B. Havell, *Indian Sculpture and Painting*, 2nd edn, London, John Murray, 1928, plate XXXVII.

[7] The state of cessation of individual existence. Buddhists believe that cycles of rebirth are ended by the extinction of separate consciousness.

[8] See Colin Cunningham, 'The Parthenon marbles', in Perry and Cunningham, *Academies, Museums and Canons of Art* (Book 1 in this series).

[9] See Catherine King, 'Italian artists', in Barker, Webb, and Woods, *The Changing Status of the Artist* (Book 2 in this series).

The urbanity of Havell's and Coomaraswamy's prose disguises the polemical status of their arguments. The conflict had come to a head in 1910 in London and consisted of a three-cornered tussle among:

(i) those like Birdwood who held that there was no fine art in India at all and therefore Indian art was inferior to European art;

(ii) those like Smith who thought that there was some fine art in India, which was equal to that of Europe;

(iii) those like Coomaraswamy who treated Indian and European art with parity, on the basis that distinctions between fine and decorative or applied art are always erroneous.

This conflict over definitions of art was taking place against the background of growing interest in the non-representational imagery of the latest modern European art. The artist and art critic Roger Fry (1866–1934) was playing a key role in introducing knowledge of French modern painting – with its abstract, symbolist, or expressive qualities – and the appreciation of non-European art to British audiences at this time. It was his review of four books, which appeared in the *Quarterly Review* in January 1910 entitled 'Oriental art', that raised the level of controversy. The texts reviewed were: Coomaraswamy, *Medieval Sinhalese Art*, and Havell, *Indian Sculpture and Painting*, both printed in London in 1908; Gaston Migeon, *Manuel d'art musulman: les arts plastiques et industriels* (*Handbook of Muslim Art: Modelling and Manufacture*), Paris, 1907; and Lawrence Binyon, *Painting in the Far East*, London, 1908. Fry considered that new kinds of art required new kinds of art history. Coomaraswamy's book was 'not concerned with the history of great masterpieces; his work is almost as much sociological as aesthetic; he seeks to investigate and explain the methods of Sinhalese craftsmen' (Fry, 'Oriental art', p.226). Fry emphasized that admiration for the non-representational styles of both medieval European art and contemporary modern European art, opened the way for those Europeans who had acknowledged that there were a variety of ways of making good art in the European tradition, to be ready to see that there were a variety of worthy art forms outside Europe as well:

> When once we have admitted that the Graeco-Roman and high Renaissance views of art – and for our purposes we may conceive these as practically identical – are not the only right ones, we have admitted that artistic expression need not necessarily take effect through a scientifically complete representation of natural appearances and the painting of China and Japan, the drawings of Persian potters and illuminators, the ivories, bronzes, and textiles of the early Mohammedan craftsman, all claim a right to serious consideration. And now finally the claim is being brought forward on behalf of the sculptures of India, Java and Ceylon. These claims have got to be faced: we can no longer hide behind the Elgin marbles and refuse to look; we have no longer any system of aesthetics which can rule out '*a priori*' even the most fantastic and unreal artistic forms. They must be judged in themselves and by their own standards.
>
> ('Oriental art', p.226)

On 4 February 1910, Havell was asked to give a talk at the Royal Society of the Arts in London on the changes in art education in India. With Coomaraswamy in the audience, while Birdwood chaired the meeting, confrontation came out into the open. When Havell referred to a photograph of a stone sculpture of Buddha from Java (Plate 43) as a good example of

Plate 43 Buddha, eighth century, volcanic trachyte, Borobudur, Central Java, from V. Smith, *A History of Fine Art ...*, Oxford, Clarendon Press, 1911, plate LII.

Indian religious fine art made by sculptors who had travelled from India to Java, Birdwood said, on the contrary, that this 'senseless similitude by its immemorial fixed pose, is nothing more than an uninspired brazen [*sic*] image, vacuously squinting down its nose to its thumbs, knees and toes. A boiled suet pudding would serve equally well as a symbol of passionate purity and serenity of soul' (Smith, *A History of Fine Art*, p.2).

What imagery does Birdwood use in his diatribe?

Discussion

Birdwood uses the imagery of the King James translation of the Bible to suggest that this is an idol, like the brazen idols that had been falsely worshipped in the Old Testament, even though the sculpture was of the philosophical leader, Buddha, and was made of stone. In comparing the statue to a pudding he could be said to suggest that the sculpture resembles a product of the art of cookery – which he thought a lesser art – rather than the fine art of statuary.

◆◆

From the audience Coomaraswamy said that if Birdwood chose to call the stone Buddha 'decorative' art, then 'he preferred decorative to fine art and regarded decorative as a profounder revelation and a more living utterance than fine' (Lipsey, *Coomaraswamy*, p.38).

On 28 February, thirteen men signed a letter to *The Times* deploring Birdwood's views. Among them were Coomaraswamy's colleagues from the Arts and Crafts Movement – the architect and writer William Lethaby and the artists Walter Crane and William Rothenstein: 'We find in the best art of India a lofty and adequate expression of the religious emotion of the people and of their deepest thoughts on the subject of the divine. We recognise in the Buddha type of sacred figure one of the great artistic inspirations in the world' (Smith, *A History of Fine Art*, p.4). The signatories founded The India Society in the same year to encourage understanding of Indian culture.

The beauties of medieval Sinhalese art

Coomaraswamy was 31 in 1908 when he published his first book, *Medieval Sinhalese Art*. This charted the artistic economy of his birthplace – Ceylon – before the coming of the British Empire. Coomaraswamy considered that the effects of trading relationships with the Portuguese and the Dutch from the sixteenth century onwards had not grievously harmed medieval Sinhalese art. These traders had changed Sinhalese art somewhat by asking artists to make some new forms in imitation of objects they had brought from Europe, and had made materials like bronze more readily available. However, these innovations had not damaged the medieval system of artistic economy, which entailed a complex pattern of guilds of artists (blacksmiths, carpenters, painters) like the European guild system, which trained craftsmen and regulated them. Royal patronage, especially in relation to annual court ceremonies, ensured a flow of commissions, and rewarded artists well with gifts including land, over and above agreed payments. Artists took immense pride in their work and worked all hours to achieve what they wanted when making their temples, which Coomaraswamy called their 'cathedrals' (Plate 44). All this had been destroyed by the formal ceding of Ceylon in 1802 to the British. Coomaraswamy rejected the idea that European invaders offered the chance of progress to decadent Sri Lankan art. Instead, he argued that the introduction of industrial practices had taken the personal pleasure in the control of making objects away from the individual craftsman. Coomaraswamy asserted that traditional workshop training did not prevent outstanding talent or genius from being able to flourish, but did ensure that the individualism of all artists was cultivated:

> Such convention is a far greater help than a hindrance to real art. It does not prevent the man of genius from producing the most beautiful work possible, though ensuring that it shall so far conform to an accepted standard as to be immediate and universal in its appeal.
>
> (*Medieval Sinhalese Art*, p.48)

Although Coomaraswamy generally wrote about the world of the artist in Sri Lanka as a male world, he did show photographs of women artists at work as potters and making textiles. In terming those working on the decorative arts as artists, rather than craftspeople, he was challenging definitions of the word 'artist' that proposed it should be applied solely to those making paintings, statuary, and buildings.

Coomaraswamy did not need to have his views approved by British publishing houses, because he was wealthy enough to buy the Kelmscott Press from the estate of William Morris and have the printing of his first book done at his house, Norman Chapel, in Broad Campden, Gloucestershire, using Morris's own print workers. The numerous photographs that illustrate the book were taken by his wife, Ethel Coomaraswamy, and the line drawings and paintings of fragile works were also done by her (Plates 45 and 46). Since the book was hand printed (with a small number of copies made from handmade paper) in an edition of 425, it was a work of art in its own right, carrying high status. It became a collectors' item straight away. Coomaraswamy therefore made his debut by showing the value of Sri Lankan art in the form and content of this de luxe edition and bought himself into the centre of the English artistic avant-garde. The way in which Coomaraswamy mimicked the style of book production hitherto devoted by English intellectuals to Christian and chivalric histories of

Plate 44 Buddhist temple, or *vihare* (image-house), Lankatilaka, Kandy, Sri Lanka, fourteenth century, interior, illustration from the Bemrose Collection, Derby, from A.K. Coomaraswamy, *Medieval Sinhalese Art*, Broad Campden, Essex House Press, 1908, plate VIIIa. Photo: by courtesy of the School of Oriental and African Studies Library, London. The plate shows an image of the Buddha in a shrine, with the seven days of the week depicted on the framing arch.

medieval Europe could be interpreted according to Homi Bhabha's ideas about the critical powers of imitation.[10] As in the books of the medieval English poetry of Geoffrey Chaucer and Thomas Malory that Morris had printed, for instance, the paper was the thickest, the ink the blackest, the margins huge, and the typeface razor sharp.

Plate 45
Ethel Mary Coomaraswamy, veranda ceiling painting, Dalada Maligawa,[11] Kandy, Sri Lanka, nineteenth century, now destroyed (original in shades of brown and green), illustration from the Bemrose Collection, Derby, from A.K. Coomaraswamy, *Medieval Sinhalese Art*, Broad Campden, Essex House Press, 1908, plate XVI. Photo: by courtesy of the School of Oriental and African Studies Library, London.

[10] See the Introduction, page 14.

[11] Dalada Maligawa translates as 'temple of the tooth relic of Buddha'.

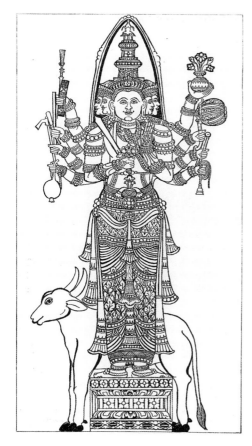

Plate 46
Devasurendra
Mahandiram of
Embekke,
*Vishvakarma
Deviyo,*[12] *c.*1903,
drawing,
illustration from
the Bemrose
Collection, Derby,
from A.K.
Coomaraswamy,
*Medieval Sinhalese
Art,* Broad
Campden, Essex
House Press,
1908, plate XXI.
Photo: by
courtesy of the
School of Oriental
and African
Studies Library,
London.

Rediscovering Rajput painting

In 1908, in *Medieval Sinhalese Art*, Coomaraswamy had claimed the mission of collecting textual and artistic evidence of Sri Lanka's uncelebrated past before it vanished. In *Rajput Painting*, published in 1916, he adopted a similar role for the painting of Rajasthan between the sixteenth and the eighteenth centuries. The book was based on his own collection, comprising nearly 1000 Rajput paintings that he had gathered together by 1913. Again, his wealth allowed him to stake out a new territory in the interpretation of cultural history. Just as with his ability to bypass the British publishing houses through buying the Kelmscott Press, here he had travelled round India literally buying the evidence for his new book. Coomaraswamy therefore personally created the category of Rajput painting. (In the intervening years, new research has been done on the paintings that Coomaraswamy collected, which has in some cases put forward new attributions and dating. For the purposes of this case study, however, I have given priority to Coomaraswamy's interpretations and deductions.)

Coomaraswamy used *Rajput Painting* to give an idealized picture of the Indian 'self-rule' of Hindu princes who stood firm against the invasion by Muslims and Christians, and reiterated that the history of Indian painting was definitely not one of decay and decline. He argued that this painting was the art of the people: open and accessible to all.

He asserted that Rajput painting preserved the tradition of the court art of Ajanta and Sigiriya, which had been made between 300 and 800 and which was much admired. He explained that after this time, between the period from which the murals at Ajanta survive and the preservation of paintings in some Jain manuscripts of the early fifteenth century, nothing was recorded of Indian painting. But he argued that the tradition of the grand Ajanta wall paintings was sustained, even if evidence of its transmission was lacking. In support of this, he pointed to large drawings in his collection, which he dated as made in the eighteenth century, of musicians for a scene of Radha and Krishna[13] dancing (Plate 47), which were used to trace designs onto the wall by painters making large-scale murals. In his view, such assured representation could not be a sudden achievement, but must depend on a vanished tradition connecting late Rajput painting to the earlier art of Buddhism and early Hinduism, which had survived in rock paintings and were widely acclaimed. Coomaraswamy claimed that Rajput painting was made by the original Aryan or Hindu communities, who had been besieged

[12] The Hindu god Vishvakarma, revealer of craftsmanship and architecture, was the tutelary god of artists.

[13] Krishna is a Hindu god, believed to be the eighth incarnation of Vishnu and the embodiment of love and joy. According to Hindu mythology, Radha was his mistress during a period when he was living among herdsmen.

by Mughal and British invaders for eight centuries and had survived either
on the plains of Rajputana[14] or by having withdrawn to the Himalayan
foothills. As with Sri Lanka, he saw these self-sufficient civilizations vanishing
in what he called a 'tornado' of westernized education. His nationalism was
evident again in the way he sought to distinguish Rajput art from the Mughal
art made for invading Muslim princes.

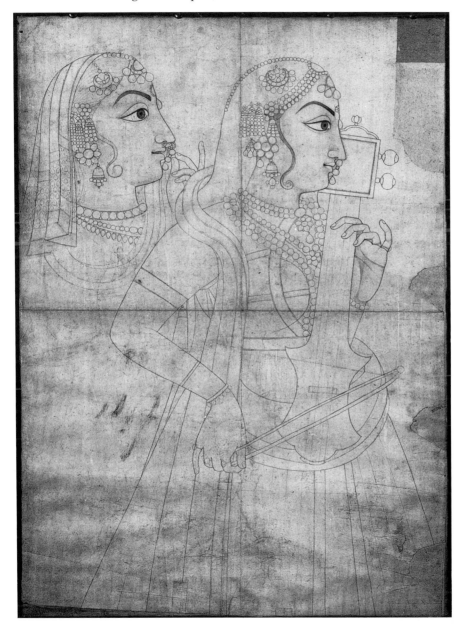

Plate 47 *Two Musicians: Singer and Sarangi Player*, cartoon for a mural of *Rasalila*
showing dance of Krishna and the *gopis*,[15] according to Coomaraswamy eighteenth-
century, Jaipur, Rajasthan, but according to the present curators *c*.1800, Rajput,
Rajasthani School, drawing on paper, 51.4 x 50.8 cm, Metropolitan Museum of Art,
New York, Rogers Fund, 1918.

[14] Group of princely states chiefly comprising what is now Rajasthan.

[15] *Rasalila* is the circular dance of the *gopis*, or milkmaids, with Krishna, who, according to
Hindu mythology, multiplied himself so that each thought she was dancing with him.

Coomaraswamy pictured Rajput communities as ruled by benevolent and well-educated Rajas,[16] like the painter, poet, and mystic devotee of Krishna, Raja Savant Singh:

> The time had not yet come when a wealthy Indian found it needful to hang a Royal Academy picture on the walls of a Clapham villa to prove himself an educated man. India was not yet governed by movable officials, ignorant if not contemptuous of all that most engages the hearts and minds of the people.
>
> (Coomaraswamy, *Rajput Painting*, p.82)

Coomaraswamy represented the Rajput princes as sovereigns who shared the culture of their subjects and whose education was broader than that provided by an English university. He presented a vision of a court art made so that it spoke as much to the ordinary people as to its princely commissioners. He quoted the *shastra*[17] (the 'Arthashastra' or 'Rule of Statecraft' written in the third century by the statesman and philosopher Kautilya) to explain that rulers who acquire new territories 'should follow the people in their faith with which they celebrate their national religious and congregational festivals and amusements' ('Artasastra of Kautilya', p.164). Coomaraswamy deplored the way in which British rulers had failed to follow such advice and had destroyed Indian artistic traditions in the process. Quoting from the *shastra* was important, because European colonists tended to claim that their subjects had no adequate written or oral histories or theories about art or society. The *shastras* proved them wrong.

Coomaraswamy set out to define Rajput painting by comparison with the acclaimed art of the Mughal courts. He considered that Mughal painting was too naturalistic.

Look at Plates 48 and 49. Can you explain his views ?

Discussion

Coomaraswamy, who preferred medieval symbolic to classical realistic representations, was wary of naturalistic portrayals like those for which the Mughal artists were famed.

◆◆◆

Mughal painting flourished between the mid-sixteenth and the early eighteenth century, and recorded the appearance of the court in portraits as well as events of importance to the prince, such as ambassadorial visits and battles won (Plate 48). In contrast, Coomaraswamy claimed, Rajput portraits of rulers did not record an individual's appearance but rather suggested an idea of his personality (Plate 49). He proposed that realism was an imperial style of painting imported to India by Mughal and then British invaders. He argued that realism was exclusively for aristocrats and he also compared the way Mughal art was made by named artists at court with the academic production of art by named masters in Europe from the sixteenth century onwards. Although the signatures of many of the Mughal artists prove that they were native Indians, the Mughal rulers had, in his view, imposed their patterns of production. Whereas Mughal painting was mostly secular, Coomaraswamy saw Rajput painting as 'hieratic' (by which he meant religious) and idealizing, not realistic. Instead of grand court scenes, he said,

[16] Indian princes or kings.

[17] Theoretical treatise on any subject, including statuary and architecture.

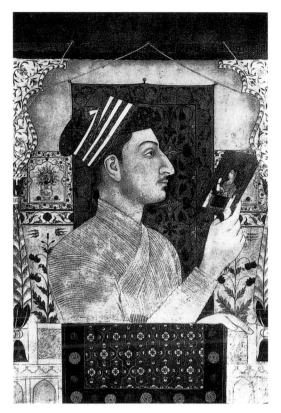

Plate 48 *Prince Dara Shikoh on the Balcony of his Palace in Delhi, Holding a Portrait of his Wife, Naditah Begum, c.1630,* Victoria Memorial Collection, Calcutta.

Plate 49 *Raja Hataf Bandral,* eighteenth century, painting on paper, 14.5 x 20.8 cm, according to Coomaraswamy Jammu or Chamba, Pahari,[18] Ross-Coomaraswamy Collection. Courtesy, Museum of Fine Arts, Boston.

the Rajput painter made images of homely events, which were nevertheless deeply symbolic in meaning, and intended to please ordinary as well as aristocratic viewers because they illustrated legends well known to all:

> It is possible to make of the study of Mughal Painting an *affair* of names and dates after the approved European *fashion.* This will never be possible with Rajput Art which like all *Ancient* Indian art, is typically anonymous and conservative. Mughal art, however magnificent its achievements, was but an episode in the long history of Indian painting.
>
> (Coomaraswamy, *Rajput Painting,* p.6; italics in original)

The subject-matter of *Rajput Painting*

Coomaraswamy decided to organize his account by focusing on iconography, because, he explained, the primary function of Rajput painting was the communication of narratives and ideas. For him the constant theme of this style of painting was that of hopes for union with the divine symbolized by scenes of love. In these scenes of love, he wrote, Rajput painting 'creates a magic world where all men are heroic, all women are beautiful and passionate and shy, beasts both wild and tame are the friends of man, and trees and flowers are conscious of the footsteps of the Bridegroom [the god Krishna] as he passes by' (*Rajput Painting,* p.7).

[18] Pahari means 'of the hills' and is a generic term applied to Indian painting made in the Punjab hills.

The main subjects were the Sanskrit epics of the *Ramayana* and the *Mahabharata*, the household literature of India which provided in his view such a range of improving and uplifting moral examples that they were able to produce a highly cultivated nation without universal literacy. In addition, painters illustrated different musical modes, which were categorized according to the emotion to be evoked. Coomaraswamy eulogized Rajput painting as expressing 'profound accomplishment, tenderness and passionate intensity' (*Rajput Painting*, p.3). His overt motives in stressing such qualities as gravity, reverence, tenderness, and moral edification were perhaps partly to counter any imputation of lasciviousness, lest images of human love be read as titillating by the prudish. Indeed, he quoted his favourite passage from the poet William Blake: 'The soul of sweet delight can never be defiled' (*Rajput Painting*, p.42). On a level of which he was probably unaware, Coomaraswamy's readings of Rajput paintings as representations of divine, through human, love define the feminine in highly stereotypical terms, and ones that played, in part, to contemporary Edwardian sentiment. Coomaraswamy defended his idea of traditional Hindu values in a paper read to the Sociological Society in London in 1912. In it he outlined his idea of the ideal woman 'beautiful and gentle, considering her husband as her god' (*Sati*, p.4). Ostensibly, however, he was keen to emphasize that Rajput painting had been ignored because European colonists did not believe that India could produce anything that 'appeals to the mind and to deep feeling' (*Rajput Painting*, p.6, n.3).

European models of development

Coomaraswamy followed the models of European art history (on European art) in telling a story of the progress of painting from the sixteenth century to a peak in the late eighteenth century. He suggested that in India this peak was followed by a decline caused by British invaders' neglect and disruption. The paintings he used to illustrate this theory were sheets from large portfolios narrating well-known epics or songs. They were storyboard paintings, each with a short caption, which, he suggested, narrators of familiar, traditional stories used to accompany their exposition to groups of listeners, or which related to the playing of music.

The earliest examples of this genre made in the sixteenth century and early seventeenth century evinced 'impeccable draughtsmanship and constant invention with savage vitality' (Coomaraswamy, *Rajput Painting*, p.12). In Plate 50, for instance, a village maiden is shown risking her reputation by leaving her house to walk through the rain and wind, seeking her lover. According to Coomaraswamy, this is a moral exemplar of what must be sacrificed by those seeking to embrace the divine. In judging progress in Indian painting, Coomaraswamy looked for qualities of more animation, more tender feeling, more technical command in draughtsmanship, and greater brilliancy and luminosity of colour, and gave as examples such paintings as those illustrating the *Ramayana* (Plates 51–53). In Plate 51, for example, we see the army of Rama[19] encamped before the city of Lanka (back left), where the demon king Ravana, who has kidnapped Rama's wife, Sita, is besieged.

[19] Hero of the *Ramayana* and the seventh incarnation of Vishnu.

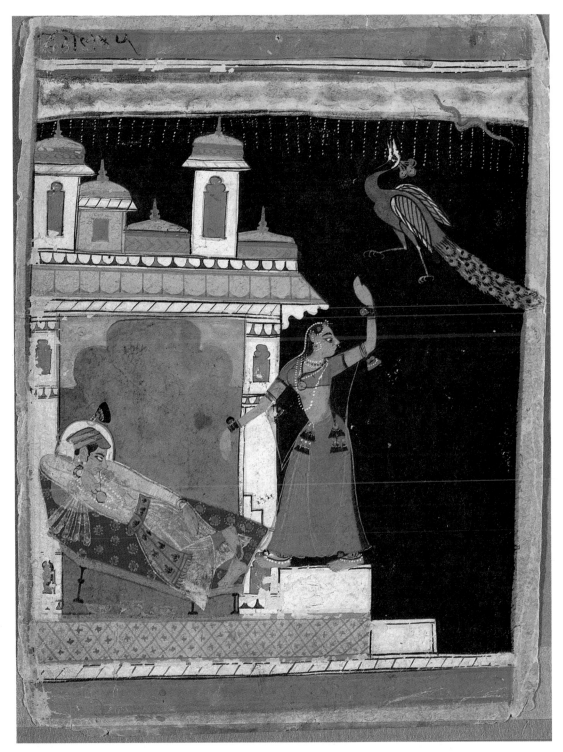

Plate 50 *Village Maiden Comes to her Lover in a Night of Wind and Raiṇ*, inscribed 'Madhu Madhavi
Ragini',[20] according to Coomaraswamy sixteenth century, Rajasthan, now regarded as 1630–40, Malwa,
Central India, colour on paper, 19.1 x 14.6 cm, Cleveland Museum of Art, gift of J.H. Wade, 1925.

[20] Mahdu Madhavi means 'honey-sweet'. In Indian music, a raga or ragini is a framework
for improvisation based on a given set of notes and rhythmic patterns.

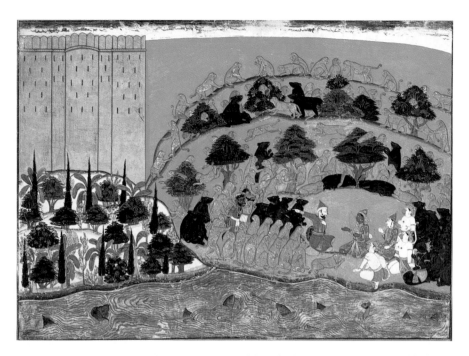

Plate 51 *The Spies Suka and Sarana Discovered by Vibishana to Rama Encamped before Lanka*, according to Coomaraswamy seventeenth-century, Jammu, Pahari, now regarded as *c.*1720, Guler, Pahari, painting on paper, colours and gold, 58.2 x 82 cm, Ross-Coomaraswarmy Collection. Courtesy, Museum of Fine Arts, Boston.

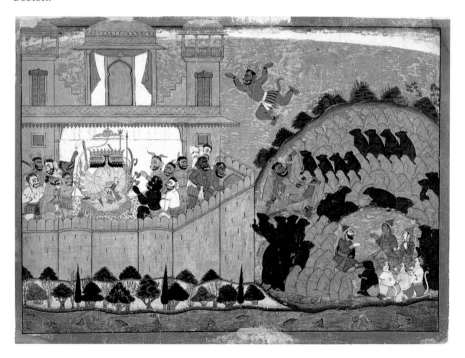

Plate 52 *Ravana Sends the Spy Sardula to Rama's Camp, He is Captured, and Rama Sends him Back*, according to Coomaraswamy seventeenth century, Jammu, Pahari, now regarded as *c.*1720, Guler, Pahari, painting on paper, colours and gold, 60 x 82.7 cm, Ross-Coomaraswamy Collection. Courtesy, Museum of Fine Arts, Boston.

Plate 53 *Vibishana and the Monkey and Bear Leaders with their Army Protect the Stricken Rama and Lakshmana,* according to Coomaraswamy seventeenth century, Jammu, Pahari, now regarded as *c.*1720, Guler, Pahari, underdrawing on paper, 59.4 x 84 cm, Metropolitan Museum of Art, New York, Rogers Fund, 1919.

Ravana's good brother, Vibishana, is in the centre, pointing to the spies of the demon king, whom the monkey and bear army fighting for Rama have captured. Rama, on the right (with his brother Lakshmana and the captains of the bears and monkeys) listens to Vibishana's speech. In Plate 52, the story begins on the left, with the exit of the spy Sardula from the city of Lanka. His capture by bears and monkeys is shown in the centre, then to the lower right is the debate about his future by the leaders Rama, Lakshmana, and Vibishana, and finally we see him allowed to fly back, above. King Ravana is represented in the city of Lanka to the far left. Plate 53 represents another episode in this story of the fight by Rama to rescue his bride from the city, only here he and his brother have been vanquished, while some of his army look on mournfully and others hold weapons in case his attackers return. The careful and animated underdrawing awaiting the attention of the painter is visible.

Coomaraswamy saw continued development with paintings such as that shown in Plate 54, which he characterized as 'well and vigorously designed often with a decorative simplicity suggestive of large-scale mural art' (*Rajput Painting*, p.18). He reserved the highest praise for paintings that he dated as made in the second half of the eighteenth century, writing that they were equal to those of the classic art of Ajanta (*Rajput Painting*, p.22). Here he was following European writers who had taken the phrase 'classic art' (used since the eighteenth century to denote Greek art worthy of emulation) and transposed it to India to describe early Hindu and Buddhist art. He described these artists as having great technical skill, which was used to create effects of animation, and their work as showing flawless lyrical sentiment without verging on the sentimental. He found these qualities in such scenes as that

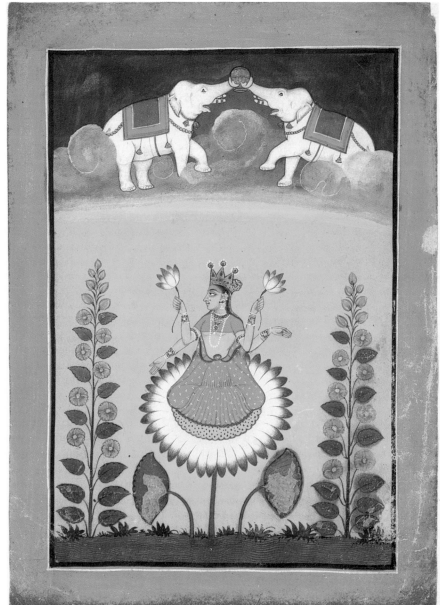

Plate 54 *Maha Lakshmi*[21] *Risen from the Waters on a Lotus Throne is Washed by Elephants*, dated seventeenth century by Coomaraswamy in 1916, but revised to eighteenth to nineteenth century, painting on paper, 15.3 x 21.2 cm, Jammu, Pahari, Ross-Commaraswamy Collection. Courtesy, Museum of Fine Arts, Boston.

shown in Plate 55, where Krishna (who has fallen in love with Radha, a married herdswoman) is surrounded by herdsmen making music while milkmaids welcome them. Using a bird's-eye viewpoint and the most delicate range of tints, the painter suggests the cattle crowding the street and entering a courtyard, where Krishna's adoptive father, his foster mother, and his elder brother greet the herdsmen and their charges. By the early nineteenth century, Coomaraswamy considered, Rajput painting was past its zenith, because it emphasized the sentimental and theatrical rather than expressing sincere and genuine feeling (Plate 56). In his view, its decline was hastened by British neglect (see *Rajput Painting*, p.23).

[21] Wife of Vishnu.

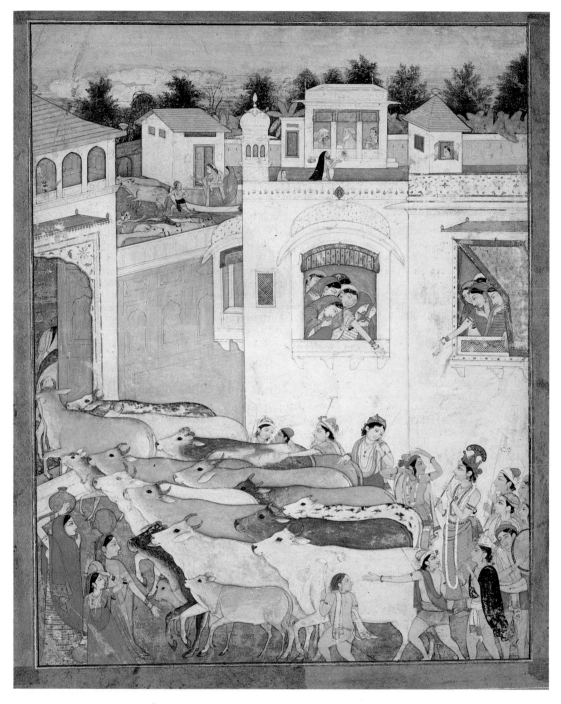

Plate 55 *Krishna Returning with the Cows at Dusk*, according to Coomaraswamy late eighteenth century, opaque watercolour on paper, 27 x 21.6 cm, Kangra, Pahari, Denman W. Ross Collection. Courtesy, Museum of Fine Arts, Boston.

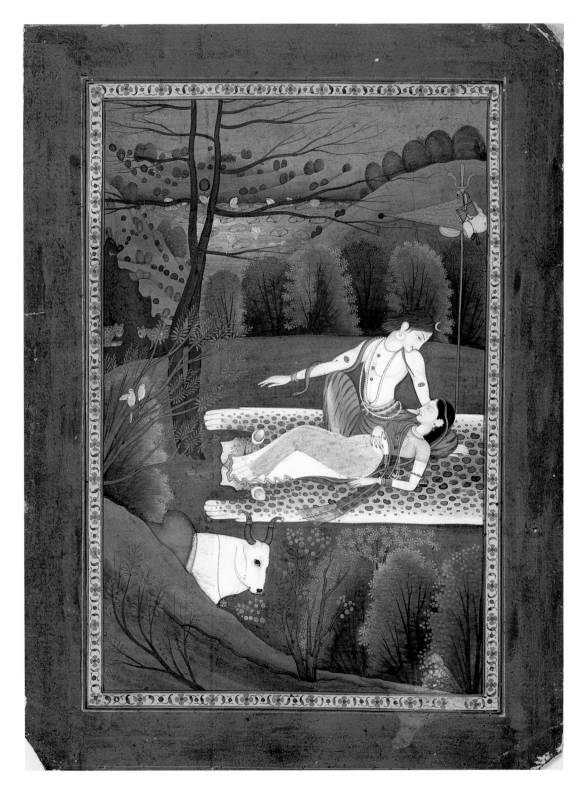

Plate 56 *Shiva and Parvati*, according to Coomaraswamy late eighteenth to early nineteenth century, now regarded as *c.*1780–90, painting on paper, 29.5 x 21.3 cm, Garhwal, Pahari, Ross-Coomaraswamy Collection. Courtesy, Museum of Fine Arts, Boston.

Coomaraswamy admired the subtlety of such images as *Shiva and Parvati* (Plate 56), even though he considered that the content might be verging on the sentimental. In this painting, the artist suggested depth by overlapping forms, by alterations in both hue and tone, as well as a variety of suggested textures, both opaque and semi-transparent. Shiva is shown honeymooning in the Himalyan forests with his consort, Parvati, who has already gone to sleep. The lovers lie on a leopard skin (Parvati's feet neatly tucked between its ears). Some animals (watchful leopards and Nandi, Shiva's bull steed) are wakeful too. The moonlit scene itself suggests some of the god Shiva's powers, for he wears as an attribute the moon on his brow, as well as having extra eyes in his forehead and forearms. Beside him is his trident, a pennant, a drum, and his begging-bowl as an ascetic. Wound about him is a snake, while he is skirted by a tiger skin. At the centre of the painting is, significantly, the elegant but powerful hand of the god.

In conclusion, Coomaraswamy insisted that the same subject could be treated again and again without monotony, as, for example, in the story from the *Mahabharata* of the miracle of the attempt to unveil Draupadi,[22] who had prayed to Krishna not to be so revealed (Plates 57 and 58). (Whereas Plates 57 and 58 both represented the king seated among his councillors in quite comparable ways, the artists placed very differently the five pandavas[23] shuddering at the attempt to punish the woman. In Plate 57, they are clustered to the left hiding their faces in horror, while in Plate 58 the artist seated them right. In Plate 57, the heroine threatened with stripping is to the right. In Plate 58, the assault on her has been pushed to the left.) Coomaraswamy believed that art shared with music the property of repetition without monotony:

> There is a close analogy between the set theme of the picture and the set form of the raga: in each case a skeleton or as the Indians say, the trunk of the tree, is given, and each artist must add the leaves and branches himself. Just as no song is ever exactly repeated, so no picture; but each fresh rendering is closely related to the others. This is a theory of art entirely differing from the modern European conception of professional art; there each subject treated by a master, is once and for all done with, and no artist dare deal with it, lest he should be accused of plagiarism or lack of originality. Thus one is misled to think of art as a treasury of masterpieces by men of exceptional genius. But Hindu art both hieratic [religious] and vernacular, has always been more or less a national art, determined by the wish to have certain groups and ideas constantly represented.
>
> (*Rajput Painting*, p.25)

Coomaraswamy pitied the modern European artist who had the burden of finding his own technique and was 'left to find and solve his own problems' (*Rajput Painting*, p.24). Instead, he praised art forms made, he believed, *by* the people *for* the people. These, he said:

> like all Primitives aimed at giving clear and edifying expression to certain intuitions which everyone desired should be thus clearly and frequently expressed, they formed a part of popular religion in just the same way as the sculptures and painted windows of a Gothic church.
>
> (*Rajput Painting*, p.6)

[22] A queen who was threatened with the public shaming of having her clothes taken off her.

[23] Ascetics who were all brothers and all married to Draupadi.

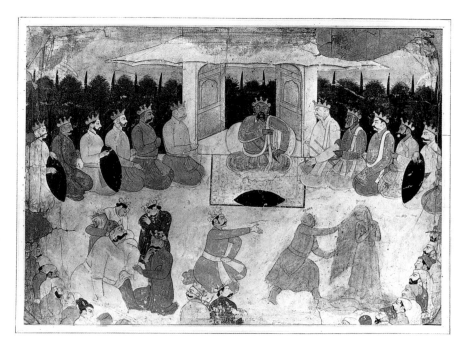

Plate 57
*Krishna Prevents
the Unveiling of
Draupadi*,
according to
Coomaraswamy
seventeenth or
early eighteenth
century, Kangra,
Pahari, now
regarded as
*c.*1740, Guler,
Pahari, unfinished
sketch lightly
tinted and cut
down. © The
Board of Trustees
of the Victoria
and Albert
Museum, London.

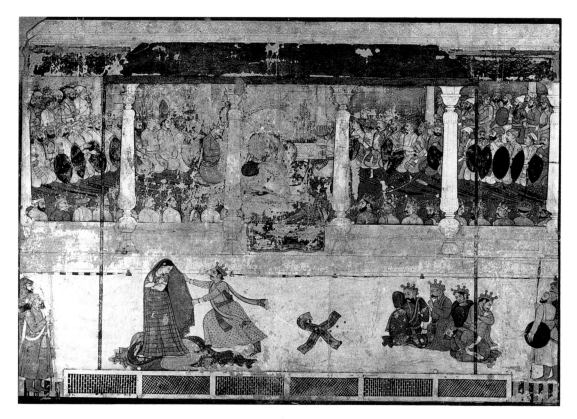

Plate 58 *Krishna Prevents the Unveiling of Draupadi*, according to Coomaraswamy late seventeenth or early eighteenth century, painting on paper, 28 x 38 cm, Kangra, Pahari. Photo: by courtesy of the Government Museum and Art Gallery, Chandigarh.

Here Coomaraswamy was using the term 'Primitives' in the original meaning in relation to European art, since it was first used in the mid-nineteenth century in Europe to describe *primitivi* or Italian painters working before the use of academic techniques and regarded for this reason as possessing a simple, straightforward, and unaffected style.

Conclusion

Coomaraswamy selected ideas from European art historians to form a new set of hypotheses and interpretations that could foster honourable identities for Indians. In the guise of a 'native' historian, he asserted the right to tell the story from the point of view of specialist 'native' expertise, but also obtained access to the colonizers' institutions, which authorized what counted as knowledge. Although Coomaraswamy very much belonged to the culture that had educated him to employ categories of 'race', 'nationality', and gender uncritically, he set out to change colonizing peoples' evaluations of the art of subject peoples. He gathered new data in the form of the *shastras*, and documented the art of Sri Lanka and northern India, as well as transposing European ideas to the study of colonized peoples' art works. It was his aim to change the situation in which 'modern Indians refuse to believe that such a thing as Indian art ever existed', and he looked forward to a time when 'an age of criticism and research shall have made her [India] mistress of herself' (*Rajput Painting*, pp.82–3).

References

'Artasastra of Kautilya' (Book XIII, chapter V) (1910), trans. R. Shamasastry, *Indian Antiquary*, vol.39, June, pp.161–4.

Barker, E., Webb, N., and Woods, K. (eds) (1999) *The Changing Status of the Artist*, New Haven and London, Yale University Press.

Birdwood, G.C.M. (1880) *The Industrial Arts of India*, London, Chapman Hall.

Coomaraswamy, A.K. (1908) *Medieval Sinhalese Art*, Broad Campden, Gloucestershire, Essex House Press.

Coomaraswamy, A.K. (1913) *Sati: A Vindication of the Hindu Woman*, London, Sherratt & Hughes.

Coomaraswamy, A.K. (1916) *Rajput Painting: being an account of Hindu paintings of Rajasthan and the Punjab Himalayas from the sixteenth to the nineteenth century described in relation to contemporary thought*, London, Oxford University Press.

Fry, R. (1910) 'Oriental art', *Quarterly Review*, vol.212, no.422, January, pp.225–39.

Havell, E.B. (1928) *Indian Sculpture and Painting*, London, John Murray (first published 1908).

Lipsey, R. (1977) *Coomaraswamy: His Life and Work*, 3 vols, Princeton University Press.

Morris, M. (ed.) (1910–15) *The Collected Works of William Morris*, 26 vols, London, Longmans, Green.

Morris, W. (1947) *On Art and Socialism: Essays and Lectures*, ed. H. Jackson, London, John Lehmann.

Ruskin, J. (1852) *Stones of Venice*, in *The Complete Works of John Ruskin*, ed. E.T. Cooke and A. Wedderburn (1903–9), 37 vols, vol.X.

Smith, V. (1911) *A History of Fine Art in India and Ceylon from the Earliest Times to the Present Day*, Oxford, Clarendon Press.

Westmacott, R. (1864) *Handbook of Sculpture*, Edinburgh, A. & C. Black.

Preface to Case Study 4: Reversing the direction of the colonial gaze

CATHERINE KING

In considering aspects of culture and imperialism, it is a key task to compare the kind of resistance possible while colonial systems held sway (such as that of Coomaraswamy) and the kind produced after direct rule ended. In Case Study 4, we turn to consider the post-colonial viewpoint of Partha Mitter. The case study looks at the way European scholars have read (and continue to read) Indian art as 'decadent', and proposes other preferable lines of enquiry. It distils one of the main fields of Mitter's research as it builds on his doctoral thesis, published as *Much Maligned Monsters: A History of European Reactions to Indian Art* (1977), which was undertaken with the supervision of the art historian E.H. Gombrich. Mitter challenged the sweeping world view that the scholar Edward Said has characterized in *Culture and Imperialism* (1993) as the normal assumption of imperialist viewers. Coomaraswamy had rebutted some European evalutions by comparing Indian art to European medieval styles, and had offered new interpretations and new data on Sri Lankan and Indian art. Mitter, however, is able to take an even more independent line (arguably made possible by the fact of political independence) and has set out to discover for European culture the history of *its* ideas. In a neat riposte to the way generations of Europeans saw themselves as giving the history of Indian art to Indians, Mitter has returned the history of western ideas about Indian art – to the West.

In *Much Maligned Monsters*, Mitter traced the application of theories of racial superiority to the evalution and categorization of pre-colonial Indian art in writings like those of Fergusson in the mid-nineteenth century; he noted, for example, Fergusson's unfavourable comparisons between pre-colonial Indian art and the traditions of classical Greek and Roman art. Mitter also analysed the evaluations of Havell and Coomaraswamy, with their enthusiastic assumptions that pre-colonial Indian art was similar to that of medieval Europe. Mitter regarded both approaches as blinkered, since neither set of viewers was willing to treat Indian art independently of western canons – be they classical or medieval.

In *Much Maligned Monsters* and Case Study 4, Mitter argues that the way forward is 'to restore the religious, cultural and social contexts of Indian art. In the process we shall have to make a conscious effort to learn what actual standards of art criticism were in operation among those Indians who had created these works and among those for whom they were created' (*Much Maligned Monsters*, p.286). Indian artists and patrons recorded and transmitted their own canons in the *shastras*. Patrons documented their intentions and responses in inscriptions, and a long literary tradition provided evidence of the values and aspirations of successive audiences. Furthermore, the study of the development of different forms – such as the Buddhist *stupa* and the

Hindu temple, and the images of the Buddha and Shiva in their different guises – reveals successive artists contributing to a group or canonical sequence of solutions regarded as worthy of emulation: that is, to the making of a tradition whose priorities are discernible to the extent that they can be seen as exploring a specific art form. Therefore, Mitter concludes by asking for research that considers the history of Indian ideas of beauty and Indian taste in art.

'Decadent' art of south Indian temples

PARTHA MITTER

Decadence and cultural decay

A distinguished anthropologist, Arthur Maurice Hocart, was the Archaeological Commissioner for Sri Lanka for a number of years, during which he published extensively on the ancient Buddhist and Hindu monuments of the island. In 1934, he published a paper with the intriguing title 'Decadence in India', conjuring up the steamy, unwholesome world of a tropical forest exuding a sickly sweet smell of death and incense. The paper has relevance for the study not only of the general history of India but of Indian art and architecture as well. No other scholar to my knowledge ever used the concept of decadence so systematically in order to construct an overarching theory of culture. Hocart offered certain general ideas about the moral decadence of a society through a formal analysis of its art and architecture. While Hocart's main concern was ancient India, he chose to support his thesis with examples from Sri Lanka, whose antiquities were better known to him. In this case study, I will explore some of the ways in which Hocart and other western historians constructed a history of Indian art and architecture founded on ideas of cultural decadence and degeneration. Such concepts were rooted in a value system that prevented these thinkers from understanding the original social and religious meanings of Indian art.

Hocart's argument about the moral decline of Sri Lanka rested on a contrast between the simple artistic style of Anuradhapura, the early capital of Sri Lanka (about second to eighth centuries), and the 'florid' manner and 'violent motions' at the expense of form to be found in the later capital at Polonnaruva (twelfth century). The earlier 'progressive' art of Anuradhapura was captured in the slim and vivacious figures of the fifth-century Sigiriya paintings (Plate 59). This kind of representation was in Hocart's view to be contrasted with the later 'decadent' style of the sculpture of the reclining Buddha at Polonnaruva (Plate 60). The 'Anuradhapura' period was chosen by archaeologists as the 'classical' age of Sri Lankan art because its simplicity appealed to western taste. By the same token, terms like 'florid' and 'violent motions' – applied by Hocart to the art of Polonnaruva – were the standard criticisms of the European Baroque style by classicists.

After considering Sri Lanka, the anthropologist turned to his central theme, the cultural decay of India. As with Sri Lanka, Hocart's diagnosis of India's degeneration was based on a contrast between early 'classical' and later 'decadent' art. For him, Indian art, which began with the simple elegant art of Sanchi in central India, attained perfection in the Gupta period in the fifth

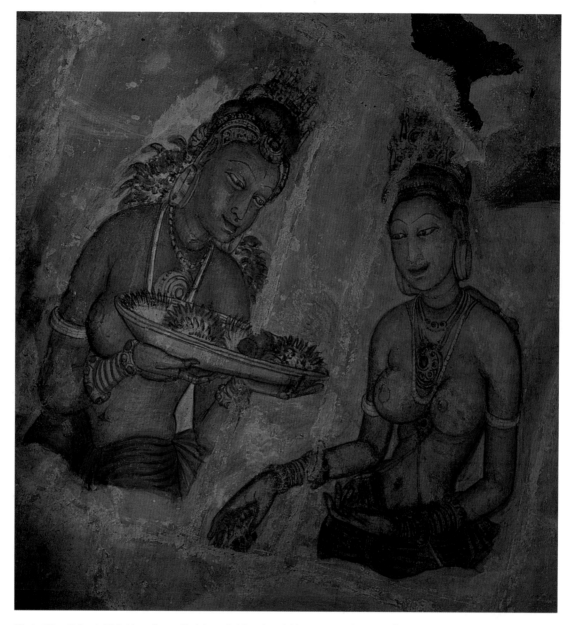

Plate 59 *Celestial Maiden*, from Sigiriya, Sri Lanka, fifth century, fresco. Photo: Douglas Dickins, London.

century, the climax of ancient Indian culture, which centred on the ideal image of the Buddha. It should be noted that Sanchi was the location of one of the first great monuments to the Buddha celebrating his nirvana. The monument, perhaps completed in the second century, contains some of the liveliest representations of the Buddha's life (Plates 61–64). The Great Stupa at Sanchi was one of the most important symbols of Buddhist religion. When pilgrims visited the Great Stupa, it was customary for them to walk around the building reading episodes from the Buddha's life, which were related on a series of relief sculptures on the gateways (*toranas*).

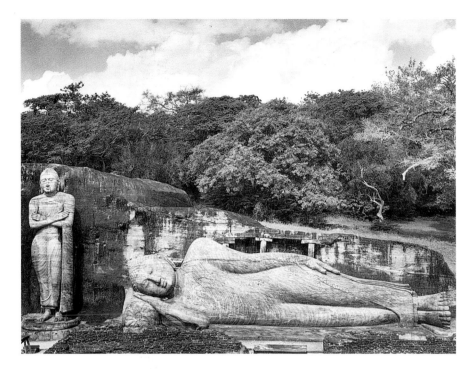

Plate 60 Colossal image of the Buddha's nirvana, from Gal-Vihara, Polonnaruva, Sri Lanka, twelfth century, sandstone, length 14.02 m. Photo: Douglas Dickins, London.

Plate 61 Great Stupa, Sanchi, Madhya Pradesh, India, third century BCE to second century CE. Photo: Douglas Dickins, London.

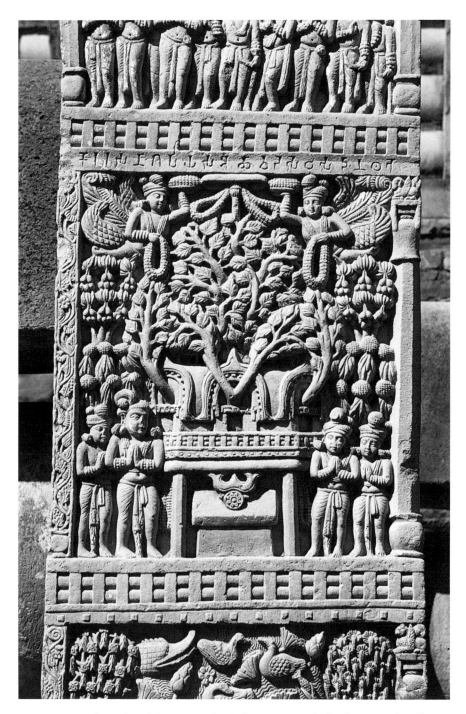

Plate 62 Worship of Buddha's tree of enlightenment with the three jewels of his enlightenment (as a trilobate shape), detail of *torana*, Great Stupa, Sanchi, Madhya Pradesh, India, third century BCE to second century CE. Photo: © Anil S. Modi / Images of India / DPA.

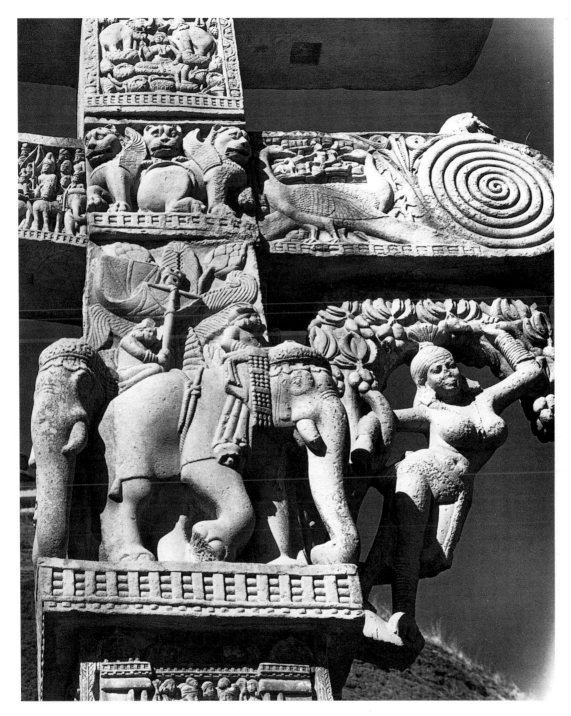

Plate 63 *Yakshi*,[1] lions, peacocks, and elephant process in honour of the Buddha, detail of east *torana*, Great Stupa, Sanchi, Madhya Pradesh, India, third century BCE to second century CE. Photo: Douglas Dickins, London.

[1] Female demi-god or local deity of fertility giving wealth and making plants grow, still worshipped today. At Sanchi the *yakshi* signifies the honour paid by local deities to the new spiritual devotion to the Buddha. In legend the *yakshi* kicks a tree (shown as a mango in Plate 63) and causes it to flower and fruit. All the principal events in the lives of the Buddha were associated with trees.

Plate 64
The Great Departure,[2] detail of east *torana*, Great Stupa, Sanchi, Madhya Pradesh, India, third century BCE to second century CE. Photo: © Anil S. Modi/Images of India/DPA.

According to Hocart, the Indian classical phase gave way to the 'romantic', by which he meant the Hindu period from around the tenth century onwards. But, he conceded, even 'those who do not like its violence and defiance, its exaggeration and the cult of the monstrous, must allow a certain greatness to that art' ('Decadence in India', pp.86–7). The clash of western classical and Hindu tastes, evident in the description of multiple-limbed Hindu gods as 'monstrous', has a long history. The novel element in Hocart's writings was to define these deities as 'decadent' (Plate 65).

Plate 65
Ganesha, Pahari, *c.*1720, pigment on paper, British Museum, London. Photo: by courtesy of the Trustees of the British Museum.

[2] The buddha is shown in continuous historical narrative clockwise, carried away from family concerns by his horse. The central tree suggests the tree beneath which he meditated to achieve enlightenment.

Disagreeing with the Sanskritist Arthur Anthony MacDonell's hypothesis that the many arms of the Hindu deities were symbolic representations of 'supra-human power', Hocart argued that Indian artists had not been aiming for the kinds of excellence in realistic representation and convincing anatomical detail that western artists had sought. Instead, they worked to represent spiritual truths: 'the inevitable tendency of the Indian mind' (Hocart, 'Many-armed gods', p.92). Hocart was thus helping to construct the idea that 'the Indian mind' was different from that of the European. While all ancient mythologies imagined many-headed deities, the aesthetic sense of the peoples of Egypt and Greece had prevented them from taking the Indian path. The early Buddhist art (about second century BCE to first century CE) also abhorred that excess, being constructed in a period when the supposedly 'monstrous' Hindu gods were banished to the nether regions. By the mid-nineteenth century the region known as Gandhara-Bactria began to be excavated, and a great quantity of Hellenistic and Roman objects were found. European Orientalists were excited by the idea that Graeco-Roman art inspired Indian art and had influenced the formation of the image of the Buddha (Plate 66). They felt confident of this interpretation because of the accounts of Alexander the Great's invasion of India in the fourth century BCE.

The 'perfection' of early Buddhist art managed to suppress Hindu excesses temporarily, Hocart believed, but increasing racial mixtures and consequent social decadence allowed the 'monstrous' gods to re-emerge. Finally, 'the revolt wore itself out, the energy departed, the monstrous ceased to be vigorous and was merely tame, and nothing was left but that standardised and uninspired art which was the only art known to most Europeans' (Hocart, 'Many-armed gods', pp.93–5). These are the terms in which Hocart described the process of India's artistic decadence (compare Plates 62 and 67).

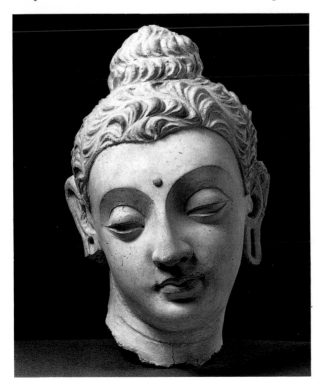

Plate 66
Head of Buddha, from Gandhara, Pakistan, third century, stucco, height 29 cm, Victoria and Albert Museum, London. Photo: by courtesy of the Trustees of the Victoria and Albert Museum.

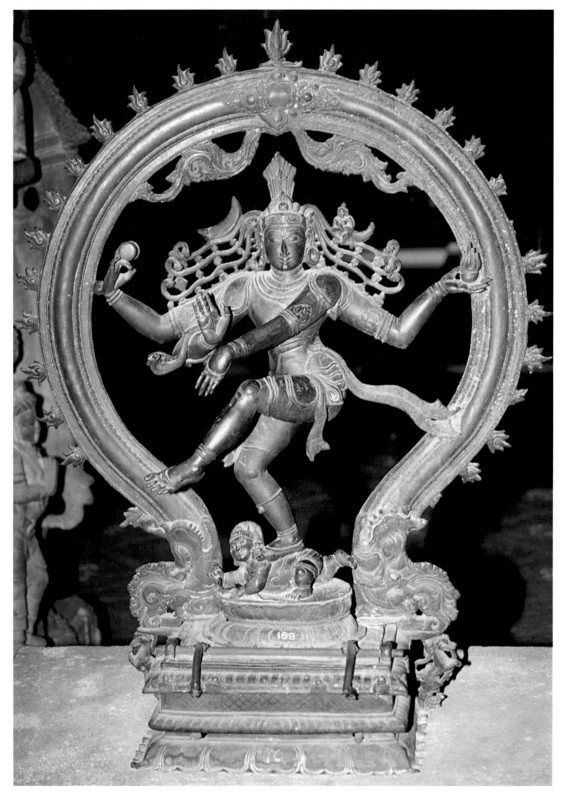

Plate 67 *Shiva as Nataraja, c.* twelfth century, Temple Museum, Madurai, Tamil Nadu, India. Photo: © N.G. Sharma/Images of India/DPA.

The ideas of 'decadence' and 'degeneration' were inherited by Hocart from late-nineteenth-century intellectual developments in the West. The *fin de siècle* sense of doom and decay, epitomized by Max Nordau's celebrated book, *Degeneration*, was the symptom of a crisis in western self-representation. Evolution and degeneration, optimism and pessimism, were the Siamese twins in the 'century of progress'. While the nineteenth century's dominant belief was in inexorable progress, even its arch-priest, the philosopher Georg Friedrich Hegel, had moments of doubt. He worried about the material and moral chasm opening up underneath the glittering surface of western progress as over-refinement led to degeneration. In the great march of history, those nations that failed to progress inevitably decayed. According to this view, non-western nations had always been in a permanent and unchanging state of stagnation; therefore, all they did was degenerate.

The puzzle that had faced social scientists since the mid-nineteenth century was as follows: why, if Europe had progressed, had other cultures degenerated? According to Hocart, the corruption of early 'classical' Buddhist art by 'monstrous' Hindu gods could be explained as the degeneration of Aryan civilization in India through the mixing of Aryan and non-Aryan blood. The multiple-limbed deities, he wrote, were the product of a non-Aryan mentality, whose traces were still to be found in the 'coolie art' of the simple folk. Images associated with village worship (Plate 68) were held in contempt by European Orientalists as relating to a vulgar set of beliefs – unlike the higher Brahmanical religion. In endless debates among German and French Romantics on the origins of the Aryan races, India acted as the original Aryan homeland, even as Sanskrit was the primordial language. However, from this initial prominence, India was held to be stuck in a time warp, while the European Aryans continued their triumphal progress. India's degeneration followed the pattern of all oriental nations. Yet what was the particular cause of her degeneration? The answer was provided by the French thinker, Joseph Arthur de Gobineau, in his *Essai sur l'inégalité des races humaines* (*Essay on the Inequality of the Human Races*) (1853–5). Inequality between the races was inherent and immutable. Of the three great races in human history – the superior Aryan (white), the inferior yellow and black – the last two, the *Untermenschen* (literally, under peoples) enjoyed a preponderance of numbers. Racial mixture inevitably followed Aryan

Plate 68 Village shrine, open-air altar with image of Surya (the sun god) facing the *linga* in *yoni*,[3] Garha, Madhya Pradesh, India. Photo: Curt Maury, *Folk Origins of Indian Art*, 1969, New York, Columbia University Press, figure 7.

[3] *Linga* is a phallic emblem and *yoni* is a symbol of the female vulva; both are fertility symbols.

conquests, giving rise to the corruption of the original culture. For Gobineau, India's present degeneration became an object lesson on the corruption of a high civilization through miscegenation between the Aryans and the Dravidians (supposed to be the original native inhabitants of south India and categorized as speaking languages outside the Indo-European family). Each successive racial mixture sapped the vigour of the original stock in India. Cultural decline in India was exemplified by the degenerate and superstitious theocracy that was Hinduism.

When British rule in India began in 1757, British attitudes to Hinduism showed an openness born of the rational cultural climate of the European Enlightenment,[4] which was lost in the rise of Christian evangelism in the nineteenth century. To the Victorian evangelist and campaigner against slavery William Wilberforce, the eroticism and idolatry of Hindu religion as expressed in art were especially repellent. And nowhere is the term 'decadent' more ubiquitous than in writings on Hindu art and architecture.

What we have not considered until now is the source of Hocart's inspiration. This was Fergusson, the pioneering architectural historian who formulated the basic rules for studying Indian architecture in the late nineteenth century. Fergusson applied the prevailing doctrine of evolution to explain the rise of art in India. Since historians were keen to place art history on a scientific footing, they evaluated artistic traditions by their capacity to progress. Judged by the classical canon, all non-western art – including that of India – was unprogressive. Fergusson made the following statement:

> Sculpture in India may fairly claim to rank, in power of expression, with medieval sculpture in Europe, and to tell its tale of rise and decay with equal distinctness; but it is also interesting as having that curious Indian peculiarity of being written in decay. The story that [Leopoldo] Cicognara tells [of European art] is one of steady forward progress towards higher aims and better execution. The Indian story is that of backward decline, from the sculptures of Bharhut and Amaravati … to the illustrations of [Henry] Colman's *Hindu Mythology*.
>
> (*A History of Indian and Eastern Architecture*, p.34)

According to Fergusson's criteria of 'inverted' evolution, an initial golden age in Indian art was succeeded by a continuous decline. The art of the golden age was the mirror image of western classical art, with simplicity and economy as its guiding principles. The Buddhist art at Sanchi and Amaravati admirably fitted this description (Plates 61–64 and 69). It is no accident that Hocart compared the Buddhist painting of Anuradhapura (Plate 59) with the sculpture of Amaravati (Plate 69); both belonged to the 'classical' period when artists delighted in slimness and vivacity. According to Hocart, being under Greek tutelage, Buddhist art was averse to violence, extravagance, and profusion. The art that succeeded the early Buddhist monuments, he insisted, was the product of Hinduism, the degenerate religion of non-Aryan

[4] Scholars in the Enlightenment or 'Age of Reason' during the eighteenth century sought knowledge (for example, the Asiatic Society of Bengal was founded in 1784 to study Indian civilization), and they sought to undertake rational enquiry into all issues, dispelling Judeo-Christian prejudices. Some philosophers, questioning received views, proposed that only education and social circumstances explained cultural differences; in their view, the distinction between Indians and Europeans was merely a matter of contrasting laws and institutions (see Bury, *The Idea of Progress*, pp.167–8). Openness to different ideas meant that, for example, Jean-Jacques Rousseau proposed that too much civilization was damaging and an Arcadian existence of herding and gathering was preferable (Bury, *The Idea of Progress*, pp.180–1).

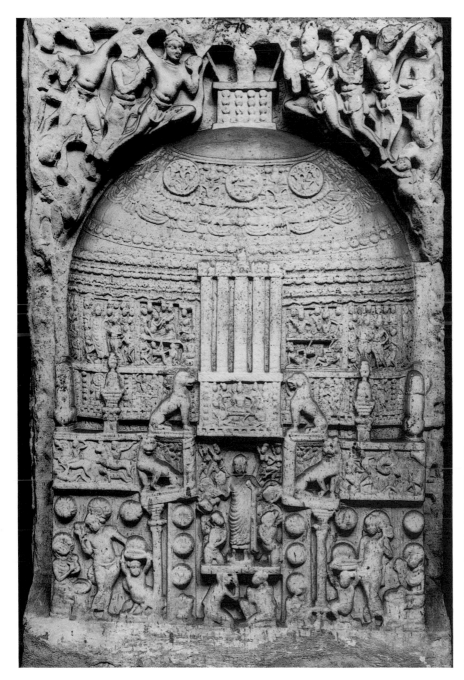

Plate 69
Slab showing
stupa with
Buddhas and
other figures,
from Amaravati,
Andra Pradesh,
India, late second
or early third
century, white
marble, height
126.5 cm, British
Museum,
London. Photo:
by courtesy of the
Trustees of the
British Museum.

inspiration. Fergusson, who inspired Hocart, found the explanation for this debasement in Gobineau's doctrine of racial miscegenation: that 'inferior' breeds were produced when 'higher races' mixed with 'lower races'.

The archaeologist John Marshall (1876–1958) added a refinement to Fergusson's theory. While early Buddhist art was pure and elegant, the actual golden age of Indian art was the fifth century, the Gupta period, when technique complemented the ideal in the perfect Buddha image. The Gupta Buddha, which combined formal elegance and spiritual serenity, was considered the epitome of Buddhist art (Plate 70). I am not suggesting that

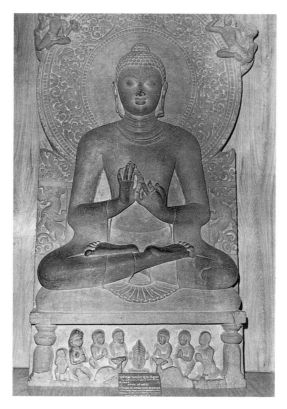

Plate 70 Gupta Buddha, from Sarnath, Uttar Pradesh, India, *c*.475, sandstone, height 160 cm, Sarnath Site Museum, Sarnath. Photo: Douglas Dickins, London.

Marshall's views were unfounded. The Gupta Empire, which had unified a large part of India under its aegis, is generally considered as the golden age of ancient India. Sanskrit literature and learning reached a high level of sophistication in the fifth century, while people in general enjoyed prosperity under Pax Gupta (the Gupta Peace) – the peace made possible by strong Gupta government.

But we should let Hocart describe the golden age:

> [art] enters on what we may call the classical phase which culminates in the fourth and fifth centuries of our era, the period known as the Gupta era. It has all the characteristics which mark classical art elsewhere: mastery of technique, perfection of form, aspirations that do not transcend the means of expression, self-restraint, the complete adaptation of the means to the end.
>
> ('Decadence in India', p.85)

Self-restraint may be a virtue in an individual, but it is puzzling as to why it should be a precondition of artistic perfection upheld by Hocart, unless we recall the principles of order and restraint which had been part of the European system of artistic values from the time when Vasari wrote his history of art in the sixteenth century. From this pinnacle, reached through the artistic process begun with early Buddhist art, it was artistic decay all the way. What we discover is that, with minor differences in detail, Hindu art from the tenth century onwards was viewed by all western writers as a deterioration of the original ideal expressed in Buddhist art. Hocart contrasted such perfection with later 'romantic' excesses: the violence, the exaggeration, and the cult of the monstrous in Hindu art.

Look back now and note the descriptions of 'classical style' in Indian art used by western writers. Do you think the adjectives and phrases are plausible descriptions of the works of art to which they refer (Plates 59, 61–64, 66, 69–70) compared with the later ones illustrated so far?

Discussion

When I came to match the adjectives to the images, I felt that there was often a big gap. The terms 'simple', 'slim', 'vivacious', and 'elegant' could be applied to Plate 59 or Plate 66, for instance, but I felt that the sculptures from the *stupas* at Amaravati and Sanchi were complex and rich, not simple. And my first reaction to Plate 60 had been one of admiration at its simplicity and serenity. Then again, I thought the Ganesha (Plate 65) was elegant and vivacious. With the more evaluative terms like 'perfect', 'ideal', 'pure', 'progressive', 'high aims', and 'restrained', arguably the writers did not have sufficient knowledge about the choices available to the artist, the original functions of the image, or the variety of spectators' responses to make these sorts of claim. Claims as to mastery of technique and the attainment of a balance between what was possible given the medium and technique and what was to be expressed again did not seem to be related to comparative evidence. In fact, the whole idea of using a set of concepts derived from European art historians' views about ancient Greek and Roman art, and trying to fit them onto the works of sculptors creating images in the Indian subcontinent 2000 years earlier seemed bizarre – even preposterous.

◆◆

Indian art history – a discipline that was dominated by western writers – is saturated with the idea of decadence. South Indian architecture, Fergusson wrote in 1876, 'became so fixed [in the eleventh century] that it should endure for five centuries afterwards, with so little change, and with only that degradation in detail, which is the fatal characteristic of art in India' (*A History of Indian and Eastern Architecture*, p.392). Even within the south, Fergusson favourably compared the 'pure' plain surfaces of early temples, such as those dedicated to Shiva and Vishnu at Mamallapuram (Plate 71), with later ones at Madurai. Plates 72–74 show the *gopuras* from the temple to the great goddess Minakshi and Shiva at Madurai, 'where barbarous vulgarity had done its worst' (*A History of Indian and Eastern Architecture*, p.404). It was through Fergusson that Madurai came to represent the worst excesses of Hindu art and architecture, but he was simply articulating brilliantly what was an ingrained idea among western art historians.

One would have expected differently from Ernest Havell, Fergusson's rival and the foremost critic of his 'archaeological' approach, who insisted that one had to discover the aims of the Indian artists in order to grasp their achievements. But he too was seduced by Fergusson's powerful theory:

> It is, of course, a defect inherent in the quality of art such as this, that in its romantic imaginativeness and the energy of its creative power it has the tendency to become sometimes incoherent, and to lose the sense of co-ordination and aesthetic unity. But this is to say that all art in its decadence converts its merit into an offence, just as a beautiful body from which life had departed begins to putrefy.
>
> (Havell, *The Ideals of Indian Art*, p.181)

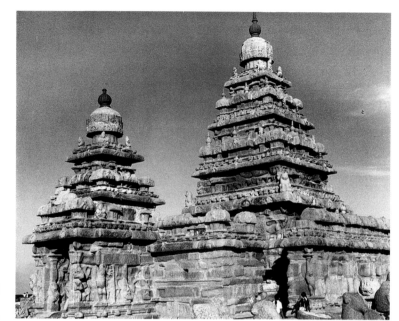

Plate 71
'Shore Temple',
Mamallapuram,
Tamil Nadu,
India, first third
of eighth century.
Photo: Douglas
Dickins, London.

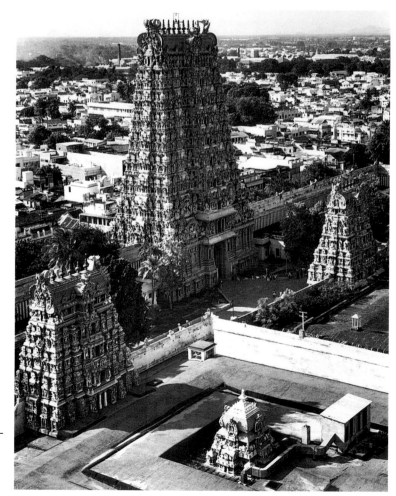

Plate 72
West *gopuras* of
the Minakshi
temple from the
south-east,
Madurai, Tamil
Nadu, India, mid-
seventeenth
century. Photo:
Douglas Dickins,
London.

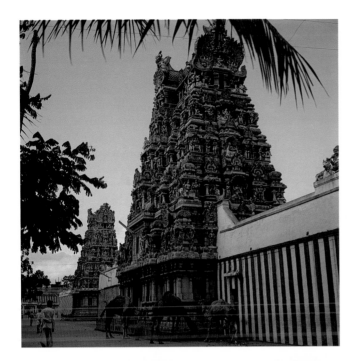

Plate 73
Gopuras of the
Minakshi temple,
Madurai, Tamil
Nadu, India, mid-
seventeenth
century. Photo:
Douglas Dickins,
London.

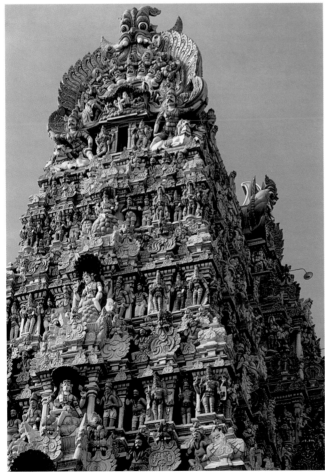

Plate 74
Detail from *gopura*
of the Minakshi
temple, Madurai,
Tamil Nadu, India,
mid-seventeenth
century. Photo:
Douglas Dickins,
London.

After World War II, scholars writing in North America, the United Kingdom, and Germany became somewhat wary of earlier certitudes. Percy Brown, whose work on Indian architecture is still (1998) the standard textbook on the subject, generally took a workman-like approach. But he too succumbed to the temptation to describe a small eighteenth-century shrine in the Shiva temple at Thanjavur as being of a very brilliant decadence in no way discreditable to its creators (*Indian Architecture*, p.100). Benjamin Rowland complained in 1953 of 'the stultifying effect of adherence to technical recipes and systems of canonical proportion' in a period of mass production at Madurai. In comparison with earlier works of architecture, the immense quantity of delicate carving was 'part of that insatiable desire for richness of effect which seemed to have overwhelmed Indian architects of this last period [sixteenth century onwards] described as one of brilliant decadence' (*The Art and Architecture of India*, p.193). In 1959, Hermann Goetz blamed south Indian temples for projecting a false image of Indian art in the West, which created the prejudice against Indian art as a whole as the abstruse nightmare of a fanatical, priest-ridden world interested only in the beyond (*India*, p.198). This judgement had been justified to some degree, but merely with regard to the final decadence of a once great civilization and a once remarkable tradition of art. In 1970, Hugo Munsterberg commented:

> the late and decadent nature of the Madura [Madurai] temples is most clearly seen in the elaborate sculptural decoration of the huge towers over the entrances to the temple compound. They show a lessening both of spiritual feeling and quality of artistic performance. The forms of the gods and goddesses portrayed are at the same time more naturalistic than those used in the earlier carvings and highly mannered so that the effect is artificial and often ugly.
>
> (*Art of India*, p.119)

Decline rather than decadence

Can we, then, not speak of decadence at all? I think we first need to ask, 'decay for whom?' We also need to distinguish between the self-image of the society studied and the image created by later historians. In art history, decadence becomes a surrogate for bad taste, with reference to the rich ornamentation of Hindu temples. For Fergusson, the evidence of degeneration in south Indian temples was the absence of rules in architecture and the tasteless decoration. But tasteless for whom? The present-day viewer may find less difficulty than Fergusson did in appreciating that the twelfth-century patron of the Chennakeshava temple at Belur considered its sculpted dancers a charming and decorous adornment (Plate 75). The decorations on the *gopuras* at Madurai may be repellent to western taste, but they did appeal to the south Indians for whom they were built. It is no accident that Hindu art, in its licentious exuberance, is often compared with Baroque and Rococo, the two western styles that, as E.H. Gombrich has pointed out, flout the classical canon (*Norm and Form*, pp.81–98). Rowland makes this clear: the 'extraordinary dexterity in the working, or, perhaps better, torturing, of the stone medium is as much a sign of decadence in sixteenth-century India as it is in Italy of the Baroque Period' (*The Art and Architecture of India*, p.319).

One may argue, with some justification, that we often encounter the phenomenon of decline with regard to western artistic traditions. It takes place for a variety of reasons within artistic genres or styles. Certain peaks

Plate 75
*Beauty and
Mirror* (dancer
with a mirror),
1117–1220,
relief,
Chennakeshava
temple, Belur,
Karnataka,
India. Photo: ©
M. Amirtham /
Images of
India / DPA.

are reached and are then followed by a falling off in standards of skill and craftsmanship. But as should be clear from the writers under review, this was not what they meant. We may recall Vasari's famous opening lines in his *Lives* of 1568, where he described painting in medieval Florence (which he disliked) as degenerate: 'These [arts] like the other arts and like human beings themselves, are born, grow up, become old and die' (*Lives*, p.46). His belief that the original classical ideal had decayed in the Middle Ages was based on an analogy between historical process and the ages of humanity. As the writer Erwin Panofsky (1892–1968) has shown, Vasari sought to steer a precarious course between external causes and inner decay in the demise of ancient classical art (*Meaning in the Visual Arts*, pp.215–21). However, since Vasari 'degeneration' as a value judgement, going beyond mere decline in craftsmanship, has stayed on in western writings on art. Hocart could have confined himself to an actual 'falling off of workmanship' at Polonnaruva from the early Anuradhapura period, which he occasionally did. But he was convinced that 'technical considerations carry far less weight with Indians than with us' ('Decadence in India', p.86). His moral position sprang from the aesthetic judgement that ornament, however skilfully carved, was meretricious.

Decadence is a favourite, all-embracing term used by colonial historians to mark their moral disapproval of certain aspects of Indian culture. Of course, such usage is not confined to Indian culture. Richard Gilman, in his witty little book entitled *Decadence: The Strange Life of an Epithet*, calls decadence a 'freelance epithet' (like progress, for instance), an unstable word whose meaning and significance change with shifts in moral and cultural attitudes. It has been used to condemn as morally corrupt widely differing aspects of western culture that had lost favour for that moment; it refers to cultural periods that had supposedly become decrepit by losing their earlier healthy state. Most often the word is used to conjure up visions of sensuality, effeminacy, corruption, and decline associated with oriental empires. The more recent example of the Nazi condemnation of 'decadent art and music' shows how one group can use the term to denigrate what it feels threatened by.

While there has been a great deal of work on overt colonial intervention in the field of knowledge (such as western archaeological expeditions), there have been far fewer explorations of the conceptual framework that informs western representations of the 'other'. Often seemingly innocent and reasonable words such as 'decadence' tend to perpetuate the dominant values disguised as rational discourse. Behind them is the ingrained belief in the absolute value of western canons that remains the hidden agenda of many 'objective' descriptions of non-western cultures.

An alternative art history

How, then, can we read Hindu art and architecture? Let us remind ourselves of the main western criticisms. The evolution of ancient Indian art, for example, is seen in the following terms: the 'simple', elegant Buddhist art attained perfection in the fifth century and was followed by decadent Hindu art. Such an evaluation, which reflects the classical ideal of simplicity as perfection, refuses to accept the ornamentation of Hindu temples as an essential component of Indian taste. And nowhere is the difference between India and the West more profound than in their respective tastes and values. Yet western historians have often judged Hindu aesthetic concerns from the standpoint of western artistic values. Surely, the interesting question is not so much what Indian art shares with western art but in what ways it differs from it. The unique qualities of Indian art can be appreciated less by a stylistic analysis based on western categories or by metaphysical generalizations than by a cultural history that places Indian art in its social and religious setting.

In the last two decades, scholars have begun to question western art history that treats Indian art as an adjunct of universal art history, opening the way for general works that may offer a fresh approach to the subject. The thrust of recent scholarly arguments has been the changing patterns of patronage and their relationship with artistic production. The Hindu temples and Hindu gods that emerged in the early Christian era were part of the religious movement known as *bhakti*, or devotion to a saviour god. Unlike Christian architecture, the Hindu temple was not built as a prayer hall, but is literally the 'residence' of the deity where it is served by devotees. Hindu sculptures were inspired by *Puranas*, the *bhakti* texts, which told stories of Vishnu, Shiva, and Devi (the great goddess), the great saviour deities eternally battling with evil.

As for the simplicity of Buddhist art in contrast to the florid richness of Hindu art, Buddhist art is simple not in the classical stylistic sense – of displaying plain surfaces, geometrical clarity, and serene idealization – but rather in a technological sense. It has to do with the fact that Buddhist art is the early phase of Indian art when it had not yet attained technological maturity. In the case of Hindu architecture, instead of the simplicity preferred by classical and Renaissance builders, temple builders aimed at combining a strict architectural design with rich surface decoration. Such an aim attained fulfilment not in the fifth century as claimed by earlier art historians, but much later, in the tenth century, when form and meaning fused in a magnificent synthesis. In the south, the most unique creations such as the *gopuras* arrived even later, in the sixteenth and seventeeth centuries.

The criticisms of European historians show their failure to interpret the meaning and function of sacred edifices. Here are suggestions for a possible alternative approach. First of all, let us think about the role played by ornament not only in the conception of the Hindu temple but in the whole of ancient Indian civilization. When Fergusson condemns the lavish decoration of *gopuras*, he fails to recognize that ornamentation of the temples is not an afterthought but has specific symbolic and religious functions in the culture. Far from being mere decoration, it is of intrinsic importance. The examples of ornate *gopuras* at Madurai and Thanjavur are worthy of note (Plates 72–74, 76). So too are the monumental decorations of the temple at Konarak in Orissa (Plates 77 and 78). At Konarak the original structure has collapsed. What remains consists of the front hall or *jagamohan*. The temple complex was originally conceived as a monumental chariot being dragged by seven proud horses. One of the striking aspects of the temple is the way the grand overall conception is combined with a range of decorations, from large-scale sculptures to the most exquisite (mostly erotic) detail, which gives a great sense of jewel-encrusted splendour. Basically, the traditional Indian approach is very different from our own modern outlook on architectural decoration. The concept of ornament played a central role not only in art but in other areas, in both sacred and secular spheres. Ancient Indians regarded ornament as a *sine qua non* of beauty; things lacking in ornament were considered imperfect or incomplete. The Sanskrit verb *alamkar*, to decorate, literally means 'to make enough'. If we turn to Sanskrit high literature, we find that it revels in the wealth of rhetorical ornaments – metaphors, similes, alliterations, and other literary effects. In short, the function of ornament is to add richness, to heighten mood and emotion. The art historian Philip Rawson makes a perceptive comment on the use of ornament in Sanskrit literature (1968):

> The Indian idea of ornament was that it represented radiance and the wealth of imaginative allusion. It awoke in an unsoundable depth echoes of meaning and intuitions of relationships amongst our perceptions of the real world which no everyday prose could elicit.

('An exalted theory of ornament', p.222)

Thus, one of the main currents in the history of Indian taste thrived precisely on such rich elaborations of ornament, perhaps as much in literature as in the visual arts – an aesthetic outlook that was in most cases incompatible with the western classical canon.

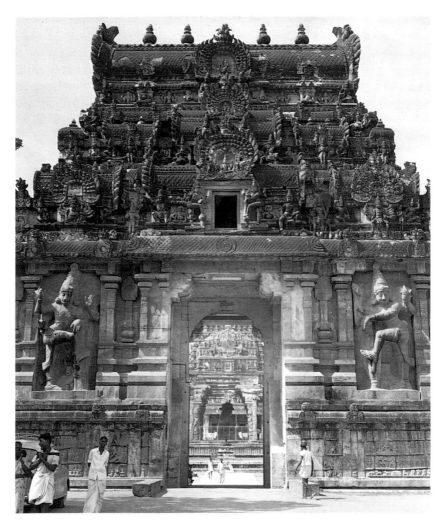

Plate 76
Sculpted figures
from inner *gopura*
from the east,
Brihadishwara
temple dedicated
to Shiva, built for
Raja Raja at
Thanjavur, Tamil
Nadu, India,
985–1013. Photo:
Douglas Dickins,
London.

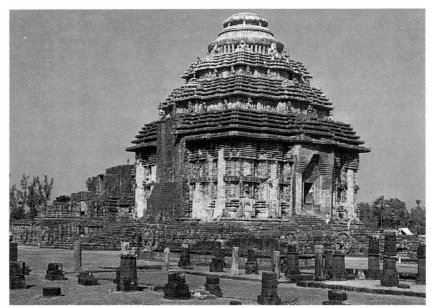

Plate 77
Sun temple,
jagamohan from
the south-east,
Konarak, Orissa,
India, 1238–58.
Photo: Douglas
Dickins, London.

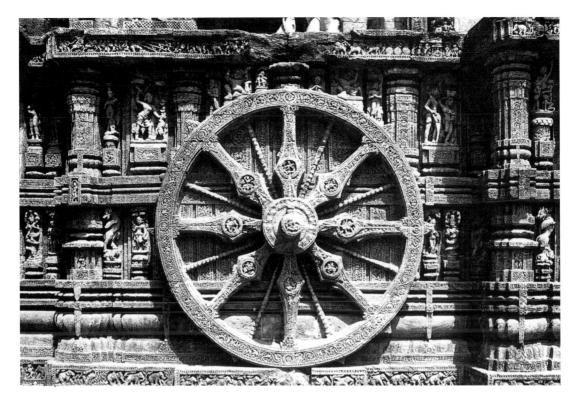

Plate 78 Wheel on plinth of the Sun temple, Konarak, Orissa, India, 1238–58. Photo: Ancient Art and Architecture Collection Ltd.

Pause now and look carefully at the sculpted *gopura* from the Brihadishwara temple (Plate 76). What effects do you think its tenth-century commissioners hoped to create? How do you think the sculptures relate to the architecture?

Discussion

If you knew nothing about this temple, you might think that the effect of the two large figures on either side of the doorway – and indeed of the ornament on the roof – was ebullient and welcoming to worshippers. The architectural articulation is perfectly symmetrical, as is the sculptural adornment. Historical research, however, has revealed that the *gopura* is based on strict mathematical principles in order to express order and control. The elevation is articulated in terms of a series of niches flanked by grouped pilasters framing powerful sculptures of two door guardians as aspects of Shiva. These guardians were made to represent the protection of the sanctity of Shiva, god of death (and life), and are here shown as violently menacing his enemies. Equally protective in meaning seem to be the 'faces of glory' or *Kirtimukha* piled above the portal and symbolized by a feline head with bulging eyes and lower jaw missing (unfortunately these are difficult to identify in the plate). The sculptures are very much integrated with the architecture and not additional ornament. Although the guardians are carved in the deepest relief, they are still not quite detached from their background; indeed, no south Indian statuary in stone is free-standing, for it seems always to be intended to be seen as part of a huge composition.

◆◆

Reading Hindu temples and images

Finally, one more problem that bothered Fergusson deeply: why do the outer *gopuras* become progressively higher and grander than the main temple itself the further they are away from the main temple – the periphery dwarfing the superstructure? To Fergusson this was nothing less than the equivalent of a solecism. This view misunderstands the intention and purpose of these sacred structures. In Plate 72, which is of the *gopuras* at Madurai, we see the tallest tower, which is situated furthest from the temple, while the shorter towers on either side are closer to the temple. The problem has been addressed by art historians in a range of literature published over the last half century. James Harle, the authority on the *gopuras*, concludes that they represent considerable technical achievement and are of exceptional significance in the south Indian temple plan (Harle, *Temple Gateways*). As early as 1946, Stella Kramrisch made the observation that the layout of south Indian temples continued the time-honoured Indian tradition of open-air sacred enclosures protected by high walls (referred to by Kramrisch as 'hypaethral'). It is, I think, possible to go a little further. Each Hindu temple is conceived as the abode of a particular deity, which resides in the *garbha grha* (womb chamber), the sacred centre from which energy emanates and flows in all directions. The deity is surrounded by a whole hierarchy of other deities, with minor spirits at the periphery, all arranged according to a descending scale of purity, with the centre as the purest. Louis Dumont's classic *Homo hierarchicus* (*Hierarchical Man*) examines the importance of the twin concepts of purity / pollution in the Hindu caste hierarchy. In the god's dwelling in the temple, the need was all the more urgent to keep out pollution from the mundane world. The imposing gate towers placed exactly according to compass points were meant to preserve the purity of the god. The height of the *gopuras* thus increases towards the outer limits of the sanctuary. If these towers were to serve as protective barriers to pollution, the higher they were the better chance they stood of fulfilling their role. In the words of Kramrisch:

> The devolution of the South Indian Prasada (sanctum), the shrinkage of its height in comparison with the Gopuras, the gate towers of the surrounding walls, whose height increases with their distance from the temple in the centre, appears a paradoxical development, but it may be understood as a return to type.
>
> (*The Hindu Temple*, vol.1, p.204)

Finally, to counter the description of Hindu gods as monsters, we may quote René Grousset, who offers a different, poetic reading of the god Shiva in his role as Nataraja (Plate 67):

> Whether he is surrounded or not by the flaming aureole [*prabhamandala*], the circle of the world which he both fills and oversteps – the King of the Dance is all rhythm and exaltation. The drum he sounds with one of his right hands draws all creatures into this rhythmic motion … One of his left hands holds the fire that animates and devours the worlds in a cosmic whirl. One of the god's feet is crushing a dwarf [called ignorance], for this dance is danced upon the bodies of the dead, yet one of the right hands is making a gesture of reassurance … the King of the Dance wears a broad smile. He smiles at death and at life, at pain and at joy alike … His art is the faithful interpreter of the philosophical concept … The very multiplicity of arms, puzzling at it may seem at first sight, is subject in turn to an inward law, each pair remaining a model of elegance in itself, so

that the whole being of the Nataraja thrills with a magnificent harmony in his terrible joy. As though to stress the point that the dance of the divine actor is indeed a play [*lila*] – the sport of life and death, the sport of creation and destruction, at once infinite and purposeless – the first of the left hand hangs limply from the arm ... in a *gajahasta* [arm like an elephant trunk] ... while the gyration of the legs in its dizzy speed would seem to symbolise the vortex of phenomena.

(*India*, pp.252–5)

Conclusion

Instead of explaining Indian art, the concept of 'decadence' was simply used as a catch-phrase to express disapproval of Indian taste. Often, seemingly reasonable words like 'decadence' actually serve to privilege the western canon. Our attempt to appreciate art forms such as those of Buddhist and Hindu cultures, which are aesthetically far removed from western taste, requires rather that we study them in their own cultural setting. In short, we need to try and imagine, as well as research into, the conditions in which artists produced their work and in which patrons commissioned works of art. Only then can we get an idea of the quality and importance of Buddhist and Hindu art works: as far as possible, on their own terms.

References

Brown, P. (1971) *Indian Architecture: Hindu and Buddhist Periods*, Bombay, D.B. Taraporevala (first published 1947? [no date]).

Bury, J.B. (1955) *The Idea of Progress: An Inquiry into its Origin and Growth*, New York, Dover (first published 1932).

Dumont, L. (1967) *Homo hierarchicus: Essai sur le système des castes*, Paris, Gallimard.

Fergusson, J. (1876) *A History of Indian and Eastern Architecture*, London, John Murray.

Gilman, R. (1979) *Decadence: The Strange Life of an Epithet*, London, Secker & Warburg.

Goetz, H. (1959) *India: Five Thousand Years of Indian Art*, London, Methuen.

Gombrich, E.H. (1966) *Norm and Form: Studies in the Art of the Renaissance*, London, Phaidon.

Grousset, R. (1932) *India* (Volume 2 of *The Civilizations of the East*), London, Hamish Hamilton.

Harle, J. (1963) *Temple Gateways in South India*, Oxford, Cassirer.

Havell, E.B. (1911) *The Ideals of Indian Art*, London, John Murray.

Hocart, A.M. (1934) 'Decadence in India', in *Essays Presented to C.G. Seligman*, ed. E.E. Evans-Pritchard *et al.*, London, K. Paul, Trench, Trubner.

Hocart, A.M. (1929) 'Many-armed gods', *Acta Orientalia*, vol.5, pp.91–6.

Kramrisch, S. (1946) *The Hindu Temple*, 2 vols, University of Calcutta.

Mitter, P. (1977) *Much Maligned Monsters: A History of European Reactions to Indian Art*, Oxford, Clarendon Press.

Munsterberg, H. (1970) *Art of India and Southeast Asia*, New York, H.N. Abrams.

Nordau, M. (1993) *Degeneration*, University of Nebraska Press (first published Berlin, 1892).

Panofsky, E. (1955) *Meaning in the Visual Arts*, New York, Doubleday.

Rawson, P. (1968) 'An exalted theory of ornament', in *Aesthetics in the Modern World*, ed. H. Osborne, London, Thames & Hudson.

Rowland, B. (1953) *The Art and Architecture of India*, London, Penguin.

Said, E. (1993) *Culture and Imperialism*, London, Chatto & Windus.

Vasari, G. (1965) *Lives of the Artists*, trans. G. Bull, Harmondsworth, Penguin.

Preface to Case Study 5:
Approaching art made in China

CATHERINE KING

In the previous case study, we found Partha Mitter calling for historians to concentrate on considering the taste of the makers and viewers of art in the past. But how is this task to be approached? Part and parcel of such an undertaking is the investigation of the makers' and viewers' own changing concepts and categories of art. Case Study 5, by Craig Clunas, who teaches Art History at the University of Sussex, explores something of the powers and subtleties encountered in attempting to understand different perceptions related to different works of art.

The aspirations of many nineteenth- and early twentieth-century historians to acquire objective knowledge and discover laws of historical development and decline encouraged grand claims for scholars' ability to map the art of the past, whether to further imperialist ideas (like Fergusson) or anti-imperialist stances (such as that of Coomaraswamy). From the 1960s onwards, however, scholars, like Mitter, have tended to undermine such confidence by showing the extent to which knowledge is socially and culturally 'situated'. Consequently, scholars who have helped to set the agenda of the 'new art history' have adopted tentative positions in interpreting the art of the past and a reflexive stance – noting (in so far as this is possible) the ways in which their own and others' knowledge is situated. Researchers like Clunas have sought to reconstruct the ways in which works of art were designated, made, received, and used at different times, but they also emphasize the impossibility of seeing works of art exactly as did their original makers and viewers, drawing attention to the gaps in information, and the 'situatedness' of the later historian.

In Case Study 5, we turn away from the Indian subcontinent to consider Clunas's analysis of the long shadow cast by European imperialist scholars even over the interpretation of the past art of areas that never came under direct European colonial rule. Clunas looks at the way imperialist viewpoints have extended into the interpretation of works of art made in China, and samples strategies for avoiding the assumptions embodied in such viewpoints. In one of his previous studies, *Superfluous Things: Material Culture and Social Status in Early Modern China*, Clunas emphasized that the meanings of critical terms applied to works of art are continually shifting and are used variously by different viewers so that they never comprise 'a static language' (*Superfluous Things*, p.2). However, he distinguished terms and categories employed in the early modern period which he called 'emic' (meaning that they were used when the artwork was made) from terms he called 'etic' (meaning ones imposed anachronistically by the historian) (*Superfluous Things*, p.74). In a later study, *Fruitful Sites: Garden Culture in Ming Dynasty China*, Clunas again insisted that meanings were 'changing and contested' (*Fruitful Sites*, p.207). In this research, which investigated the meanings of gardens between *c.*1450 and *c.*1650 in the Jiangnan area on the lower Yangtze River,

Clunas discussed the variety of readings of gardens possible in this period and the way in which they were subject to 'the pull of a number of discursive fields' since they were evaluated not only in terms of art but also of property, social status, numerology, the understanding of plants, and cosmology (*Fruitful Sites*, p.177).

In *Superfluous Things*, Clunas assumed an idea of art that matched that of the élite he was studying. He criticized historians purporting to develop the 'new art history' since

> despite claims to reject the whole notion of an established canon, the majority of recent work remains centred on the same types of artistic practice as does the work it seeks to supplant. I have therefore in this book sought to find ways of talking about the deployment of luxury objects in late Ming China [1368–1644] which were equally valid for categories like painting, with a highly self-conscious aesthetic of their own, and for clothing, where no such coherent framework of ideas exists ready made in the Chinese sources.
>
> (p.3)

In *Fruitful Sites*, Clunas stressed that gardens had been treated as works of art by some owners and viewers some of the time according to their usages (along with all the other evaluations they had assigned to them). Therefore, rather than considering 'the concept of a work of art as a type of thing, a pre-existent category', he preferred to treat the concept as entailing 'a fluctuating manner of categorising that is historically and socially specific and contested' (p.13).

In Case Study 5, Clunas explores ways in which art in China may be misread as unchanging and as backward-looking in westernized interpretations of 'Chinese art', and considers the challenges entailed in understanding the changing, complex, and variable conditions of viewing and evaluating works of art made in China.

What about Chinese art?

CRAIG CLUNAS

Writers in China have concerned themselves with the visual arts for a period of over 2000 years. Very large quantities of writing on art survive from all periods of Chinese history, including extensive works on the biographies of painters (which were written many centuries before Vasari's *Lives of the Artists*), technical treatises, theoretical statements of great sophistication, and comprehensive histories of painting. The world's first printed book to be illustrated with reproductions of works that actually existed was produced in China in 1607. Much of this literature is now available in English translation, and some of it has been known outside Asia for nearly 200 years. Yet many of the standard works of art history for the English-speaking world either ignore China altogether, or else restrict their coverage to a very limited series of generalizations. For example, *The Story of Art* by E.H. Gombrich includes a few pages on China in a chapter entitled 'Looking Eastward', which makes it clear that in the (singular) story of art the people doing the looking stand very firmly in something called 'the West'. It is as if 'art history' and 'Chinese art history' are two very different things.

This case study will introduce some examples of Chinese writing about the history of art in China, as well as some of the central ideas that educated Chinese people used in considering issues of representation and picture-making. It will also consider the place of 'Chinese art history' in the broad field of study today, looking at how Chinese art has been written about by Europeans and Americans in recent times.

The history of art in China

Although the case study will focus on the history of *painting* in China, it is important to understand that the value placed on different forms of artistic expression in China may not be the same as it has been historically in Europe. As with Europe, the 'hierarchy of the arts' (that is, which art forms have been most valued) has not been constant across time. However, it is in general true to say that for about the last 2000 years the greatest prestige has attached to the art of calligraphy, that is, the writing of the Chinese script (Plate 79). It is, for example, an art still practised by many political leaders in China in the present century.

Painting has come second to this, which is reflected in the order of the words in the term *shu hua*, 'calligraphy and painting', always written in this way. Although the Chinese script (the individual elements of which are usually called 'characters' in English) is in no sense made up of 'pictures', most Chinese theories of the image held that both writing and painting had a common origin, and were related at the conceptual level. For example, in the

Plate 79
Huang Tingjian,
opening section
of a hand scroll
on paper,
containing the
sequence of
poems *Pine Wind
Pavilion*, written
1101–5, 131.8 x
1119.2 cm,
National Palace
Museum, Taipei,
Taiwan. Photo:
National Palace
Museum, Taipei,
Taiwan.

fourteenth century, the statesman and philosopher Song Lian repeated long-established ideas when he stated in an essay entitled 'The Origins of Painting':

> If there were no writing there would be no means to record things; if there were no painting there would be no means to show things. Is it not that these two reach the same point by different routes ? Thus I say that writing and painting are not different Ways, but are as one in their origin.
>
> (Clunas, *Pictures and Visuality in Early Modern China*, p.109)

Western accounts of Chinese art usually treat calligraphy much less thoroughly than they do painting, which is the apex of the hierarchy in European terms. The other two elements of the European system of 'fine arts', namely architecture and sculpture, have not, prior to this century, been seen in China as possessing anything like the same prestige as calligraphy and painting. Relatively little was written about them, and we have almost no biographical information on the practitioners of these skills, in contrast to the large amounts written about calligraphers and painters. This does not mean that architecture and sculpture were of no importance, but it does mean that they were understood as being conceptually different from calligraphy and painting. At various times in China's past, prestige has been accorded to other types of object, some of which would now be placed in the (lower) category of 'crafts' or 'decorative arts'. For example, during the Ming dynasty in China, embroidered pictures or pictures of silk tapestry made on a loom (Plate 80) were in certain contexts catalogued as equivalent to paintings made with a brush on silk or paper. Today, embroidery is given a lower position than painting, or at best is viewed as a separate 'decorative' 'art'.

Prior to the early twentieth century, Chinese writers, both within the Chinese-speaking world and beyond it, did not use a single term to encompass all the forms now thought of as the 'fine arts'. The word *meishu* was re-appropriated from Japan to serve as a blanket term for all the 'fine arts' in the European sense, and in modern Chinese it can be used to cover all sorts of object: ceramics, textiles, crafts such as metalworking and lacquering, as well as sculpture, painting, and calligraphy.

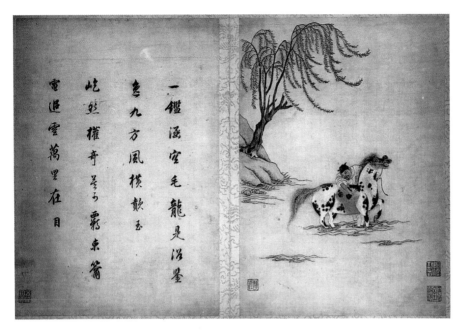

Plate 80
Han Ximeng,
Washing a Horse,
from an album of
copies of early
painting, 1634,
embroidery on
silk, 33.4 x
24.5 cm, Palace
Museum, Beijing.
Photo: The Palace
Museum, Beijing.

The extensive theoretical writing on calligraphy and painting in China dates back to at least the fourth century, when details of the careers of individual painters and vivid descriptions of specific works of art first appear, none of which now survive in their original form. Processes of canon-formation begin at this time too, with artists like Gu Kaizhi[1] (*c*.345–*c*.406) establishing themselves as among the key famous names (Plates 81 and 82).

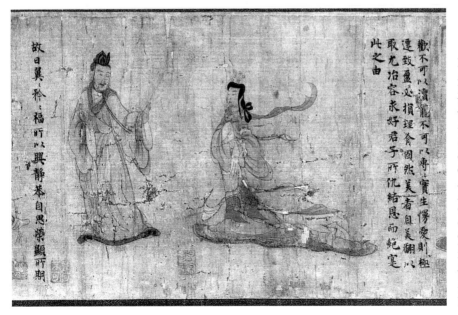

Plate 81
Attributed to Gu
Kaizhi but now
believed to have
been painted in
the Tang dynasty
(618–906) as a
close copy of the
original,
*Admonitions of the
Instructress to
Court Ladies*,
detail, hand scroll
on silk, British
Museum,
London. Photo:
by permission of
the Trustees of
the British Museum.

[1] The family name, or surname, comes first in Chinese, which is here spelled in the pinyin system for turning Chinese characters into the Latin alphabet. The same artist might be referred to in some books as Ku K'ai-chih.

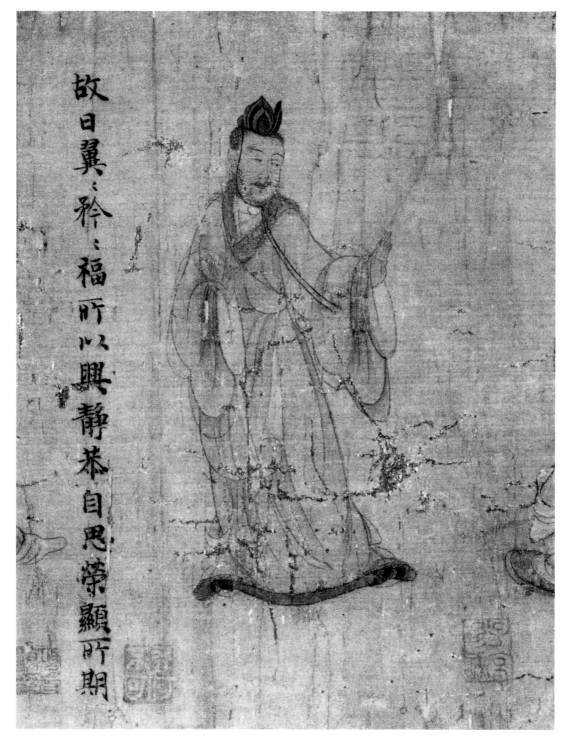

Plate 82 Attributed to Gu Kaizhi but now believed to have been painted in the Tang dynasty as a close copy of the original, *Admonitions of the Instructress to Court Ladies*, detail, hand scroll on silk, British Museum, London. Photo: by permission of the Trustees of the British Museum.

Gu, who holds his place in the canon of Chinese painting to this day, also wrote extensively on technique, and on theories of the image, establishing a tradition whereby the leading artists and the leading theorists were often the same people (not so regularly the case in Europe). He is famous above all as a painter of the human figure, and it is clear that at this early period it was this kind of subject that dominated painting in China. Such work was frequently executed at the courts of rulers, and displayed there either in the form of painting on plastered walls or of scrolls. The subject-matter was often didactic, as in the scroll *Admonitions of the Instructress to Court Ladies* (Plates 81 and 82), showing models of ideal male and female behaviour. Theories of the image down to Gu's time held that much of the value of a painting lay in the value of its subject-matter (an aesthetic position paralleling in some ways that of the Greek philosopher Aristotle (384–322 BCE), whose influence on European artistic theory has been enormous). In the third century, the imperial prince Cao Zhi wrote:

> Of those who look at pictures, there is not one who, beholding the Three Majesties and the Five Emperors, would not look up in reverence; nor any that before a painting of the degenerate rulers of the Three Decadences would not be moved to sadness.
>
> (Bush and Shih, *Early Chinese Texts on Painting*, p.26)

However, this view of the didactic role of painting was not to endure, and much painting in China came at a very early date to be judged more on the *how* than the *what* of representation. Painters came to be measured against the criteria set down by the sixth-century writer Xie He, in his 'Six Laws' (or 'Six Elements'):

> What are these Six Elements? First, Spirit Resonance which means vitality; second, Bone Method which is [a way of] using the brush; third, Correspondence to the Object which means the depicting of forms; fourth, Suitability to Type which has to do with the laying on of colors; fifth, Division and Planning, that is, placing and arrangement; and sixth, Transmission by Copying, that is to say the copying of models.
>
> (Bush and Shih, *Early Chinese Texts on Painting*, p.40)

These are enigmatic even in Chinese, and very hard to translate into English, with several competing attempts to understand them having been made by modern scholars. What is important to notice is that, however they are interpreted, the 'Laws' privilege expression by the artist ('Spirit Resonance', vitality) over the transcribing of visual phenomena. A ninth-century text, for example, tells of the wife of an eminent official who is shown two portraits of her husband, and asked to comment on them:

> She replied, 'Both paintings are likenesses, but the second one is better.' Again he asked, 'Why do you say that?' She responded, 'The first painting has merely captured my husband's appearance, while the second has also conveyed his spirit vitality … It has caught his personality and his manner of laughing and talking.'
>
> (Bush and Shih, *Early Chinese Texts on Painting*, p.57)

This position was systematized in the eleventh century by a group of intellectuals, of whom the most important was Su Shi. A very famous poem by him sums up his doctrine:

> If anyone discusses painting in terms of formal likeness,
> His understanding is close to that of a child.
> If someone composing a poem must have a certain poem,
> Then he is definitely not a man who knows poetry.
> There is one basic rule in poetry and painting,
> Natural genius and originality.
>
> (Bush and Shih, *Early Chinese Texts on Painting*, p.224)

Elsewhere, Su discusses at greater length the association of painting with individual creativity, and the importance of the artist having more than merely technical skill if he (and there is a clear implication that the artists is usually *he*) is to deal with the complexity of phenomena observed in the world. He writes, 'The artisans of the world may be able to create the forms perfectly, but when it comes to the principles, unless one is a superior man of outstanding talent, one cannot achieve them' (Bush and Shih, *Early Chinese Texts on Painting*, p.220). This stresses the importance of painting as a means of communicating the artist's ideas that is independent of the subject-matter of the work. Such views support a shift of attention nearly 1000 years ago from the subject of the picture to the manner in which it is executed, a shift that European culture found it very difficult to make prior to this century. This situation is only explicable by relating it to some very fundamental issues in the way certain Chinese writers have understood the world and its workings. These provide a distinctive philosophical basis for picture-making that is very different from that prevailing in most of European history. It is necessary to take a look at these issues, even if they cannot be gone into in detail.

Picture-making and representation

In Europe, ideas of the image and of representation owe a great debt to the Greek philosopher Plato (*c.*429–347 BCE), whose concept of *eidos* (Greek, ideal form), as laid out in Book 10 of his work *The Republic*, has been and remains immensely influential. For Plato, actual objects visible in the world about us are merely poor reflections of the ideal and unchanging forms of things, present in some superior realm of transcendence (about which he is very vague), 'above and beyond' the world we inhabit. His thought, and much European thought subsequent to him, privileges 'being', the unchanging, the constant, over 'becoming', the changing, the situation in flux. A representation, for example a painting, is for Plato but a poor reflection of a poor reflection of the ideal form, and hence to be despised as being at several removes from ultimate truth. After the dominance of Christianity, Plato's ideas were modified to situate the ideal forms of things with the unchanging God who created all. If representations were inferior to ultimate reality, they were nevertheless related to it by a series of links, which provided a justification of representation. By the Renaissance in Europe, the possibility of the artist achieving direct contact with the realm of the ideal formed an important part of artistic theory.

Much Chinese thought, by contrast, privileges 'becoming', accepting change and flux as the natural condition of the cosmos.[2] There is no creator God and very little emphasis on myths of the creation (or indeed the end) of the universe. A painting is therefore not simply an attempt to 'represent' (*re*-present) something called 'reality', which is existing elsewhere, beyond the picture. Rather the relationship between the picture, the maker of the picture, and the subject of the picture is much more of a shared enterprise. The fourteenth-century artist Wang Lü (Plate 83) describes the process whereby he created a set of small paintings of Mount Hua in terms that allow a great deal of agency to the mountain itself, as an active teacher of the artist not as the passive recipient of his 'realistic' gaze:

> I kept my paintings at home, and once someone by chance saw them. He thought they were contrary to all painting styles, and with surprise asked, 'Who is your master ?' I replied, 'I take my heart-mind to be my teacher. It takes as its master my eyes, which in turn revere Mt. Hua as their teacher.'

(Liscomb, *Learning from Mt. Hua*, p.62)

Plate 83
Wang Lü,
Reclining on the Steps of the Shrine Hall, album leaf, ink and colour on paper, 34.7 x 50.6 cm, Palace Museum, Beijing. Photo: The Palace Museum, Beijing.

Obviously, it should not be assumed that the theoretical positions written down by Chinese male intellectuals are the only key to understanding the history of painting in China. A great range of formats, of subject-matters, and of styles has existed at various periods. Many pictures survive that are, for a variety of reasons, very different in manner from that promoted by theorists like Su and Wang. These include narrative subjects (Plate 84) and portraiture (Plate 85). Nor should it be assumed that the theoretical positions can be explained thoroughly in the relatively small amount of space allotted to Chinese art within this book. However, a consideration of them may help to explain why a Chinese and a European picture of the same date look so different.

[2] See François Jullien, *The Propensity of Things: Towards a History of Efficacy in China.*

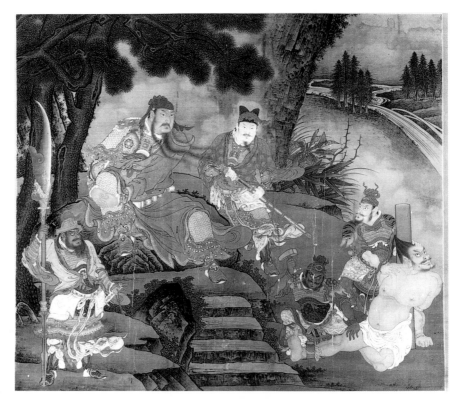

Plate 84
Shang Xi, *Guan
Yu Captures an
Enemy General*,
early fifteenth
century, hanging
scroll on silk,
200 x 237 cm,
Palace Museum,
Beijing. Photo:
The Palace
Museum, Beijing.

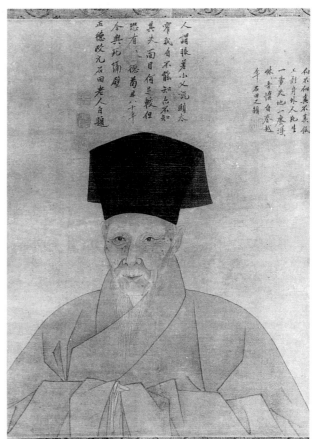

Plate 85
Anonymous, *Portrait
of Shen Zhou at Age
Eighty*, 1506, hanging
scroll on silk, Palace
Museum, Beijing.
Photo: The Palace
Museum, Beijing.

Please look at *The Flagellation* by Piero della Francesca (Plate 86) and *Poet on a Mountain Top* by Shen Zhou (Plate 87). How and why are the two works different?

Plate 86 Piero della Francesca, *The Flagellation*, c.1460, tempera on panel, 59 x 81.5 cm, Galleria Nazionale, Urbino. Fratelli Alinari, Florence.

Plate 87 Shen Zhou, *Poet on a Mountain Top*, Ming dynasty, album leaf mounted as a hand scroll, ink on paper, 38.7 x 60.2 cm, Nelson–Atkins Museum of Art, Kansas City, Missouri. Purchase: Nelson Trust.

Discussion

The subject-matter and the treatment of the paintings is very different. The European painting depicts an episode in a story, whereas the Chinese painting shows a scene or landscape without an obvious narrative content. Whereas *The Flagellation* is peopled with figures, *Poet on a Mountain Top* shows only one. The oil painting employs rich colours by comparison with which the album leaf appears subdued, but the delicacy of the individual brushstrokes is highlighted in the contrast. The two paintings embody the different assumptions of the two cultures as to what constitutes excellence in artistic practice.

◆◆◆

The two pictures are by contemporaries, but they have very different theoretical bases, and are trying to do very different things. For the Chinese artist Shen Zhou (1427–1509), 'telling a story' is not what art sets out to do, whereas for the Italian artist Piero della Francesca (1410/20–92), the *istoria*, or subject, of a picture is its prime element, as laid down by the Italian artist and theorist Leon Battista Alberti (1404–72). From the Italian point of view, the Chinese picture lacks this central feature; it does not seem to be 'about' anything. From the Chinese point of view, the Italian picture is totally lacking in 'brush method', the visible expression of style and of artistic personality. The Chinese picture, although it has a sense of spatial recession, is not obsessed with the mathematically calculated fixed point perspective of the Italian one. Nor is colour of central importance. Perhaps most importantly, the Chinese picture, by its prominent inscription at the upper left (a poem composed by Shen himself), brings literally to the foreground the fact that it is a picture, marks on the surface of a sheet of paper, and not an illusionistic window onto a world. The first European comments on Chinese painting, in the seventeenth century, stress its lack of 'proper' perspective. The first Chinese comments on European painting, at around the same time, see it as an interesting optical trick, but lacking in real artistic value.

For much of China's history, the most prestigious genre of painting has been landscape (Plate 88); history painting, the summit of the European hierarchy of genres, has by contrast been less esteemed. The painting of landscape, what in Chinese is called *shan shut*, 'mountains and water', has long been linked with the amateur ideal in Chinese art. A contemporary of Su Shi named Guo Roxu wrote:

> I venture to note that the rare works of the past were mainly those by talented worthies of high position or superior gentlemen in retirement, who cleaved to loving-kindness and sought enjoyment in the arts or explored the abstruse and plumbed the depths, and their lofty and refined emotions were all lodged in painting. If a man's condition has been high, his spirit consonance cannot but be lofty.

(Bush and Shih, *Early Chinese Texts on Painting*, pp.96–7)

Plate 88 Guo Xi, *Early Spring*, 1072, hanging scroll ink on silk, 158.3 x 108.1 cm, National Palace Museum, Taipei, Taiwan. Photo: The National Palace Museum, Taipei, Taiwan.

The image of the disinterested scholar, expressing his untrammelled emotions and feelings through the medium of landscape paintings, is a staple of many older books on the subject of Chinese art, as well as being a literary trope found extensively in Chinese writing of the past. It is certainly the case that men and women of high social standing, up to and including certain Chinese emperors themselves, were active as painters in a way that is not paralleled in Europe (despite claims to the contrary by writers of the Renaissance like Alberti). The image of withdrawal from the mundane world has recently been challenged by a number of scholars, who have pointed out that even 'amateur' painters of high standing in China were involved in social and patronage networks of great complexity, and seldom painted 'just because they felt like it'. Even those artists who, by their status as landowners or holders of the imperial degrees (which qualified them to serve as members of the state bureaucracy), had no need to paint for a living, regularly produced work as part of a network of social obligations and reciprocal gift-giving. For example, *Befriending the Pines* (Plate 89) was painted by the upper-class artist Du Qiong for his brother-in-law, on the occasion of the latter's assumption of a new name.

The different hierarchy of subject-matters in Chinese as opposed to European painting throws new light on the important question, 'Why have there been no great women artists?' In posing this question in 1989 with regard to Europe (typically 'artist' was used to stand for 'European artist'), the art historian Linda Nochlin was able to draw attention to women's exclusion from the academic structures necessary to artistic success in early modern Europe, and in particular to women's exclusion from the all-important practice of life drawing (Nochlin, 'Why have there been no great women artists?'). Clearly, this is not the explanation in the Chinese case, where drawing from life formed no part of artistic training. Nor can it be argued that women were barred from travelling and seeing the landscape, since it was not the case that sketching in the open air was an essential part of the practice of landscape art in China. Women did paint landscapes (Plate 90), but women who painted (and these tended to be either relations of male professionals, relations of upper-class amateurs, or trained courtesans) were more likely to be restricted to flower painting, a less prestigious subject, even if one also practised by many men. The answer to the question must be essentially the same as the one Nochlin gives and must involve challenging the way 'great artist' has been defined. In China, this may be significantly different from the definition used in the European tradition, but China too excluded women from the institutions that provided the informal preparation for artistic 'greatness'. It was women's exclusion from the social networks of upper-class male interaction and bureaucratic patronage, networks that were crucial to the formation of the canon of 'great artists' in China, that above all led to the marginalization of woman painters (and calligraphers). Another angle on this question for both Chinese and European art would be to question the very way in which 'art' has been defined. We need to seek a more inclusive definition, which would incorporate the arts that women have been allowed to practise, to achieve a wider scope for the history of art.

Plate 89 Du Qiong, *Befriending the Pines,* mid-fifteenth century, hand scroll on paper, 29.1 x 92.3 cm, Palace Museum, Beijing. Photo: The Palace Museum, Beijing.

Plate 90 Lin Xue, *Landscape after Huang Gongwang,* first half of sixteenth century, fan leaf, ink on gold paper, 19 x 56 cm, Museum für Ostasiatische Kunst, Cologne. Photo: Rheinisches Bildarchiv, Cologne.

European writing about Chinese art

As stated at the outset of this case study, there is a very large, self-conscious tradition of writing about art within China. The first large-scale attempt to provide a collection of artists' biographies, and to characterize their style, was a book called *Li dai ming hua ji* (*Records of the Painters of Successive Dynasties*), written in 843 by Zhang Yanyuan. Zhang categorizes over 370 painters from the very earliest times to his day, and sets a pattern for writing about painters that was to be extremely long lasting. In the case of many artists within the Chinese tradition, we have the same sorts of personal detail about their lives and work that are found in the writing of Vasari many centuries later (and in some cases we even have exactly the same stories about them, written down in China hundreds of years before they surface, almost certainly coincidentally, in Europe). For example, we know of Wen Zhengming, one of the great upper-class amateur painters of the Ming period, what he normally had for lunch, and that he had notoriously smelly feet.

Plate 91
Shitao, *Waterfall*,
1671, hanging
scroll on paper,
Musée Guimet,
Paris. Photo:
Musée Guimet,
Paris.

The famous opening sentences of Gombrich's *Story of Art*, to the effect that 'There really is no such thing as Art. There are only artists', could arguably have provided him with a basis for an extensive treatment of China.

However, the way Chinese art is written about in *The Story of Art* is very different from the way in which the author treats the art of Europe, which forms the bulk of this enormously influential and popular book. Rather than building the account around named artists, only one, Gu Kaizhi, is mentioned at all. Painting in China is instead associated above all with ideas of religious practice, and seen as essentially unchanging across a very long time span. In treating it in this way, Gombrich is showing himself to be heir to a western tradition of writing about China (and Chinese art) which stresses continuities rather than change and which attempts to reduce the wide range of artistic expression in China to an essence, what Chinese art is 'really' all about. This tradition has a history that goes back above all to the philosopher Hegel, one of the first to articulate the absolute contrast between a dynamic, forward-moving 'West' and a static, unchanging 'East'. The fact that Gombrich chooses to treat the Islamic world and China in the same chapter is the clearest possible symptom of his Hegelian roots. The two cultures have nothing in common except for being 'not western', and so serve to define who 'we' who 'look eastwards' are. The current fashion for the term 'non-western art' as a way of lumping together everything that is 'not us' is a continuation of the same position.

One of the common ways of approaching art in China involves seeing it as uniquely bound up with the study of its own past, and the reworking of old themes. Such a view allows the holder to point to works such as those shown in Plates 88 and 91, created 600 years apart, and stress what is the same about them (they are both landscapes) rather than what is different (not just style, but the social roles of the two artists and the audiences for their work).

The word 'archaism', meaning a return to the ancient, is often used. Yet 'archaism' is not used to describe the phase of European art that involved the close study and use of very ancient models in the visual arts, or the continued relevance of scenes from classical Greek mythology to European artists of the nineteenth century. Instead, the former has, since the nineteenth century, been called the Renaissance, or 're-birth', a birth being above all a beginning,

something new, rather than an obsession with the past. The same is true of a term like 'neo-classicism', which might equally be described as an 'archaistic' movement in art (but never is). This is part of the dynamic West/static East division, which has been built into art history since its beginnings as an academic discipline in the nineteenth century. It affects the writing of the art history of many parts of the world other than China.

However, the Chinese situation is perhaps rather distinctive, in that China never formed the direct colonial possession of any single European power, even if it was the object of all sorts of indirect political and economic domination.[3] The desire on the part of many western writers to pin down the 'essence' of Chinese art is a way of reducing the threat it poses to *the* single, linear history of art as a story that takes place above all in Europe. The diversity and self-consciousness of China's own large body of statements about art can only really be dealt with by being ignored (difficulties of language are often a convenient excuse here). The European interpretation of Chinese art creates particular problems when it comes to writing about the developments in art in China in the nineteenth and twentieth centuries, since it is a position that makes the idea of 'modern Chinese art' an impossibility. A thing is either 'Chinese' in which case it has to be in a traditional format (Plate 92), or else 'modern', in which case it is not 'really Chinese' (Plate 93).

This is now as much of a problem for writers in China as it is for those outside. Thus, a work like the self-portrait of the painter Guan Qiaochang (Plate 94) is often omitted from general histories of Chinese art, whatever language they are written in. This artist, for example, finds no place in most modern Chinese encyclopaedias of art, or in general exhibitions of Qing dynasty (1644–1911) painting. Outside China, his work is subsumed under the special category, 'Chinese export art'.

[3] This means, for example, that the work of the scholar Edward Said, and in particular his *Orientalism* (1978), has been less influential in China than it has in other countries such as India. Said sought to explain the way in which much non-European art had been constructed as the art of inferior subject peoples. Chinese art has in part escaped this interpretation and most Chinese scholars today do not see themselves as heirs to colonial subjects.

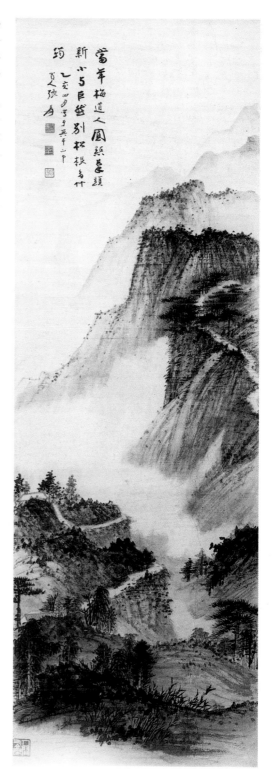

Plate 92 Zhang Daqian, *Landscape*, 1935, hanging scroll on paper, British Museum, London. Photo: by permission of the Trustees of the British Museum.

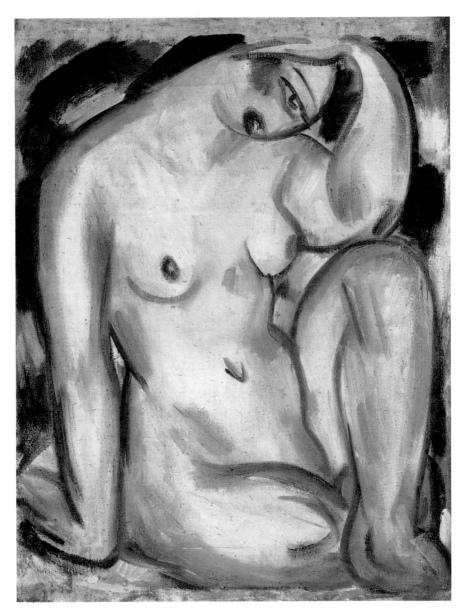

Plate 93
Lin Fengmian,
Nude, *c*.1934, oil
on canvas, laid on
board, 80.7 x
63.2 cm, Private
Collection. Photo:
by courtesy of
Christie's Hong
Kong Ltd.

The artist, who spent his entire career within the boundaries of the Chinese empire, exhibited at the Royal Academy of Arts in London as early as 1835, but his work poses a terrible problem for the structures of art history as a discipline in the United Kingdom. As a painter in oils, he is excluded from the collections of the Department of Oriental Antiquities at the British Museum and the Far Eastern Department of the Victoria and Albert Museum (not 'Chinese' enough). As a 'Chinese artist' he is ignored by the Tate Gallery, the National Gallery, and the National Portrait Gallery, and consequently omitted from their collections also.

In *The Meeting of Eastern and Western Art* (1989), the art historian Michael Sullivan pointed out the unfairness whereby the use by European or American artists of Asian ideas is seen as creative (think of the Impressionists and Japanese prints), whereas the use by Asian artists of ideas developed outside

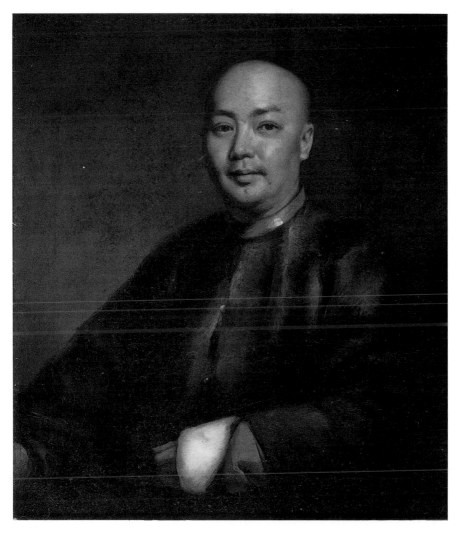

Plate 94
Guan Qiaochang
(Lamqua), *Self-portrait*, late
1840s, oil on
canvas, 27.3 x
23.2 cm, Peabody
Essex Museum,
Salem, Mass.
Photo: by
courtesy of the
Peabody Essex
Museum, Salem,
Mass.

Asia is seen as *un*creative, sterile borrowing.[4] This double standard is still pervasive in the writing of art history, and contemporary artists from China, wherever they happen to live, still find it very hard to get their work shown outside the restricted context of 'Chinese art'. Many scholars are now aware of the problems brought about by past practice, but change is difficult to achieve within the limits of art history as a discipline. If you stop to consider the effect of the inclusion of only a single case study about China in a series of books whose themes include *The Changing Status of the Artist* (in Europe) and *Gender and Art* (in Europe), you will become aware of the extent to which, whatever our intentions, this balance serves to reinforce the idea of the history of art in something called 'the West' as a historical and contemporary norm.

Look now at *Wintry Trees* (Plate 95) by Wen Zhengming (1470–1559) and *Self-portrait* (Plate 96) by Ren Yiong (1820–57), and consider how the range of methodologies used by western art historians might be applied to understand these works of art.

[4] The same point about unfair comparisons was made more extensively by Martin Powers in a paper called 'Re-examining the "West"'.

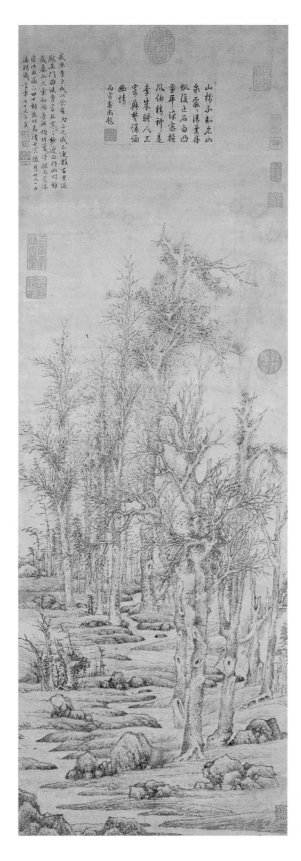

Plate 95
Wen Zhengming, *Wintry Trees*, 1543, hanging scroll on paper, British Museum, London. Courtesy, the Trustees of the British Museum.

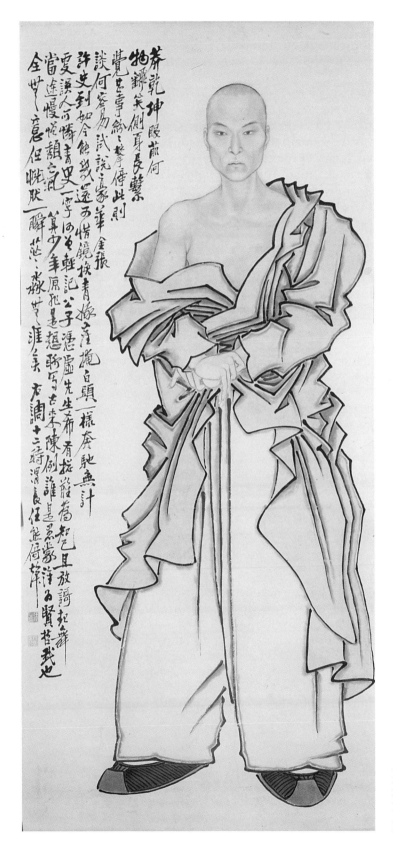

Plate 96
Ren Yiong, *Self-portrait*, 1850s,
hanging scroll on paper,
177 x 79 cm, Palace Museum,
Beijing.

Discussion

(The discussion provides new information about the works and the artists to illustrate the possible approaches to analysis and interpretation.)

Documentary/biographic analysis

Wen is one of the most famous of Chinese 'literati' ('educated amateur') artists, and is firmly established in the canon of major Chinese painters. His work has been extensively written about since his own time. It has also been extensively faked. Issues of connoisseurship, the identification of authentic works, are important in Chinese painting studies. The inscriptions and seals of the artist and of previous owners are useful in this respect, as well as revealing something of the circumstances in which a picture was painted (in the case of *Wintry Trees*, as a reciprocal gift for a friend who visited the artist to condole him on the death of his wife).

Ren was a professional artist working in Shanghai. He is one of a group of Shanghai artists in the late nineteenth century who introduced new styles of painting that appealed to the popular imagination. Their approach to art and the professional nature of their work contrasted with that of the literati artists.

Stylistic analysis

Traditional discussions of a picture like *Wintry Trees* might concentrate on its links to the style of earlier artists, a topic that Wen himself raises in his inscription. By contrast, Ren's *Self-portrait* has recently come to be a much-discussed work because of its possible superimposition of a western code of representation on assertive calligraphic brushwork.

Formalist/iconographic analysis

Western approaches such as formalism and iconology have had a definite, if limited, impact on how such works have been studied.

Contextual analysis

More recently, scholars interested in the social history of art have drawn attention to the kinds of interaction between members of the élite for which works like *Wintry Trees* were created, and also to the history of their transmission through subsequent collections. One of the collections to which Wen's *Wintry Trees* belonged was that of the Qianlong emperor (reigned 1736–95). This great imperial collection was divided as a result of the politics of the twentieth century, with part of it accompanying the Nationalist government to the island of Taiwan, and part remaining in Beijing, the capital of the People's Republic of China. The Beijing collections did not begin to be extensively published until the 1970s. They contain many objects of a type outside the traditional art-historical canon, including works like Ren's life-size *Self-portrait*.

Psychoanalytic analysis

The powerful gaze of the artist/subject makes Ren's *Self-portrait* of great interest to scholars working with new psychoanalytic approaches, or exploring the construction of gender or the role of subjectivity in Chinese art.

◆◆◆

It is only quite recently that the painting of nineteenth-century China has been seen as other than the product of an age of 'decline' and we need now to build on this changing perception. Instead of approaching the art of China with preconceived ideas based on stereotype, perhaps we in the West should be asking what Chinese artists see in their work and derive from it, as well as listening to how Chinese art historians wish to interpret it. It may be time to lay aside our European expectations and be open to the answers we receive.

References

Bush, S. and Shih, H. (1985) *Early Chinese Texts on Painting*, Cambridge, Mass. and London.

Clunas, C. (1991) *Superfluous Things: Material Culture and Social Status in Early Modern China*, Cambridge, Polity Press.

Clunas, C. (1996) *Fruitful Sites: Garden Culture in Ming Dynasty China*, London, Reaktion Books.

Clunas, C. (1997) *Pictures and Visuality in Early Modern China*, London.

Gombrich, E.H. (1995) *The Story of Art*, London, Phaidon (first published 1950).

Jullien, F. (1995) *The Propensity of Things: Towards a History of Efficacy in China*, trans. J. Lloyd, New York.

Liscomb, K.M. (1993) *Learning from Mt. Hua: A Chinese Physician's Illustrated Travel Record and Painting Theory*, Research Monographs on Anthropology and Aesthetics, Cambridge.

Nochlin, L. (1989) 'Why have there been no great women artists?', in *Women, Art and Power: and Other Essays*, London, Thames & Hudson.

Powers, M. (1997) 'Re-examining the "West"', in *Chinese Painting in the Twentieth Century: Creativity in the Aftermath of Tradition*, ed. Y. Cao and J. Fan, Hangzhou, pp.465–96.

Said, E.W. (1978) *Orientalism*, New York, Pantheon.

Sullivan, M. (1989) *The Meeting of Eastern and Western Art*, University of California Press.

ART AND ARTISTS IN COLONIAL
AND POST-COLONIAL CULTURES

Preface to Part 2

CATHERINE KING

Craig Clunas emphasizes that western priorities have created a situation in which the adjectives 'modern' and 'Chinese' appear incompatible in relation to art: 'modern' means westernized, while Chinese art is supposedly traditional. The incorporation by artists working in China of elements deriving from contact with European or North American artists is treated in the West as imitation rather than innovation. The effects of proposing, to quote Clunas, the West as 'historical and contemporary norm' have been arguably even stronger in areas over which European colonialists gained direct territorial control. European colonizers tended to see their own artistic traditions as continually progressing, with their artists successively challenging the achievements and conventions of the generation that taught them. On the other hand, the art of colonized peoples or those outside territories occupied by Europeans and their heirs was said to be decadent (India), or static (China), or primitive (Africa). Only European artistic traditions were held by Europeans to be able to develop modernity: that is, the condition in which artists undertake a critique of the work of their predecessors in a self-conscious manner so as to create works suited to a new age.

In the second part of this book, we turn to a selection of case studies that suggest how artists who were either colonial subjects or the heirs of the colonized have negotiated and questioned the assumption that only Europeans and their descendants make traditions of modernity.

Colonial artists

In Case Study 6, Tim Benton probes the conditions under which in Brazil around 1800 António Francisco Lisboa produced sculptures and buildings that, according to a contemporary official in his home area, won him the title of 'another Praxiteles'.[1] These conditions included the fact that he would have been perceived as a second-class citizen because he was the descendant of an African slave. The exquisite churches and the dramatic sculptures of Lisboa are evidence of the ambitions of the largely European-descended élite patrons in the mining community of Ouro Preto. They testify to their concern to possess art that was beautiful and highly innovative: fit for their 'new Athens'. In addition, Benton argues that a formal analysis of the unified effects of the architecture attributed to Lisboa suggests that he developed a thoughtful critique of the design tradition in which he had been trained. In the twentieth century, scholars such as Gilberto Freyre have also argued that

[1] Praxiteles was a famous fourth-century Athenian sculptor.

Plate 97 (Facing page) Tayo Quaye, detail of *The Man* (Plate 159).

Lisboa's designs, especially those for his statuary, expressed his own political revolt against European masters. However, Lisboa and his fellow artists did not record their views in any surviving texts.

By contrast, when we turn in Case Study 7 to consider the work of Rabindranath Tagore in India in the early twentieth century, we find a situation in which artists were explicitly debating ways of asserting artistic independence from European dominance, in parallel with political action. Whereas the emphasis in the first part of this book is on the way colonizers and colonized have interpreted the art of the past that had been made by colonized peoples before the advent of European government, in the second part we study not only the arguments of art historians, but also the way in which artists themselves during and after imperial control have consciously used their artworks to question assumptions that 'West is best'.

In Case Study 7, Catherine King analyses the environment in the 1920s in which Rabindranath Tagore outlined a way forwards for modern art both in practice and in theory. She looks at a variety of contemporary responses to his pictures and subsequent evaluations of his work. While some of his contemporaries sought to make a modern national art deriving from local Rajput and Mughal styles, Tagore asserted the right of artists in India to adapt methods and motifs from any other cultures, just as Europeans were doing. Tagore wanted Indian independence, but he eschewed exclusive concern with nationalism in art as in politics, and travelled the world lecturing nations on the need to move towards internationalist values – and thereby stand above even imperial affiliations. Tagore made his bold assertions in a society in which colonial rulers played direct roles in debates about the agenda for a new Indian art. They held controlling posts in art colleges (with members of the Tagore family allowed to deputise occasionally), provided exhibition spaces and awards (which Tagore's relations sometimes won), funded art journals, and dominated patronage.

The heirs of colonized peoples

We move in Case Study 8 to look at artists belonging to a former colony and compare how they were able to set about generating their own debates about modernity once they had achieved political independence. Catherine King uses art made in Nigeria c.1960–c.1990 to trace the way in which artists see their practices as developing from strong bases in local art-making regardless of whether they overtly draw on motifs or media from those art practices. Artists in Nigeria do not regard their modern art as given to them by another culture but as developed by them through invention and appropriation. In their view, European artists are indebted to developing traditions of abstraction made in Africa, while, reciprocally, artists in Nigeria are heirs to changing traditions, for example of realism, produced in Europe. Some artists in Nigeria have chosen to make designs with some reference to local topics, media, techniques, and forms. Others have preferred to invent using visual language, which they characterize as being more international in import. The foundation of journals, colleges, and exhibition spaces in Nigeria has assisted artists in defining their own diverse and shifting distinctiveness. Nevertheless, some artists draw attention to the continued power of outside patrons and the way in which buyers who want art made in Africa to look stereotypically 'African' may force types of distinctiveness onto artists working in Nigeria.

Scholars' viewpoints

In Case Study 6, with which we begin Part 2, Benton discusses how we now assess Lisboa's work and considers the way scholars with different views about the nature of Brazilian society and its relationship to Europe have written accounts that defended or attacked his reputation as an artistic leader and innovator. These include such texts as the celebratory biography by Rodrigo Brêtas (1858), written soon after it was forbidden to import slaves to Brazil (1853), and Freyre's (1947) interpretation of Lisboa's work as proof of the creativeness of the cultural mixing that had given birth to Brazilian nationhood and social cohesion. Such interpretations were called into question by the critical accounts of writers such as José Mariano Filho (in 1947), who challenged most of Brêtas's data, and Augusto de Lima Junior (in 1962–3), who asserted that Lisboa never existed at all and was a politically motivated legend concocted by Brêtas. As Benton shows, twentieth-century Brazilian architects also acclaimed Lisboa, depicting his work as a bright star on the national stage and Lisboa himself as father of a tradition in which Brazilians vied with European artistic ideas.

'O Aleijadinho': sculptor and architect

TIM BENTON
WITH NICOLA DURBRIDGE

Introduction

In 1930, in the town of Ouro Preto in Brazil, a number of events were held to celebrate the bicentenary of the birth of a sculptor and architect. Intellectuals, architects, and politicians made speeches, there was an exhibition, and a book of photographs of his work was published, with an introduction by one of Brazil's leading modern architects, Lúcio Costa. The object of this attention was António Francisco Lisboa, who was known by the nickname '*O Aleijadinho*' ('the little cripple').

Aleijadinho was probably born in 1738; he died in 1814. That he was born the illegitimate son of a white Portuguese *carpinteiro* (carpenter and builder) and an African slave, and that he suffered in later life from a terrible wasting disease, makes his achievement more remarkable. He grew up in a remote region of what was then a Portuguese colony (now the district of Minas Gerais), where the discovery of gold and diamonds early in the eighteenth century led to a lawless scramble for riches. Part of this wealth went into the construction of churches and chapels, many of which were either designed or decorated by Aleijadinho. The work he produced has been celebrated by some architectural historians (mostly European) as a high achievement of European culture. Brazilian art historians have tended to divide into two groups. One group sees in him a symptom of the growing independence of colonial Brazil from Portugal (both critical of and superseding the culture of the colonial masters). For the other group, his mixed-race parentage presents a challenge: was this 'mulatto' man born on the margins of society an architect in the European sense at all, or were his talents those of a gifted craftsman, copying forms derived from European prototypes?

Aims

Our primary aims in this essay are to investigate the assumptions that underlie interpretations of Aleijadinho's work and to consider how these were influenced by attitudes to his ethnic and colonial status. This includes asking in what ways the views of critics and commentators have been influenced by their own relationships to the colonization of Brazil by the Portuguese. For example, the earliest record of Aleijadinho's fame, dating from the 1790s, may have been influenced by a movement towards independence from Portugal in the eighteenth century known as the *Inconfidencia* (literally, 'No confidence', or Resistance), which encouraged the children of colonizers, born in Brazil, to search for distinctive local cultures to set against that of Portugal. We shall also consider ways in which the evaluation of Aleijadinho's work has been shaped by the nature of the surviving documentary evidence. Archivists began collecting evidence early in the twentieth century, but the circumstances in which Aleijadinho had worked placed limits on the documentation produced.

A secondary aim is to reflect on what we know or can surmise about the historical conditions in which the artist worked, as well as what can properly be deduced from the work he left behind. We shall be asking if, by analysing a building, we can determine whether a single architect/designer was responsible for its shape, and, if so, whether (given that some historians argue that he was primarily a sculptor) that person was Aleijadinho. We shall be scrutinizing work that has been attributed to him to decide whether Aleijadinho was an innovator or an imitator. In doing so, we shall keep in mind that designers often innovate and assimilate the conventions of the past in a tradition.

The first part of the case study will introduce you to Aleijadinho's work in its architectural context, to try to establish whether it was dependent on Portuguese prototypes or whether it could be thought of as 'innovative' or 'critical' of the dominant modes of production. We will then look more closely at the conditions under which Aleijadinho worked and how these conditions may have influenced both his production and the way he has been perceived. Finally, we will consider how Aleijadinho's career has been interpreted by a range of authors and whether their views were determined by their relative positions in terms of colonial experience and ethnic status.

The architectural context

Aleijadinho was born in the town then known as Vila Rica (Rich City), which served as the capital of the colonial administration of Minas Gerais. Vila Rica was later renamed after its principal parish, Ouro Preto (Black Gold, named after the black ore whose discovery in the mountain of Italcolomi in 1698 triggered a gold rush). Ouro Preto was laid out along a series of ridges joining the congestion of the gold mine workings to the hilltops where the better off established their parish churches and the chapels of their confraternities or brotherhoods (Plates 98 and 99). The *Irmandados* or lay brotherhoods were groups of people who came together for worship, charitable work, and mutual support. Membership was governed by ethnicity and/or occupation and divisions were strictly enforced. Some brotherhoods were more powerful, as they grouped together influential white men from the landed or professional classes. Others were more modest, being craft based. The brotherhoods were responsible for

Plate 98 View of Ouro Preto. Photo: Tim Benton, by courtesy of the Conway Library, University of London.

Plate 99
View of the
church of
Nossa
Senhora do
Carmo, Ouro
Preto. Photo:
Tim Benton.

commissioning many of the churches and chapels in the region and even the
less privileged brotherhoods commissioned expensive chapels, often using
Portuguese-born architects.

The towns of Minas Gerais lie on or around a plateau separated from the
port of Rio de Janeiro by a fortnight's perilous journey through mountainous
terrain where the dangers of wild animals, poisonous snakes, and bandits
took a steady toll (Plate 100). You might assume from this that Minas
Gerais was cut off from developments in Europe, but, according to one
twentieth-century authority on Portuguese and Brazilian Baroque
architecture, Robert C. Smith:

> Of all the former European colonies in the New World, it was Brazil that most
> faithfully and consistently reflected and preserved the architecture of the mother-
> country. In Brazil were never felt those strange indigenous influences which in
> Mexico and Peru produced buildings richer and more complicated in design
> than the very models of the peninsular Baroque … And the proof of this lies in
> the constant imitation in Brazil of the successive styles of architecture in vogue
> at Lisbon and throughout Portugal during the colonial period.
>
> ('The colonial architecture of Minas Gerais in Brazil', p.110)

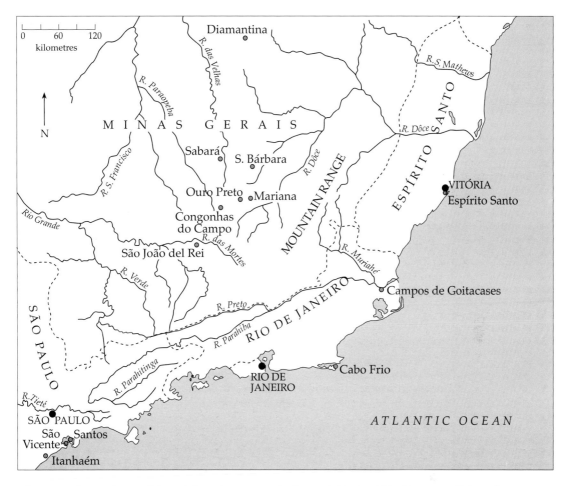

Plate 100 Map of central Brazil, based on a map in Germain Bazin, *L'Architecture religieuse baroque au Brésil*, Paris, Éditions d'histoire et d'art Librairie Plon, 1956–8, vol.1, *Étude historique et morphologique*, p.375.

Some churches on the coast of Brazil were actually designed in Portugal and imported stone by stone. This was impossible in Minas Gerais, due to its geographic location. The flow of people and ideas into Minas Gerais was restricted by the authorities in an effort to control the smuggling of gold. There was no university in Brazil and no authorized publishing house. Despite these conditions, books and prints were available, and relatively humble administrators, such as Joaquim José da Silva, the Alderman of Mariana (a town near Ouro Preto), writing in 1790, knew enough to refer to Italian Renaissance architectural treatises and to compare buildings in Minas Gerais to ancient buildings in Rome.

Baroque and Rococo in Brazil

Aleijadinho learnt about architecture from his father, Manuel Francisco Lisboa, and from his uncle, António Francisco Pombal, carpenters who emigrated to Brazil in the 1720s. Their work can be seen as typical of traditional architecture in Portugal at the time.

Nossa Senhora do Conceição (Our Lady of the Immaculate Conception), the Matriz (mother church) for the newly created parish of António Diaz in Ouro Preto was built in 1733–42 to the designs of Manuel Francisco Lisboa. His brother-in-law was commissioned to carry out much of the carpentry. The plan of the church follows the scheme of a single nave with flanking corridors, which developed simultaneously in Portugal and in Brazil in the late seventeenth century. The corridors served practical functions (circulation, insulation, and storage of equipment for religious festivals) and also gave access to the pulpits, which were located in the middle of each nave wall. The chancel, known as the *Capela Mor* (Major or High Altar Chapel), was separated from the nave by railings. These kept the different constituents of the congregation apart: the public in the middle and the clergy or brothers in the space nearer the *Capela Mor* and in front of the side altars, at which other brotherhoods held their masses.[2] The chancel was narrower than the nave, which allowed room for wider corridors leading to the sacristy located behind the high altar (Plate 101). It was here that the clergy or brothers would enrobe. From the outside, the building can be seen to divide into three 'boxes': nave, chancel, and sacristy. The façade was flanked by twin towers, with a central window above the doorway which deflected the main entablature (Plate 102). As Smith says, this kind of church was recognizably 'Portuguese' in its component elements (nave, pulpits, etc.) and in its restraint (it lacked the riot of ornament that characterized much colonial architecture in South America). On the other hand, the combination of corridor plan, 'three box' construction, and twin towers flanking a central window at the west end adds up to a distinctive type, which was multiplied throughout Brazil.

While the parish of António Diaz was building its church, the original parish of Ouro Preto did not stand still. Work rebuilding the Matriz, Nossa Senhora do Pilar (Our Lady of the Pillar), was begun in 1731 and inaugurated in 1734. The plan of the church shows the typical arrangement of the *Capela Mor*, with a sacristy behind it. The nave, on the other hand, has no corridors and resembles a large hall (Plate 103). An ambitious project of internal decoration was started in 1736, and Pombal (Aleijadinho's uncle) designed a church within a church, a 12-sided rhomboid created in wood. He used giant pilasters and integrated the side altars into a single, flowing rhythm. The interior can be seen, in European terms, as part of the development of the Baroque style, in which the rigidity of rectangular forms of plan and straight walls began to give way to a more dynamic effect of curving walls and complex geometrical plans (Plate 104). However, and again from a European perspective, the parish churches of António Diaz and Ouro Preto would have been considered rather old-fashioned. As da Silva had noted in 1790, the source for Pombal's giant pilasters was the treatise *L'Idea dell'architettura universale* (*The Idea of a Universal Architecture*) (1615), by the Italian Renaissance architect Vincenzo Scamozzi, hardly the latest word in architectural fashion.

[2] Sometimes other brotherhoods had altars in the chapels of the most privileged brotherhoods to associate themselves with this authority and also because wealthy people often belonged to more than one brotherhood. In other cases, a brotherhood had an altar in another brotherhood chapel while it waited to build its own chapel.

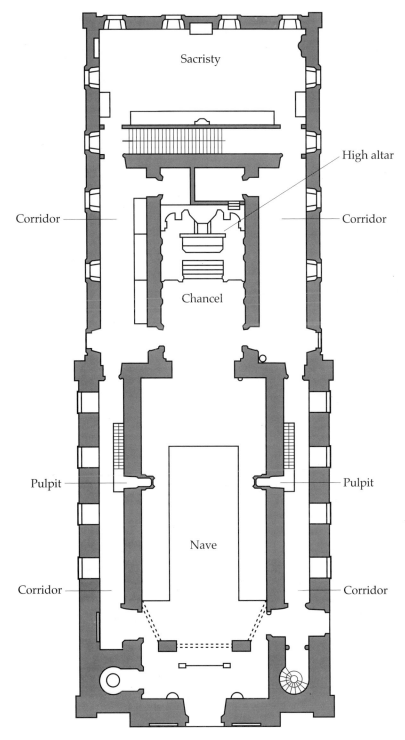

Plate 101 Nossa Senhora do Conceição, parish of António Diaz, Ouro Preto, 1733–42, plan. Photo: from Germain Bazin, *L'Architecture religieuse baroque au Brésil*, Paris, Éditions d'histoire et d'art Librairie Plon, 1956–8, vol.1, *Étude historique et morphologique*, figure 80.

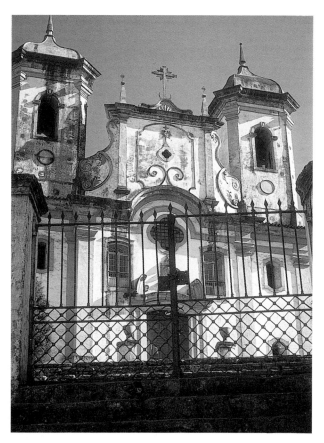

Plate 102 Nossa Senhora do Conceição, parish of
António Diaz, Ouro Preto, 1733–42, façade.
Photo: Tim Benton.

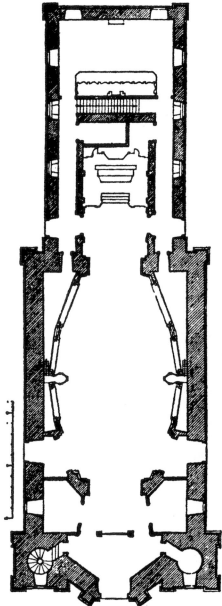

Plate 103 Nossa Senhora do Pilar, Ouro
Preto, 1731–4, plan. Photo: from Germain
Bazin, *L'Architecture religieuse baroque au
Brésil*, Paris, Éditions d'histoire et d'art
Librairie Plon, 1956–8, vol.1, *Étude
historique et morphologique*, figure 61.

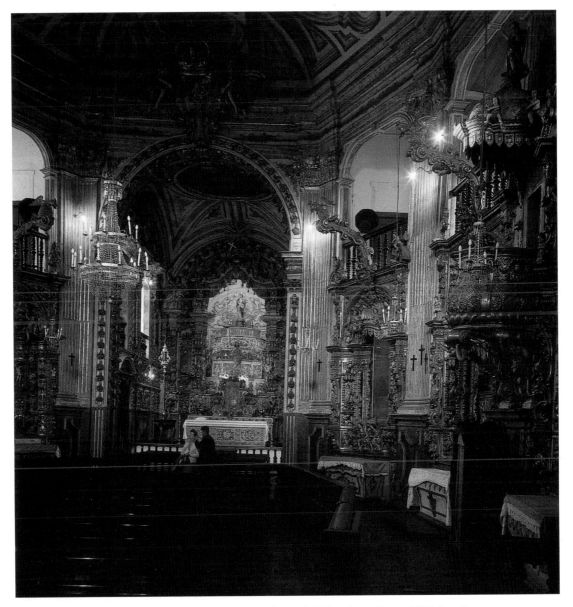

Plate 104 António Francisco Pombal, Nossa Senhora do Pilar, Ouro Preto, 1736, interior.
Photo: Tim Benton.

An expression of a more up-to-date Baroque style was the church of São
Pedro dos Clerigos (Saint Peter of the Clerics), Mariana, begun between 1764
and 1773. The two intersecting ovals that can be seen in the plan have a
markedly different effect (Plate 105). This building was left incomplete in
1820, but it may have influenced the building of the confraternity chapel of
Nossa Senhora do Rosario dos Pretos (Our Lady of the Rosary for the Black
People) in the parish of Ouro Preto, which was begun some time after 1753.
Note again the two ovals on the plan (Plate 106) and their correspondence
with the curved exterior walls (Plate 107). These two buildings were identified
by the architectural historian J.B. Bury, writing in the 1950s, as remarkably
'modern' reflections of European Baroque architecture in Brazil. Documents
suggest that both were designed by men of Portuguese extraction.

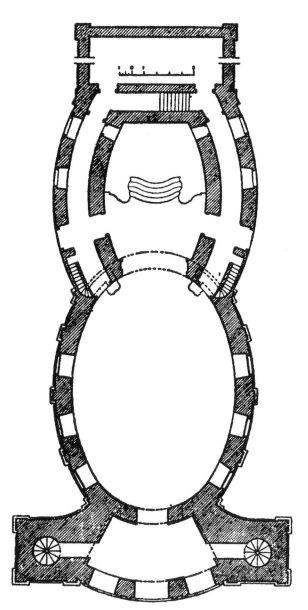

Plate 105 São Pedro dos Clerigos, Mariana, begun
c.1764–73, plan. Photo: from Germain Bazin,
L'Architecture religieuse baroque au Brésil, Paris, Éditions
d'histoire et d'art Librairie Plon, 1956–8, vol.1, *Étude
historique et morphologique*, figure 66.

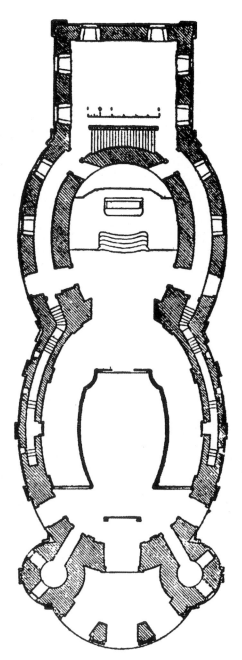

Plate 106 Nossa Senhora do Rosario dos
Pretos, Ouro Preto, begun after 1753
completed 1784, plan. Photo: from
Germain Bazin, *L'Architecture religieuse
baroque au Brésil*, Paris, Éditions d'histoire
et d'art Librairie Plon, 1956–8, vol.1, *Étude
historique et morphologique*, figure 67.

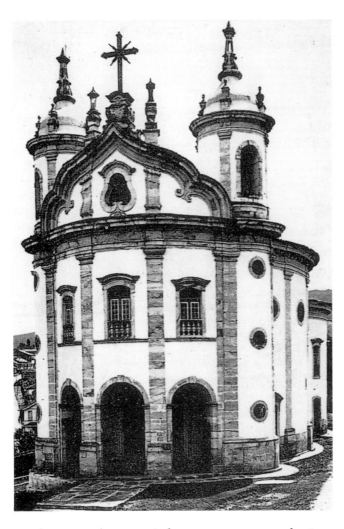

Plate 107
Nossa Senhora do Rosario dos Pretos, Ouro Preto, begun after 1753 completed 1784, façade. Photo: from Germain Bazin, *L'Architecture religieuse baroque au Brésil*, Paris, Éditions d'histoire et d'art Librairie Plon, 1956–8, vol.1, *Étude historique et morphologique*, p.375.

By the 1760s, the latest fashion in Europe was the Rococo decorative style. Originating in France, as a style of interior decorating using easily worked materials (stucco and wood), the style was less formal than the Baroque and included swirling, asymmetrical, and fanciful motifs. In the Austrian Empire, southern German states, and part of Switzerland, the Rococo was characterized by a light tonality (typically white and gold in interiors) and a virtuoso, frothy sculptural quality. Early in his career, Aleijadinho developed a highly personal style of decorative sculpture, which has been compared to European Rococo and for which no precedents exist in Brazil. For example, the reliefs carved by Aleijadinho on the pulpits in São Francisco do Assis in Ouro Preto (1769–72) are recognizably Rococo in their freedom of expression, asymmetry, and informality (Plate 108). This development is not easily explained. It is possible that Aleijadinho had seen and been inspired by engravings of Rococo decoration. Another factor that may have encouraged Aleijadinho to adopt this highly decorative style was the availability of easily carved soapstone – first used by his father for detailing. This stone is so soft in its natural state that it can be scratched with a fingernail, but it hardens to a crisp, durable finish, which preserves detail for centuries. Aleijadinho became an expert in the use of this material for interior and exterior work.

A further example of his Rococo decorative sculpture is the frontispiece[3] that he added to the façade of the confraternity chapel of Nossa Senhora do Carmo, Ouro Preto, in 1771 (Plates 109 and 110). His father had designed the chapel in 1766, but the brotherhood later decided to make the façade more impressive by setting the towers back slightly, introducing a curve in the façade itself, and commissioning Aleijadinho to carve an elaborate frontispiece around the central door (Plate 111). Aleijadinho used Itacolomi stone for the door frame and soapstone for the decorative details. The fact that considerable sums were spent revising a work barely completed indicates that the new Rococo style, of which Aleijadinho seems to have been the most talented exponent, was highly prestigious.

Aleijadinho as Rococo architect

We will now look at two churches and discuss the evidence for Aleijadinho's participation (as architect and/or sculptor) in these projects, since this evidence has been contested.

Plate 108
Aleijadinho, São Francisco do Assis, Ouro Preto, 1769–72, stone pulpit. Photo: Tim Benton.

São Francisco do Assis, Ouro Preto

Thanks to an exhaustive study of the surviving documents, we know a great deal about the construction and decoration of São Francisco do Assis (Saint Francis of Assisi), the chapel of the 'whites-only' brotherhood of Saint Francis in Ouro Preto. The entrepreneur builder of the church was the Portuguese-born Domingos Moreira de Oliveira, who worked on it until the completion of the exterior fabric in 1794. Nothing in de Olivieira's career indicates ambitions towards architectural design. We know that Aleijadinho designed part of the façade, since there was a payment to him in 1774–5 for a drawing of the portal and there seems to have been a redesign of the façade at this point. In the 1790s, furthermore, Aleijadinho was named as one of the assessors of the chapel's construction and decoration, a mark of honour and respect that may be enough to identify him as the architect of the whole work.

However, the stone sculpture for the interior of the chapel was contracted to another Portuguese-born entrepreneur, José António de Brito. The latter undertook to supply the Itacolomi stone and soapstone, transport it to the site, and work it to the designs given. This was the kind of capital-intensive work from which men like Aleijadinho were excluded by laws discriminating against 'non-whites'. Since experts agree that much of the sculpture is by Aleijadinho, we may assume that the work was subcontracted to him.

[3] Decorative element framing the entrance(s) and window(s) of a façade.

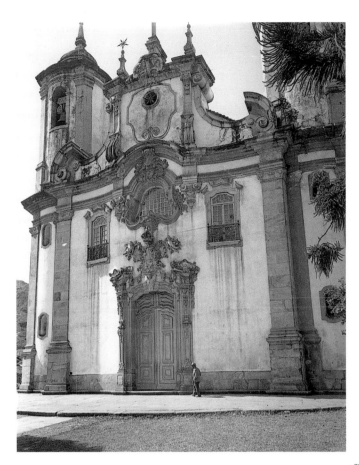

Plate 109
Nossa Senhora
do Carmo, Ouro
Preto, designed
1766, façade.
Photo: Tim
Benton.

Plate 110 Nossa Senhora do Carmo, Ouro Preto, designed 1766, transverse section, from Germain Bazin, *L'Architecture religieuse baroque au Brésil*, Paris, Éditions d'histoire et d'art Librairie Plon, 1956–8, vol.1, *Étude historique et morphologique*, figure 92.

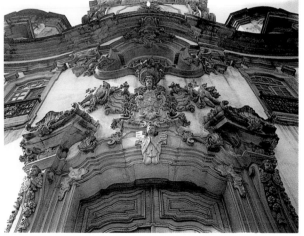

Plate 111 Nossa Senhora do Carmo, Ouro Preto, 1771, detail of sculpture over doorway. Photo: Tim Benton, by courtesy of the Conway Library, University of London.

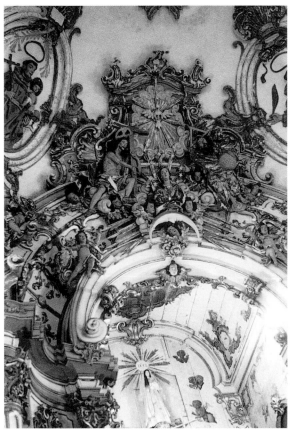

Plate 112
São Francisco do Assis, Ouro Preto, completed 1794, interior of the *Capela Mor* showing the arch framing the high altar. Photo: Tim Benton, by courtesy of the Conway Library, University of London.

Aleijadinho's name crops up repeatedly in the accounts in ways that confirm that he had a major hand in the decoration. For example, although de Oliveira was contracted to erect the pulpits in soapstone, Aleijadinho was paid a small sum for 'working the stone of the pulpits' (probably carving the relief scenes on them) between 1769 and 1772 (Plate 108). The sculpture decorating the ceiling of the *Capela Mor* (Plate 112) was contracted to Henrique Gomes de Brito (presumably a relative of José António de Brito), but Aleijadinho was the main recipient of piece-work payments for sculptural work. In the case of the high altar (1778–9) (Plate 113), Aleijadinho was paid both for the drawing and the work. Although the side altars in the nave (Plate 114) were not actually made until 1829, the craftsman was instructed to execute them 'to the design of António Francisco Lisboa'.

The documents support two possible hypotheses. Either the work was carried out by a number of different entrepreneurs and craftsmen, among whom J.A. de Brito and de Oliveira undertook the major share (judging by the sums paid), or the work followed a masterplan and detailed drawings by one man, Aleijadinho, who was subcontracted to carry out parts of the sculpture. In favour of the latter hypothesis is the high regard in which Aleijadinho was held by the officials of the 'whites-only' brotherhood for which the chapel was built. They invited him to act as assessor of the work of Portuguese-born contractors on several occasions, most significantly at the point of completion of the architectural work on São Francisco in 1794.

After considering the merits of the two hypotheses, we will have to form our own judgements, based on what we can see and whether we think there is an underlying idea, for which Aleijadinho was responsible, that ties the whole building together (architecture and sculpture, exterior and interior). To consider this further, we would like you to look at the plans and illustrations of São Francisco do Assis in comparison with those of Nossa Senhora do Carmo (which was begun by Aleijadinho's father).

Start by looking at the plans of Nossa Senhora do Carmo and São Francisco do Assis (Plates 115 and 116). What seem to be the main differences in the designs for the two buildings?

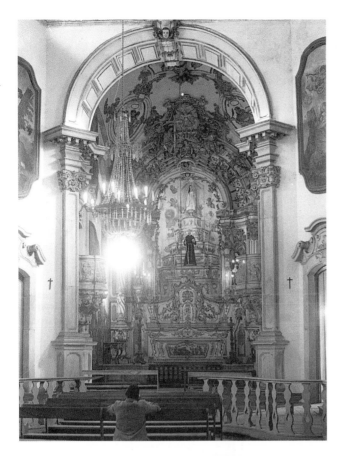

Plate 113
São Francisco do Assis, Ouro Preto, completed 1794, interior looking towards the *Capela Mor*. Photo: Tim Benton, by courtesy of the Conway Library, University of London.

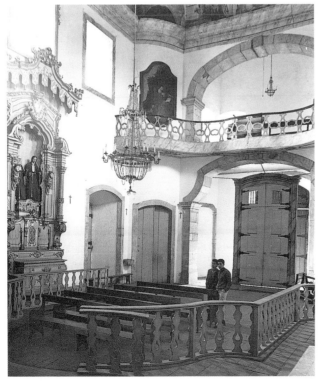

Plate 114
São Francisco do Assis, Ouro Preto, completed 1794, interior looking towards the entrance. Photo: Tim Benton.

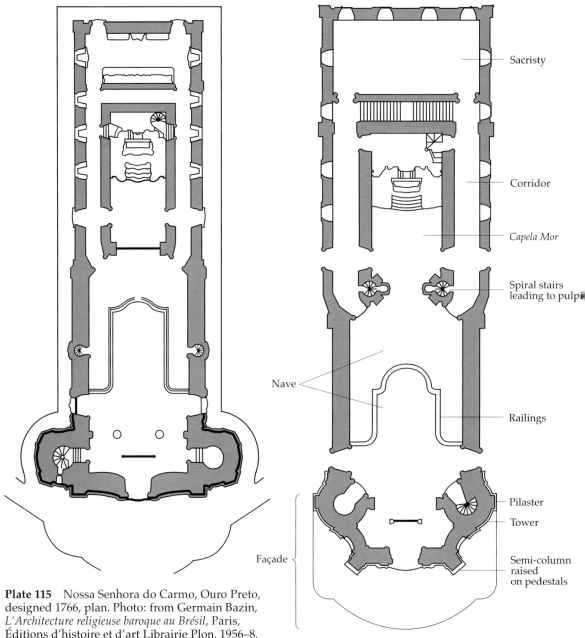

Plate 115 Nossa Senhora do Carmo, Ouro Preto, designed 1766, plan. Photo: from Germain Bazin, *L'Architecture religieuse baroque au Brésil*, Paris, Éditions d'histoire et d'art Librairie Plon, 1956–8, vol.1, *Étude historique et morphologique*, figure 85.

Plate 116 São Francisco do Assis, Ouro Preto, completed 1794, plan. Photo: from Germain Bazin, *L'Architecture religieuse baroque au Brésil*, Paris, Éditions d'histoire et d'art Librairie Plon, 1956–8, vol.1, *Étude historique et morphologique*, figure 86.

Discussion

The plan of Nossa Senhora do Carmo provides an intriguing comparison with that of São Francisco. The basic idea is the same: a typical 'three box' construction. There is a nave without corridors or aisles clearly differentiated by railings from a *Capela Mor*. The *Capela Mor* is flanked by wide corridors, which lead to a sacristy at the rear. Perhaps the most distinctive difference is at the entrance: the straight lines and square-set towers at the entrance to

Nossa Senhora do Carmo contrast markedly with the more fluid curves and angles at which the towers are set at São Francisco. The rigid / fluid distinction continues within the bodies of the churches. For example, at Nossa Senhora do Carmo the plan shows spiral stairs leading up to the pulpits set into the straight lines of the corridor walls – thus the lines remain unbroken. At São Francisco, the spiral stairs are placed centrally, concealed in the thickness of the massive piers framing the entrance to the *Capela Mor*. From the plan it is easy to see the convex curves leading to the piers. These curves mirror those at the entrance, shaped by the circular towers. Overall, the architect seems to have done what was possible to produce a less rigid, more dynamic design in São Francisco, with curving walls and a more complex plan resulting in a 'flowing' effect.

◆◆◆

Keeping the plan of São Francisco in mind, look now at the illustrations of the building itself: Plates 112–114 (for the interior) and Plates 117–119 (for the exterior). You might also like to remind yourself of the pulpit carved by Aleijadinho (Plate 108). What features would you identify as likely to contribute to the dynamic potential observed in the plan? Do you discern signs of unity of purpose between the plan and architectural and sculptural detail?

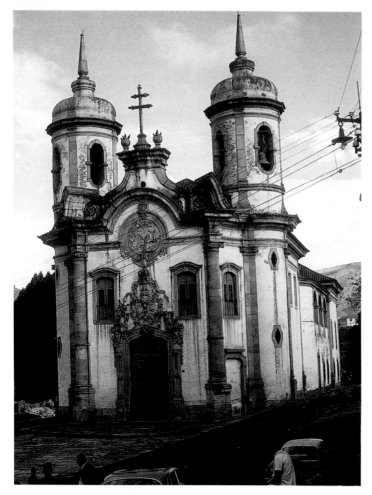

Plate 117
Aleijadinho, São Francisco do Assis, Ouro Preto, completed 1794, façade. Photo: Tim Benton.

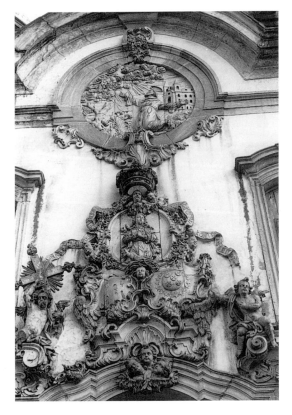

Plate 118 Aleijadinho, São Francisco do Assis, Ouro Preto, completed 1794, stone carving on façade. Photo: Tim Benton.

Plate 119 São Francisco do Assis, Ouro Preto, completed 1794, detail of junction between façade and towers. Photo: Tim Benton, by courtesy of the Conway Library, University of London.

Discussion

In the interior, the junction between the *Capela Mor* and the nave is dramatized by the convex curves already noted on the plan, which guide the eye to the piers forming the triumphal arch framing the *Capela Mor* (Plate 112). The depth of the arch, with its coffered soffit,[4] helps to lead the eye into the richness of the *Capela Mor* (Plate 113). The composite pilasters on their high bases are angled to contribute to the framing of the view. The convex curves at the entrance end of the nave, which form part of the circular towers, intrude to create a play of three-dimensional curves (Plate 114).

On the exterior, the circular towers, flanking and set back from the plane of the straight façade, are linked to it by concave sweeps, which create a tension and build a climax towards the gable (Plate 117). The half-columns on either side of the portal have been angled out in a way that invites the viewer to enter the door. This device echoes the way the pilasters are set at angles in the interior to frame the entrance to the *Capela Mor*. The overall effect of the façade is one of extraordinary concentration, with the towers hovering behind and over the façade and a framing effect that focuses the eye on the carving above the doorway (Plate 118). It is clear that there has been a marked effort to integrate architectural and sculptural effects.

◆◆◆

[4] Decoration of the underside of an arch (the soffit), consisting of square, rectangular, or polygonal recessions in plaster, wood, or stone.

We will elaborate briefly on some of these points to draw out particular ways in which the architect has been innovative and how in some cases these may be used to substantiate the claim that Aleijadinho was responsible.

On each side of the church, in the central part of the external walls above the level of the corridors, there are three arches, which mark the distinction between nave, *Capela Mor*, and sacristy (Plate 117). However, it is the façade that most clearly shows the effort to integrate architectural and sculptural effects.

Where other churches had a window above the door, breaking through the entablature, here we find a roundel carved by Aleijadinho, with a relief showing the stigmatization[5] of Saint Francis, the patron saint of the chapel (Plate 118). This roundel was in the brief from the first contract of 1766. Aleijadinho seems to have added the elaborate decoration linking this to the doorway and the little bits of rocaille decoration around the lower edge of the roundel in 1774, since he is named as the author of the drawing of the doorway.

In managing the transition from the circular towers to the straight façade, the architect handled problems of architectural articulation that had not been attempted before in Minas Gerais (Plate 119). For example, the half-columns flanking the façade are set so that the entablature turns by 45°. The architect has used this idea to attach a fragment of pediment above the entablature which seems to project the eye into space, in an imaginary arc which continues the movement from the side.

Inside the *Capela Mor* is what appears at first sight to be a riot of ornament (Plate 112). Compared with most Baroque ornamentation in Brazil, however, there is a delicate touch, with the white painted wall showing through and a light tonality emphasized by large windows. The light tonality, and free, asymmetrical ornamentation that flows around the main motifs defines this decoration as Rococo rather than Baroque. The overall effect is what has come to be called the *estilo Aleijadinho* (Aleijadinho style).

Our belief is that Aleijadinho drew together in São Francisco what he had learned from his father and uncle about the traditional Minas Gerais exterior and interior, and what he had picked up about Baroque planning from São Pedro dos Clerigos and Nossa Senhora do Rosario, and mixed these with his own distinctive Rococo decorative style. The result has a dynamic quality about it, as if the church as a whole was moulded to a single idea, which we take to be a sign of integrated architectural composition.

São Francisco in São João del Rei

If São Francisco do Assis in Ouro Preto is the most developed example of the *estilo Aleijadinho*, a confirmation of Aleijadinho's ability to conceive complex architectural effects may be found in a drawing for the façade of São Francisco in São João del Rei that the twentieth-century art historian Germain Bazin (*Aleijadinho et la sculpture baroque au Brésil* (*Aleijadinho and Baroque Sculpture in Brazil*), 1963) and others have attributed to Aleijadinho (Plate 120). The drawing does not quite match the façade of the chapel of São Francisco in São João del Rei as built, which was completed in 1789 (Plate 121). This may

[5] The miraculous appearance of wounds in his feet, hands, and side replicating those of Christ on the Cross. The saint would have received these as a gift from God, showing identification with the suffering of Christ during the Crucifixion.

be explained by the fact that a local mason and entrepreneur, Francisco de Lima Cerqueira, took on the building contract and introduced a number of alterations in construction and in the execution of the decorative work. Although the general idea of the façade was based on São Francisco do Assis in Ouro Preto, the round towers are integrated more smoothly with the façade (albeit lacking some of the drama of the original). The roundel with the stigmatization of Saint Francis has been replaced by a circular window.

The plan of the church of São Francisco in São João del Rei incorporates two innovations: the oval nave is expressed externally in curving side walls, and the sacristy is moved to the side of the *Capela Mor*, avoiding the need for flanking corridors (Plate 122). When da Silva (see pp.149–50) declared in 1790 that this church was Aleijadinho's masterpiece, he may simply have been reporting his own or the most recent opinion. However, the church has a unity of conception linking plan and elevations that are seen in few other Brazilian churches and there is nothing to indicate that de Lima Cerqueira had either the experience or the aesthetic ambition to aim for these effects.

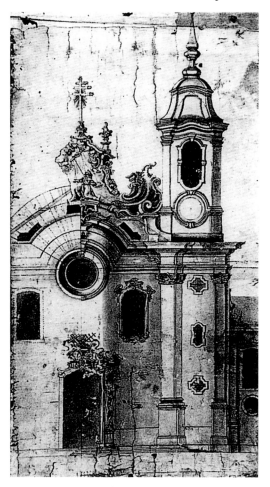

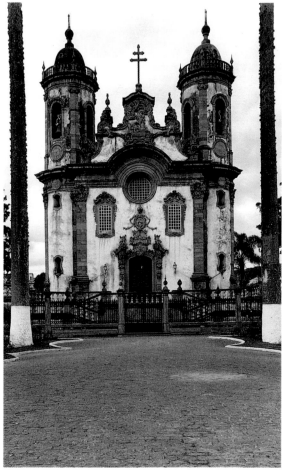

Plate 120 Aleijadinho, drawing for São Francisco, São João del Rei, Museo de l'Inconfidencia, Ouro Preto. Photo: from Germain Bazin, *Aleijadinho et la sculpture baroque au Brésil*, Paris, Le Temps, 1963, p.130.

Plate 121 Aleijadinho and others, São Francisco, São João del Rei, completed 1789, façade. Photo: Tim Benton.

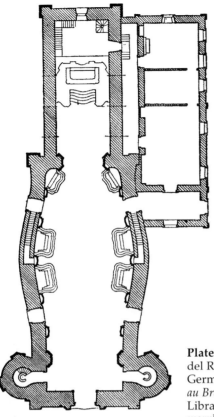

Plate 122 São Francisco do Assis, São João del Rei, completed 1789, plan. Photo: from Germain Bazin, *L'Architecture religieuse baroque au Brésil*, Paris, Éditions d'histoire et d'art Librairie Plon, 1956–8, vol.1, *Étude historique et morphologique*, figure 87.

The architectural debate

There has been a debate among European and North American historians about how to interpret Aleijadinho's originality. In 1952, Bury (see p.153) looked for the influence of the work of Italian Baroque architects in Portugal, such as Guarino Guarini's work in Lisbon: 'It is among eighteenth century buildings which follow Guarini's tradition in Piedmont, Austria, Bohemia and Southern Germany that there are to be found the closest parallels of the Estilo Aleijadinho churches of Minas Gerais' ('Estilo Aleijadinho and the churches of eighteenth century Brazil', p.99).

For Bury, therefore, sophistication in Brazilian architecture could be measured in part by its openness to European influences.

For Bazin, however, writing in 1956, the development of architectural styles in Minas Gerais was more self-sufficient. He explained the development of the oval plan and the use of curving walls as beginning with the interior decoration in Nossa Senhora do Pilar by Pombal, and reaching its high point in the mature style of Aleijadinho in São Francisco do Assis.

Pursuing a different line of argument in an article entitled 'Baroque et Rococo dans l'architecture de Minas Gerais' ('Baroque and Rococo in the architecture of Minas Gerais') in 1966, the art historian Yves Bruand argued that Aleijadinho was more of a sculptor than an architect. Bruand drew attention to Aleijadinho's qualities as a carver in works securely attributed to him such

as the façade of Nossa Senhora do Carmo (Plate 109). In such compositions, we may well be struck by the richness of the decorative sculpture and the subtlety of the effects.

Does this mean that we should agree with Bruand and see Aleijadinho essentially as a sculptor? To investigate this question, we will now turn to examples of Aleijadinho's free-standing sculpture and consider their formal qualities and their style.

Aleijadinho as sculptor

The first two works of free-standing sculpture to be linked to Aleijadinho by documentary evidence were for the confraternity chapel of Nossa Senhora do Carmo, Sabará. A payment to Aleijadinho of 50 oitavos for 'Saints' for the altars is dated 1778–9. Aleijadinho's wooden statue of Saint Simon Stock retains its original polychromy (Plate 123). The saint's face is represented in wide-eyed attention, as if at the moment of the vision of the Virgin Mary he claimed to have received. In the tradition of Iberian medieval and Renaissance sculpture, enamel eyes are used, and the treatment of the drapery is highly naturalistic. The expression is very striking, but, from a European perspective, the conventions used would have been considered archaic. For example, the curving line that joins nose to eyebrows (a device emphasized by the wrinkled forehead), which focuses our gaze on the eyes, would suggest a lack of familiarity with the more modern Baroque. It seems likely that Aleijadinho had no access to examples in the modern tradition. Such sculpture as he might have seen in Rio de Janiero would have tended to be conservative. Whereas architectural ideas might travel in the form of drawings or engravings brought by Portuguese immigrants, the more subtle effects of contemporary European Baroque sculpture could not be transmitted so easily. The work is best understood in stylistic terms as conforming to a European tradition and powerfully executed within that frame. It is open to debate whether Aleijadinho either could or should have adopted a more up-to-date style.

Plate 123 Aleijadinho, *Saint Simon Stock*, detail of head, 1778–9, Nossa Senhora do Carmo, Sabará. Photo: from Germain Bazin, *Aleijadinho et la sculpture baroque au Brésil*, Paris, Le Temps, 1963, p.175.

Aleijadinho's best-known work in sculpture is the series of 60 cedarwood figures representing life-size scenes from the Passion of Christ[6] and 12 soapstone figures of the prophets of the Old Testament, which he executed towards the end of his life for the pilgrimage church of Bom Jesus de Matosinhos, Congonhas do Campo (Plate 124). All over Europe there were pilgrimage churches of a similar type. Pilgrims progressed on their knees between shrines representing the Passion of Christ, in contemplation of the Crucifixion.

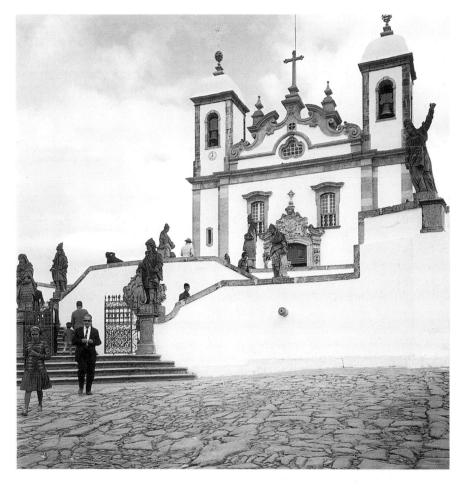

Plate 124
Bom Jesus de Matosinhos, Congonhas do Campo, 1796, exterior. Photo: Tim Benton.

In Congonhas do Campo, the pilgrimage route zig-zags up the steep hill towards the church (Plate 125). Six chapels were laid out along this route, each containing a scene of life-size polychrome statues in cedarwood. Judging from the very variable quality of craftsmanship, some of the figures were clearly made by Aleijadinho's assistants. It is likely that the figures of Christ, at least, were by Aleijadinho himself (Plate 126). The polychromy of these statues was carried out by professional painters. The concentration of expressive means on the head and hands can be explained partly by the fact that most sculptors' experience was formed by creating figures used for representing patron saints in processions, with arms and head articulated to

[6] The events immediately leading up to and including Christ's sufferings and death on the Cross, following the accounts in the gospels.

dramatize poses of benediction, prayer, or wonder. The sculptor's role, with these figures, was limited to the carving of the head, hands, and feet, and we know that Aleijadinho made several of these in his career. There are awkwardnesses arising from the conventions expected in processional figures, such as a tendency to set his faces in profile for maximum impact, and in the tradition of the public procession Aleijadinho mixed high tragedy with caricature and the grotesque (Plate 127). The fact that the Roman soldiers in these scenes were caricatured, with bulbous split chins and monstrous noses, has been interpreted as a dig at the Portuguese ruling classes (Plate 128).

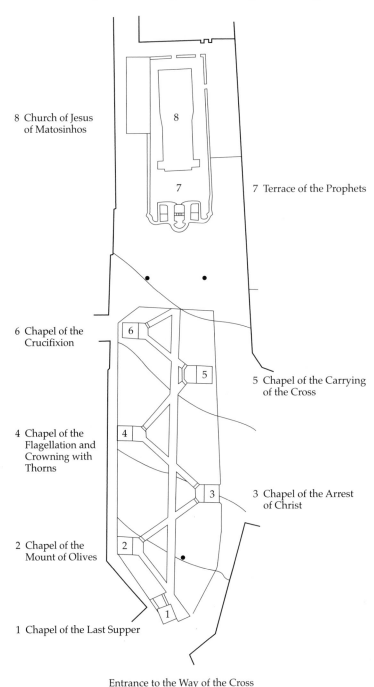

8 Church of Jesus of Matosinhos

7 Terrace of the Prophets

6 Chapel of the Crucifixion

5 Chapel of the Carrying of the Cross

4 Chapel of the Flagellation and Crowning with Thorns

3 Chapel of the Arrest of Christ

2 Chapel of the Mount of Olives

1 Chapel of the Last Supper

Entrance to the Way of the Cross

Plate 125
Plan of the pilgrimage route on the hill of Bom Jesus de Matosinhos, Congonhas do Campo. Photo: from Germain Bazin, *Aleijadinho et la sculpture baroque au Brésil*, Paris, Le Temps, 1963, p.222.

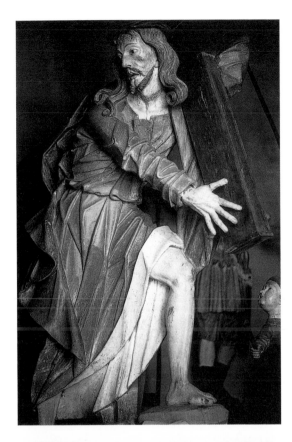

Plate 126 Aleijadinho, *Christ Carrying the Cross*, 1796–9, Bom Jesus de Matosinhos, Congonhas do Campo. Photo: Tim Benton.

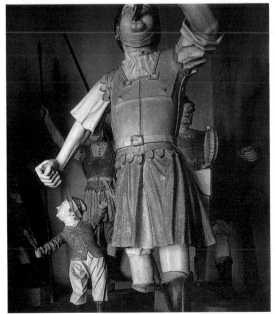

Plate 127 Aleijadinho, *Soldier and Child*, detail of *Christ Carrying the Cross* (Plate 126). Photo: Tim Benton.

Plate 128 Aleijadinho, *Roman Soldier*, detail of *Christ Carrying the Cross* (Plate 126). Photo: from Garciela Mann, *The 12 Prophets of Aleijadinho*, Austin and London, University of Texas Press, 1988, p.48. Photographs by Hans Mann. Copyright © 1967, renewed 1996. By permission of the University of Texas Press.

The 12 life-size soapstone figures of prophets that Aleijadinho carved for the flights of steps in front of the church belong to a medieval tradition in which the prophets of the Old Testament stand as witnesses to Christ's coming to take away the sins of mankind (Plate 129). Since medieval times, however, the prophets could also be interpreted as fierce critics of the status quo, preaching destruction to materialistic societies.

Other critics have commented on the errors (of proportion and anatomy) that can be found in these statues as evidence of Aleijadinho's limitations. For Father Júlio Engrácia: 'He [Aleijadinho] had no idea of human beauty, or wanted to reduce all these statues to his own defective body' (*Relação Cronológica do Santuário da Irmandade do Senhor Bom Jesus de Congonhas do Campo*).

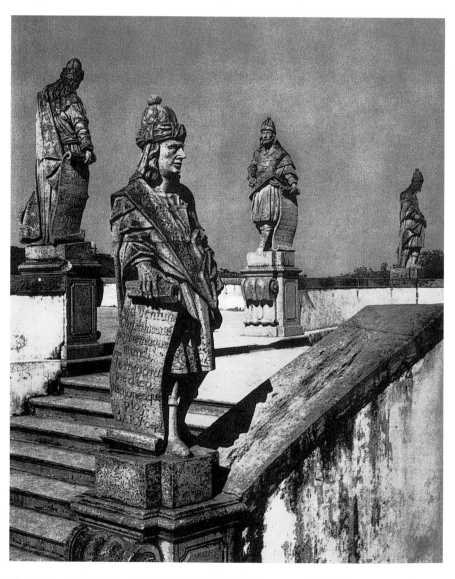

Plate 129 Aleijadinho, *The Prophets of the Old Testament*, 1800–5, Bom Jesus de Matosinhos, Congonhas do Campo. Photo: Tim Benton.

The use of public sculpture to make a grand rhetorical gesture in an architectural setting had been explored in Europe in the Baroque period by artists like the papal sculptor and architect Gian Lorenzo Bernini. Aleijadinho certainly captured the spirit of such work, but where he could have seen anything like it is not clear. For the source of the poses, clothing, and attributes of the prophets, Bazin has suggested a set of Florentine engravings of the 1470s. Some of the attributes of the prophets were fixed, in accordance with tradition, but there is a striking relationship between the unusual headwear of the figures and the Florentine engravings. The laurel wreath around Daniel's head follows precisely the example of the Florentine engravings and must have a western source. Aleijadinho also provided some curious features all his own. To accentuate the shadow-lines on the eyes, and perhaps to give an effect of age-old mystery, he rendered some of the faces in an almost Asiatic form, with long, slanting eyes (Plate 130). The sculptures as a whole have a kind of archaic power, which can best be compared to late medieval or early Renaissance European sculpture.

Our analysis has revealed Aleijadinho to be an exponent within a tradition, but also someone who pushed at the boundaries and expectations of his society to create his intensely powerful effects. In our view, any attempt to distinguish between his sculpture and his building designs overlooks the importance of historical context. In the eighteenth century, the skills of the sculptor merged with those of the architect and were often interchangeable. In the traditions in which Aleijadinho was educated, the carver and builder had interlinked training.

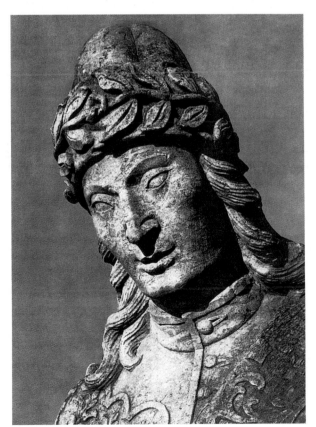

Plate 130
Aleijadinho, *Daniel*, detail of *The Prophets of the Old Testament* (Plate 129). Photo: from Garciela Mann, *The 12 Prophets of Aleijadinho*, Austin and London, University of Texas Press, 1988, p.93. Photographs by Hans Mann. Copyright © 1967, renewed 1996. By permission of the University of Texas Press.

Historical context

Despite his low standing as a 'mulatto' in a colonial society, Aleijadinho developed a prestigious reputation during his lifetime, not only as a craftsman but as an architect, someone whose ideas about how a building should look as a whole were valued. The most prestigious brotherhoods in Ouro Preto and the surrounding area competed for his advice and for the new look he could bring to their chapels. To understand how his artistic reputation and his low social standing interact, we must now look in more detail at his life and circumstances.

Aleijadinho was probably born in 1738, the illegitimate son of Manuel Francisco Lisboa, a recently immigrated Portuguese carpenter who had some success as architect, builder, and entrepreneur in Ouro Preto. We know that Aleijadinho was illegitimate because his father married a woman from the Azores in 1738, by whom he had three daughters and a son. Although the details of Aleijadinho's birth are not documented, it is known from eyewitness descriptions that he was of mixed descent. It follows almost certainly that his mother was born in Africa (probably Angola) and brought as a slave to Ouro Preto. Illegitimacy and mixed race were commonplace in Minas Gerais. By 1776, around half the 300,000 people in Minas Gerais were, or had been, enslaved Africans. Aleijadinho himself went on to father an illegitimate son, Manuel Francisco Lisboa, in Rio de Janeiro in 1776, whose mother, Narcissa Rodrigues da Conceição, was of mixed ethnic origin.

Rodrigo Brêtas, Director General of Public Instruction in Minas Gerais, wrote a memoir of Aleijadinho in 1858. He met Aleijadinho's daughter-in-law and knew other people who had met the artist. If his report can be relied on, Aleijadinho was:

> dark brown: he talked with a loud voice and in an exuberant way, his temperament irritable, his stature low, with an obese and badly shaped body, his face and head round and large, black curly hair, a vigorous beard, his nose regular and slightly pointed, thick lips, big ears and short neck.
>
> (Bazin, *Aleijadinho*, p.91)

All contemporary witnesses of Brazilian life obsessively record the darkness of people's skin and any features that could be connected with their ethnic origin. On the degree of 'blackness' depended a whole system of prejudice and legal restriction.

The cities of Minas Gerais relied on tradesmen, craftsmen, musicians, soldiers, labourers, and domestic servants born out of wedlock of Portuguese immigrant fathers and enslaved African women. Legislation prevented those of African descent from bearing arms except in segregated regiments in the militia, wearing European clothes, congregating in public (except on special feast days), serving in the clergy or in the civil administration, and, in practice, owning property.

Despite the prejudices of the ruling classes, however, the volatility of circumstances during the gold rush meant opportunities for those of mixed parentage to make money and establish reputations. Thus, some artists and musicians of African descent achieved a measure of fame and fortune. For example, Valentim da Fonseca e Silva (Master Valentine), whose mother was

of African lineage, was taken to Portugal as a child and returned to Rio to establish a successful career as a sculptor. The musician Domingos Caldas Barbosa went to Lisbon in 1775 and rose to be President of the Nova Arcádia Literary Academy, albeit not without suffering racist abuse.

According to Brêtas, Aleijadinho could read and write and may even have studied Latin. His signature and the many examples of his handwriting that have survived indicate a confident scribe. Da Silva recorded that Aleijadinho was taught to draw and paint by the coin engraver João Gomes Batista, who worked in the mint at Ouro Preto and had himself been trained in Lisbon. Clearly, it was important to these men of European descent to establish that Aleijadinho had 'civilized' and 'European' credentials, in order to understand how he mastered the idiom of Baroque and Rococo architecture and sculpture so well.

Aleijadinho's working conditions

To work as a carpenter or builder in Portugal or her colonies in the eighteenth century, it was necessary to register in a craft corporation and obtain a licence. The corporations were medieval institutions and were strictly craft based. Each elected a 'Judge' every year who had powers to control the trade, limit entry to the craft, and represent the craft to authority if necessary. In Minas Gerais, licensing was controlled by the Town Council, which could insist that only those with their own capital and labour force could qualify. Freed slaves and anyone thought to possess too high a proportion of African blood were excluded. In these conditions, most of the craftsmen of African descent who built the chapels and churches of Ouro Preto were forced to apply every six months for 'temporary licences' to practise their craft. Aleijadinho's father and his uncle were licensed as carpenters, but it seems that Aleijadinho was not officially licensed to practise in any of the craft corporations.

The licensing and commissioning processes do not always make it clear who was responsible for what. This fact alone may have fed alternative interpretations of Aleijadinho's work.

A licensed craftsman could be commissioned in a number of ways. In many cases, he would contract for specific tasks (normally decorative carpentry or fine joinery) and, as a man of capital, he could take on a sizeable building contract and subcontract others. Consequently, records of payment tell little about who carried out particular aspects of work on a project. Typically, however, the main entrepreneurs did not work to their own designs but to those of an 'approved plan'. Since the plan or sketch was rarely explicitly paid for, the role of architect is largely undocumented. Designs might come from masters in any of the crafts, from a priest, or even from a committee.

Two types of commission signified confidence in individuals as having the all-round expertise of an architect. The first was when experts were called on to give their opinions on competitive tenders, and the second was when experts were asked to assess that work carried out was to a standard and conformed to the plans. It is possible, therefore, to establish who was regarded as competent in what we would now call 'architecture', but more difficult to establish who made the architectural designs for any one building. In the case of Aleijadinho, we have evidence of him operating at several levels of competence: making drawings, carrying out sculptural decoration, and acting

as assessor of the work of others. Drawings have been attributed to him that show understanding of architectural syntax (Plate 120). The documentary evidence suggests, therefore, that Aleijadinho was not barred from any of the 'architectural' roles in the design of buildings, but only from acquiring overall building contracts.

He was also barred on ethnic grounds from the two richest brotherhoods (those of São Francisco do Assis and Nossa Senhora do Carmo). Paradoxically, Aleijadinho did some of his best work for these brotherhoods.

Those of African descent could also found their own brotherhoods, such as the brotherhood of Nossa Senhora do Rosario dos Pretos (Our Lady of the Rosary for Blacks), and build elaborate chapels, often commissioning architects of Portuguese descent in the process (Plates 106 and 107). These brotherhoods also afforded some status to craftsmen excluded from the craft corporations; Aleijadinho belonged to the Brotherhood of Saint Joseph, reserved 'for blacks' (*dos pardos*), and served as its President for one year.

As noted at the outset, much of the significant architectural work in Ouro Preto was sponsored by the brotherhoods. The artistic views and expectations, ethnic attitudes, and wealth of these powerful patrons need to be included in any account of Aleijadinho's work. Similarly, the way these patrons wanted their buildings to be used (for example, for grand funerals and festive processions) also helps us understand the dramatic and theatrical effects they commissioned.

Historiography

The historiography of Aleijadinho's celebration as a Brazilian national hero began 44 years after his death when Brêtas wrote his biography of the artist (1858). Although Brêtas shows great sympathy and admiration for his subject, as a government official he betrays many of the assumptions regarding ethnicity and ideas of genius characteristic of his class and origin. For example, Brêtas attributed Aleijadinho's illness to a venereal condition promoted by youthful excesses, perhaps assuming that Aleijadinho's 'black blood' or his artistic temperament made him vulnerable to such temptations. Aleijadinho seems to have died destitute, despite the fact that he was described during his lifetime by da Silva as the 'Praxiteles' of Vila Rica (a comparison with 'the best' art of Greece that is itself revealing of western bias). Brêtas explains this by saying that he was robbed by clients and shared everything with his two African slaves. It is possible that Brêtas thought of this, too, in essentialist terms, as characteristic of Aleijadinho's ethnic origin.

By the end of the nineteenth century, Ouro Preto was at the margins of Brazilian economic, intellectual, and social life and scholars began to reconstruct the history of Minas Gerais during its 'golden age' in the eighteenth century. Motivated by the desire to conserve the vanishing archaeological heritage, a law was passed in 1920 protecting sites and monuments of interest. In 1933, the whole town of Ouro Preto was declared a national monument and Brêtas's biography was republished with an explanatory introduction. In 1936, a government department was founded with the aim of documenting Brazil's heritage. Volunteer researchers combed

the archives to reconstruct the history of the brotherhoods. The effect of this work was to celebrate the achievements of Aleijadinho above those of his contemporaries.

At this time, when the Brazilian President Vargas was moving towards alignment with European Fascism, nationalist writers took sides on the issue of the dependence of the 'Brazilian character' on the 'immoral miscegenation' of the pioneer generations. Some writers saw the emergence of the nation as a struggle to exorcize the multiracial features of the eighteenth century and to celebrate the supremacy of the 'white' ruling class. For José Mariano Filho, writing in 1947, it was inconceivable that Aleijadinho could have been an architect, comparable to 'sophisticated' Portuguese and Italian architects of the period. Filho accused archivists of constructing a myth about Aleijadinho. For Filho, Aleijadinho could only have been a talented decorative sculptor, whose intuitive and 'barbaric' skill was perfectly suited to the sculptures at Congonhas do Campo, but who could not have designed the churches of São Francisco do Assis in Ouro Preto or São Francisco in São João del Rei.

In 1962–3, another Brazilian writer, Augusto de Lima Junior, denied the existence of Aleijadinho altogether. According to Lima Junior, Brêtas was an impostor who had invented the evidence of da Silva: in his view, there was no 'mulatto cripple called António Francisco Lisboa'. Instead, he identified 'António Francisco Lisboa' as a Portuguese entrepreneur who was a member of the brotherhood of Saint Francis. Bazin showed that such accusations were based on misreading of documents.

These attacks on the fame of Aleijadinho were probably made in reaction against *The Masters and the Slaves* (1933) by the historian Gilberto Freyre. In this book, Freyre argued that 'the first forcefully creative artistic expressions' of Brazil had been largely the result of 'our mixed blood' (*The Masters and the Slaves*, p.295).

For Freyre, Aleijadinho was a significant figure in the development of Brazilian national identity. He wrote:

> Aleijadinho, the mulatto sculptor of the colonial churches of the eighteenth century … was one of the few artists who emerged with a socially significant artistic message and a technique notable for its creative impulse, for its audacity and for its non-European characteristics at a time when there predominated, in Brazil, an academic literature and an art of strict imitation and copy … He worked with the help of faithful black slaves. And it is easy to see how significant were the material and social conditions which favoured the technically non-European and socially and psychologically anti-European qualities of his sculptures. If I interpret his work correctly, it can be said of him that he was, and still is, an expression of revolt against the social situation and the desire of the Brazilian, 'native' and mulatto, to liberate himself from the slave labour for white or European masters, and royal explorers.
>
> (*Interpretação do Brasil*, pp.280–1, trans. T. Benton)

According to Freyre, the figures of Roman soldiers made by Aleijadinho for Congonhas do Campo were caricatures of European officials, immoral clerics, and merchants exploiting the people. And he associated Aleijadinho with a tradition of satiric poems, lampoons, and practical jokes with which 'Brazilians' (that is, those locally born, of whatever ethnic origin) tormented newly arrived Portuguese officials.

Aleijadinho's achievements were interpreted differently by scholars of different periods and backgrounds. In what ways do his ethnicity and environment appear to have been related to opinions of his work as an architect?

Discussion

For colonial contemporaries or near contemporaries, Aleijadinho was to be celebrated as a famous architect and sculptor, already talked about by foreign visitors. Although Brêtas's account is consistent with a racial stereotype, this did not appear to diminish his opinion of Aleijadinho's worth.

For later European and North American architectural historians, Aleijadinho's colour was not an explicit issue at all, but his colonial status raised the question of whether he was influenced by European work or whether he created his own style from local sources.

The reaction in the twentieth century against the celebration of Aleijadinho's fame can be explained in part by the fact that architecture had come to be considered a more 'sophisticated' and intellectual skill than sculpture. For some Brazilian authors, it seemed difficult to envisage a 'second-class' citizen like Aleijadinho mastering this difficult art (with its connotations of conceptual complexity).

◆◆◆

Conclusion

Aleijadinho clearly had the skills and some of the knowledge to emulate the most subtle examples of Baroque and Rococo architecture, but he must also have been obliged to invent for himself many of the most impressive solutions in his buildings. As a sculptor, since he lacked any first-hand experience of top-quality European Baroque sculpture, he was forced to invent his own style. He took conventions based on the old-fashioned examples he might have seen in Rio de Janeiro and gave them the dynamic movement that the Baroque style required. His decorative sculpture is particularly successful in this respect, in that he could manipulate the semi-abstract forms with complete freedom. For a historian used to the conventions of European architecture, Aleijadinho's work can be understood and appreciated without any knowledge of local conditions. I find it difficult to see any evidence in his work of those African cultural traditions that Brazilian scholars have noted in other media (music, sculpture, and dances). The problems Aleijadinho has caused twentieth-century Brazilian critics seem mostly to have stemmed from the circumstances of evolving Brazilian national consciousness. Nevertheless, an understanding of the conditions in which Aleijadinho worked and his relative isolation may help to explain the daring of his formal expression. Judgements of value are not made in a void. For example, like Lúcio Costa and Oscar Niemeyer, two of Brazil's leading modern architects, I consider Aleijadinho to be a highly inventive and original architect. For them, his originality lies in his distinctive difference from the architecture of the colonizing power. My delight in his work is accentuated by the recognition of European forms in his buildings, in a countryside and in historical conditions that are very remote from my own. It is perfectly valid, and indeed

enriching, to criticize work from different perspectives. The historian must be careful not to read into an artist's work characteristics simply because they seem to fit with what is known about the artist's life and times or elements for which our own culture predisposes us to look. Aleijadinho's work survives analysis from many different perspectives because there is enough complexity and richness in it to defy over-simple explanations.

References

Bazin, G. (1963) *Aleijadinho et la sculpture baroque au Brésil*, Paris, Vevey.

Brêtas, R.J.F. (1858) 'Traços biográficos relativos ao finado António Francisco Lisboa', *Correio Oficial de Minas*, nos. 169 and 170.

Bruand, Y. (1966) 'Baroque et Rococo dans l'architecture de Minas Gerais', *Gazette des Beaux-Arts*, vol.67, pp.321–38.

Bury, J.B. (1952) 'Estilo Aleijadinho and the churches of eighteenth century Brazil', *Architectural Review*, vol.115, February, pp.93–100.

Engrácia, Padre J. (1908) *Relação Cronológica do Santuário da Irmandade do Senhor Bom Jesus de Congonhas do Campo*, São Paulo.

Freyre, G. (1947) *Interpretação do Brasil*, São Paulo.

Freyre, G. (1971) *The Masters and the Slaves: A Study in the Development of Brazilian Civilization*, trans. S. Putnam, New York, Alfred Knopf.

Smith, R.C. (1939) 'The colonial architecture of Minas Gerais in Brazil', *Art Bulletin*, vol.21, no.1, pp.111–59.

Preface to Case Study 7:
Independence from Empire and an
international style

CATHERINE KING

In Case Study 6, we looked at the way in which the art of Aleijadinho was interpreted as evidence that new world artists could vie with those of the old world. We saw that in commissioning and instructing artists to make civic and ecclesiastical buildings, the patrons of Minas Gerais opted for styles that were transformations of styles and genres derived from the art of the European colonizers. We learned that the testimony of a contemporary civic official shows that Aleijadinho, in spite of his lowly hybrid status, was compared with an ancient Greek sculptor, indicating the superlative quality of his work. The striving for exquisite results evident in Aleijadinho's buildings and the powerful dramatic expressiveness in his sculpture suggest an artist developing in inventive ways genres taken over from European-based traditions. Although, as Tim Benton shows, Aleijadinho's work has been associated with early movements for Brazilian independence, these associations are unproven, not least because no textual evidence of Aleijadinho's aims and views has so far been discovered.

In Case Study 7, we move to consider a society in India *c*.1900–*c*.1930 in which, in contrast, the issue of seeking political independence from the British government was overt and was focused on the creation of a new nation. The debate about how best to create art for a new society entailed questioning whether and how a new art could be 'Indian', and what its relation should be to new, and older, art practices in Europe.

In this case study, we consider the art made by Rabindranath Tagore from *c*.1928 onwards. In doing so, we will be looking at an artist who took an internationalist approach, which urged exchange of views between 'East' and 'West', rather than eastern boycott of western artistic traditions. At the same time, we will refer to other contemporary practices, including the use of styles relating to past art, which were designated as 'Indian' and identified with nationalism. A key issue to consider in retrospect is the extent to which it was possible for artists to produce critiques of the unequal relations between colonizers and colonized in India that were not themselves in some sense products of that relationship. This phenomenon has been analysed most influentially by Edward Said in *Orientalism*. Said defined 'Orientalism' as a key discourse of imperialism, whose basis 'is the ineradicable distinction between Western superiority and Oriental inferiority', and which 'influenced the people who were called orientals as well as those called occidental' (*Orientalism*, p.42). Thus, the colonial scholars who had written the history of 'Indian' art (such as those considered in Case Studies 2–4) provided the data towards which some patriotic artists turned to find emblems of cultural autonomy. In this case study, we look at the way in which Tagore too was positioned by imperialist assumptions (here, of spiritual 'East' and scientific 'West'), even as he urged artists, educationalists, and writers to close the supposed divide, and learn from one another.

Rabindranath Tagore: making modern art in India before Independence

CATHERINE KING
WITH NICOLA DURBRIDGE

Rabindranath Tagore and the Tagore family

Rabindranath Tagore (1861–1941) was born into a prominent landowning family of scholars and artists in Calcutta, who had played a key role in the Bengali Renaissance – the creation of a rich body of poetry, novels, and drama in the Bengali language in the first half of the nineteenth century. These works were felt to recapture the quality of ancient Indian literature, while adapting western genres. The Tagores had gone into business with a British colonial partner (see Robinson, *The Art of Rabindranath Tagore*, p.116). The name 'Rabindranath' means 'sun lord', whilst 'Tagore' is an anglicization of 'Thakur', an honorific name given to Brahmins: that is, families belonging to the caste from which priests could be derived. However, the Tagore family had lost priestly status through having been tricked into eating beef,[1] and as a consequence of this pollution its members were designated 'Pirali Brahmins'. The writer Shrimati Lila Ray suggested (1967) that the family's experience as an ostracized minority contributed to its openness to contact with the colonizers' culture and commerce (*Formative Influences in the Life of Rabindranath Tagore*, pp.13–14). Tagore was educated at the Bengal Academy and at Saint Francis Xavier's School, both in Calcutta, as well as by tutors in his home and by his father. He built on family tradition, writing poems, music, plays, and novels in Bengali, which were read around the world in translation. His success and productivity were both great. Indeed, he is credited with authoring 100 books and 2500 songs over six decades. In 1901, Tagore founded his own school – the Shantiniketan School (the name means 'the abode of peace') – at his country estate at Birbhum, north-west of Calcutta. This became a university in 1921, providing Tagore with a prestigious academic base from which to speak. In 1913, he was the first non-European to receive the Nobel Prize for Literature. He was knighted by the British in 1914, although he revoked the title in 1919 following the massacre at Amritsar.[2]

Tagore's lecture tours

Tagore was exceptionally well informed about a variety of cultures, as a result of the regular world-wide lecture tours he undertook from 1912 onwards, during which he raised funds for his school and university. On these lecture tours, he created a reputation as a revered teacher on matters of culture, politics, and education, reaching out beyond the limits of British imperial control.

[1] The cow is a sacred animal in the Hindu religion.

[2] Amritsar, a city in north-west India, is the centre of the Sikh faith. On 13 April 1919, British government troops fired on a political gathering there, killing and wounding Indian civilians.

Tagore argued that, while the West could offer India science and its discoveries for human welfare, the East had a special religious gift to offer the West, for it was 'India's mission to realize the truth of the human soul in the supreme soul': 'Because we have faith in this universal soul, we in the East know that Truth, Power, Beauty, lie in simplicity – where it is transparent, where things do not obstruct the inner vision' (*Personality: Lectures Delivered in America 1917*, pp.138, 25). In some ways, therefore, he reinforced the imperialist discourse of the mysterious East with its spiritual secrets so different from the rational West.

Nevertheless, Tagore spoke as an authority in correcting western misunderstandings:

> We have often heard the Indian mind described by western critics as metaphysical, because it is ready to soar into the infinite. But it has to be noted that the infinite is not a mere matter of philosophical speculations to India; it is as real to her as the sunlight.
>
> (*Personality: Lectures Delivered in America 1917*, p.26)

Indians did not see him as taking a subordinate position in the East/West exchange. As Ramananda Chatterjee, editor of a Calcutta journal entitled *The Modern Review*, wrote in the volume honouring Tagore on his seventieth birthday in 1931: 'His hands reach out to the West and the East to all humanity, not as those of a suppliant but for friendly grasp and salute' (*The Golden Book of Tagore*, p.vii).

Significantly, Tagore called his university 'Vishva Bharati' meaning 'The centre of learning for the whole world' (*The Golden Book of Tagore*, p.305). There, he invited all equally to pursue the study of comparative religion. As Chatterjee reported: 'He wants that there should be no racialism, no sectarian and caste and colour prejudice in his institution' (*The Golden Book of Tagore*, p.ix).

Beginning to paint

Tagore started painting in 1928 when he was 67 and produced over 2000 paintings before his death in 1941. He used ink on paper – a medium declaring his professional identity as a writer. His initial pictures were developed, in fact, from doodles covering erasures he had made when he was writing. He had no formal artistic training and he used his pen, his fingers, a twig, or a rag to make his images. He claimed that he avoided representing from life and never started with a preconceived idea.

Have a look at some of Tagore's pictures (Plates 131–136). Write down your responses. What do these images make you feel or think? What elements does the artist prioritize – for example, textural and tonal qualities; composition; or detail?

Plate 131
Rabindranath
Tagore, *Untitled*,
ink and
watercolour on
paper,
24 x 31.8 cm,
Rabindra Bharati
Society, Calcutta,
Acc 2203.
© Vishva Bharati
University. Photo:
by courtesy of
Andrew
Robinson.

Plate 132
Rabindranath
Tagore, *Untitled*,
ink on paper,
25 x 20.4 cm,
Rabindra Bharati
Society, Calcutta,
Acc 2206.
© Vishva Bharati
University. Photo:
by courtesy of
Andrew
Robinson.

Plate 133
Rabindranath
Tagore, *Untitled*,
ink on paper,
21.8 x 27.5 cm,
Rabindra Bharati
Society, Calcutta,
Acc 2137.
© Vishva Bharati
University. Photo:
by courtesy of
Andrew
Robinson.

Plate 134
Rabindranath
Tagore, *Untitled*,
ink and
watercolour on
paper,
48 x 60.8 cm,
Rabindra Bharati
Society, Calcutta,
Acc 1900.
© Vishva Bharati
University. Photo:
by courtesy of
Andrew
Robinson.

Plate 135 Rabindranath Tagore, *Untitled*, 1936, ink on paper, 56 x 38.5 cm, K.B. Acc 387. © Vishva Bharati University. Photo: by courtesy of Andrew Robinson.

Plate 136 Rabindranath Tagore, *Untitled*, ink on paper, 50 x 29.5 cm, Rabindra Bharati Society, Calcutta, Acc 1955. © Vishva Bharati University. Photo: by courtesy of Andrew Robinson.

Discussion

There seems to be an emphasis on different textures: these sometimes appear rough and unpolished as though they are sketches for carved reliefs. The images also seem to stress simplified forms, whether curved or geometrical, rather than detail. Subtle shading and linear perspectival constructions appear to have been ignored: such elements would be unlikely in unplanned works. Sometimes the effects are ugly or comic, and often they are bleak. (Even when inks from a wider colour palette are used, the hue is of overall blackness.) Tonal variation is also restricted, for bold effects. Although the images sometimes refer to known objects and creatures, the aim of the unplanned works seems to be to suggest a mood, or invite the viewer to explore a mood.

◆◆◆

Plate 135, which introduces perspective, differs from the others in being a work consciously based on French Impressionist art that Tagore had seen. It is dated 1936 and represents a change in terms of the development of much more control and planning in his works. In 1930, there were thirteen exhibitions of Tagore's paintings, and from then on, every few years, his work

has been shown, not only in India but also in North and South America, the Soviet Union, Malaysia, Japan, France, Italy, Sri Lanka, Switzerland, Pakistan, and the United Kingdom. Whereas the work of Aleijadinho was ignored, after his initial success, for half a century, Tagore's paintings have been kept in the public eye continuously since he began painting.

Pause for a moment and think how the social and artistic statuses of the two artists compare.

Discussion

Like Aleijadinho, Tagore was the subject of European colonizers, and as such was in an inferior position. Aleijadinho was treated as an impure hybrid and, with some parallel, the Pirali Brahmins were regarded as impure because they had polluted themselves and fallen from the high Brahmin caste. However, partly by building on the social and cultural status of his family, Tagore had obtained a reputation as a world-class modern poet and an advisor to the modern world, which enabled him to launch his career as a modern artist. Aleijadinho's fame was, in contrast, confined during his lifetime to his home area.

◆◆

Tagore explained that he had begun making art when he started to beautify the erased words in his pages of manuscript while composing poetry. In an article entitled 'My pictures', published in *The Modern Review* in December 1930, he wrote:

> One thing which is common to all arts is the principle of rhythm which transforms inert materials into living creations. My instinct for it and my training in its use led me to know that lines and colours in art are no carriers of information, they seek their rhythmic incarnation in pictures. Their ultimate purpose is not to illustrate or to copy some outer fact or inner vision, but to evolve a harmonious wholeness which finds its passage through our eyesight into our imagination. It neither questions our mind for meaning nor burdens it with un-meaningness, for it is, above all, meaning.

> Desultory lines obstruct the freedom of our vision with the inertia of their irrelevance For this reason the scattered scratches and corrections in my manuscripts cause me annoyance. They represent regrettable mischance, like a gapingly foolish crowd stuck in a wrong place undecided as to how or where to move on. But if the spirit of a dance is inspired in the heart of that crowd the unrelated many would find a perfect unity and be relieved of its hesitation between to be and not to be. I try to make my corrections dance, connect them in a rhythmic relationship and transform accumulation into adornment.

> This has been my unconscious training in drawing. I find disinterested pleasure in this work of reclamation, often giving to it more time and care than to my immediate duty in literature that has the sole claim upon my attention, often aspiring to a permanent recognition from the world. It interests me deeply to watch how lines find their life and character as their connection with each other develops in varied cadences and how they begin to speak in gesticulations

> In the manuscript of creation there occur erring lines and erasures, solitary incongruities, standing against the world principle of beauty and balance, carrying perpetual condemnation. They offer problems and therefore material to the *Visvakarma*, the Great Artist, for they are the sinners whose obstreperous individualism has to be modulated into a new variation of universal concord.

And this was my experience with the casualties in my manuscripts, when the vagaries of the ostracized mistakes had their conversion into a rhythmic inter-relationship, giving birth to unique forms and characters. Some assumed the temperate exaggeration of a probable animal that had unaccountably missed its chance of existence, some a bird that only can soar in our dreams and find its nest in some hospitable lines that we may offer it in our canvas. Some lines showed anger, some placid benevolence, through some lines ran an essential laughter that refused to apply for its credential to the shape of a mouth which is a mere accident. These lines often expressed passions that were abstract, evolved characters that hung upon subtle suggestions. Though I did not know whether such unclassified apparitions of non-deliberate origin could claim their place in decent art they gave me intense satisfaction and very often made me neglect my important works.

('My pictures', pp.603–4)

This is a condensed piece of writing, but, re-reading it, can you pick out the salient points in Tagore's attempt to explain how he came to make art and how he perceives the content of his work?

Discussion

Tagore proposes rhythm as the core principle of art and sees art as making order and formal unity out of randomness. He emphasizes that the purpose of using lines and colours is not to represent either an 'outer fact' (an object we could recognize as having been imitated) or an 'inner vision' (a precise thought or idea). Rather, the form of the lines and the colours creates a 'harmonious wholeness', which *is* the meaning. He may create 'unique forms', which assume the 'exaggeration of a probable animal', or suggest 'passions that were abstract' (anger, laughter), but Tagore rejects the idea that his lines and colours are 'carriers of information'. He understands them rather as a 'rhythmic incarnation' purposefully seeking out a meaningful existence through interconnection. Rhythm in this view is a dynamic force with a life of its own; Tagore can 'watch how lines find their life and character' and his images can evolve unplanned ('apparitions of non-deliberate origin').

Tagore uses the word 'adornment' of his work and gives it a highly positive meaning. 'Adornment' appears to describe the ultimate achievement, given his conception of the significance of rhythm in art; it refers to 'rhythmic connections', which constitute the 'perfect unity' that is his art. While clearly delighting in the wordless meaning of these transformations, he is nevertheless somewhat diffident about their status: perhaps they are not 'decent art'? He indicates that they make him neglect the writings that form 'my important works'. At the same time, he suggests a comparison between the way 'erring lines' offer 'problems and therefore material' on a human level, and the way the universe works, as the 'Great Artist' goes about creating harmony out of the incongruities of the cosmos.

❖❖

Tagore stated that he had been encouraged when he had shown his work in 1928 to the Argentinean poet Vittoria Ocampo, but, talking to the Royal India Society in London in 1930, he said that he had been diffident about the merit of his paintings until he came to Europe and found them warmly praised by 'some artists whom I chanced to meet in the South of France' (Archer, *India and Modern Art*, p.72).

From manuscript designs to modern art

It has been suggested that Tagore was encouraged to develop his unplanned manuscript designs as a result of encountering European interest in abstract art and similar non-deliberative ways of achieving images. As the art historian Ratan Parimoo has pointed out (1989), he was able to see the work of artists who used these methods, such as Paul Klee, on his lecture tours during the 1920s. In 1921, he had visited Paris, Berlin, and Weimar. On his invitation, the Bauhaus group[3] based at Weimar mounted an exhibition in Calcutta in 1922, where paintings by Wassily Kandinsky (*Creation*) and Klee (*Passing Through an Open Door*) were displayed (Parimoo, *Rabindranath Tagore*, pp.35–8). In 1959, the art historian William Archer and, later, Parimoo also noted that there was discussion of these methods in Indian journals. For instance, in 1917, an article in *The Modern Review* considered the use of random writing or doodling to release images from the subconscious, which was called 'automatism' by its European exponents, the Surrealists[4] (Parimoo, *Rabindranath Tagore*, p.34; Archer, *India and Modern Art*, p.56). Parimoo also pointed out that some of Tagore's pictures resembled designs produced by the indigenous peoples of the Americas, both before colonization (pre-Columbian pottery) and afterwards (Inuit carvings). Tagore had seen these on his lecture tours and Parimoo suggested that he wished, like some contemporary European artists, to pay tribute to the skills in abstract form developed by 'primitive' peoples. He 'could perhaps be regarded as the first Indian painter to have been aware of the qualities of primitive art' (Parimoo, *Rabindranath Tagore*, pp.39–40). The very fact that he was relatively untrained could have encouraged him, since some European artists at this time claimed that art that appeared untutored in European representational skills was to be admired. There is evidence of Tagore's interest in 'automatism' from his theoretical stance on education. He believed in the importance of the subconscious for teaching children: 'Their subconscious mind is more active than their conscious one, and therefore the important thing is to surround them with all kinds of activities which could stimulate their minds' ('My school', p.2).

Tagore's views on the benefits of internationalism meant that he looked positively on artistic interchange. In 1926, in a lecture entitled 'The Meaning of Art', he argued that societies could no longer live in narrow confines:

> There was a time when the human races lived in comparative segregation and therefore art adventurers had their experience within a narrow range of limits, deeply cut grooves of certain common characteristics. But today that range has vastly widened, claiming from us a much greater power of receptivity.
>
> (Archer, *India and Modern Art*, p.55)

Writing more intimately (to the educationalist Charles Freer Andrews on 13 March 1921), Tagore maintained that he could not be hostile to western art. He described an American art critic who had told him how much he

[3] German school of art and architecture (1919–33), which advocated closer links between technology and art and design.

[4] Members of a movement in French art and literature (1919 onwards), who believed in drawing on the subconscious for inspiration, rejecting reason and preconceptions.

hated 'Indian pictures', but ended by saying that although he felt he should have retaliated he could not do so: 'I always try to understand western art and never hate it' (Andrews, *Letters from Abroad*, p.105).

He also argued that human creativity knew no topographical boundaries, since it was the manifestation of a cosmic power. In *Glimpses of Bengal* (1921), he wrote:

> Whatever I truly think, truly feel, truly realise – its natural destiny is to find true expression. There is some force in me which continually works towards that end, but is not mine alone – it permeates the universe. When this universal force is manifested within an individual, it is beyond his control and acts according to its own nature; and in surrendering our lives to its power is our greatest joy.
>
> (Archer, *India and Modern Art*, p.50)

Tagore was interested in learning from elements of European art that fell outside the confines of ideas sifted by British rulers for Indian consumption. As he wrote to Andrews from Paris (on 19 September 1920):

> I admit that the light of Europe's culture has reached us. But Europe, with its corona of culture is a radiant idea. Its light permeates the present age; it is not shut up in a single bull's eye lantern, namely some particular people from Europe who have come to us in India.
>
> (Andrews, *Letters from Abroad*, p.23)

This letter explains, I suggest, why Tagore might have enjoyed telling the Royal India Society in London that he had not been confident of his abilities until he received the praise of artists, not in Britain, but in France.

Modern art in Bengal *c.*1900–*c.*1930

Although Tagore was untutored in technical terms, his decision to paint was taken with considerable knowledge of the cultural politics of art in India. Members of his family had played important roles as patrons during the previous century. Their grand house at Jorasanko in Calcutta had been built in the style of an Italianate Renaissance villa, adorned with matching classicizing sculpture and paintings by artists who used European representational conventions. Members of his family had founded journals carrying art criticism, and he had contributed articles on art criticism himself. He had invited artists as guests and as art teachers to Shantiniketan, while his brother and two nephews had trained as artists in the Calcutta School of Art. Indeed, his brother Jyotindra had been trained as a portrait painter, working in the realist styles being taught at this school until the turn of the century.

The 'academic realist' style, as the art historian Tapati Guha-Thakurta has termed it (1992), came increasingly from 1900 to be represented by Indian observers as spineless dependence on colonizers' ideas. For instance, in reviewing the Government School of Art Exhibition at Calcutta in 1930, Suniti Kumar Chatterji castigated the 'dull lifelessness of essays by Indian artists in the European or pseudo-European style' ('The Government School of Art Exhibition', p.226). However, Guha-Thakurta has pointed out that a taste for western art was a major status symbol in the second half of the nineteenth

century among the members of the new Bengali aristocracy, such as the Tagore family, who also 'cultivated local literature, learning, music and religion' (*The Making of a New 'Indian' Art*, p.49). During the earlier part of Tagore's career, an academic realist style could be regarded approvingly by those of nationalist sentiment as worthy of appropriation by Indians, since it could be seen as expressing the ideas and values of epic Sanskrit literature and Hindu mythology. It was from this perspective that, writing in Bengali, Tagore reviewed examples of such styles enthusiastically in 1900 (Guha-Thakurta, *The Making of a New 'Indian' Art*, p.111). Nationalist readings of academic realism are interesting: they signal the possibility that a colonized people may devise and articulate its own perspective on a contemporary art practice – one to which it has contributed. So, despite the pre-eminence of colonial orthodoxy in artistic matters (the colonial presence dominating the patronage of art as well as its teaching institutions, exhibitions, and journals), the colonized in this instance were able to find their own voice and use it.

A dramatic shift in perspective took place in the decade 1900–10, however, when Indian audiences turned against what they now dubbed 'imported realism'. One of Rabindranath Tagore's nephews, Abanindranath Tagore (1871–1951), took a leading role in a new movement. This proposed a fresh route to producing a national style of modern art suited to the political independence for which nationalist movements were by then openly working. This style is variously termed New Indian Art or the Indian Revivalist or Neo-Bengali style and was encouraged and enabled by the patronage of the Principal of the Calcutta School of Art, Ernest Havell. Havell reformed the School's curriculum to make exemplars of pre-colonial Indian art the basis of instruction. Artists turned to past art forms of the subcontinent – such as the pictorial modes of Ajanta, Mughal, and Rajput painters – as well as to contemporary folk art, all of which were supposedly untouched by westernization (Plate 137). Although other areas in the subcontinent were also experimenting, it was the Neo-Bengali style that came to be most closely associated with a new phase of nationalist direct action.

The search for an art to express native autonomy through boycotting colonizers' imported styles coincided in 1903–8 with the political movement to refuse foreign imports at its peak. In 1913, Coomaraswamy and a convert to Hinduism, Margaret Noble, who played a central role in the Indian nationalist movement, published a book entitled *Myths of Hindus and Buddhists*. They commissioned exponents of New Indian Art under the supervision of Abanindranath Tagore to produce all the illustrations in styles that recalled the Rajput painting that Coomaraswamy was then collecting and researching for his book *Rajput Painting* (see Case Study 3). *Myths of Hindus and Buddhists* included a painting by K. Venkatappa of Rama sending his signet ring to his wife Sita by means of the messenger monkey Hanuman (Plate 138).

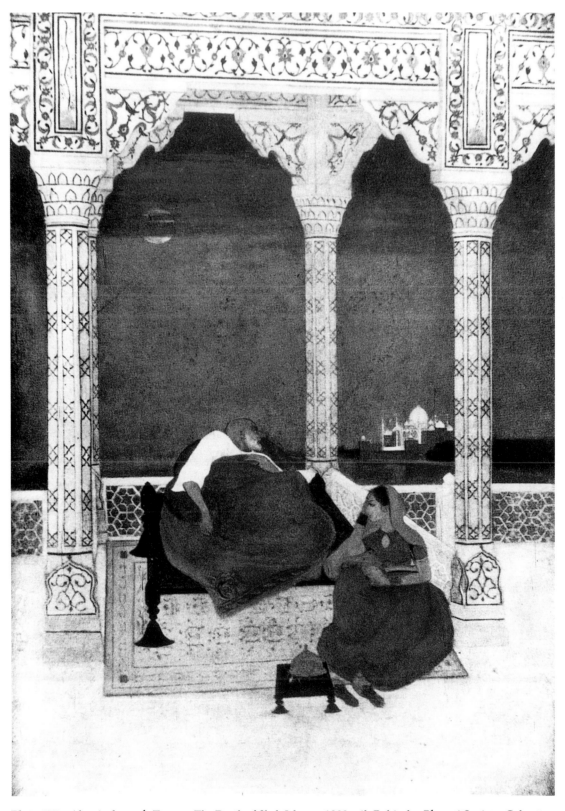

Plate 137 Abanindranath Tagore, *The Death of Shah Jehan*, *c*.1900, oil, Rabindra Bharati Society, Calcutta.

Plate 138 K. Venkatappa, *Rama Sends his Signet Ring to his Wife Sita by means of the Messenger Monkey Hanuman*, 1913, printed on Japanese vellum, number 75 of 75 copies, from A.N.K. Coomaraswamy and M. Noble, *Myths of Hindus and Buddhists*, London, George Harrap, 1913, plate VI, opp. p.64. Photo: by courtesy of the Trustees of the British Library, London.

Look back to the plates in Case Study 3 and try to decide what designs Plates 137 and 138 most obviously draw from.

Discussion

While the exquisitely naturalistic setting and detailing of Plate 137 seem to relate to the realism of Mughal traditions shown in Plate 50, the bold composition of Plate 138 recalls the animated storytelling developed by Rajput painters (Plates 53–55).

◆◆◆

You may have noticed that New Indian Art used styles related to both Hindu and Muslim traditions. The aims for a new national identity for the peoples of the subcontinent allowed the placing together of the different traditions.

At the same time, members of the movement advocating New Indian Art were seeking to make artistic alliance with other Asian nations, especially Japan, with a view to ranging an eastern artistic bloc against the West. These Pan-Asian ideas were introduced to the Tagore family in 1902, when Okakura-Kakuzo, a Japanese art theorist and art school administrator, visited Calcutta. The Tagore household provided studio space for subsequent visiting Japanese artists. Rabindranath Tagore sustained these artistic connections in 1917 when he returned from a lecture tour of the United States of America and Japan accompanied by the Japanese artist Arai-San and asked him to teach in his school (Alokendranath Tagore, *Abanindranath Tagore*, p.32).

At first sight, these developments might seem to constitute a highly transgressive indigenous movement to change art. However, Guha-Thakurta warns: 'To a large extent, again, it was Western intervention – this time, the claims and verdict of a new influential group of Orientalists – which took the lead in remoulding attitudes' (*The Making of a New 'Indian' Art*, p.146). The search for independent inspiration was set by the western and western-influenced scholars who had dominated history writing in relation to the different arts in the subcontinent – most recently Coomaraswamy and Havell. In retrospect, the results have been seen as less independent of European influence than their proponents claimed. In 1993, the art historian Purushottama Bilimoria described New Indian Art as 'a synthesis of the literal and romantic, Victorian and Indian, and Eastern and Art Nouveau' ('The enigma of modernism', p.37). Nevertheless, at the time the overt rejection of the West as contemporary norm and the interest in encouraging a Pan-Asian movement caused a stir. In conjunction with the simultaneous political action, a painting styled like that shown in Plate 138 could allow oppositional readings.

How might one interpret the image shown in Plate 138 from the perspective of a colonial Indian subject?

Discussion

Although it was customary to show Rama as black skinned and Hanuman as pale skinned in the epic of the *Ramayana*, the portrayal of the seated Rama with his head haloed in dull gold (as an avatar of Krishna) giving his orders to the obedient white monkey suggests a delightful reversal of colonial roles, and it shows another set of meanings for white skin from those imposed by the British when they came to the subcontinent.

◆◆◆

There were, however, those who were critical of the attempt to make a new art for a new society by reference to past precedents in stylistic terms. Rabindranath Tagore's other artistic nephew, Gaganendranath Tagore (1867–1938), took steps in an alternative direction when in 1920 he began adapting the methods of European Cubist artists to Indian subjects (Plate 139). In Plate 139, for example, he uses Cubist methods of breaking up the form as if into basic geometric constitutents. However, the subject he chose was not a view of a real city. It was an imaginary view of the legendary city of Dwarka, as described in the *Mahabharata*. The gates, lake, palaces, and mountainous setting derive from the epic. It seems possible that it was Gaganendranath's example that Rabindranath followed in part. Indeed, in 1926, he urged in *The Meaning of Art* that a new Indian painting should be invented, not transposed from past models: 'I strongly urge our artists vehemently to deny their obligation to produce something that can be labelled Indian Art according to some old world mannerism. Let them proudly refuse' (Parimoo, *Rabindranath Tagore*, p.30).

Plate 139
Gaganendranath Tagore, *The Legendary City of Dwarka*, c.1925, watercolour, Rabindra Bharati Society, Calcutta.

Reception of his pictures

During 1930, a travelling exhibition of 300 of Rabindranath Tagore's pictures was mounted to accompany a lecture tour beginning in Paris (Plate 140). It proceeded to Birmingham and then London, then Berlin followed by Dresden, Munich, Copenhagen, Moscow, New York, and Boston. The lecture tour took the theme 'The Religion of Man' (the topic of the Hibbert Lectures Tagore had been invited to deliver in Oxford that year). As on all his tours, Tagore raised money to fund his school and university project, in this case partly through the sale of his pictures.

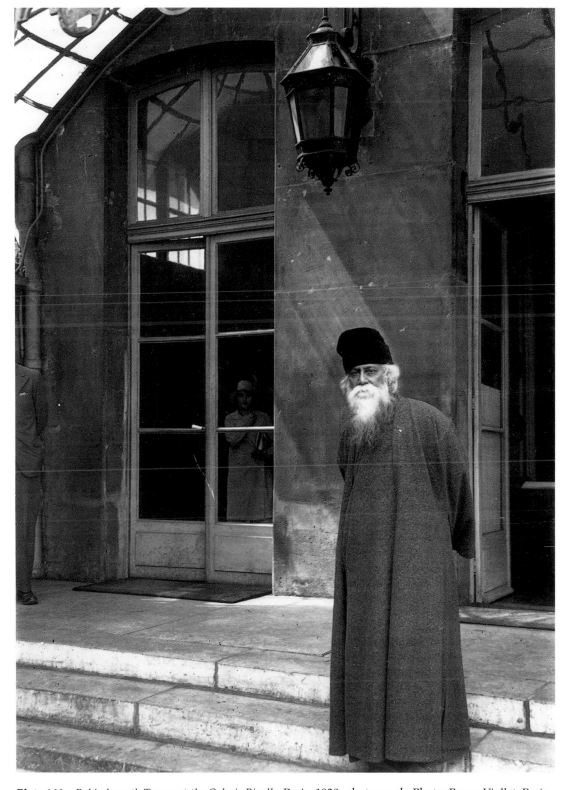

Plate 140 *Rabindranath Tagore at the Galerie Pigalle*, Paris, 1930, photograph. Photo: Roger-Viollet, Paris.

In the statement he made in the exhibition catalogue, he refused to explain his pictures, for, he said, 'it is for them to express and not to explain'. He went on to state: 'Love is kindred to art, it is inexplicable. Duty can be measured by the degree of its benefit, utility by the profit and power it may bring, but art by nothing but itself' (*Exhibition of Paintings*, unpaginated). These were ideas about the autonomy of art that paralleled theories of abstract art being promoted in Europe.

Coomaraswamy was asked to write the 'Foreword' to the exhibition catalogue. He praised Tagore's 'satisfying composition, clear cut rhythms and definition of forms' and he asked whether European artists and critics would admire Tagore as 'the first Modern Primitive'. After all, he added, they had 'so long striven for and praised the more calculated primitivisms, archaisms, and pseudo-barbarisms of European origin' (*Exhibition of Paintings*, unpaginated).

What do you think Coomaraswamy meant? Consider what is involved in the idea that one could be modern and primitive at the same time.

Discussion

Coomaraswamy was pointing to the central paradox of European modernism. We know from Case Study 3 that he promoted the worth of pre-colonial Indian art and values. In his view, contemporary European systems were inferior to these so-called archaic designs and ways of thought. Here he makes it clear that he thought Europeans only really approved their own imitations of the archaic or barbaric.

◆◆◆

According to a European definition of the term, Tagore could be regarded as a modern artist, because he adopted many European modernist ideas, incorporating them in his own works. For example, he placed stress on the autonomy of art and used methods analogous to those of some European modernists such as the Surrealists. However, there were other European modernist tenets with which Tagore fitted less well. For instance, modernist Europeans admired the skills in abstract design that they believed were possessed by artists from technologically less developed societies who had not learned the conventions of academic realism. Tagore was from such a society. India was regarded as relatively 'primitive' by Europeans and he was untutored in realist or any other art skills. But did European artists who were trying to shed realist skills and learn from 'primitive' art accept those they regarded as primitive as their equals: as able to generate their own modern art? Did they see them as able to appropriate as they saw fit from the aims and means of European artists or any other artistic traditions from other parts of the globe? The import of these questions is that at this period the idea of a 'Modern Primitive' was a considerable challenge to western expectations.

European critics avoided confronting the questions raised by Coomaraswamy's 'Foreword'. Instead, they enthused about Tagore's work, while relating it to other European and eastern art.

Read the following review by Joseph Southall,[5] who saw the travelling exhibition of Tagore's pictures in Birmingham in June 1930. Note how Tagore's work is represented:

> Tagore's drawings are, as I see them, the work of a powerful imagination seeing things in line and colour as the best Oriental sees them, with that sense of rhythm and pattern that we find in Persian or Indian textiles and craft work. The colour sense is indeed superb. But there is much more than this; there is deep feeling and apprehension of spiritual life and being, of men and animals, expressed in their features, their movements, their outward forms, lines and colours.
>
> (*Paintings by Rabindranath Tagore*, p.1)

Discussion

Tagore is seen as an Oriental who possessed for reasons of cultural (and possibly racial) origins a special ability to use colour, rhythm, and pattern. His work is compared to the decorative arts, but at the same time is seen as deeply spiritual. (Given Southall's background, it seems likely that he admired skills in 'textiles and craft work'.)

◆◆◆

Guha-Thakurta has emphasized that at this period British Orientalists like Havell promoted the idea that all Indian art was to be admired as expressing 'a sublime spiritual aesthetic which was uniquely Eastern' (Guha-Thakurta, *The Making of a New 'Indian' Art*, p.146). Such a reading would have been encouraged by the themes of comparative religion and mysticism on which Tagore spoke. Indeed, the parallels between the way Southall and Tagore wrote of his pictures suggests that colonizers and colonized could share in a common discourse.

Now consider the views of an anonymous critic from the publication the *Vossische Zeitung*, writing in Berlin on 17 July 1930. How does he or she perceive Tagore's work, in the extract below?

> The coloring employed in the illustration of monkeys, tigers, swans, vultures and other beasts of prey is typical of innate tastes of an ancient civilization: against a black background – the night enveloping the dreamer – there stand out designs in shades of red, brown and yellow, rich and vivid to a degree. Deep mysterious chords are struck, serving as a background for some clearly outlined object.
>
> There is a remarkable similarity between Tagore's manner of piercing through outer reality and that of modern European and particularly of German artists. Some of his animals may be taken as representative of Christian Morgenstern's art. There are shadowy outlines of the human figure suggestive of [Edvard] Munch. There are groups and heads forcibly reminding one of [Emil] Nolde.
>
> (*Paintings by Rabindranath Tagore*, p.11)

Discussion

Although Tagore had emphasized that the creatures he conceived were imagined, the critic recognized a jungle of animals, mostly from the 'mysterious East' in the colours of non-European peoples (red, black, brown,

[5] Southall (1861–1944) was an artist and architect and was President of the Birmingham Royal Society of Arts. He was influenced by the ideas of Ruskin and Morris.

and yellow). This colour sense was stated to be innate, not acquired. The critic then proceeded to compare the images to ones by contemporary Europeans.

◆◆

For Indian audiences the emphasis might be different. Have a look at what the editor of *The Modern Review* wrote in the extract below dated 1931 and note what is stressed:

> They are neither what is known as Indian art, nor are they mere imitation of any ancient or modern European paintings. One thing which may perhaps stand in the way of the commonalty understanding and appreciating them is that they tell no story. They express in line and colour what even the rich vocabulary and consummate literary art and craftsmanship of Rabindranath could not or did not say. He never went to any school of art or took lessons from any artists at home. Nor did he want to imitate anybody. So he is literally an original artist.
>
> (Chatterjee, *The Golden Book of Tagore*, p.xi)

Discussion

The stress seems to be on the complete independence of Tagore's pictures, in their freedom from the influence of both Indian and European art.

◆◆

Conclusion

In the decades leading up to and following Indian Independence in 1947, Tagore came to be described as the founding father of modern painting in India. He seems to have welcomed such a role. In *Art and Tradition* (1939), he urged artists to explore:

> Let us take heart and make daring experiments, venture out onto the open road in the face of all risks, go through experiences in the great world of the human mind, defying holy prohibitions preached by prudent little critics.
>
> (Parimoo, *Rabindranath Tagore*, p.31)

In 1941, following his death, Nandalal Bose, an artist who had taught at Shantiniketan, described Tagore's importance: 'If Rabindranath seems rough and destructive, it is because he is breaking the ground anew for us that our future flowers may be more surely assured of their sap' (Archer, *India and Modern Art*, p.79). Archer took a similar view, writing that Tagore had given Indian art 'a new start' with the same 'revolutionary' effect that Henry Moore had had on English art: 'Inner assurance was the quality needed and because Rabindranath Tagore possessed it above all else, he was able to break the impasse which confronted modern Indian painting' (*India and Modern Art*, p.79). When Geeta Kapur curated an exhibition demonstrating the range of modern painting in India, entitled 'Six Indian Painters' (Tate Gallery, London, 1982), she too placed Tagore first (Kapur, *Six Indian Painters*).

Tagore's reputation as an artist has been highly resilient. This is in part because he founded an institution that sustained his fame, and also because of his distinctive contribution to the fight for Indian independence. As the statesman Jawaharlal Nehru explained in 1931: 'Rabindranath Tagore has given to our nationalism the outlook of internationalism and has enriched it with art and music and the magic of his words' (Chatterjee, *The Golden Book of Tagore*, p.183). However, I suggest that it has also been because his artistic approach provided a relatively satisfying resolution, balancing tensions between westernization, modernization, and nationalism. Tagore was a patriot who spoke of 'our artists' and was a major artistic ambassador for India. But he rejected the idea of using 'some old world mannerism' to represent new national identities in art. Instead, he advised innovation – the quality associated with modernity. He made images using methods analogous to those adopted in the West, but with distinctive results, and taking an internationalist outlook he proposed viewpoints that might stand above ideas of division between East and West.

References

Andrews, C.F. (1924) *Letters from Abroad*, Madras, S. Ganesan.

Archer, W.G. (1959) *India and Modern Art*, London, George Allen & Unwin.

Bilimoria, P. (1993) 'The enigma of modernism in early twentieth-century Indian art: schools of oriental art', in *Modernity in Asian Art*, ed. J. Clark, University of Sydney, East Asian Series, no.7, Wild Peony, Sydney, pp.29–44.

Chatterjee, R. ed. (1931) *The Golden Book of Tagore: A Homage to Rabindranath Tagore from India and the World in Celebration of his Seventieth Birthday*, Calcutta, The Golden Book Committee.

Chatterji, S.K. (1930) 'The Government School of Art Exhibition at Calcutta', *The Modern Review*, vol.XLVII, February, pp.225–33.

Exhibition of Paintings by Rabindranath Tagore (1930) Foreword by A.K. Coomaraswamy, New York.

Guha-Thakurta, T.G. (1992) *The Making of a New 'Indian' Art: Artists, Aesthetics and Nationalism in Bengal, c.1850–1920*, Cambridge University Press.

Kapur, G. (1982) *Six Indian Painters*, London, Tate Gallery.

Paintings by Rabindranath Tagore: Foreign Comments (1932) Calcutta, Art Press.

Parimoo, R. (1989) *Rabindranath Tagore: Collection of Essays*, New Delhi, Lalit Kala Akademi.

Ray, S.L. (1967) *Formative Influences in the Life of Rabindranath Tagore*, Poona University Press.

Robinson, A. (1989) *The Art of Rabindranath Tagore*, London, Deutsch.

Said, E. (1991) *Orientalism: Western Conceptions of the Orient*, Harmondsworth, Penguin (first published 1978).

Tagore, Alokendranath (1989) *Abanindranath Tagore: Prince Among Painters*, trans. Arundhati Tagore, New Delhi, National Book Trust, India.

Tagore, Rabindranath (1917) *Personality: Lectures Delivered in America 1917*, London, Macmillan.

Tagore, Rabindranath (1930) 'My pictures', *The Modern Review*, vol.XLVIII, December, pp.603–5.

Tagore, Rabindranath (1931) 'My school', *The Modern Review*, vol.XLIX, January, pp.1–4.

Preface to Case Study 8: Developing the agenda for independence

CATHERINE KING

Making art in a newly independent nation

Rabindranath Tagore and the exponents of New Indian Art were operating before the granting of independence to India. As we have seen, ideas of autonomy and equality with the West were central to their debates about modern art practices in India. But how did such debates appear to those in newly independent Nigeria, that is, in a society that no longer just aspired to independence but had actually achieved it?

In Case Study 8, we consider the interpretation of the period *c*.1920–*c*.1990 by the Nigerian artist and historian Chika Okeke, written for the catalogue of an exhibition called 'Seven Stories about Modern Art in Africa'. Chika Okeke traced three approaches to making modern art in Nigeria.

First came a pre-independence phase, in which artists tended to appropriate western techniques of academic realism to represent local subjects and concerns. Chika Okeke aligns this approach with the appropriation by European artists of techniques of abstraction learned from artists working in Africa. It is important to consider this pre-independence phase because the artists who were working during this period have been treated by Nigerians as the founders of modern art in their country.

The initial years of independence brought the beginnings of two other approaches pursued concurrently. One of these was called 'Natural Synthesis'. This drew on locally developing traditions, whether of subject-matter, style, technique, or materials. Chika Okeke notes the way in which artists adopting this approach united imagery from art forms made by different peoples within the Federal Republic of Nigeria[1] to create a national style. These artists also aimed to incorporate elements of art practices from schools of art outside Nigeria, as required. Central to this approach was and still is the exploration of the work of individuals designated as artists who operate outside the framework of an art college education. This includes weavers, dyers, textile printers, house painters, body painters, potters, leather workers, and calabash decorators, who train in a household or workshop.

The other approach identified by Chika Okeke was, in contrast to the movement for Natural Synthesis, one in which artists were standing aside from the exploration of locally developing traditions and turning instead to 'the international art scene'. This approach, which began in the 1960s, has become increasingly attractive as an option in the 1980s and 1990s.

[1] On achieving independence from British colonial rule in 1960, the Federal Republic of Nigeria was founded, with three large regions – eastern, western, and northern – and the capital Lagos. In 1991, the capital was moved to Abuja and the country is now administered as 30 states.

At present, there are artists who would identify themselves as heirs of the movement for Natural Synthesis and also groups adhering more to the internationalist viewpoint. However, the two approaches should not be thought of as completely different from one another. Artists working within the philosophy of Natural Synthesis have always appropriated from artistic traditions outside Nigeria, while artists with an internationalist orientation have been keen to make objects relevant to Nigerian audiences – for example, by giving their work titles that make best sense to local viewers or by using some local media.

Chika Okeke is an artist, curator, and critic who lectures at the Department of Fine and Applied Arts at the University of Nigeria, Nsukka, in the Eastern Province. Although he trained and works in one of the academic centres associated with developing Natural Synthesis (Nsukka), he has been fastidious as an historian in giving equal attention to other approaches.

One aim of this case study is to pursue the interpretation by a Nigerian historian of the making of a modern art in Nigeria , to learn how the story looks from a Nigerian point of view. Thus, we shall follow Chika Okeke's account of what he calls the 'quest' for modern art in Nigeria. By and large, we shall take a chronological path through this story, but interweaving it you will find examples of the three approaches to modern art-making outlined above, including work that predated the granting of independence.

A second aim is to note Chika Okeke's critical and historical priorities and to some extent those of the artists he analyses. (For example, we shall find that he, and they, seem to be prioritizing qualities of independence: control over decision-making, development, and inventiveness. Indeed, there appears to be a strong overlap between values in art and values in politics and society here.)

As a third aim, we want to give a sense of how the images mentioned by Chika Okeke could be read by Nigerian audiences. We have expanded on some works by the artists he cites, in an attempt to draw out aspects of their design or meaning a little further.

Modern art in Nigeria : independence and innovation

CATHERINE KING
WITH NICOLA DURBRIDGE

The 'quest' and its background

Nigerian independence was declared in 1960. The task some artists and historians saw for themselves was to create a new modern art in keeping with an independent Nigeria. Western ideas of how modern art should be represented in Nigeria were still dominant. Among the reasons for this were the spread of western media and the continued presence of western teachers in art schools and universities. Nevertheless, independence created a society ready to debate and negotiate a position for itself and its art in a global culture. Independence meant the creation of a new state ready to commission public works and brought new opportunities for private patrons.

In 1995, Chika Okeke was commissioned to write an essay on the development of modern art in Nigeria for the catalogue to the exhibition 'Seven Stories about Modern Art in Africa' held in London. He chose as his title 'The quest from Zaria to Nsukka'. In the essay, Chika Okeke compared the intrepid search for gold or the source of a river in the colonies to the search of modern artists in Africa. To match this metaphor, the heading that he chose for the first section of his essay was 'Charting the journey'. (The exhibition looked at modern art in seven countries in Africa, including Nigeria. It was divided into seven sections and the catalogue consisted of seven essays, one summarizing artistic developments in each country. The editor of the catalogue, Clémentine Deliss, gathered together a variety of shorter texts by different authors, which were grouped for their relevance to the seven essays and comprised reprints, translations, and some specially written articles. In writing this case study, we have drawn extensively on this material.)

'Charting the journey': Aina Onabolu, realism, and the beginnings of academic art education *c.*1920–60

Looking back over the twentieth century, Chika Okeke drew attention to what he termed, using his metaphor of exploration, the 'pioneering efforts' of the Nigerian artist Aina Onabolu (1882–1963) in venturing into the interior of European art in order to take its riches. Onabolu was a portrait painter with a successful studio in Lagos, who worked in a western realist style. Although he visited Paris and London in the period 1920–2, for study purposes he was largely self-taught. Onabolu petitioned the colonial government to have some western artistic techniques taught in secondary schools, and in 1927, through the appointment of a director of art education for the colony, Kenneth Murray, this came about. Chika Okeke regarded Onabolu as proof that an artist from Africa could master western modes of painting, and saw him as founder of the academic teaching of modern art in Nigeria. By 1960, through their joint efforts, art was being taught to tertiary level at the Government College, Umuahia, and at the colleges of arts, science, and technology set up at Lagos, Zaria, Enugu (soon to move to Nsukka), and Ibadan (Plate 141).

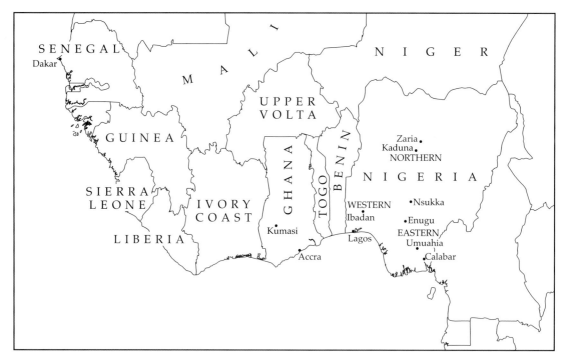

Plate 141 Map of West Africa.

Chika Okeke's explanation of this early phase of modern art in Nigeria follows the interpretation presented by the Ghanaian historian Kojo Fosu. In Fosu's view:

> At a time that European artists were beginning to appreciate the aesthetic qualities of African traditional art, and were therefore experimenting with them in their own works, African artists were equally fascinated with European aesthetic conventions of realism and were also experimenting with them in their own works.
>
> (*Twentieth-Century Art in Africa*, p.6)

Like Fosu, Chika Okeke treated cultures as equals, as being 'other' to one another, each taking foreign elements and making them their own. The interest in realism during this pre-independence period, to which Fosu refers, may be seen in the portrait of a young woman by Akintola Lasekan, who was self-taught, like Onabolu, but who earned his living as a newspaper cartoonist (Plate 142). We can see something of the importance that Chika Okeke attached to Onabolu's petition for academic art teaching in Nigeria from his praise of the role played by Ben Enwonwu (1924–94). He considered Enwonwu was Murrays's most influential pupil in the early years of independence. From 1944, Enwonwu, son of a workshop-trained sculptor, studied at Ruskin College, Oxford and then Goldsmiths' College and The Slade School of Fine Art, both in London. He became Nigerian Federal Arts Advisor for the first twelve years of independence, with responsibility for all government spending on art. According to Chika Okeke, Enwonwu used the approaches, media, and techniques being taught at London art schools, but he employed them to explore local subject-matter such as masquerades (masked dances in which the dancers are used by the Igbo people to represent spirits)

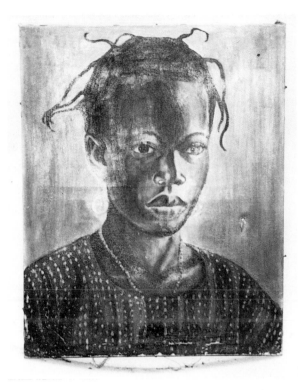

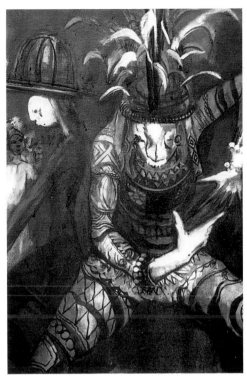

Plate 142 Akintola Lasekan, *Portrait of a Young Woman*, *c.*1940, oil on canvas, 61 x 30.5 cm, Collection of Afolabi Kofo-Abayomi, Lagos. Courtesy, Clémentine Deliss, School of Oriental and African Studies, London.

Plate 143 Ben Enwonwu, *Masquerade Dancer*, date, medium, and size not known. Courtesy, Clémentine Deliss, School of Oriental and African Studies, London.

(Plate 143). Chika Okeke presented Enwonwu as a role model for modern Nigerian artists because of his high professional status and his decision to 'return his sensibilities to the art and cultural traditions of his own people, the Igbo' (Chika Okeke, in Deliss, *Seven Stories*, p.45).

However, for Chika Okeke, the artists Onabolu, Lasekan, and Enwonwu were only isolated pioneers and it was group action that was required to enable a widespread independent modern art movement to be founded in Nigeria. This group action took place just before and after independence was declared.

Group action at Zaria (1958–61): creating Natural Synthesis

In the view of Chika Okeke, a fundamental move towards making modern art in Nigeria was the creation in 1958 of the Zaria Art Society by students at the College of Arts, Science, and Technology in Zaria in the Northern Province. This college taught artists and teachers of art, using staff who were, with one exception, westerners. In the light of the dominance of western approaches in their official tuition, and the imminent prospect of independence, eight of the students formed a society to discuss what a new Nigerian art might aim for, and how artists could train to produce it. The president of the society in 1959, Uche Okeke (not a relation of Chika), later described the debate that the members had conducted during a year of discussion.

Read the following extract from this description. What kind of modern Nigerian art did the group envisage?

> We are now aware of the fact that our art should be based on our past, present and possibly on our future ways of life in this country. In all, we are fully aware of our responsibilities as Nigerian artists. We know that art is a fallow field in this country and one that has unfortunately suffered from the hands of the short-sighted schemers of our inadequate educational system. The unfortunate position into which we are thrown calls for hard work and we have right from the beginning dedicated ourselves – our very beings – to champion the cause of art in Nigeria and indeed, in Africa. In our difficult work of building up a truly modern African art to be cherished and appreciated for its own sake, not only for its functional value, we are inspired by the struggle of such modern Mexican artists as Orozco[2] and his compatriots. We must free ourselves from mirroring foreign culture. This great work demands willpower, originality and above all, love of our fatherland. We must have our own school of art independent of European and Oriental schools, but drawing as much as possible from what we consider in our clear judgement to be the cream of these influences, and wedding them to our native art culture.
>
> (Uche Okeke, in Deliss, *Seven Stories*, p.210)

Discussion

The group considered that modern art must be based on local ways of life (past, present, and future) and exuded optimism (the 'fallow field' ready to be fertile), idealism, and patriotism. Members conceived of a modern art that would be appreciated 'for its own sake, not only for its functional value'. They took the image of marriage to represent the relationship that an independent Nigerian school of art should have to foreign cultures. In their view, modern art would be the offspring of wedding the best of European and Oriental art forms to 'our native art culture'.

◆◆

The eight students forming the Zaria Art Society were: Bruce Onobrakpeya, Yusuf Grillo, Uche Okeke, Demas Nwoko, Simon Okeke, Oseloka Osadebe, Okechukwu Odita, and Ogbonaya Nwagbara. They produced a variety of experimental work. For instance, Onobrakpeya chose subjects from the folk stories of the Urhobo and Benin peoples; Nwoko made images of everyday scenes of local life; Uche Okeke drew on images used in body and house painting (Plate 144); and Grillo took themes expressing indigenous beliefs such as that depicted in his *Mother of Twins Dances to Protect Them*. Grillo was a Muslim who had been born in Lagos. All the others had been educated in Christian schools, but were aware of local culture, including art and religion. While Grillo was a Yoruba and Onobrakpeya was an Urhobo, all the rest were Igbo.

In 1960, Uche Okeke wrote a manifesto for the group, which identified the important social and cultural roles that artists in Nigeria should play. Artists were charged with 'the great work of building up new art culture for a new society'. One idea that the manifesto incorporated from European art history was that of a rebirth of culture. This idea captured the mood – the vigour and questioning – of independence: 'This is our age of enquiries and reassessment

[2] José Clemente Orozco (1883–1949) worked in Mexico and developed murals that celebrated the life and history of the Mexican people, combining aesthetic and social concerns.

Plate 144 Uche Okeke, *Onalu*, 1958, ink on paper, Collection of the artist.
Reproduced from Uche Okeke, *Drawings*, Ibadan, Mbari Publications, 1961, p.13.

of our cultural values. This is our renaissance!' The manifesto advocated what
it called 'natural synthesis'. The choice of the term 'natural' may have been
made to contrast an organic compound composed of different elements with
the artificial joining of old and new or foreign and local produced by
colonization. The manifesto considered that modern art should take from
traditional religious art the idea that art should have some function. However,
the group saw its modern function in terms of helping to change 'mind and
attitude towards cultural and social problems'. The group was sympathetic
to the new western concept that art should be appreciated for art's sake, but
it did not envisage aesthetic values being pursued separately from functional
ones. The manifesto indicated that the group regarded it as futile to copy
'our old art heritages', but saw the new art developing from the old functional
art in which 'religious and social problems were masterly resolved'. The
manifesto emphasized the high status of the artist in pre-colonial traditions,

calling the artist 'priestly', 'because his noble act of creation was looked upon as inspired'. This old art had produced 'the greatest works of art ever fashioned by men'. For the Zaria Art Society, the touchstones for contemporary art were local solutions, local judgements, and local histories rather than mere reflection of European trends. The manifesto stated:

> The artist is essentially an individual working within a particular social background and guided by the philosophy of life of his society. I do not agree with those who advocate an internationalist art philosophy: I disagree with those who live in Africa and ape European artists. Future generations will scorn their efforts. Our new society calls for a synthesis of old and new, of functional art and art for its own sake. That the greatest works of art ever fashioned by men were for their religious beliefs go a long way to prove that functionality could constitute the base line of most rewarding creative experience.
>
> (Uche Okeke, in Deliss, *Seven Stories*, pp.208–9)

Although Chika Okeke followed Onobrakpeya (one of the eight founder members) in describing the group as 'rebels' (Fosu, *Twentieth-Century Art in Africa*, p.56), it seems important to emphasize that the group does not seem to have wanted to raise its status above that of artists trained in workshops and households. Instead, Onobrakpeya (whose father was a workshop-trained sculptor) stated that its members wished contemporary artists to receive the 'dignity accorded to traditional artists and art in Africa' (Fosu, *Twentieth-Century Art in Africa*, p.56). Indeed, in the ethos of independence, great pride was and is invested in all local art forms.

Early development of Natural Synthesis *c.*1960–70

The Zaria Art Society made a lasting impact on the debate about how to make modern art in Nigeria. After the Society was disbanded at its members' graduation in 1961, members went on to fulfil a range of roles in teaching, museum work, art and architecture, and journalism, allowing them to spread their ideas.

The 'Zaria rebels' chose to represent themes from Nigerian life and beliefs in their art work, but in retrospect, in 1995, Chika Okeke regarded another development as the most significant. This was the revolutionary idea of bringing local designing methods into the academic studio, for which Uche Okeke was responsible. Uche Okeke led the way in researching the traditions of abstraction that had gone on developing throughout the colonial period. He studied the methods used by his Igbo people to create designs for painting and engraving the walls of houses and shrines as well as for painting women's bodies. According to Chika Okeke, Uche Okeke asked his mother to teach him, since mural and female body design are the exclusive skills of women in Igbo society, and he also studied others' designs in museums, photographs, and tracings. The name given by the Igbo to such painting is *uli*, a term meaning 'trace'. Chika Okeke summed up *uli* in this way: 'The *uli* lexicon, though varied and dynamic, consists mainly of abstract forms derived from nature: animal, plant and cosmic forms. The artist distils the formal essence of the design elements through manipulation of line' (Chika Okeke, in Deliss, *Seven Stories*, pp.47–8). Something of this variety can be gauged from Plate 145 showing a *uli* house design and Plate 146 recording a *uli* body design.

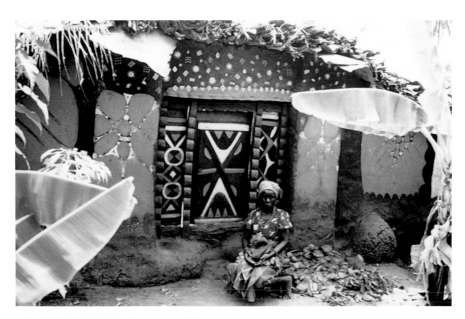

Plate 145
Okanumee Mgbadunwa, *Uli* (house painting), 1987, Nnobi, Eastern Province. Courtesy, Whitechapel Art Gallery, London.

Plate 146
Uli drawing for hips of women, *c*.1935, charcoal on transparent paper, 25.2 x 19 cm, from Akwa District, Eastern Province, Pitt Rivers Museum, Oxford, donated by W.B. Yeatman. Reproduced from Elizabeth Péri-Willis, *Uli Painting and Igbo Identity*, PhD thesis, University of London, 1997, figure 87.

Plate 147 Uche Okeke, *Lament of the Funerary Cult* (Igbo folk tale), 1958, pen and ink, 27 x 19 cm, Collection of the artist. Reproduced from Uche Okeke, *Drawings*, Ibadan, Mbari Publications, 1961, p.9.

Uli methods were used by Uche Okeke in his own art and (through the work of his pupils at the University at Nsukka) have become an element in design teaching elsewhere in Nigeria (Plate 147). These methods provide a Nigerian alternative to European draughtsmanship. Uche Okeke's contemporaries in the Zaria Art Society adopted analogous procedures. For example, Onobrakpeya made body-marking designs created by his Urhobo people the focus of his *Women Bathers in a Stream* (Plate 148).

Plate 148 Bruce Onobrakpeya, *Emete Ayuvbi* (*Women Bathers in a Stream*), 1972, plastograph, 46.9 cm x 62 cm, Collection of the artist. Reproduced from Bruce Onobrakpeya, *The Spirit of Ascent*, Lagos, Ovuomaroro Gallery Production, 1992, p.139.

Uli relies on handling of line to summarize complex substances, shapes, movements, or textures. Uche Okeke developed his use of *uli* from designs dealing with a small number of elements (Plates 144 and 147) to large, complex compositions (Plate 149).

Look at Plates 147 and 149. Compare the ways in which Uche Okeke developed his use of line.

Plate 149 Uche Okeke, *Baptism*, 1974, wood block print on paper, Collection of the artist.
Reproduced from Simon Ottenberg, *New Traditions from Nigeria*, Washington, D.C., Smithsonian
Institute Press, 1997, plate 51.

Discussion

In *Lament of the Funerary Cult* (Plate 147), a variety of lines and dots suggests almost familiar features like eyes and mouths as well as the strangeness of spectres (from Igbo folk tales associated with death). Lines are clustered to indicate shading and depth in the lower visages. The way complex patterns are placed in areas notionally between the spirits' faces draws attention to the picture plane. There is a balance between inviting the viewer to recognize the representation (of spirits) and enjoying looking at the way the lines trace patterns on a flat surface. *Baptism* (Plate 149), dating from more than a decade later, indicates Okeke's further technical development. This is a controlled display of a wide repertoire of linear patterns with exuberant and dynamic curves in abundance and none of the hesitancy present in the *Lament of the Funerary Cult*. Heavy contours suggest the crowd of witnesses to the baptism. The Cross in the background indicates that this is a Christian rite. Rich patterns indicate water, and perhaps a pebbled beach, which could allude to the baptism of Christ at the River Jordan. As with *Lament of the Funerary Cult*, the invitation to recognize what is represented is at the same time an invitation to notice how satisfyingly the composition is designed.

◆◆◆

There were advantages to using *uli* and other design practices of women if seeking to develop a distinctively Nigerian art practice fit for an independent society. Women's designs were considered to be relatively untainted by colonial appropriation, since colonialists had not been able to collect them, other than in tracings and photographs. (Women in Nigeria repaint their houses and shrines regularly as they weather, and body painting is even more frequently remade. Consequently, the designs are impermanent and unportable.) There was a possible advantage for *male* artists in developing ideas taken from *uli*. The fact that this designing was exclusively women's work could allow college-trained men to emphasize that they were making a different kind of art from that of the household- or workshop-trained artists. As noted earlier, college-trained artists were *not* thinking of distinguishing their practice in terms of higher status. You may recall Onobrakpeya's statement that the 'Zaria rebels' wanted equality of status for artists of the different traditions.

The option of looking for inspiration to local traditions of making bronze or wooden sculptures was more problematic. Western collectors had displayed such sculptures in museums in the West in ways that made them appear savage, impulsive, and primitive. It remains difficult for Nigerian artists to rescue these works from colonial devaluations and have them seen as cultivated, well thought-out designs.

However, college-trained artists did explore a variety of ways of producing sculpture. Onobrakpeya, for example, created sculptures that referred to the shrine art of Nigerian peoples (Plates 150 and 151). Onobrakpeya's *Shrine Set* recalls the male tradition of artist as priestly figure, which the Zaria Society had admired. In addition, he drew on a variety of local art forms, for example the gold weights of Ghana and the leather work of northern Nigeria. However, he also took what he considered appropriate from schools of art outside

Africa: for instance, he used imported stainless steel. Onobrakpeya incorporated his own technical discoveries in employing what he called 'plastocast' (which uses plaster of Paris to cast resin and fibreglass). In *Shrine Set*, he united plastocast with the traditionally used local media of wood and bronze. In his book *Symbols of Ancestral Groves* (1985), Onobrakpeya stated that he wished to 'draw attention to our myths, legends and history, and to present in visual forms our time-honoured philosophies and to comment on current problems' (Picton, *Image and Form*, p.22). He aimed at a broad audience: 'Since the basic aim is to present ordinary ideas in an exciting manner to attract the attention of the ordinary person, my eyes are open to accidental results which turn up in the process of using material old and new' (Picton, *Image and Form*, p.22).

While emphasizing the importance of reaching a wide audience, he pursued the idea of art as personal expression and discovery, calling the studio he built in 1976 in Lagos 'Ovuomaroro', the name of his paternal grandmother, meaning 'self examination leading to self knowledge and self development' (Picton, *Image and Form*, p.22).

Plate 150
Bruce Onobrakpeya, *Shrine Set*, 1980, plastocast, plastograph, copper, bronze, plywood, and stainless steel, 305 x 305 x 183 cm, Collection of the artist. Courtesy, Clémentine Deliss, School of Oriental and African Studies, London.

Plate 151 Bruce Onobrakpeya, detail of *Shrine Set* (Plate 150), Whitechapel Art Gallery, London.

Pupils of Natural Synthesis 1970–90

Chika Okeke traced the way younger generations – who were pupils of members of the Zaria Art Society, whether at art college or in a studio – developed the ideas of Natural Synthesis.

The Zaria Art Society had suggested that modern artists had an important moral role to play in society. Chika Okeke particularly admired the work of his own teacher, Obiora Udechukwu, in this respect. Udechukwu was a pupil of Uche Okeke, when Uche Okeke became head of department at Nsukka University in 1972 after the civil war in Nigeria. Chika Okeke described Udechukwu as 'distilling the *uli* essence of elegance and sensitivity of line' (Chika Okeke, in Deliss, *Seven Stories*, p.56). We can see the sort of moral point Chika Okeke admired in Udechukwu's satirical image of the *Politician* (Plates 152 and 153). In this drawing, the politician smokes restfully while his tiny minions toil like insects below.

Plate 152 Obiora Udechukwu, *Politician*, 1989, pen on paper, 48 x 36 cm. Courtesy, Elizabeth Péri-Willis.

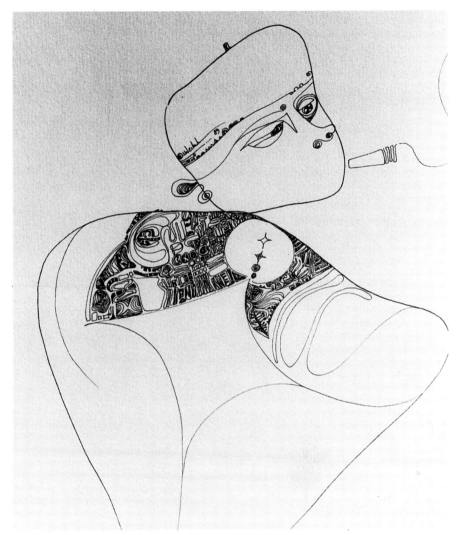

Plate 153
Obiora
Udechukwu,
detail of *Politician*
(Plate 152).

Chika Okeke drew attention to the part played by another of his teachers, El Anatsui, in developing the approach of Natural Synthesis at Nsukka. Anatsui, a Ghanaian, demonstrated the value of cross-national exchanges in West Africa, since he brought imagery drawn from the art forms of the Asante people practised round Kumasi, where he was educated, to Nsukka in 1975. Ghanaian artists had developed an approach somewhat similar to that of Natural Synthesis which they referred to as 'Sankofa', after the name in the Asante language (Twe) given to the sankofa, a bird that proverbially retraces its steps to find a titbit it has passed. The word in Twe also means 'return' and 'retrieve'. Anatsui stated that for him 'Sankofa' meant:

> a reaction to a conscious and forcible attempt to denigrate a people's culture and replace it with an extraneous one … It recognised also that there are always elements of an invading culture which stay behind; you cannot obliterate it completely because every culture has its positive aspects. Thus the essence [of sankofa] was neither a wholesale return to the past nor a total exclusion of external influence. The thrust was inward orientation and selectivity.

(Péri-Willis, 'Chambers of memory', p.81)

In other words, he felt that artists needed to study their local art forms and, when they were sure of their position, they could take what they required from outside sources.

At Nsukka, Anatsui began also to research the modes of abstraction practised in *uli* design, and to pursue further his interest in retrieving the systems of signs used to record events and ideas in Africa. In Ghana, he had studied *adinkra* sign systems, the pictographs developed to indicate changing beliefs amongst the Asante and invented for printing mainly on cloth (Plate 154). In Nigeria, he studied *nsibidi*, the secret sign language used by the Leopard Society of the Ibibio people, around Calabar in the Eastern Province (Plate 155). He treated these as design resources, and valued them as testimony of the record-keeping of peoples misrepresented by colonizers as being without textual history. In the statue *Adinsibuli Stood Tall* (1995), Anatsui employed *adinkra*, *nsibidi*, and *uli* designs (from which the name *Adin-sib-uli* is derived) on the interior of a giant figure made from two discarded wooden mortars used for pounding palm kernels (Plate 156). In the title he suggests that the viewer should look up to the civilizations of West Africa (among which are those of the Asante, the Ibibio, and the Igbo).

Gye Nyame (except God).
Symbol of the omnipotence and immortality of God.

Osrane (Moon).
"Osrane mmfiti preko nntware man"
It takes the moon some time to go round the nation.

Adinkrahene (Adinkra king).
Chief of all the adinkra designs, forms the basis of adinkra printing.

Nkonsonkonson (link or chain)
We are linked in both life and death. Those who share common, blood relations never break apart. Symbol of human relations.

Sankofa (return and take it).
"Se wo were fi na wosan kofa a yennkyi."
It is no taboo to return and fetch it when you forget. You can always undo your mistakes.

Plate 154 *Adinkra* symbols. © Ablade Glover, Artists' Alliance Gallery, Accra.

Plate 155
Nsibidi, pictographs 1–11, 13 (out of 97) 'Marriage and home life', from J.K. Macgregor, 'Some notes on "Nsibidi"', *Journal of the Royal Anthropological Institute*, vol.XXXIX, 1909, pp.13–14.

1 and 2. Married love (2, with pillow).
3. Married love with pillows for head and feet – a sign of wealth.
4. Married love with pillow.
5. Quarrel between husband and wife. This is indicated by the pillow being between them.
6. Violent quarrel between husband and wife.
7. One who causes a disturbance between husband and wife.
8. A woman with six children and her husband; a pillow is between them.
9. Two wives with their children (a), of one man (b), with the roof-tree of the house in which they live (c). The tree is put for the whole house.
10. A house in which are three women and a man.
11. Two women with many children in the house with their husband …
13. A woman with child.

As well as studying the art forms of West Africa, Anatsui also selected techniques and tools from outside Africa. For instance, from the 1980s onwards, he adopted the use of a blow-torch and a chain-saw to make his wooden sculptures. For him, the use of the powerful western blow-torch to sear the wood when he was making a sculpture signified the devastation of Africa by slavery. The saw recalled the way colonization had cut up territory into geometrical pieces. In *Leopard Cloth*, for example, Anatsui placed four sawn planks together as a reminder of the way in which the imperial boundaries carved up the land on the map of West Africa (Plates 141 and 157). To allude to the destruction of people, a segment branded with small figures has been partly burned away. Nevertheless, the title *Leopard Cloth* suggests that some institutions survived slavery and colonization. According to the research of Elizabeth Péri-Willis, the leopard cloth was worn by members of the Leopard Society, who used *nsibidi* for their secret records. She noted that Anatsui took from *nsibidi* the motif of the triangular leopard's claw for the patterning of the upper area of his sculpture and that the leopard signified power. She also explained that the dot within a circle, which Anatsui employed for the design at the base, indicated kingship in *adinkra*. It seems, therefore, that *Leopard Cloth* suggests the survival of some power and leadership in Africa despite devastation (Péri-Willis, 'Chambers of memory', pp.85–6).

Plate 156 El Anatsui, *Adinsibuli Stood Tall*, 1995, iroko, aluminium sheet, wire, and tempera paint, height 239 x 40 x 37 cm, October Gallery Trust, London.

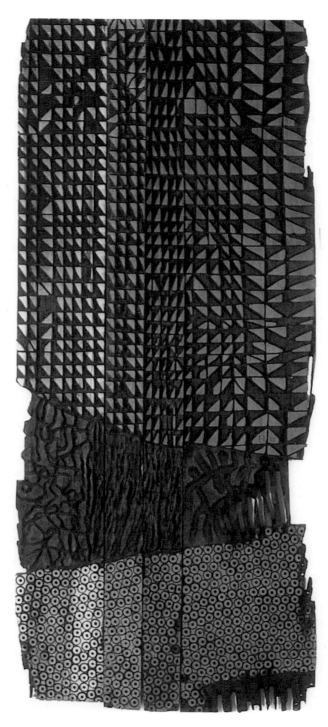

Plate 157 El Anatsui, detail of *Leopard Cloth*, 1993, four woods, right to left: mansonia, opepe, camwood, oyili-oji, 162 x 69 x 3 cm, October Gallery Trust, London.

There were no women in the Zaria Art Society. The imagery used by the members was masculine. They spoke of artists as 'priestly' and of a 'virile school of art'. Indeed, in the Northern Province where Zaria is situated women were not granted the vote at independence. However, opportunities opened up for some women to practise as pupils of the members of the Zaria Art Society. For example, during the mid-1980s, Ndidi Dike trained at Nsukka with Anatsui and went on to produce images using a variety of local media such as banana fibres, seeds, and sand. She then moved towards a form of sculpture using wood-cutting and burning techniques. According to Chika Okeke, these sculptures make reference to 'something tellingly African' by incorporating animal and vegetable fibres, brass figurines, coins, and shells but the forms 'merely suggest cultural provenance, making no definite claim' (Chika Okeke, in Deliss, *Seven Stories*, pp.68–9) (Plate 158). Chika Okeke writes with a degree of puzzlement as to why Dike avoided wholesale adoption of *uli* methods. It seems possible that while male artists could assert their modernity by developing elements in local female painting methods, women could assert their capacities as modern artists more effectively by taking over the traditionally masculine preserve of sculpture. The title of Dike's work *Ikenga* refers to the spirit who is thought to watch over the power of the individual to enhance what is allotted by destiny. The shape suggests a row of wooden figures laid side by side at a shrine. While European collectors had shown such figures separately, propped on their feet like European civic statues, the figures had been made to lie together flat.

Plate 158
Ndidi Dike, *Ikenga*, 1993, wood, 60 x 75 cm, Collection of Captain Uzman Mu'azu. Courtesy, Clémentine Deliss, School of Oriental and African Studies, London.

Udechukwu, Anatsui, and Dike were all in some way heirs to Uche Okeke, but Chika Okeke also noted the roles of the pupils of other members of the Zaria Art Society. For example, he discussed the work of Tayo Quaye, who was a pupil of Onobrakpeya and Grillo in Lagos (Plate 159). Quaye was a student at Saint Gregory's College where Onobrakpeya taught, then worked as an assistant in the latter's studio, and proceeded to become a student of Grillo at Yaba College of Technology. Quaye did this youth service away from Lagos, in the Northern Province at Kaduna, near Zaria, and has remained there. (The youth service was designed to encourage a sense of Nigerian identity across different areas.) Quaye was inspired by motifs from local textiles and the designs carved on calabash gourds, as well as metalwork

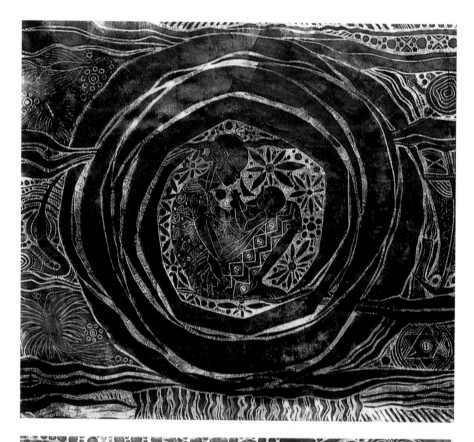

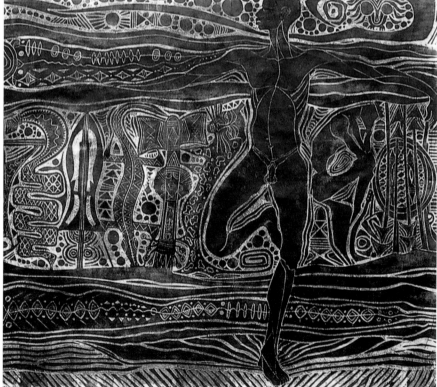

Plate 159
Tayo Quaye, *The Man*, 1995, lino engraving on Japan paper, 92 x 200 cm. Courtesy, Gasworks Studios, London. (The long section of engraving is shown in two parts, one above the other.)

and leatherwork designs made in the Lagos area and Kaduna. He also uses some imported materials. In *The Man*, he created a composition that is boldly structured yet rich with intricate patterning. In the work (he explained), he shows a man struggling against the difficulties of life, signified by the wild animals and the clusters of weapons. The woman and child are treated differently from the man: while they are concerned with one another, the man stands alone.

Outside Natural Synthesis *c.*1960–90

The Zaria Art Society had disparaged 'those who advocate international art philosophy' (Uche Okeke, in Deliss, *Seven Stories*, p.208), regarding them as merely *purporting* to represent art beyond national boundaries, but actually just imitating Europeans. However, Chika Okeke noted the presence of artists throughout the period who took a different view. He highlighted Erhabor Emokpae (1934–84) as an example. Emokpae had originally trained at the Yaba Technical Institute, Lagos, in commercial art. Chika Okeke interpreted his work in formal terms as tending to 'abstraction and severe stylisation' and saw this as Emokpae's 'own way of rejecting colonialism' (Chika Okeke, in Deliss, *Seven Stories*, p.52).

Please look at Plate 160. What features of the image do you find striking and what are their effects?

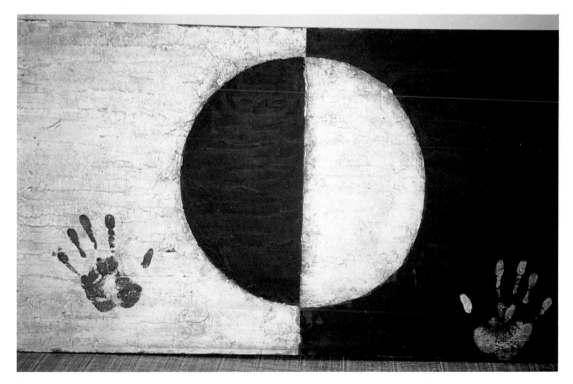

Plate 160 Erhabor Emokpae, *Struggle Between Life and Death*, 1962, oil on board, 61 x 122 cm, Collection of Afolabi Kofo-Abayomi, Lagos. Courtesy, Clémentine Deliss, School of Oriental and African Studies, London.

Discussion

Emokpae is using the western media of panel and oil paint. The overall effect is of simplicity and severity because of the use of two hues, black and white, and two semi-circles. There is a sense of balance because of the even disposition of elements on either side of the central vertical axis. Yet the two halves of the composition are diametrically opposed in hue: black on white and white on black. These evenly balanced and opposed elements are joined in shape to form a large rectangle in the centre of which is a circle. The idea that the hues and shapes are locked together is enhanced by the way that the surface white layer of paint has had a black one placed beneath it and vice versa. Although the design is remote from ordinary reality because it is abstract, the small scale and the use of hand prints give a feeling of closeness and human contact.

◆◆

This bold design may be related to Emokpae's philosophy of life: 'I see in life and death a dialogue between the womb and the tomb. They are the parentheses within which we love and hate, laugh and cry, grow and decay' (Jegede, in Deliss, *Seven Stories*, p.199). According to his biographer, Dele Jegede, Emokpae viewed abstraction as belonging to artists in Africa: 'Abstraction which has been appropriated by the white cultural establishment and sanctimoniously installed as the soul of modernism is, in the artist's view, modern only to them: African art has always been based on abstraction' (Jegede, in Deliss, *Seven Stories*, p.200).

Pause and consider the implications of Jegede's use of the word 'always'.

Discussion

The implication seems to be essentialist – that skills in abstraction are inherent in African artists. This was a strong line of argument to rebut western or any other critics who suggested that Africans were imitating western modernists. (As discussed in the Introduction to this book, it is a line of argument that has been criticized to the extent that it sets limits on what artists in Africa may choose to do in the future.)

◆◆

Chika Okeke stressed that the College of Arts, Science, and Technology at Zaria (which had become Ahmadhu Bello University in 1966) had taken little notice of the pleas for 'natural synthesis' from its students, and had proceeded to encourage subsequent students to adopt an 'international art philosophy'. This phrase refers to the idea that there is a universal language of modern art, which stands outside local and particular cultural meanings. Chika Okeke is clear that artists in Nigeria could contribute to this universal language of colour and form. He explained that at Zaria students had been taught 'that the painter must explore colour in order to understand fully its nuances, its hidden character. In the process the artist unites established theories of colour with his own personal experience with painting processes and media' (Chika Okeke, in Deliss, *Seven Stories*, pp.60–1).

Chika Okeke saw the painting of Gani Odutokun, who had been trained at Zaria in the 1980s, as representative of such a 'universalist' approach. Where the strategies of Natural Synthesis could perhaps be regarded as seeking to

create an identifiably 'Nigerian modern art', Odutokun, and Emokpae before him, might be perceived as taking another route: that of producing modern art that just happened to be made in Nigeria.

Chika Okeke saw Odutokun as working in terms of the new global community:

> For Odutokun the world was his constituency, and he was the legatee of its multiculturality. The only determinants of the sources from which he drew inspiration are technical studio exigencies and the changing environment. He reclaimed the individual freedom of the artist: the freedom to absorb or reject any particular art tradition, also the freedom to combine all since the modern artist is the product of many cultures, the new global experience.
>
> (Chika Okeke, in Deliss, *Seven Stories*, p.61)

Odutokun described his method of painting as that of 'accident and design' and of watching colour move, or directing it, across the surface to signify his vision of world cultures coming together, both by accident and intention (Plate 161). For Chika Okeke, Odutokun reinstated Zaria to its earlier position of influence.

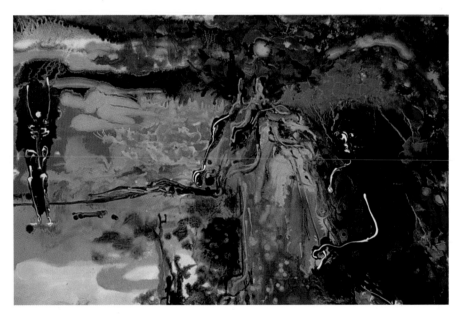

Plate 161
Gani Odutokun, *Untitled* [*Horse and Rider*], c.1994, medium and size not known. Courtesy, Clémentine Deliss, School of Oriental and African Studies, London.

The 1958 Zaria Art Society had regarded the creation of a national identity with optimism. But three decades later, in a country which had suffered civil war and in which democratic institutions had been challenged in the name of national unity, artistic reliance on local and national identities may well have seemed somewhat more problematic than it did on the eve of independence.

The Eye Society, Ahmadhu Bello University, Zaria 1989

In 1989, another society, the Eye Society, was founded at Zaria by Jacob Jari, Jerry Buhari, Matt Ehizele, Gani Odutokun, and Tonie Okpe. It had a new agenda. This time the members were not protesting students but mature practising artists. They published a manifesto, which is reproduced in full below.

Please read the manifesto carefully and pick out what you see as the salient points.

> The Society believes in the freedom of the artist to use his varying experiences for the benefit of mankind. Such experiences embrace the whole of human imagination – deriving, for example, from such phenomena as nature, tradition, science and technology.
>
> While it acknowledges the presence of tradition in all societies it is aware, however, that every society is affected by cultural changes. These changes may be brought about or are influenced by the culture of others. It is insincere, therefore, for an artist to pretend not to notice these changes and to insist on portraying his society as if it were static. The Eye believes that the visual arts provide the forum whereby the dynamism of culture can be appreciated. Thus the Society does not expect artists to be tied down to mere local expectations to the detriment of other dynamic cultural developments of mankind through art. It identifies the seeming absence of progress in most developing nations as a resultant effect of such self-limiting methods that usually are propagated by those who often wish that artists chart a direction purportedly national in appearance but essentially parochial. In the present African and Nigerian circumstance, the Society believes that the artist should not be seen to propagate artistic narrow-mindedness.
>
> (Chika Okeke, in Deliss, *Seven Stories*, p.212)

Discussion

The main points would seem to be as follows. Too exclusive a reliance on developing art in relation to local traditions is seen as allowing static, narrow, and closed art practice. In contrast, approaches that are open to cultural change and the cultures of others may encourage more dynamic development and may perhaps be more genuinely 'national'.

◆◆◆

In 1995, Jari explained the views of the Eye Society a little further. The economic crash in Nigeria during the 1980s had left artists impoverished, which encouraged them to produce work to please buyers. Inside and outside Nigeria, patrons expected African artists to create objects that looked distinctly 'African'. But bowing to such expectations could only lead to a situation where 'western connoisseurs will advise African artists not to attempt to produce works in the manner of the international art scene, because such works – regardless of their efforts and without exception – will be distinctly inferior' (Jari, in Deliss, *Seven Stories*, p.213). The Eye Society sought to educate the Nigerian public to appreciate contemporary art, 'irrespective of what inspires its production' (Jari, in Deliss, *Seven Stories*, pp.213–14). By 1989, therefore, the desire to assert Nigerian identity through drawing on local art forms might be interpreted as limiting artistic development if pursued as an exclusive strategy.

The new society founded its own journal: *The Eye: A Journal of Contemporary African Art*. Whereas the Eye Society put forward *one* approach, the journal encouraged debate. Writing in it in 1993, for instance, Jari drew attention to the way 'Africa' had been created by colonizers. He summed up the three alternative paths that he saw artists as taking in a search for a new African art: 'There are those who suggest a return to traditional sources while there are others who insist that we must be part of the global idiom which acknowledges the eclecticism of contemporary practice that transcends

boundaries. A third group advocates a synthesis of the two' ('The search for a new African art', p.1). In his article, Jari argued that there was more to carving out one's identity than relying on one's own developing traditions. He pointed out that just as Picasso had not become an African when he turned to Africa for inspiration, so African artists could be interested in the ideas of artists outside Africa while retaining their sense of independence. Jari himself used coloured corn stalks, with their local connotations, to make a statement about the state of the nation. He explained that in employing objects discarded after the harvest he wished to suggest a second harvest: 'In a sense it is an attempt to convey the belief that Nigeria's terrible state of affairs today can be corrected by the values and the very people who have been discarded' (Jari, in Deliss, *Seven Stories*, p.214). The composition of his pictures, using the sheen and varied textures of corn, does not, however, allude directly to any previous art form made in Africa (Plate 162).

Plate 162
Jacob Jari,
Mummy is Happy,
c.1993, cornstalk
and paint on
board, size not
known. Courtesy,
Clémentine
Deliss, School of
Oriental and
African Studies,
London.

Jerry Buhari produced effects that Chika Okeke described as 'transcultural', since he created oil paintings – such as his *Ritual Pots Series* – that employ techniques of automatic painting. In automatic painting, chance effects are made by running paint off tilted surfaces (Plate 163). Chika Okeke suggested that such paintings demonstrate the way intuition takes over from logical reasoning and also that the waste of paint dripping off the edges signifies the destruction of the environment (Chika Okeke, in Deliss, *Seven Stories*, p.65).

Plate 163
Jerry Buhari,
Ritual Pots Series,
1994, oil on board,
diameter 61 cm.
Courtesy,
Clémentine
Deliss, School of
Oriental and
African Studies,
London.

While asserting the importance of moving on artistically, the Eye Society took the Zaria Art Society as a model for effecting change. It honoured Zaria's role in the founding of the history of contemporary art in post-colonial Nigeria by, for instance, including essays celebrating the sixtieth birthdays of Uche Okeke and Bruce Onobrakpeya, by Jerry Buhari and Gani Odutokun, respectively, in its journal.

Chika Okeke did not propose a single approach to making modern art, but presented the approaches of Natural Synthesis, internationalism, and academic realism as judicious strategies for artists to have followed. Indeed, he advocated a 'multi-perspectival' view of the three approaches. In doing so, he was following the historiographical theories of his former tutor at Nsukka, Olu Oguibe. He used the metaphor of a masquerade to illuminate the potential he sees in multi-perspectival understanding. A masquerade – a performance in which dancers enter an arena each dancing 'those steps best suited to their type, stature and size in order to enthral the audience and themselves' (Chika Okeke, in Deliss, *Seven Stories*, p.74) – is regarded as having to be seen from different angles in order to be appreciated fully. For Chika Okeke, this is also true of the different approaches to modern art in Nigeria: these 'performances' or different art practices, are best understood when seen in the round and from different angles. He cited an Igbo proverb – '*Aka Weta*', 'the mouth fills faster the more hands feed it' – to explain his delight in varieties of viewpoint, and interpreted the proverb thus: 'When there are many critics with differing persuasions and attitudes practising, art criticism gets richer' ('Beyond either/or': towards an art criticism of accommodation, p.92). 'Since there are several masquerades,[3] the one thing that unifies all is the space where the events take place. That arena is Nigeria, and the summation of the ever-changing experience of the masquerades is perhaps what we might call Nigerian Art' (Chika Okeke, in Deliss, *Seven Stories*, p.74). We can think of Chika Okeke as emphasizing democratic values, in assuming that different artists and approaches might be equally good and in wanting to take account of different viewpoints on them.

National and African identities: fixed or unfixed

In both the 1960 Zaria and 1989 Eye manifestos, reference was made to the over-arching possibilities inherent in 'African art', but whereas in 1960 the emphasis was on creating a new national identity, by 1989 the concern was to question the inflexible expectations of patrons as to 'Africanness'. Attitudes towards defining national or continental identities seem to have shifted during the period 1960–89. As we shall see, they appear to be continuing to shift: away from ideas of 'essential' identities, which may be uncovered, or of national characteristics, which may be formed and consolidated, and towards the idea that identities are constantly being made and remade.

In the early years of independence, the arguments of such thinkers as Léopold Senghor, President of Senegal, tended to hold sway. Senghor both wrote books and organized exhibitions, such as the 'Premier Festival Mondial des Arts Nègres' (First World Festival of Negro Art) (held in Dakar, Senegal, in 1966).

[3] Masquerades may be performed for different purposes, whether social, such as initiation ceremonies or entertainment, or religious, in drawing on or averting spiritual powers or celebrating great men after death.

Senghor argued that 'black art' was 'an essential component of the universal civilisation' and that African culture had made a crucial input into European culture because of the way Greece drew on the ideas and art of Egypt (Senghor, in Deliss, *Seven Stories*, pp.225–7). Senghor argued that the way forward was to seek 'our redeemed identity':

> We must be ourselves, cultivating our own distinctive values, like those found when we went back to the sources of negro art: those values which, over and above the underlying unity of their humanity, because they were born of biological, geographical and historical particulars, are the hallmarks of our originality.
>
> (Senghor, in Deliss, *Seven Stories*, p.226)

During the next two and half decades, such essentialist views of an African art in which Nigerian or Senegalese art would play a part have tended to fall from favour. New views of African identities see them as fluid, constantly changing, and not related to biology, or, necessarily, to retrieval from the past.

The hesitance with which Jari referred to 'African' art in 1993 may be highlighted, for instance, by considering the near-contemporary view, in 1990, of the Sudanese artist Hassan Musa who replied, on being asked to define African art:

> There is no more African art except in Western museums. There is no more Africa except in tourism, and no more African except in International Aid. What Africans are producing now in Africa is not 'African art'. It is just art produced by people who consider themselves partners in a world that they invent every instant.
>
> (Musa, in Deliss, *Seven Stories*, p.241)

It seems that, to fit an ever-changing, indeed futurist, vision of modern art, such as that of Musa, and one that includes artists who move across national borders, the phrases 'modern art in Africa' or 'modern art in Nigeria' may now be preferred. (You may recall that, in Case Study 5, Craig Clunas suggested that the topic 'art in China' could invite a more open enquiry into the activities of artists than the phrase 'Chinese art'.)

Conclusion

In 1958, the Zaria Art Society believed that 'international art philosophy' cloaked the continued European dominance of world culture, since Europeans claimed to stand above ethnic identity and make art that was universal. During the thirty years after independence, a further shift in definitions of contemporary art has taken place, in part because of the critiques of modern art by post-colonial societies: the shift to postmodernism. One version of postmodernism considers that artists of different cultures may practise on an equal footing, on the assumption that they are all, equally, 'ethnic' and all the product of continual cultural interchanges. The re-emergence of the idea of an international art that is a genuinely global one helps to explain why the 'internationalist art scene' may now be viewed with less suspicion by some artists. It can be argued that the idea of transnational art production is still prone to being driven by western agendas. Nevertheless, this case study has shown how vigilant artists have been towards the threat of outside control.

It has followed the way artists have worked to create a position in which they determine decisions on art in Nigeria.

The Indian context (*c.*1900–*c.*1930) considered in Case Study 7 was very different from that of Nigeria (*c.*1920–*c.*1990). Nevertheless, modern artists in both India and Nigeria seem to have explored a similar range of options in their search for an appropriate contemporary practice. At an early point, some artists sought to adopt western realistic skills. Later, some groups associated independence with the use of forms or ideas that they saw as distinctive to Indian/Nigerian societies. However, others sought to reach an independent position by making art that looked to cultural interchange from an international arena beyond the bounds of British colonial relations (India) or national boundaries (Nigeria). In both countries, therefore, the emphasis seems to have been on asserting artistic equality: by demonstrating mastery of realistic skills to make new meanings; by exploring ways in which 'modern' can mean indigenous rather than westernized; or by choosing to work in the international arena, supposedly outside western and non-western dichotomies.

References

Deliss, C. (ed.) (1995) *Seven Stories about Modern Art in Africa*, London, Whitechapel Art Gallery.

Fosu, K. (1993) *Twentieth-Century Art in Africa*, Accra, Artists' Alliance (first published Zaria, 1986).

Jari, J. (1993) 'The search for a new African art', *The Eye: A Journal of Contemporary African Art*, vol.2, June, pp.1–5.

Okeke, C. (1997) 'Beyond either/or: towards an art criticism of accommodation', in *Art Criticism and Africa*, ed. K. Deepwell, London, Saffron Books.

Péri-Willis, E. (1998) 'Chambers of memory', in *El Anatsui: A Sculpted History of Africa*, London, Saffron Books, pp.79–8.

Picton, J. (ed.) (1997) *Image and Form: Prints, Drawings and Sculpture from South Africa and Nigeria*, London, School of Oriental and African Studies.

Preface to Case Study 9:
Liberated colonial others

CATHERINE KING

Case Studies 7 and 8 have provided two 'snapshots' of the debate about making modern art: in India *c.*1900–30 and in Nigeria *c.*1960–90. From the evidence surveyed, the key ideas seem to be the assertion of artistic development, inventiveness, and freedom. This is, generally, in relation to independence from western ascription or controls, but it is also, in some situations, a reaction to internal pressures arising from what were or are considered to be restrictive nationalist agendas.

The history of modern art in India and Nigeria can be viewed in positive ways. Artists in the two countries may be perceived as appropriating academic realism from the West and making it their own through adaptation to local uses and meanings. Equally, they can be regarded as demonstrating that modernity belongs to them, in making a new art for a new society with very selected reference to western art traditions (Nigeria) or, supposedly, with no reference at all (India). From an internationalist viewpoint, they can be seen as exercising the freedom to take from any art tradition and work for a global audience, thereby situating artists beyond imperial or post-imperial assumptions and standing aside from expectations that they should represent group cultural identities.

Each of these possibilities could also be interpreted negatively, depending on historical circumstances and viewpoints. For example, forms of academic realism could be seen as too dependent on western modes. New Indian Art could be thought of as influenced to too great a degree by colonial scholars and as being too tied to the past to be really free in inventiveness. Natural Synthesis could be criticized as too independent in its interest in local and African art forms, and as risking lack of development and allowing introspective confinement rather than freedom of choice. The internationalist outlook could, by contrast, be seen as too open, given that the global arena might be regarded as prone to western control.

The priority given to artistic development, inventiveness, and freedom suggests how important they are, in providing the possibility of walking out of the role of the subordinated 'other' – to become what Rasheed Araeen in the following and final case study calls 'liberated colonial others'. In the case of India and Nigeria, the emphasis seems to have been on dismantling the expectations that tended to treat the colonized and their heirs as an undifferentiated mass, trailing behind the ever-inventive and changing modernity of 'western' art. Artists in these countries wanted to assert the validity of their own judgements concerning their own changing requirements. They highlighted the importance of differences and similarities between various developing traditions of art-making, without regarding the West as contemporary norm, and indicated their willingness to enter the international arena on an equal footing, to treat others' creations as worthy of recording and of critical discussion.

The author of Case Study 9, Rasheed Araeen, who has worked as an artist in the United Kingdom since 1964, created an important forum to enable just this kind of global critical viewing and debate, in the journal *Third Text*, which he founded in 1987 to publish 'third-world' viewpoints. The concomitant of an inclusive art history and criticism is, in Araeen's view, a history of western modern art that includes the participation, from within the territory of the colonizers and their heirs, of those designated as 'non-western'. He considered this issue in the groundbreaking exhibition he entitled 'The Other Story' in 1989, when he gathered together a group of works by AfroAsian artists who have made art in the United Kingdom during the twentieth century. Although they had in his view 'engaged with the idea of modernity, post modernity, and its formations' (*The Other Story*, p.105), they had not been allowed to enter into the history of modern art in the United Kingdom:

> It is this entry which allows his or her work to be discussed seriously and to be recognized for its historical significance. What we face here is the dominant ideology of an imperial civilization for which the racial and cultural difference of the colonized constitutes Otherness. And of course the Other is part of its history as long as it stays outside the master narrative.
>
> (*The Other Story*, p.9)

In the following account of his artistic work, Araeen describes how he himself has so far been forbidden entry into the imperialist master narrative. Araeen sees the enterprise of making modern art as requiring the ability of individuals to liberate themselves from local, national, religious, or cultural prescriptions in order to make bold and unpredictable innovations. Freed from preconceptions, they may wish to make overt reference to cultural identities (Plate 183) or they may not (Plate 166). He considers that the institutions that control the production of modern art in the West in the post-colonial era (education, display, critical review, commissioning) have avoided accepting the descendants of the colonized as autonomous individuals. Instead, they define them as 'other', locked into their supposed communities of origin and designated as 'culturally different'.

Araeen suggests that western enthusiasm for 'cultural difference' and the benefits of a 'multi-racial' society since the 1960s may simply transpose earlier colonialist desires for separate development. Although the circumstances of artists working in and outside what Araeen calls the western 'citadel of modernism' are very different, the artists considered in Case Studies 7 and 8 share with him the enterprise of insisting on being treated as free agents (in so far as this may be regarded as possible), with the group and individual rights of self-definition that belong to the process of decolonization.

The artist as a post-colonial subject and this individual's journey towards 'the centre'

RASHEED ARAEEN

Introduction

What is a post-colonial subject? Is this a white/European 'self' who is somehow reluctant to come to terms with post-coloniality and realize his or her liberation from the legacies of an imperial past, or is it a liberated colonial 'other'? My concern here is with the latter, the post-colonial subject who is now supposed to have been displaced from his or her place of origin and is lost in the wilderness of global migration. Although I am dealing with the predicament of this subject, he or she cannot be separated from the white/European subject: both are entangled in a post-colonial struggle for redefinition.

Liberation from colonialism presupposes liberation from a past that was defined by colonialism and its view of history. The dynamic of this history denied the colonized people any creative place in it. It was therefore important for the liberated people to seize the dynamic of history again, its modernity, and locate themselves within it; and redefine their post-colonial subjectivity. However, this was not easy for the artists who wanted to enter the central space of modernism and deal with its most advanced ideas, as their newly independent countries were still suffering from the legacies of colonial under-development and lack of modern art institutions. The paradox is that they therefore had to leave their own 'liberated' countries and undertake a journey towards the very metropolis that was the centre of the West's colonial empire. It was there that they wished to realize their full creative potential and reclaim their place in history.

In this case study, which has two parts, I will attempt to deal with this paradox or problematic situation. In the first part, I will discuss some issues regarding the problems the post-colonial subject faces on entering 'the centre', the West, and trying to locate him- or herself within the history of modernism. The second part deals with an example – my own work as an artist – which shows how an artist from the periphery *can* locate him- or herself within the metropolitan centre, and thus confront the dominant theory of art, with its continuing colonial ideology, which underpins the eurocentricity of the mainstream art history of our modern times.

The post-colonial subject and the West

Some years ago, I was invited to a conference in Rotterdam, which discussed the invisibility in Europe of what were referred to as 'artists from other cultures'. The dominant view was that this was due to the inability of Europe to come to terms with cultural differences underlying these artists' works. I, on the other hand, argued that this view was based on ignorance of what

actually was produced by these artists, which had very little to do with cultural differences. On the contrary, many of these artists had left their own cultural milieus exactly in order to be in the modern metropolis and to explore, like their European contemporaries, new ideas and produce work that was new and significant in the context of the development of modern art in the twentieth century. But this created a problem for the West and its art institutions, which still maintained their eurocentric structures formed during colonialism, differentiating between the ruler and the ruled. The presence in post-war Europe of post-colonial artists, who had liberated themselves from colonial bondage, posed a challenge to this eurocentricity, and the only way the establishment in Europe could deal with this challenge was to ignore these artists. This fact was made clear in 'The Other Story', an art exhibition that I curated for the Hayward Gallery in London in 1989, but again its impact did not touch the intransigence of art institutions, which still saw post-colonial artists as being outside the mainstream history of British art.

The question now really is: why are art institutions in the West even today closing their eyes to the fact that the post-colonial artist has intervened in the genealogy of post-war developments in modern art and has thus contributed to these developments? Why is the history of modern art of the twentieth century still the history of art produced only by white European and North American artists? To be specific, why are the 'other' artists being denied their rightful place in it?

The dialectics of liberation from colonialism, whether political, economic, or cultural, demand that both the colonizer and the colonized liberate themselves at the same time. But, unfortunately, the West has not yet come to terms with this historical process; its institutions are still resisting a change in their structures and are thus maintaining an imperialist world view as part of the West's continuing political, economic, and cultural world domination. This has lead to a neo-colonial situation, mistakenly called post-coloniality, which does not recognize the liberated 'other' as a historical subject[1] – as part of the historically transforming processes of modernity.

However, the 'other' artists – who in general came from the West's ex-colonies in Africa, Asian, and the Caribbean, hence I will use the term 'AfroAsian artists' – could not be ignored forever. They had to be recognized as they had become part of European society, but to recognize them in the same way white/European artists are recognized would obviously disrupt the white genealogy of the history of modern art. Thus, art institutions faced, and they still face, a serious dilemma: how to recognize AfroAsian artists but without locating their work in the same historical paradigm as that of their white contemporaries, and at the same time make it appear that art institutions are not discriminating between white and non-white artists. The solution was to adopt a cultural theory that would connect the work of AfroAsian artists to the cultures they had originated from in Africa or Asia and then evaluate their significance in relation to their own traditions, while providing both white and non-white artists a common space for the circulation of their works.

The most disturbing aspect of this is that even post-colonial cultural theories that engage with art do not somehow recognize this problematic situation,

[1] In sociological theory, a historical subject is someone thought capable of taking an active role in shaping events.

and continue to privilege cultural differences as the basis of artistic practice by the post-colonial artist. It is no wonder that there is now so much talk about the 'in-between space' (see Homi Bhabha, *The Location of Culture*, pp.1–4), legitimated by the art institutions. This is a mythical space between the periphery and the centre through which the post-colonial artist must pass before he or she becomes a fully recognized historical subject. This has let the art institutions in the West 'off the hook' and provided them with a new framework – multiculturalism – by which the 'other' artist can be kept outside mainstream art history and at the same time promoted and celebrated on the basis of his or her cultural difference. In other words, multiculturalism is now a new institutional strategy of containment.

Thus, AfroAsian artists have now been pushed into a new marginality of multiculturalism, in which only the expressions of cultural differences are seen to be authentic. This is justified and legitimated on the basis of a desire by AfroAsian communities to preserve their own cultural traditions in the West. This desire is understandable, given the diasporic situation these communities feel themselves to be in. But why should this mean that individuals from these communities are necessarily trapped within this situation, and that they have been unable to experience the world outside their own cultural boundaries, particularly when these experiences are concerned with what leads to the production of art?

The problem with the policies of multiculturalism, or theories of cultural diversity, is that they have failed to address the main issue of art as an individual practice rather than an expression of community as a whole, or of art as an expression of a post-colonial subject who, in order to come to terms with his or her modernity, must to some extent free him- or herself from the constraints of a specific culture.

To be more specific, it is important not only to make a distinction between collective cultural manifestations of a community and individual production of art, but also to recognize that there may exist a problematic relationship between the collective and the individual, to the point of creating a rupture between the two. This has, since the Renaissance, been recognized in the case of the western individual, but this modern subjectivity has continued to be denied to the 'other' even after the philosophical basis on which the colonial separation between the 'self' and the 'other' was constructed has collapsed. In fact, there is no justification in maintaining this separation after the collapse of the West's colonial empire and the liberation of the colonized, particularly when there is now enough evidence that the post-colonial artist has entered the space that was once meant to be exclusively occupied by the white/European artist.

In the face of multiculturalism, which has provided an opportunity for many AfroAsian artists to pursue successful careers, but who, with success in the marketplace, show no concern with the issues I have raised here, the problem of institutional control and containment has now become very difficult to deal with. In fact, the artists who are now being promoted and celebrated in the West on the basis of their cultural differences are being used by the establishment as a shield against any attack on the policies of its art institutions.

However, I still maintain that the post-colonial artist has a historical responsibility to present a critical position with regard to imperialist assumptions, which should go beyond concern only for a successful career. It is not just about entry into the space that was previously forbidden and a demand for recognition, irrespective of the nature of the artist's work. This responsibility entails that, while we enter the system, we should confront the colonial legacies that continue to underpin its art institutions.

It is therefore important, for me, to persist in an artistic position that challenges all the colonial structures or frameworks, including the ones that are legitimated by post-colonial cultural theories. These structures predetermine, constrain, and control in particular the artistic practice of those who are now being defined as 'artists from other cultures'. In a global society in which the individual is an autonomous subject, a historically significant art (one that invents, and comments critically on events) cannot be produced by a theory that predetermines its specific cultural framework. The history of the last hundred years of modern art in particular shows that art produces its own framework at the point of its realization, determined not by *a priori* theory but by the specificity of its development at a particular point in history and the pursuit of the individual to further this development. The journey of the so-called 'other' artist from the periphery to the metropolitan centre has been part of a struggle to participate in this development, which demands a framework that is not constrained by specific cultural traditions or boundaries. But if this framework is not institutionally available to all artists, because of racial or cultural differences, then it is not only a violation of the basic human freedom to determine one's own ways or methods of expression but also a negation of the fact that those who were once colonized by the West are no longer colonial subjects but free agents of history and have the right to act as such.

From the periphery to the centre

I will now show you, through the example of my own work, that this journey of the 'other' artist towards the centre did not produce a loss, neither did it stop at the threshold of modernism, as is implied by some post-colonial cultural theorists, even when such a stoppage would have offered a lucrative career as an 'exotic' artist. On the contrary, this journey led the post-colonial artist into the centre, where it became possible for him or her to challenge, in the tradition of the avant-garde, and change the prevailing course of dominant art history.

For me, this journey begins at the place of my birth, which is in a country now called Pakistan. I would like to go through part of this artistic journey, which has not yet ended, and share with you its memories.

I was born in Karachi, Pakistan. In the mid-1950s, when I was 20, I came across modern art and became fascinated by it. But I had no idea then that this fascination would lead me to a life-long commitment to art. My ambition at the time was to become a modern architect, but there was no school of architecture in Karachi. And my parents were not rich enough to send me abroad for education. So I studied civil engineering, while continuing doing art as a hobby.

But in 1959, while I was still studying civil engineering, I began to produce experimental work in architecture, painting, and sculpture, the modernism of which surprised me. So I decided to be a professional artist. The ideas that underlie my early work in Karachi were seminal and remained the basis of my subsequent work over the last 40 or so years.

In the works I produced at this time (Plates 164 and 165), I was not only looking for a new form, unlike my contemporaries who were experimenting with borrowed western forms in order to produce modernist works, but I was also attempting to deal with what I had actually experienced in my environment. The first work was inspired by children playing hula-hoop (a subject that was not considered suitable for a painting), and the second was about a phenomenon that I had witnessed in my neighbourhood: old bicycle tyres being discarded by burning them on rubbish heaps.

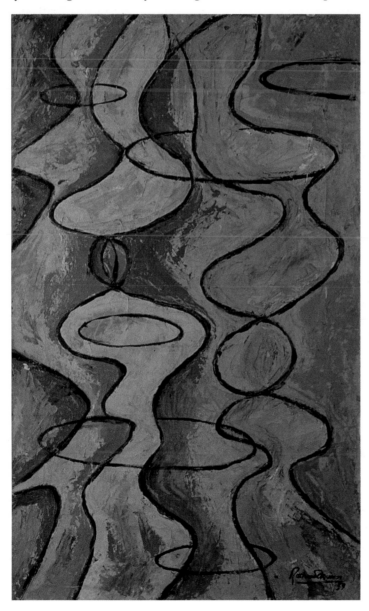

Plate 164
Rasheed Araeen,
*Ham Raqs
(Dancing
Partner)*, 1959,
oil on canvas,
40 x 60 cm.
Photo: by
courtesy of
Rasheed Araeen.

Plate 165 Rasheed Araeen, *Burning Bicycle Tyres*, 1959 (reconstruction 1975), fire, rubber, and steel, size variable. Photo: by courtesy of Rasheed Araeen.

Both these works are about transformation, in the sense that ordinary and banal encounters are transformed into works of art. But the second work, *Burning Bicycle Tyres*, is also involved in a material and conceptual process, in which two rubber tyres are burnt and transformed into four metal loops, which goes beyond the conventional way of making and looking at things.

I did these and subsequent works (Plate 166) in a cultural milieu that was dominated by the emerging post-colonial middle class that took pride in imitating whatever it could get from the West. This milieu also provided the basis for the development of modernism in Pakistan. The work of European artists working in the twentieth century, such as Picasso, Georges Braque, Henri Matisse, Marc Chagall, and Paul Klee, was the inspiration for most of my contemporaries in Karachi and also provided the criteria by which modern art in Pakistan was and is still being evaluated. Abstract expressionism, for example, came to Karachi in 1959 and immediately had its imitators, who are still working as successful artists.

Plate 166 Rasheed Araeen, *Untitled* (A1), 1961, ink on paper, 27.5 x 20 cm. Photo: by courtesy of Rasheed Araeen.

It was therefore very difficult for me to continue exploring new ideas in art and live as an artist in my own country. It became almost impossible to be innovative. So, in 1964, I decided to leave my country to live in Europe.

My destination was Paris, but on arrival there I found the city very difficult to cope with, particularly as I did not speak French, and so I decided to come to London. I found the art scene here so exciting that I decided to stay. It was an encounter with an environment that was new and intellectually inspiring, and I immediately felt that this was the place where I could realize my ambition to do something extraordinary.

As I have said, I was really excited by the art scene in London, but, when I saw the work of the sculptor Anthony Caro, my excitement turned into fascination (Plate 167). The way he used industrial material such as steel girders was an approach I had not seen before (I was then totally ignorant of the work of another twentieth-century sculptor, David Smith), and it put me on a path to become a truly modern sculptor.

Plate 167
Anthony Caro, *Early One Morning*, 1962, sculpture, 289.6 x 619.8 cm. Photo: by courtesy of Rasheed Araeen, printed by permission of the Trustees of the Tate Gallery, London.

However, despite my great fascination with Caro's work, I did not follow in his footsteps in the way some of his contemporaries followed him in the early 1960s. It was partly to do with my temperament, but I also did not have the material resources and expertise to do that kind of work, which turned out to be a good thing. Moreover, by 1965, the work of Caro and others was institutionally well established and had lost its critical edge. So I began to think how I could do something different, something more challenging; I was aware that if I wanted to do something new and significant I had to go beyond what was prevailing. But 'going beyond' is not easy; there is no logical way to arrive at something that could be a new breakthrough. One must have great patience and be able to seize the moment when it does happen, so I had to wait.

Meanwhile, I began to be critical of Caro's work. I began to feel uncomfortable with the way Caro *composed* his work. But that was not enough. It did not provide me with an alternative, until one day at the end of 1965, when I was working as an engineering assistant with British Petroleum's petrochemical section, I found myself drawing on paper equal size steel girders, which were arranged symmetrically. And that was it. I immediately realized that I had found what I was looking for. I did not, of course, understand its full significance immediately, except that the idea of making sculpture this way was new and challenging. Following the girder pieces, I developed a system based on the lattice structure that is commonly used in engineering, resulting in a series of works based on the symmetrical permutation of a single modular unit (Plates 168 and 169).

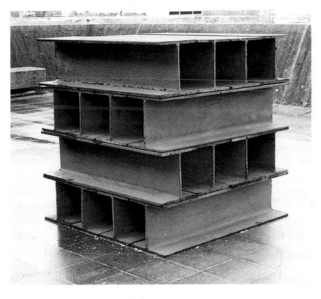

Plate 168 Rasheed Araeen, *Sculpture Number Two*, 1965/1987, painted steel, 120 x 120 x 120 cm. Photo: by courtesy of Rasheed Araeen.

Plate 169 Rasheed Araeen, *First Structure*, 1966–7/1987, painted steel, 137.5 x 137.5 x 137.5 cm. Photo: by courtesy of Rasheed Araeen.

Initially, I was following my intuition without any theoretical understanding of the work, but I did in time begin to realize that what I was doing challenged the prevailing concept of modernist sculpture, which continued to be compositional, pictorial, and hierarchical. I began to feel that it was time to free modern sculpture from gestural 'expressionism' and the irrationality of trial-and-error methods and to develop a new conceptual framework that would redefine it. It is now recognized that in the mid-1960s this kind of work represented a radical shift and a historical breakthrough, but this achievement is wrongly attributed only to American artists for reasons that I hope will be clear as I proceed further.

Why was the change from Caro's work to my work a radical shift and a historical breakthrough? This change is a very complex phenomenon, underlying a philosophical and ideological proposition. However, I will give a brief explanation.

Traditionally, particularly since the Renaissance, western art was based on asymmetric arrangements, which were achieved by dividing the flat surface of the canvas or sculptural space into unequal parts. This continued into the twentieth century even when art abandoned iconographic representation. With the exception of a very few works, such as some by the sculptor Constantine Brancusi, the painter Alexander Rodchenko, and perhaps the artist Max Bill, the whole development of modern sculpture – from Picasso to Smith, Caro, and Eduardo Chillida – was based on the idea of dynamic balance created by asymmetric composition, produced by the method of trial and error, by putting things here and there, the final result of which depended on the genius of the artist. This represented a particular philosophical idea or world view, according to which the world can only be constructed or defined by a heroic figure and in terms of its unequal parts. In other words, the dynamic of human society can only be realized by arranging its different parts hierarchically.

My own work, on the other hand, was conceived around an idea of symmetry, which thus rejected and challenged the idea of the hierarchical view of things. It also rejected the role of the artist as a 'shaman' whose touch was necessary in the production of art (in fact, my structures can be reorganized by the spectators or audience themselves). Underlying this was a philosophical proposition according to which things can and should be arranged symmetrically in order to recognize their equal status, with an implication that human society should be reorganized at its structural level on the basis of the equality of its members. Of course, I was aware that symmetry when *imposed* on society could also act as a homogenizing force, and thus prevent human individuals from acting differently and freely. I tried to deal with this problem by making the work respond to the movement of the audience or spectator; thus, the kinetic movement one experiences in the work becomes an expression of the human movement or action.

However, this work is symmetrical only at a conceptual and *structural* level. It also contains asymmetry, which can be experienced depending upon the position of the viewer in relation to the work. In fact, there is constant dynamic movement from symmetry to asymmetry and vice versa in the work when one moves around or in front of it.

Between 1965 and 1968, I carried on this work alone and in total isolation. During this time I did not personally know any artist in London, let alone any artist who was doing similar work. However, I was then not alone in my thinking, as I came to know later. There was a whole group of artists in New York who were involved in a similar pursuit, who in time became known as minimalists. When a culture or body of knowledge becomes global, it is not unusual for new ideas to emerge at the same time in different part of the world, and it should not be a surprise if minimalist thinking emerged in New York and London at the same time

However, my work has been compared, by many critics, with the minimalism of the American artist Sol LeWitt, as if to imply that I was influenced by him – which is factually untrue. Anyway, the resemblance here is superficial. The fundamental aspect of my structures is the use of the diagonal, which is absent in American minimalism. Moreover my work, unlike that of LeWitt, is not about the construction of a form, but involves reassemblages or rearrangements of found material, that is, the lattice structures that constitute our modern industrial environment (Plate 170).

Plate 170
Rasheed Araeen,
Char Yar, 1968,
painted wood,
90 x 180 x 180 cm.
Photo: by
courtesy of
Rasheed Araeen.

It is also important to remember that there was no movement called minimalism in 1965, let alone anybody in the United Kingdom who knew what was going on in New York in this respect. There were some individual artists in New York, such as Carl Andre, LeWitt, Robert Morris, and Donald Judd, who were doing work individually that displayed a common philosophy and conceptualization based on the idea of symmetry and permutation of modular units, and their works were subsequently put together on the basis of their commonalty and were historically termed 'minimalism'.

My own work, which by coincidence showed similar thinking and which was the United Kingdom's own contribution to what is now universally recognized as a historical development, has not been able to enter the history of minimalism, despite its unique originality.

My structural work had tremendous potential, sufficient for me to continue with it all my life, but I did not want to carry on doing the same kind of work so that it would become my signature tune, as it were. I have a tendency towards experimenting with new things, pushing the language of art to its breaking point. At the end of the 1970s, I thought it would be a good idea to take my ideas out of the enclosed studio or gallery space and subject them to an open environment, thus freeing them from the constraints of the conventional gallery. The open environment or space happened to be a large lake of water surrounding my studio in Saint Katherine's Docks, London, and the nature of this space demanded an entirely different conceptual approach from that of the work I had been doing in my studio; of course, what was required was something that would float. One day, I stopped on the small bridge that I had to cross to go to my studio and found myself contemplating over the water: suddenly the idea of floating discs was there (Plate 171).

The work that I made as a result comprised sixteen equal size, same colour, circular discs, forming a minimalist structure of 4 x 4. When this work was thrown onto the water, its formal structure was broken and dispersed over the water, its parts combining with the flotsam and jetsam and producing asymmetric configurations. While it maintained its symmetrical 4 x 4 structure conceptually, one could not see or experience it as such, neither could it be seen as a whole. One could see only a few discs at one time at one place, while all the sixteen discs were there together within the materiality of the work's space and conceptual frame. The word *chakras* means circles. In Hindu mythology, *chakras* are the fire circles that, by emerging from their primeval liquid state, gave birth to the universe. The connection here is incidental, or perhaps ironic.

Although my minimalist work was a response to what I encountered on my arrival in the United Kingdom, on close examination we find another connection. This has to do with the work I did between 1959 and 1962 in Karachi. It seems that the foundation for the work I did in London was already laid down, much before it was realized: the organic form of my early work was now transformed into a geometrical system (Plates 172 and 173).

My entry into and taking up a radical position in the history of modernism was due to my experience of myself as a free subject. But this created a problem for the dominant cultural theory and western art institutions. They could not accept the idea that a person from outside western culture could be a free agent of history and could, in fact, intervene by challenging prevailing ideas in a particular time in modern history and produce something that may represent a historical breakthrough. This problem is due to the fact that art institutions in the West, as I have explained before, have not yet abandoned the concept of art history and its 'Grand Narrative' that was established as part of the colonial world view, particularly the prevailing Hegelian model of art history according to which only a European could be an agent of artistic progress. Within this model, I had no place as a free agent but only as the 'other', whose role was to provide the European 'self' with an affirmation of his or her central role in (modern) history.

The realization that I was seen to be outside history was shattering for me. For some time, I lost all my self-confidence and the urge to create. I became a political activist with a belief that radical political activity was more effective

Plate 171 Rasheed Araeen, *Chakras* (*Waterdiscs*), 1969–70, painted discs and 16 colour photographs of discs in the water at Saint Katherine's Docks, London, each disc diameter 60 cm. Photo: by courtesy of Rasheed Araeen.

Plate 172 Rasheed Araeen, *Untitled* (B4), 1962, felt pen on paper, 27.5 x 37.5 cm. Photo: by courtesy of Rasheed Araeen.

Plate 173 Rasheed Araeen, *8bS* (A), 1970, painted wood, 180 x 387.5 x 37.5 cm. Photo: by courtesy of Rasheed Araeen.

than art in dealing with such a situation. Although my aim was to bring together art and politics, I soon realized that politics had its own rules and limitations, and seldom understood the complexity of an artistic endeavour and its importance. So I returned to artistic activity, realizing that there was an important struggle to be waged within art, not only in terms of questioning and changing the prevailing dominant framework of artistic practice, but also in finding a language that was not subservient to the dominant model, which was also free from the burden of merely representing what is understood by politics.

Although my early work, that is minimalist structures, was my important achievement and it also challenged the status quo, I felt unable at the time to deal with the multiplicity of my experiences in the United Kingdom within these structures. So I had to move on to something else.

Soon after I left the Black Panthers, a political organization of AfroAsian people in London whose main task was to confront and fight racism (of British society), I produced the work shown in Plate 174. It was the summer of 1973, when I was invited to take part in an exhibition in my local library. I accepted the invitation on the understanding that I would be allowed to do whatever I wanted to do during the exhibition without any interference or censorship from the organizers. Within this exhibition I placed a display, and the material of this display was changed every week for the four weeks of the exhibition's duration. The idea was not really to represent politics or produce political art, as has been commonly understood, but to develop a language that challenged the prevailing concept of art and the space in which it was exhibited, which had been depoliticized and privileged in favour of the status quo.

Plate 174 Rasheed Araeen, *For Oluwale*, 1971–3, 4 panels with newspaper clippings on hardboard, each panel 60 x 60 cm, 'Artists for Democracy', London, 1975. Photo: by courtesy of Rasheed Araeen.

Subsequently, my work went through many stages: it sometimes moved linearly and at other times in a to-and-fro manner. The struggle has always been to find a language that would express my own experiences of life, but at the same time to find ways to locate the work art-historically, not only in terms of an innovation but also as one that could maintain its challenge to the mainstream. Although by 1975 I had abandoned completely making minimalist work, there have always been references to this work in my subsequent performances, and such works as my photoworks and tape-slide pieces (Plates 175–179).

Plate 175 Rasheed Araeen, *Fire*, 1975, 24 black and white photographs, 180 x 180 cm. Photo: by courtesy of Rasheed Araeen.

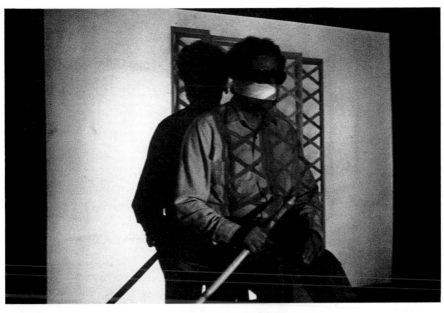

Plate 176
Rasheed Araeen,
Paki Bastard, 1977,
a performance
with slide
projection and
sound, first
performed at
'Artists for
Democracy',
31 July 1977.
Photo: by
courtesy of
Rasheed Araeen.

Plate 177
Rasheed Araeen,
Burning Ties,
1976–9, colour
photographs, 4 of
8 panels, each
panel 75 x 50 cm.
Photo: by
courtesy of
Rasheed Araeen.

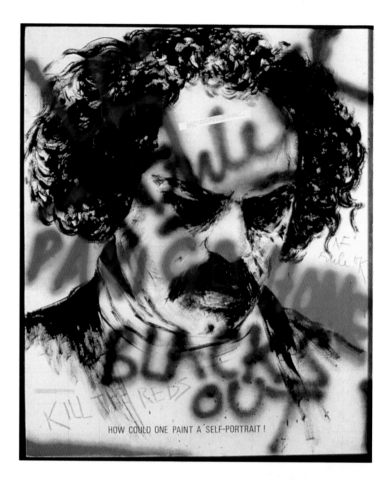

Plate 178
Rasheed Araeen,
*How Could One
Paint a Self-
Portrait!*, 1978–9,
mixed media,
120 x 100 cm.
Photo: by
courtesy of
Rasheed Araeen.

Plate 179 Rasheed Araeen, *Ethnic Drawings*, 1982, drawing on cardboard, 4 panels, each panel 77.5 x 52.5 cm, Collection of the Arts Council of England. Photo: by courtesy of Rasheed Araeen.

However, in the early 1980s, I developed a language or form that recycled and engaged with minimalism – not only my own work but the concept of minimalism – through a methodology of deconstruction, which involved parody, irony, and sarcasm. It expresses the multiplicity of one's being in a world that is no longer rigidly demarcated according to national or cultural boundaries, in opposition to the dominant system which would like to contain one's experiences within a space that is defined by specific cultural roots or origins.

This work, which comprises nine panels put together in 3 x 3 arrangement, is not a simple juxtaposition of western or eastern icons, as some critics in the West have implied, but is the result of cutting, rupturing, and polluting the purity of the dominant paradigm. First, I make a rectangular minimalist space or panel, often painted green (an allusion to, for example, nature/raw/ young/immature – all these words are taken from an English dictionary), which is cut vertically and horizontally, and then I move the four panels apart forming an empty space or cruciform. This cruciform is filled with material that is incongruent to the purity of minimalism. What is most important in this work is not merely the meaning of iconic images but their spatial location within the whole configuration. In other words, the sacred is polluted and turned into something whose significance can only be understood in terms of a penetration of one reality into another (Plates 180–182).

Plate 180 Rasheed Araeen, *Green Painting No. 2*, 1988–92, colour photographs, newspaper clippings, and acrylic on canvas, 167.5 x 226.25 cm, Fukuoka Art Museum, Japan. Photo: by courtesy of Rasheed Araeen.

Plate 181 Rasheed Araeen, *White Stallion*, 1991, colour photographs, collage, acrylic on plywood, 162.5 x 197.75 cm, Imperial War Museum, London. Photo: by courtesy of Rasheed Araeen.

Plate 182 Rasheed Araeen, *Oh Dear, Oh Dear, What a Mess You Have Made!*, 1994, vinyl emulsion on 5 cardboards and acrylic on 4 plywoods, 182.5 x 274.5 cm. Photo: by courtesy of Rasheed Araeen.

Besides the wall pieces which I have described above, I have also done some installation works, the forms of which were determined by the specificity of the space in which these installations – both physical and cultural – were located. One in particular is a billboard work that was commissioned in 1990 by the Artangel, an organization in the United Kingdom that sponsors artworks. This work, called *The Golden Verses*, was shown at about 20 different sites in London, as well as in the United States, Germany, and recently in South Africa (Plate 183). It comprises an Urdu calligraphic text superimposed on the image of an oriental carpet. The text reads:

WHITE PEOPLE ARE VERY GOOD PEOPLE. THEY HAVE VERY WHITE AND SOFT SKIN. THEIR HAIR IS GOLDEN AND THEIR EYES ARE BLUE. THEIR CIVILISATION IS THE BEST CIVILISATION. IN THEIR COUNTRIES THEY LIVE LIFE WITH LOVE AND AFFECTION. AND THERE IS NO RACIAL DISCRIMINATION WHATSOEVER. WHITE PEOPLE ARE VERY GOOD PEOPLE.

Plate 183
Rasheed Araeen, *The Golden Verses*, 1990, multicolour commercial print, installation, 300 x 600 cm, Jamaica Road, London, 1990. Photo: by courtesy of Rasheed Araeen.

Although the work is composed of the calligraphy and the carpet, which are stereotypical representations of Islamic culture in western culture, it turns the tables by incorporating the stereotypical image of western people (blonde with blue eyes) disguised in the calligraphy of the Urdu text. Most non-Urdu-speaking people thought this represented verses from the Qur'an. The work confused many people, and generated a violent response in the form of vandalism: in Cleveland, the work was burned down by an Asian group; in Germany, it was attacked by neo-Nazis with a scrawl of a swastika on it; in London, it was scribbled with graffiti by the National Front, with the words 'What's It All About, Bongo!'

This work is not about white people, neither merely a sarcastic representation of them (as understood by critics) nor a praise of white people (as understood by some Asians). It essentially deals with stereotypes in western culture, both of other cultures as well as the West's own stereotype of itself. While the stereotypes of the others keep them in a frozen or suspended state, the image

the West has created for itself is not only promoted as a privileged or superior concept of beauty but it also serves an imperial function to differentiate between the colonizer and the colonized. The work destabilizes our perception of things imposed upon us by the dominant linguistic and conceptual system.

In conclusion, I would like to present two more areas of my work which I have been pursuing since the early 1990s. I was in Karachi when the Gulf War started. While watching the bombardment of war images on CNN, the international television news network based in Georgia, Atlanta, I began to realize the growing power of globally expanding information technology, particularly in the form of satellite television. Soon after I returned to London, I set up an installation work at The Central Space in London, in which I used four television sets. The Space was filled with six inches of sand, on which were placed two of my 1960s sculptures, one arranged in the original manner on which were placed four television sets facing each other, the other fragmented and scattered around. The television sets showed live programmes broadcast from four different channels (Plate 184). Since the war was still on, the broadcast of it on one of the television sets became part of the work. The work, *What's It All About, Bongo?* (a reuse of the graffiti scribbled on the billboard work described above), as described by critic Paul Overy:

> is a much more complex work, densely layered and mapped over with different meanings, relating not only to the recent military adventure of the West, but directing the viewer back and forward in time through the artist's own career and its reception, disclosing and attempting to forestall the appropriation of and anaesthetisation of the Other.

('Rasheed Araeen', pp.22–3)

Plate 184 Rasheed Araeen, *What's It All About, Bongo?*, 1991, sand, sculptures, calligraphic frieze, and 4 television sets broadcasting live programmes from 4 channels, installation, The Central Space, London. Photo: by courtesy of Rasheed Araeen.

I do not want to add anything to Overy's interpretation except to say that the multilayering he refers to alludes to a juxtaposition of my personal history and its achievement with the destruction of Iraq. The cause of the Gulf War was not that Iraq was being ruled by a cruel dictator (who was the West's own creation), or that he had attacked and occupied a neighbouring country, but that Iraq had the ability and capacity – both material and cultural (its modernity) – to defy the West.

Since doing the work shown in Plate 184, I have done a series of works that incorporate live television broadcasts directly from available television channels. In other words, I 'steal' television programmes and use them as ready-mades, the images alluding to the tradition of western art that is based on iconographic representation. Sometimes both the images and the sounds are there, forming an unnerving cacophony in the case of multiple broadcasts. When I turn the sound off, the images are reduced to an absurd silence.

No Big Tragedy (Plate 185) is constructed inside the framework of minimalism (recalling the grid-like sculptures of Judd), comprising four sections of gold-painted bricks (using modular arrangements such as those of Andre) surrounding a live broadcast from a television channel in Japan and forming the central cruciform, the corner boxes of which are empty and are painted green. This work was conceived just before the end of Apartheid in South Africa – black, gold, and green colours allude to the African National Congress's flag, and are now part of South Africa's new flag.

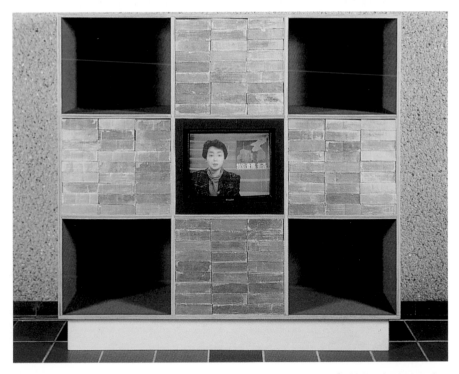

Plate 185 Rasheed Araeen, *No Big Tragedy*, 1991–3, plywood shelf, bricks painted gold, acrylic paint, and a television set broadcasting a live programme, 196.1 x 203.1 x 52.5 cm, Fukuoka Art Museum, Japan. Photo: Fujimoto Kempachi.

While trying to critique and disrupt the purity of minimalism, an approach that by now must have been obvious to you, I have also been trying, since 1990, to deconstruct minimalist sculpture without the use of iconic images. A recent example of such work, *To Whom it May Concern*, comprising a cube made of used scaffolding bars, was installed at the Serpentine Gallery, London in November to December 1996 (see the two views of the work shown in Plates 186 and 187).

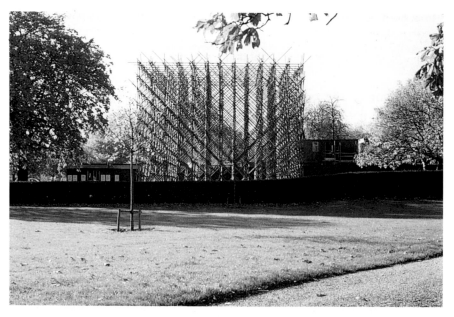

Plate 186 Rasheed Araeen, *To Whom It May Concern*, 1996, used scaffolding bars, installation, 450 x 375 x 375 cm, Serpentine Gallery, London, October–November 1996. Photo: by courtesy of Rasheed Araeen.

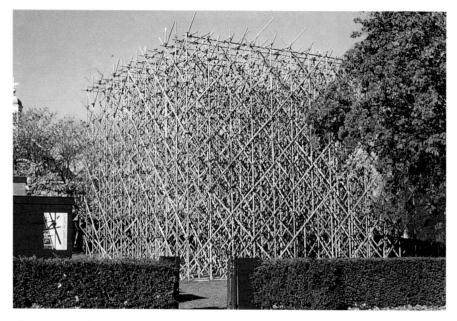

Plate 187 Rasheed Araeen, *To Whom It May Concern*, 1996, used scaffolding bars, installation, 450 x 375 x 375 cm, Serpentine Gallery, London, October–November 1996. Photo: by courtesy of Rasheed Araeen.

While talking to a friend I explained this work as follows:

> My Serpentine piece was a result of very long gestation, going back 10 to 15 years, if not more. Its self-referentiality is part of a suppressed history, and that is why it may be difficult to comprehend its full significance. The work refers to a history with an aim to recover it, not nostalgically but through a continuing process whose new materiality and temporality put it in a different historical time. The change represents a critical shift from the utopianism of my 1960s minimalist work, its presupposition of being in the mainstream, to an awareness of the problematic of its location within the system which remains indifferent to its legitimate historical position … The title of the work, *To Whom It May Concern*, is therefore ironic. I'm aware that I do not have a recognized position *vis-à-vis* the history of minimalism, but at the same time I cannot relinquish my claim to it.

I would like to conclude by saying that my text here represents only a commentary. It does not deal with the complexity of the work, which contains multilayered references to art history, to the works of other artists, to my own personal history, to my constant travelling between London and Karachi where my mother still lives. I have spoken as an artist about my own work, which is not really the way to understand its full significance; its complexity can only be disentangled through a debate and discussion of the work within the mainstream critical theory and its historical space, which have so far been denied to me. My work has developed and has lived in opposition to an institutional position, but it also has a paradoxical position in the sense that the work will attain its historical significance only when it receives an institutional legitimation. But this is a paradox whose dialectic can bring about a profound change in our perception of modernism in art and its history. We may come to see that modernism is no longer a monopoly or creation of the West and its white people, but is now the result of the creativity of different peoples from all over the world, irrespective of their cultural roots or origins or where they live.

References

Bhabha, H. (1994) *The Location of Culture*, London and New York, Routledge.

Overy, P. (1991) 'Rasheed Araeen', *Art Monthly*, April, pp.9–10.

The Other Story (1989) exhibition catalogue, London, South Bank Centre, Hayward Gallery.

Conclusion: 'Partners in a world that they invent every instant'[1]

CATHERINE KING

The dominant, western views of difference held during the European colonial past tended to represent the art of the colonized as inferior, and as either inalterable or changing in ways that were not the same as the progressive ways in which the art of the West developed. In Case Study 2, for example, Colin Cunningham showed how James Fergusson represented Indian art as decaying after an early period of prowess, and as never, even at its greatest, having equalled the art of ancient Greece and Rome. In Case Study 4, Partha Mitter demonstrated that Fergusson was just one scholar among a succession of Europeans who used this metaphor. Mitter related these views to nineteenth-century European theories of 'race'. According to these theories, the ancient art of India was the product of a 'pure', superior, Aryan 'race', who had intermarried with the 'inferior' peoples already inhabiting India, with disastrous 'hybrid' results.

Different views of cultural diversity have been pursued by the colonized, their descendants, and their advocates. Some have agreed with the essentialist idea that cultural differences are inalterable, but have 'turned the tables' by asserting that the innate abilities of the formerly colonized peoples were equal or superior to those of the colonizers and their descendants. We referred to such ideas in Case Study 8, in the views of President Senghor on the pre-colonial history of African art.

Some scholars have refuted the idea that the colonized were artistically inferior. They argued that it was the intervention of European colonists that caused decline in the arts of colonized peoples. In Case Study 3, for instance, we considered this type of interpretation by Ananda Kentish Coomaraswamy with regard to Rajput painting and Sri Lankan art. Coomaraswamy did not argue from an essentializing point of view. As child of a so-called 'mixed' marriage, he was a hybrid himself. However, he did believe, as an Indian nationalist, that British imperialism had wrecked the institutions that trained artists and provided the audiences and patrons that had made Indian and Sri Lankan art creative.

In gauging the 'ripple effect' of imperialist forms of appraisal, we have also discussed the way in which European scholars tended to interpret the past art of areas that remained outside direct colonial control. In Case Study 5, Craig Clunas examined approaches to the art forms designated 'Chinese'. He showed that 'Chinese art' was treated as relatively static and backward looking. Clunas speculated on the reluctance of European viewers to compare the way artists in China had drawn inspiration from their past to the way European artists had looked to their forbears in the classical tradition.

The western idea that the art of the colonized was different and inferior, rather than different but equal (like, for example, French, German, and Italian art)

[1] Hassan Musa, in Deliss, *Seven Stories*, p.241.

also had repercussions when it came to dominant attitudes towards the making of art by the colonized during and after colonization.

As Tim Benton points out in Case Study 6, the issue of hybridity could resurface in interpretation of artwork made in colonized areas. He highlighted the belittling of the Brazilian artist António Francisco Lisboa by some historians because of his Afro-European origins. Benton contrasts these views with positive valuations of hybridity by the Brazilian historian Gilberto Freyre. Freyre had argued that Lisboa was enabled to take the initiative in founding Brazilian art by virtue of his Afro-European birth. For Freyre, it was hybridity that was of value, since he thought Brazil had become strong through the intermixing of different peoples.

Contemporary art made by the colonized could be represented by western observers as dependent on, and imitative of, that of colonizers. We looked at the way in which efforts to rebut such accusations helped shape the debate about the course of modern art in India before colonial withdrawal (Case Study 7). In addition, we analysed the extent to which artists working in Nigeria before and after self-government also appear to have felt the need to insist on independence and originality (Case Study 8). These two case studies suggest the extent to which pervasive colonial assumptions could provoke reactive strategies.

As indicated by Rasheed Araeen in Case Study 9, the heirs of colonized peoples making modern art in the metropolis of the colonizers could also be treated as less capable of independent invention than their 'white contemporaries'. The descendants of the colonized in Europe were not regarded as artists who just happened to have, for example, African ancestors and might or might not wish to draw on a sense of this identity. Rather, they were only acceptable when they were defined as culturally different, and could be enthused over as being part of a multicultural or cross-cultural community. In Araeen's view, 'non-white artists' were being placed in a ghetto of cultural hybridity, and were not accepted as artists with the kind of freedom from cultural ties accorded to European artists. Araeen looks forward to 'a global society in which the individual is an autonomous subject'.

In Case Study 1, Gavin Jantjes reported a somewhat similar experience to that of Araeen. He was disappointed on being expected in Europe to paint like an African rather than being asked how he wished to represent himself and his views on art. However, Jantjes argued that the concept of hybridity could be used to advantage. He maintained that cultural intermixing is a feature of all societies, that diversity and syncretism are essential to human creativity and not the prerequisite of the art of those termed 'other'. If all artistic developments including those in Europe were seen as hybrid, assumptions of unbridgeable difference between non-Europeans and Europeans would dissolve. In his view, all artistic traditions can be regarded in terms of ethnicity: 'Europe can now be seen to be examining itself in the same manner it once examined others, questioning its ethnicity, sexuality and the cross-cultural referencing of its identity.' All artists are considered to make art in terms of a particular experience made up of their ideas of community past and present, without being contained by that experience.[2]

[2] These ideas are pursued further by Stuart Hall, in 'New ethnicities', in *Black British Cultural Studies*, pp.163–73.

This book has discussed a variety of ways in which art historians have interpreted and evaluated the art of the colonized and of their descendants. It is important to stress that these interpretations were often linked with assumptions about the superiority of western definitions of art and western ideas about the sorts of people who could properly be called artists.

We can trace the development in western Europe from the sixteenth century onwards of the elevation of sculpture, architecture, and painting to the status of 'high arts'. These were designated as 'fine arts' because they were said to play important roles in society: in representing moral and spiritual ideals and in creating worthy buildings for housing religious and state institutions. Artists were considered to need academic training and innate personal talent. They were contrasted with anonymous workshop- and household-trained craft workers, who were said to need only the manual skills possessed by anyone. Artists were considered to require gifts of imagination and intellect, which were not required for making 'decorative' or 'useful' arts. Elements of these beliefs continue to play a part in definitions of art in western texts in the twentieth century. For instance, the phrases 'material culture' and even, perhaps, 'visual culture' may be seen as new names with similar connotations to the older categories of 'minor arts' and 'crafts'. The point I want to make here is that these ideas about art and artists were historically produced. They arose in a particular sequence of societies. They are not fixed categories that always existed somewhere in the realm of ideas, whose truth has been discovered by the West.

The designation of particular kinds of artist as the only ones worthy of the name is arguably a counterpart to biological essentialism. Like essentialism, it may be an understandable position to take, but on balance it can only close off the possibilities for what art and artists may wish to become anywhere, any time in the future, and what future historians may wish to study as art. As a consequence, for instance, the whole of European art history before the mid-sixteenth century, and the art of the rest of the world until recently, could be seen as belonging to a secondary category of art history. In the Preface to Case Study 5, we saw Clunas rebutting such fixed definitions. He did not consider 'the concept of a work of art as a type of thing, a pre-existent category'. Rather, he preferred to treat the concept as entailing 'a fluctuating manner of categorizing that is historically and socially specific and contested'.

In Case Study 5, Clunas explored some of the ways in which artists defined art in China at different periods. For example, some artists in China had assumed a hierarchy in the visual arts. However, it was almost the reverse of that proposed in Europe in the sixteenth century. Amateur artists making landscape paintings were regarded as having higher status than academically trained artists who made narrative history painting. Because of the associations of poetry, painting, and calligraphy at this time, the differences assumed between the visual and the literary arts at some periods in Europe were inapplicable. Whereas some writers had called poetry *like* painting in Europe, some artists in China thought poetry had the same origin as painting. Such analyses underline the fact that western assumptions about differences between arts (say literature and art) are as contingent, that is to say historically specific, as differences within the visual arts.

In this book, we have noted the kinds of closure associated with fixed attitudes to art. In Case Study 2, for example, Cunningham pointed to the way Fergusson concentrated on buildings for governmental and religious purposes and ignored gardens (too decorative) and step wells (too utilitarian). In Case Study 3, we saw how Coomaraswamy criticized western ideas of high art but set in their place equally fixed views as to the superlative value of workshop- and household-training and corporate production of art.

In Case Study 6, Benton explored the difficulties in asking the seemingly innocent question 'Was Aleijadinho an architect?' Benton showed how many of the tasks we now consider the job of the architect were divided among different artists in eighteenth-century Brazil. He also highlighted the way the training and activities of figurative sculptors merged into those of masons, so that architecture and sculpture interlocked. On a personal level, in Case Study 7, we saw that Rabindranath Tagore regarded his poetry and his picture-making activities as closely related. Finally, in Case Study 8, we found that artists in Nigeria, such as Bruce Onobrakpeya, appropriated some western ideas about the importance of academic training, but that they regarded college-based art as equal to workshop and household arts, not superior.

We have sampled some of the ways in which views of difference have underpinned different interpretations of art history and different definitions of art. The issues we have looked at are not only of interest to historians and critics. They are of active and ongoing concern to artists. I therefore want to end with just two examples of art, both made in the United Kingdom, in which these issues are central.

In 1988, in *Talking Presence* (Plate 188), Sonia Boyce made a melancholy satire with reference to the representation of colonized peoples as exotic savages.

Plate 188 Sonia Boyce, *Talking Presence*, 1988, mixed media on photographic paper, 165 x 122 cm. Courtesy, Sonia Boyce.

Plate 189
Yinka Shonibare, detail
of *How Does a Girl Like
You, Get to Be a Girl Like
You*? (Plate 14).

Her collage invites the viewer to consider the viewpoints of a man and a woman who are shown as if in the privacy of their living-room gazing calmly at the jumble of the London skyline with its symbols of authority (Saint Paul's Cathedral, the Houses of Parliament, Tower Bridge). Although the figures of the people are restful, and might appear acquiescent, the title, *Talking Presence*, suggests that as representatives of the black community they are no longer mute. Boyce seems to be asking us to think about what people who have been for so long the silent observers of western domination might be saying about what these figures see before them. The objects at the centre of the picture (the shells and ship above) might indicate the journeys of the colonized and colonizers.

Yinka Shonibare's work is more jocular yet perhaps no less analytical. He has drawn attention to western distinctions between textiles and fine art in his art works (Plate 189).

Here the choice of material also alludes to the rich interchanges of global culture, which have produced cloth whose history derives from Indonesian, West African, and European roots intertwined. In addition, Shonibare explained that in employing these textiles to make Victorian dresses he wanted to emphasize that both the colonizers and the colonized could now be studied ethnographically.[3] It is the argument of this book that the art of both the colonized and the colonizers can be studied art-historically too.

References

Deliss, C. (ed.) (1995) *Seven Stories about Modern Art in Africa*, London, Whitechapel Art Gallery.

Hall, S. (1996) 'New ethnicities', in *Black British Cultural Studies*, ed. H.A. Baker, M. Diawara, and R.H. Lindeborg, University of Chicago Press, pp.163–73.

[3] Yinka Shonibare, in an interview for the BBC/OU programme, *West Africa: Art and Identities*, October 1997, A216 TV 6.

Recommended reading

The following list includes books of general interest that are relevant to the overall themes of this book:

Baker, H.A., Diawara, M., and Lindeborg, R.H. (1996) *Black British Cultural Studies*, University of Chicago Press.

Deepwell, K. (ed.) (1998) *Art Criticism and Africa*, London, Saffron Books.

Harle, J.C. (1986) *The Art and Architecture of the Indian Subcontinent*, New Haven and London, Yale University Press and London, Pelican History of Art.

Hiller, S. (ed.) (1991) *The Myth of Primitivism: Perspectives on Art*, London and New York, Routledge.

Picton, J. and Mack, J. (1989) *African Textiles*, London, British Museum Publications.

Richard Blurton, T. (1992) *Hindu Art*, London, British Museum Press.

Said, E.W. (1991) *Orientalism: Western Conceptions of the Orient*, Harmondsworth, Penguin (first published 1978).

The following list includes works that relate to specific case studies in this book:

Case Study 1

Jantjes, G. (1997) *A Fruitful Incoherence*, London, Iniva.

Case Study 2

Davies, P. (1989) *The Penguin Guide to the Monuments of India. Volume II: Islamic, Rajput, European*, Harmondsworth, Penguin.

Guy, J. and Swallow, D. (eds.) (1990) *Arts of India 1550–1900*, London, Victoria and Albert Museum.

Koch, E. (1991) *Mughal Architecture*, Munich, Prestel.

Michell, G. (1989) *The Penguin Guide to the Monuments of India. Volume I: Buddhist, Jain, Hindu*, Harmondsworth, Penguin.

Watson, F. (1979) *India: A Concise History*, London, Thames & Hudson.

Case Study 3

Archer, W.G. (1973) *Indian Paintings from the Punjab Hills*, London, Sotheby Parke Bernet.

Lipsey, R. (1977) *Coomaraswamy: His Life and Work*, 3 vols, Princeton University Press.

Case Study4

Mitter, P. (1977) *Much Maligned Monsters: A History of European Reactions to Indian Art*, Oxford University Press.

Pick, D. (1989) *Faces of Degeneration*, Cambridge University Press.

Said, E.W. (1993) *Culture and Imperialism*, London, Chatto & Windus.

Case Study 5

Bush, S. and Shih, H. (1985) *Early Chinese Texts on Painting*, Cambridge, Mass. and London.

Clunas, C. (1991) *Superfluous Things: Material Culture and Social Status in Early Modern China*, Cambridge, Polity Press.

Clunas, C. (1996) *Fruitful Sites: Garden Culture in Ming Dynasty China*, London, Reaktion Books.

Clunas, C. (1997) *Art in China*, Oxford University Press.

Clunas, C. (1997) *Pictures and Visuality in Early Modern China*, London.

Case Study 6

Bazin, G. (1963) *Aleijadinho et la sculpture baroque au Brésil*, Paris, Vevey.

Case Study 7

Guha-Thakurta, T.G. (1992) *The Making of a New 'Indian' Art: Artists, Aesthetics and Nationalism in Bengal, c.1850–1920*, Cambridge University Press.

Mitter, P. (1994) *Art and Nationalism in Colonial India 1850–1922: Occidental Orientations*, Cambridge University Press.

Robinson, A. (1989) *The Art of Rabindranath Tagore*, London, Deutsch.

Case Study 8

Deliss, C. (ed.) (1995) *Seven Stories about Modern Art in Africa*, London, Whitehapel Art Gallery.

Fosu, K. (1993) *Twentieth-Century Art in Africa*, Accra, Artists' Alliance.

Ottenberg, S. (1997) *New Traditions from Nigeria*, Washington, D.C., Smithsonian Institute Press.

Case Study 9

The Other Story (1989) exhibition catalogue, London, South Bank Centre, Hayward Gallery.

Index

Page numbers in italics refer to illustrations.